MW00577278

AUTHORIZING SUPERHERO COMICS

STUDIES IN COMICS AND CARTOONS

Jared Gardner, Charles Hatfield, and Rebecca Wanzo, Series Editors

AUTHORIZING SUPERHERO COMICS

On the Evolution of a Popular Serial Genre

DANIEL STEIN

THE OHIO STATE UNIVERSITY PRESS

COLUMBUS

Copyright © 2021 by The Ohio State University.
All rights reserved.

The various characters, logos, and other trademarks appearing in this book are the property of their respective owners and are presented here strictly for scholarly analysis. No infringement is intended or should be implied.

Library of Congress Cataloging-in-Publication Data is available online at http://catalog.loc.gov.

Identifiers: ISBN 9780814214763 (cloth) | ISBN 9780814258026 (paper) | ISBN (9780814281437 (ebook) | ISBN 9780814281468

Cover design by Christian Fuenfhausen
Text composition by Stuart Rodriguez
Type set in Palatino Linotype

For Paul

CONTENTS

ILLUSTRATIONS

ACKNOWLEDGMENTS

This book started with an application for an interdisciplinary research unit called "Popular Seriality—Aesthetics and Practices." Spearheaded by Frank Kelleter, it was funded by the German Research Foundation in 2010. Part of this unit was a collaborative project on authorization practices in superhero comics, which brought forth the coauthored essay "Autorisierungspraktiken seriellen Erzählens: Zur Gattungsentwicklung von Superheldencomics" (2012) and laid the groundwork for the argument presented in this book. I greatly appreciate Frank's personal and professional support throughout the years, and I remain deeply indebted to his stellar scholarship. I also think back fondly to the intense spirit of common purpose and interdisciplinary inspiration that made the research unit a formative experience. I want to thank all members and associated members from the first (2010–2013) funding phase, when many of us were based at the University of Göttingen, and the second phase, when some of us moved to the John F. Kennedy Institute for North American Studies at Freie Universität (2013–2016) before I found my current institutional home at the University of Siegen: Birgit Abels, Regina Bendix, Ilka Brasch, Felix Brinker, Shane Denson, Heinrich Detering, Lukas

Etter, Fabian Grumbrech, Christine Hämmerling, Christian Hißnauer, Stephanie Hoppeler, Frank Kelleter, Nathalie Knöhr, Irmela Marei Krüger-Fürhoff, Martin Lampprecht, Gerhard Lauer, Britta Lesniak, Kathleen Loock, Tonia Sophie Müller, Kaspar Maase, Ruth Mayer, Christina Meyer, Mirjam Nast, Gabriele Rippl, Stefan Scherer, Sabine Sielke, Bettina Sollor, Claudia Stockinger, Andreas Sudmann, Maria Sulimma, Bärbel Babette Tischleder, Lisanna Wiele. The research unit was a highly productive environment and brought several wonderful fellows into our orbit: Jason Mittell, Sean O'Sullivan, Julia Leyda, John Durham Peters, William Uricchio, Constantine Verevis, and Robyn Warhol. At the events we organized in those years, I also had the pleasure of connecting with scholars whose work I admire and who offered valuable insights and advice: Will Brooker, Henry Jenkins, Jared Gardner.

Beyond the research unit, I have profited from the expertise and friendship of many coeditors of comics-related publications: Michael A. Chaney, Stephan Ditschke, Micha Edlich, Lukas Etter, Katerina Kroucheva, Andreas Rauscher, and Jan-Noël Thon, as well as (once more) Shane Denson and Christina Meyer. The same is true for the African Atlantic Research Group (AARG), headed by Martin Lüthe and Robert Reid-Pharr, which has become another home away from home and provides the perfect context for my growing interest in black superheroes: Gigi Adair, Herman Bennett, Rebecca Brückmann, Claudia Crowie, Dominique Haensell, Frank Kelleter (once again), Tavia Nyong'o, Anke Ortlepp, Khary O. Polk, Michael L. Thomas, Gary Wilder, Dagmawi Woubshet. At the University of Siegen, I have found a productive space that allowed me to finish this book. First and foremost, the grant-writing activities for the Collaborative Research Center "Transformations of the Popular" (funded by the German Research Foundation starting in 2021) connected me with many colleagues across disciplines. Thanks are due especially to Niels Werber, Jörg Döring, Veronika Albrecht-Birkner, Carolin Gerlitz, Thomas Hecken, Florian Heesch, Anne Helmond, Joseph Imorde, Maren Lickhardt, Johannes Paßmann, Niels Penke, Cornelius Schubert, Matthias Schaffrick, Jochen Venus, and the rest of the team, as well as Jason Dittmer, who came to Siegen as a Bollenbeck fellow in 2017 to discuss superheroes and politics. I also want to thank my colleagues in the literature and culture section of our English department: Katrin Becker, Alessandra Boller, Lukas Etter, Christopher Hansen, Marcel Hartwig, Anja Müller, Natalie Roxburgh, Felix

Sprang, and Lisanna Wiele, as well as our secretary Anne Weber and Ute Wagner at the dean's office. Beyond Siegen, I have benefited from my membership in academic institutions, from the American Studies Association and the German Association for American Studies to the Comics Studies Society and the Gesellschaft für Comicforschung. I also thank the many colleagues who invited me to contribute essays and book chapters to edited collections and special journal issues.

One of the reviewers of the manuscript version of this book asked for a contextualization of the argument presented in the following pages with my other work on superhero comics, which makes sense since these other publications circulate like satellites around this book. Several essays were originally conceived as chapters but ended up as independent pieces, sometimes for pragmatic reasons and sometimes for thematic considerations. I did include an extended version of "Superhero Comics and the Authorizing Functions of the Comic Book Paratext," initially written for a volume titled *From Comic Strips to Graphic Novels: Contributions to the Theory and History of Graphic Narrative,* coedited with Jan-Noël Thon (De Gruyter, 2013), which became chapter 1. The case studies presented in "Mummified Objects: Superhero Comics in the Digital Age," published in the special issue *Materiality and Mediality of Contemporary Comics* of the *Journal of Graphic Novels and Comics* 7.3 (2016; ed. Jan-Noël Thon and Lukas Wilde) became part of chapter 4, while the opening paragraphs of "Spoofin' Spidey—Rebooting the Bat: Immersive Story Worlds and the Narrative Complexities of Video Spoofs in the Era of the Superhero Blockbuster" (*Film Remakes, Adaptations and Fan Productions: Remake | Remodel,* ed. Kathleen Loock and Constantine Verevis, Palgrave Macmillan, 2012) made it into chapter 3. I thank the publishers for granting me permission to include this work here.

Two essays published early on deal with manga versions of Spider-Man ("Of Transcreations and Transpacific Adaptations: Investigating Manga Versions of Spider-Man," *Transnational Perspectives on Graphic Narratives: Comics at the Crossroads,* ed. Shane Denson, Christina Meyer, and Daniel Stein, Bloomsbury, 2013) and Batman ("Popular Seriality, Authorship, Superhero Comics: On the Evolution of a Transnational Genre Economy," *Media Economies: Perspectives on American Cultural Practices,* ed. Marcel Hartwig, Evelyne Keitel, and Gunter Süß, WVT, 2014), as my initial plan had been to trace the evolution of the comic superhero beyond US borders and back. "Bodies in Transition: Queering the Comic Book Superhero" in the special

issue *Queer(ing) Popular Culture* (ed. Sebastian Zilles, of *Navigationen* 18.1, 2018) and "Conflicting Counternarratives of Crime and Justice in US Superhero Comics" in *Conflicting Narratives of Crime and Punishment* (ed. Martina Althoff, Bernd Dollinger, and Holger Schmidt, Palgrave Macmillan, 2020) tread in more political waters, focusing on (homo)sexuality and white supremacist constructions of the superhero, respectively. "Gaps as Significant Absences: The Case of Serial Comics" in *Meaningful Absence across Arts and Media: The Significance of Missing Signifiers* (ed. Nassim Winnie Balestrini, Walter Bernhart, and Werner Wolf, Brill/Rodopi, 2019) and "Can Superhero Comics Studies Develop a Method? And What Does American Studies Have to Do with It?" in *Projecting American Studies: Essays on Theory, Method, and Practice* (ed. Frank Kelleter and Alexander Starre, Winter, 2018) address key questions superhero comics raise as prime examples of popular serial storytelling.

At The Ohio State University Press, I thank the editors of the Studies in Comics and Cartoons series, Jared Gardner, Charles Hatfield, and Rebecca Wanzo, for accepting this book for publication. Thanks also go the two anonymous reviewers whose suggestions proved very valuable for the revision process, the copyeditor who caught glaring and even not-so glaring mistakes, and acquisitions editor Ana Maria Jimenez-Moreno for her diligent handling of all my questions and concerns.

In closing, I must thank two institutions that gave me access to material discussed in this book: The Edwin and Terry Murray Collection at Duke University, where I spent a few weeks in 2011 digging through their large collection of comics fanzines, and the Comic Art Collection at Michigan State University, and Randy Scott in particular, where I enjoyed another few weeks in the same year rummaging through their vast array of comic books and comic book–related materials.

Research for this book was funded by the Deutsche Forschungsgemeinschaft (DFG, German Research Foundation, FOR 1091 KE 715/5–1 and Project ID 438577023—SFB 1472).

A Note on the Text

Quoting from superhero comics can be challenging because the verbal elements of these comics are always also visual components and

thus not easily subsumed into written form. To facilitate that transition, I have changed the typical all-caps writing to standard capitalization and converted the common multiple dashes (--) to standard em dashes (—). I provide the issue number and cover date for each comic book in the text rather than include all of these comics in the list of references.

AUTHORIZING SUPERHERO COMICS

"Comics provide a vast playground to rehearse accounts of what makes us act."
—Bruno Latour, *Reassembling the Social* (2005, 55)

"Comics were not created—they evolved."
—Les Daniels, *Comix* (1971, 1)

"Comics, perhaps more so than any other medium, involve series."
—Christy Mag Uidhir, "Comics and Seriality" (2017, 248)

"Comics reading is frequently a networked reading."
—Scott Bukatman, *Hellboy's World* (2016, 22)

In 2011, DC Comics relaunched its monthly superhero series, publishing fifty-two titles that included many of its oldest continuing series. Among these titles were *Action Comics,* which had introduced Superman in 1938, and *Detective Comics,* which had initiated Batman in 1939. Apart from generating media interest at a time when sales were a fraction of what they had been during the heyday of the genre, relaunching these series achieved many other things as well. It allowed DC to reset the numbering of some series after decades of accumulating installments, with titles like *Action Comics, Detective Comics,* and *Batman* reverting back to #1 to clear the way for new narratives. The relaunch also enabled revamping the serial continuity of DC's whole multiverse, as well as assigning new creator teams to some of the company's most popular titles.

Marvel Comics, DC's main competitor, relaunched its Ultimate line of superhero comics as the Ultimate Comics Universe Reborn in the same year, updating a roster of publications that had itself been relaunched in 2000. Extending the theme of rebirth, the titles of post-2011 relaunches capture the difficulties of managing decades of serial backlog. As Marvel's *Fresh Start* (2018) illustrates, accumulating narratives can be a curse as much as a blessing, generating publicity for new iterations while making it impossible to tell stories unencumbered by the weight of the past. And while *All-New, All-Different Marvel* (2015) foregrounds the need to present the already known in the guise of the new, *Marvel Now!* (2012, 2016) and *Marvel Legacy* (2017) complete a serial tension at the core of the superhero genre: between the wish to continue and the urge to remember.[1]

What appear as unceasing attempts of the two main superhero publishers to interest new generations of readers in the seemingly outdated medium of the comic book takes on a more complex luster when we consider the extensive history of revisions and reboots that marks these endeavors as integral practices of superhero storytelling. DC, for instance, had scrapped several decades of serial continuity in its crossover event *Crisis on Infinite Earths* in the mid-1980s (Marv Wolfman et al. 4/1985–3/1986). If the narrative excess that had necessitated the provisional "death of cluttered continuity in favor of streamlined storytelling" (Friedenthal 2017, 78) at this particular moment in the history of the genre is conceptualized as a crisis caused by the near-infinite possibilities of serial narration, the titles of its belated sequels, *Infinite Crisis* (Geoff Johns et al. 12/2005–6/2006) and *Final Crisis* (Grant Morrison et al. 5/2008–1/2009), point to a second serial tension at the heart of the genre: between proliferation and the eternal promise of closure.

Analyzing these tensions, I argue in this book, can account for the genre's *longue durée*. What began in the late 1930s and early 1940s as a surprising success in Depression-era America, with 168 comic book series being published by 1941 (Raphael and Spurgeon 2003, 13),[2] has now entered "the wider cultural consciousness" as an immedi-

1. I use the names DC Comics and Marvel Comics throughout this book, knowing full well that they have a complex institutional history. DC Comics used to be Detective Comics and is now officially DC Entertainment, while Marvel used to be known as Timely/Atlas Comics.

2. Batchelor puts the number at more than 140 series by 1943, adding that Fawcett's *Captain Marvel Adventures* was selling 14 million copies in 1944 and that in the

ately recognizable yet multifaceted "superhero comic book aesthetic" (Ndalianis 2009a, 4) that extends across television series and computer games at a time when the Marvel Cinematic Universe (MCU) and the DC Extended Universe (DCU) dominate popular perception across the globe. As the citations from Bruno Latour, Les Daniels, Christy Mag Uidhir, and Scott Bukatman above suggest, my approach to the superhero genre is shaped by a sense that these tensions involve serial interactions of people and objects as human and nonhuman actors that have yet to be adequately traced. This approach diverges in at least two ways from previous genre histories. Instead of attributing innovations and changes to particular people or groups or determining market considerations and commercial concerns as the genre's guiding forces, I take the serial agencies (Kelleter 2014a) of superhero comics as material and aesthetic artifacts seriously and read them as storytelling engines and agents of cultural self-perpetuation (Kelleter 2012, 2014b). And instead of emploting my account as a teleological narrative of genre progression, I seek to unravel the mechanisms through which superhero comics have sustained their popularity throughout the twentieth and early-twenty-first centuries. This introduction outlines the four conceptual pillars of my analysis: popular seriality, actor-network, genre evolution, and authorization conflicts.

Popular Seriality

Many popular narrative forms since the nineteenth century have been serially organized, from dime novels, newspaper comic strips, film serials, and radio plays, to magazine fiction, television series, and even Hollywood film (Hagedorn 1988; Kelleter 2017). They have tended to be explicitly (and often unabashedly) commercial and (sometimes implicitly) multiauthored, and they have generally addressed large and potentially heterogeneous audiences. The same is true for superhero comics, where serial organization, commercial orientation, authorial collaboration, and audience diversification have been integral ingredients since the genre's inception in the 1930s. "Comics, perhaps more so than any other medium, involve series,"

postwar years as much as 90 percent of children and teenagers were regularly reading comics (2017, 34, 43).

Christy Mag Uidhir writes (2017, 248), and superhero comics are so closely tied to the logic of seriality that an advertisement for Milestone Comics in the 1990s offered "A Revolution in Comics, Ongoing Monthly" (qtd. in Brown 2001, 42).

In the realm of popular culture, the "dialectic between order and novelty, . . . scheme and innovation" that Umberto Eco identifies as the structural principle of serial narration (1990, 91) and that resurfaces in Will Brooker's Batman-induced notion of "a dialogue between novelty and continuity, between respect for the myth and individual interpretation" (2012, 43), becomes particularly significant. It motivates the expansion of narratives not just by officially legitimized actors (authors, artists, editors, publishers) but also by diffusely authorized and unauthorized actors whose interests in the continuation of these narratives can differ vastly from the interests of those who own the property rights. As my analysis will show, while popular serial narratives do not erase established roles of author and reader, they blur these roles by variously turning producers into consumers, authors into readers, and vice versa. Take Scottish comics author Mark Millar, who identifies as "a massive fanboy" and cites his personal history of reading comics as a badge of authorial credibility (Grauso 2015, n. pag.). Or think of Frank Miller confessing to Dwight Decker of *The Comics Journal* that he "grew up as a comic-book junkie" (2003, 15), stopped reading comics as a teenager, but then came back to them as he launched his career in the comics business.[3]

Millar and Miller are not alone in their self-positioning as professional creators doubling as comic book readers. In the 1970s, Dennis O'Neil prepared for his assignment to author Batman stories by going "to the DC library and read[ing] some of the early stories," searching for "a sense of what [Bob] Kane and [Bill] Finger were after" (Pearson and Uricchio 1991b, 18), and taking on the role of reader to become a better writer. When DC began to develop its plans for *Crisis on Infinite Earths,* it enlisted "comics guru" Peter Sanderson (Thomas and Sanderson 2007, back cover), who sifted through the company's multidecade back catalogue. Sanderson spent three years combing through the untidy histories of multiples series and universes (Friedenthal 2017, 85) to produce the knowledge necessary to

3. Regalado sees a "blurring [of] the lines between creator, producer, and consumer, sometimes to the point where such lines are indiscernible" (2015, 13).

cast the cleansing of the DC Universe through *Crisis on Infinite Earths* as a legitimate endeavor—enabling a narrative that could satisfy the collective expertise of a fandom trained to nitpick superhero continuities for many years and even decades.

Throughout the history of the genre, ongoing and intimate investments in the serial exploits of comic book superheroes have motivated different forms of authorship outside the sphere of professional cultural production. These forms range from fan letters, fanfiction, and fanart to the editing of fanzines, the drawing of amateur comics, and the creation of online commentary. As has been duly noted, the relationship between the nominal producers and consumers of superhero comics has long been characterized by a heightened sense of mutual interdependence, a sense undergirded by much-reported tales of the coveted career path from comics fan to industry professional. Julius Schwartz, Roy Thomas, and Paul Levitz are only three prominent examples of this transformation, and they, like Millar, Miller, and others, continue to play the role of the industry professional who remains a fan at heart.

The first objective of this book, therefore, is to account for the fluidity with which the roles of comic book creator and comic book reader have been performed and how this role-taking has shaped the evolution of the genre. A second goal is to trace the ways in which these roles can overlap in the activities of a single individual while simultaneously gravitating across what Matthew Pustz (1999, 18), Jeffrey Brown (2001, 201), and Bart Beaty (2012, 6) respectively call "comic book culture," the "world of comics," or the "comics world" and what I will label, with a Latourian twist, the superhero collective.

Recognizing the triple functions of popular serial narration—the self-promotion of individual series, where each installment seeks to motivate readers to return for the next slice of the action; the product differentiation that follows from competing attempts to cultivate loyal audiences; and their tendency to *"promote the medium in which they appear"* (Hagedorn 1988, 5)—my approach departs from the questions many superhero studies routinely raise.[4] These questions frequently follow the cultural studies–based "x in y" model of studying popular series (Kelleter and Stein 2012, 259). Such studies may be

4. Useful overviews are Hatfield, Heer, and Worcester (2013); Rosenberg and Coogan (2013); Gavaler (2018). On comics studies more generally, see Smith and Duncan (2012); Bramlett, Cook, and Meskin (2017); Aldama (2020); Brown, Smith, and Duncan (2020); Hatfield and Beaty (2020).

interested in the depiction of social responsibility in *Spider-Man* or of racial affiliation in *Black Panther,* the representation of gender in *Wonder Woman* or of disability in the *X-Men,* the negotiation of national myths in *Superman* or of patriotism in *Captain America,* or narratives of class or vigilante justice in *Batman* or *Green Lantern* or of global politics in *The Justice League of America* or *The Avengers.*[5] While I am sympathetic toward such studies, I find it more conducive to examine how popular serial narratives organize such contested terrain by dispersing authorial and readerly functions and how they provide the means to construct, explore, and negotiate multiple identities, including those associated with being a reader, fan, letter writer, critic, expert, hobby historian, fanzine producer, amateur artist, or industry professional, all of which intersect with gendered, sexualized, raced, and classed forms of identification. "Those who try to reduce or deduce the dynamics of serial proliferation to individual agents—be they authors, publishing houses, studios, scenes, readers, or fans—are already lost," Ruth Mayer rightly observes, because "popular seriality generates itself" (2014, 12).

Building on Mayer's work and especially on the concept of popular seriality proposed by Frank Kelleter in conjunction with the Popular Seriality research unit from which my perspective emerges, I understand superhero comics as (a) *evolving narratives* driven by a continuing feedback loop of production and reception (Kelleter 2017, 12–16); (b) as narratives of *recursive progression* that must rework their past as they renew themselves toward an open future (16–18); (c) as *narratives of proliferation* that utilize authorization conflicts to generate genre diversification (18–22); (d) as *self-observing systems and actor-networks* that constantly monitor and manage their own progress by "employing human practicioners . . . for purposes of self-reproduction" (22–26, 25); and (e) as *agents of capitalist self-reflexivity* that "creat[e] systemic trust in the improbable reality of their own—and hence their own culture's—persistence" (26–31, 30).

Actor-Network-Theory

In *Reassembling the Social: An Introduction to Actor-Network-Theory* (2005), Bruno Latour distinguishes between a notion of society as a

5. See Beaty and Woo's critique of two common approaches: "representations of *x* in comics" and "comics and the thought of philosopher *y*" (2016, 5).

tangible entity that is always already there and can be taken as the context for, and force behind, human activities, and a more fleeting, unstable sense of a collective as something that emerges from the interlocking actions of human and nonhuman actors and has no existence beyond these actions. Thinking of superhero comics as a collective, I propose, can complicate overly person-centered histories and stories of heroic individuals and can help us account for the many twists and turns that mark the genre's evolution.[6]

Reconstructing this evolution means enlisting the critical construction of the network as "a concept, not a thing out there. It is a tool to help describe something, not what is being described" (Latour 2005, 131). To speak of a network "does not designate a thing out there that would have roughly the shape of interconnected points. . . . It qualifies . . . the ability of each actor to *make* other actors *do* unexpected things" (129). Actor-network-theory, therefore, is more of a methodology than a theory: at best a theory "about *how* to study things" and an incentive "to let the actors have some room to express themselves" (142). But what about the phrase "the ability of each actor to *make* other actors *do* unexpected things," which is Latour's most crucial contribution to my reconsideration of superhero history? First, it represents an attempt to supplant cause-and-effect relations that cannot capture the dislocated and dispersed nature of action, where multiple actors, human as well as nonhuman, come together to change the status quo. "If action is limited a priori to what 'intentional,' 'meaningful' humans do, it is hard to see how a hammer, a basket, a door closer, a cat, a rug, a mug, a list, or a tag could act," Latour maintains. "By contrast, if we . . . start from the controversies about actors and agencies, then *any thing* that does modify a state of affairs by making a difference is an actor. . . . Thus, the question . . . to ask about any agent [is] simply the following: Does it make a difference in the course of some other agent's action or not?" (71).

The benefits of this approach include the recognition that superhero comics are not simply shaped by the intentional actions of human individuals but emerge from intricate interactions among different actors, including media- and format-specific affordances and the self-perpetuating agencies of serial narration. "Seriality is a principle rather than a technique," Ruth Mayer maintains, and "this

6. I am aware of the criticism that especially media scholarship (Couldry 2008) has raised against actor-network-theory but believe that it does not invalidate the usefulness of a Latourian approach to superhero comics.

principle cannot be traced back to one author, author collective, or instigator" (2014, 6). As I will show, such serial agencies become forces of genre evolution by utilizing the tension between centrifugal tendencies toward proliferation and diversification and centripetal tendencies toward containment and control.[7]

Latour identifies five sources of uncertainty as central elements of any actor-network approach that convince me to tackle superhero history from this unusual angle. The first source concerns the nature of groups. Rather than presuming the existence of stable groups, we should examine how groupings of actors struggle to uphold their group status. Consider how this complicates holistic notions of fandom or blanket assessments of corporate entities like DC and Marvel Comics or of comic book authorship as a clearly defined professional status.[8] When a recent biographer of Marvel writer and editor Stan Lee states that "Lee was generally an enthusiastic cheerleader for, and fan of, his artists" (Fingeroth 2019, 78), or when Joe Simon, cocreator of Captain America, defines himself as a "comic book maker" whose roles include "artist, writer, editor and sometimes . . . publisher" (Simon and Simon 2003, 9), conventional definitions of authorship and simple distinctions between authors and readers falter. "To delineate a group, . . . you have to have spokespersons which 'speak for' the group existence" as well as "some people defining who they are, what they should be, what they have been," Latour adds (2005, 31). The challenge, then, is to identify these spokespersons, examine the definitions of comic book making they offer, and analyze how they negotiate the meanings of the groups they allegedly represent. "Comics reading is frequently a networked reading," Bukatman rightly suggests (2016, 22).

Latour's second source of uncertainty complicates the nature of action: "When we act, who else is acting? How many agents are also present? . . . Why are we all held by forces that are not of our own making?" (2005, 43). If it is true that "action is not done under the full control of consciousness," then "action should rather be felt as a node, a knot, and a conglomerate of many surprising sets of agencies that have to be slowly disentangled" (44). Instead of assuming that we can always ascertain who is acting and what is causing this action, Latour maintains, "it's never clear who and what is acting when we

7. Uricchio and Pearson speak of the superhero's "containment and refraction" (1991, 211).

8. Burke (2013) takes the existence of a clearly recognizable fandom as a given.

act," as action "is not a coherent, controlled, well-rounded, and clean-edged affair" (46). Viewed through this lens, drawing a superhero comic or buying this comic and receiving pleasure from reading it are not completely self-controlled and fully conscious acts. They involve the agencies of different actors, including the serialized materialities of the comic book and the imaginative space it offers producers and consumers alike. They entail a complex constellation of commercial considerations and generic precursors; the availability of affordable talent and the consequences of editorial decisions; the disseminating power of mass printing and increasingly digital production; a distribution system, first via newsstands, then through comic book stores, and now mostly through online services; and audiences eager to invest their time and money in the medium.

Moreover, Latour assumes that "an 'actor' in the hyphenated expression actor-network is not the source of an action, but the moving target of a vast array of entities swarming toward it" (2005, 46). Action, in this sense, "is *dislocated.* Action is borrowed, distributed, suggested, influenced, dominated, betrayed, translated. If an actor is said to be an *actor*-network, it is first of all to underline that it represents the major source of uncertainty about the origin of the action" (46). Thus, instead of suggesting that Joe Shuster and Jerry Siegel *invented* Superman, that Bob Kane *created* Batman, that William Moulton Marston *originated* Wonder Woman, or that Jack Kirby and Joe Simon *innovated* Captain America, we should consider the dislocated actions that produced the provisional actor-networks enabling these popular characters. We should, for instance, recognize that comic books "were not created—they evolved" (Daniels 1971, 1), that they, in fact, "evolved . . . [t]hrough an informal system of swiping and homage, experimentation and refinement" (Raphael and Spurgeon 2003, 29), and not primarily as the result of individual strokes of genius. Ambitious writers and artists with individual histories and aspirations encountered a publishing industry that had already experimented with the format of the comic book (Wheeler-Nicholson's *New Fun Comics* in 1935) and speculated that new stories, rather than newspaper reprints, could become the next best-selling commodity. They found audiences that were eager to consume stories about superheroes on a monthly basis and enjoyed the patriotic mood of the narratives as the nation watched and entered World War II.

From this vantage point, comic books were not merely created through the self-determined actions of savvy entrepreneurs who saw

the sales potential and consumer base for adventure stories in a new format featuring a new type of protagonist. Rather, they facilitated the convergence of economic interests, technological possibilities, and the availability of creator teams like Shuster and Siegel, who had fed their budding imaginations with a rich diet of popular narratives and drew on this material to establish themselves in the business.[9] Once created, the mere existence of comic books as serial artifacts that could be owned made other practices possible. Superhero comics were widely read and discussed, they were swapped and collected, and they had to be produced month after month, which necessitated the employment and development of a growing pool of writers and artists whose output contributed to the solidifying of some narrative elements while fostering the differentiation and diversification of others.[10]

Latour's third source of uncertainty acknowledges "that the continuity of any course of action will rarely consist of human-to-human connections . . . or of object-object connections, but will probably zigzag from one to the other" (2005, 75). After all, "objects too have agency" (63). Without specific "intellectual technologies" (76) such as documents, charts, or maps, human activities would look a lot different, but the significance of these technologies is often overlooked. In superhero comics, these technologies range from paper quality and printing techniques to drawing styles and genre formulas, from copyright stipulations and trademark regulations to collectors' paraphernalia and mass-produced memorabilia.

The fourth source of uncertainty, matters of fact versus matters of concern, moves beyond the idea that (historical) facts are simply given and advocates tracing the ways in which such facts emerge from particular practices. This entails analyzing construction sites and making-of processes that enable facts to emerge and become recognizable as *arti*facts (Latour 2005, 88–89). Indeed, superhero comics feature public construction sites and making-of processes prominently. Think of editorials and other forms of paratextual packaging that display comic book creation in specific (and frequently fictionalized) workspaces like the Marvel bullpen, as well as the kinds of character sketches, penciled pages, and excerpted scripts often appended to graphic novel and archive editions of popular comics.

9. For biographical background on Siegel and Shuster, see Tye (2012); Ricca (2013).

10. On superhero comics as formula stories, see Blythe and Sweet (2002).

Construction sites and making-of processes are further illuminated in publications like Joel Meadows and Gary Marshall's *Studio Space: The World's Greatest Comic Illustrators at Work* (2008), Christopher Irving and Seth Kushner's *Leaping Tall Buildings: The Origins of American Comics* (2012), and Will Eisner's *Will Eisner's Shop Talk* (2001), where writers and artists converse about their modus operandi, as well as by fanzines and prozines (print and online), which frequently focus on creation and production processes. These sites and processes also surface in the comics themselves, in stories like "The True Story of Batman and Robin! How a Big-Time Comic Is Born!" from *Real Fact Comics* #5 (11–12/1946) and "How Stan Lee and Steve Ditko Create Spider-Man!" from *Spider-Man Annual* #1 (10/1964).[11]

Latour's fifth source of uncertainty views the writing of an actor-network account as a risky venture. The riskiness of tracing the genre evolution of superhero comics through their serial mode of storytelling stems from the proliferation and variance of actions and actors that make their way into—and essentially coproduce—this account (2005, 22). If all human and nonhuman actors "engage in providing controversial accounts for their actions as well as for those of others, . . . [e]very single interview, narrative, and commentary, no matter how trivial it may appear, will provide the analyst with a bewildering array of entities to account for the hows and whys of any course of action" (47). Latour adds that the actors themselves "deploy the full range of controversies in which they are immersed" and suggests that "we follow the actors' own ways and begin our travels by the traces left behind by their activity of forming and dismantling groups" because "actors, too, have their own elaborate and fully reflexive meta-language" (23, 29, 30).

The riskiness of an actor-network account of superhero comics results to a large degree from problems of availability (not all actions can be traced), challenges of accessibility (even if preserved, we may not be able to trace the traces), and issues of manageability (the mass of material is overwhelming). As I argue elsewhere (Stein 2018b), one way out of this conundrum is to identify the "a priori assumptions" and "tacit premises" (Fluck 2009, 17) that underlie existing superhero histories. Such accounts are not confined to human actors, such as comics publishers, writers, artists, readers, and self-identifying fans.

11. Cover dates do not indicate the date when the comics appeared (which was several months earlier) but the date when they were supposed to be taken off the racks to make room for the next batch of periodicals.

They are also offered by nonhuman actors, including the comic books themselves, and they are enabled and enhanced by the paratextual and epitextual spaces of engagement and controversy these comics create.[12]

Instead of simple cause-and-effect narratives, actor-network accounts "replace as many causes as possible by a series of actors" (Latour 2005, 59). Consider the example of puppeteers and their marionettes:

> Although marionettes offer, it seems, the most extreme case of direct causality—just follow the strings—puppeteers will rarely behave as having total control over their puppets. They will say queer things like "their marionettes suggest them to do things they will never have thought possible by themselves." . . . So who is pulling the strings? Well, the puppets do in addition to their puppeteers. It does not mean that puppets are controlling their handlers—this would be simply reversing the order of causality. . . . It simply means that the interesting question at this point is not to decide who is acting and how but to shift from a certainty about action to an *uncertainty* about action—but to decide what is acting and how. (59–60)[13]

Applying these ideas to superhero comics, it is neither the creators nor their readers or even the comics themselves that directly bring a certain character, storyline, or series into existence, but indeed the complex interaction of all of these and many other actors whose serial agencies come together in the act of superhero storytelling. Superhero historiography, however, is steeped in the search for origins and innovation—for first appearances, original creations, and influential inventors (Beaty and Woo 2016, 2)—in an attempt to counteract the tendency of modern aesthetics to equate "the products of mass media . . . with the products of industry insofar as they were produced *in series*," considering "'serial' production . . . as alien to . . . artistic invention" (Eco 1985, 162). Adopting an actor-network approach does not preclude an interest in innovations but concentrates instead on how something becomes recognizable and starts acting as an innovation: "*Innovations* in the artisan's workshop, the engineer's design department, the scientist's laboratory, the marketer's trial panels,

12. Genette (1997) distinguishes between text and paratext (peritext plus epitext).
13. Latour references Nelson (2001).

the user's home, . . . [where] objects live a clearly multiple and complex life through meetings, plans, sketches, regulations, and trials . . . appear fully mixed with other more traditional social agencies" (Latour 2005, 80). As self-observing narratives, superhero comics frequently showcase specific workspaces and design processes, where objects and human agencies interact and where genre evolution becomes particularly visible. As serial narratives, they constantly remind us "that things *could be different,* or at least that *they could still fail*" (89)—underscoring the historical contiguities of the genre (*it could be different*) as well as its perpetual precariousness as a serial narrative (*it could still fail*).

Genre Evolution

Superhero comics have long dominated the production of American comic books, and the genre itself has been shaped, for much of its history, by two companies, DC and Marvel. Randy Duncan and Matthew J. Smith underscore the significance of this ownership concentration, noting that DC and Marvel covered more than 70 percent of the market in the late 2000s (2009, 91), a position they continue to defend against publishers like Image Comics and Dark Horse.[14] And even though superhero comics are not the only popular genre in the history of American comics—horror, western, romance, sci-fi, and crime comics come to mind—they have been widely perceived as the industry's "mainstream" against which "alternative comics" (Hatfield 2005) often position themselves. As Charles Hatfield, Jeet Heer, and Kent Worcester put it: "The superhero is not just another genre, but one that has made all the difference" (2013, xii).

In an essay on superhero history, Henry Jenkins assesses the implications of this peculiar situation: "Understanding how the superhero genre operates requires us to turn genre theory on its head," he writes. "Genre emerges from the interaction between standardization and differentiation as competing forces shaping the production, distribution, marketing, and consumption of popular entertainment" (2009, 17). Associating the central mode of genre evolution with the dialectic of standardization and differentiation that

14. On the political economy of ownership concentration in comics, see McAllister (2001).

characterizes all forms of serial storytelling and shapes the tension between the "recurrent stock situations which animate [serial] stories" as well as the "inexhaustible characters" that complicate their "iterative scheme" (Eco 2004, 159–60), Jenkins suggests that "standardization and differentiation . . . operate differently in a context where a single genre dominates a medium and all other production has to define itself against, outside of, in opposition to, or alongside that prevailing genre." Here, "difference is felt much more powerfully *within* a genre than *between* competing genres," which accounts for the "persistence and elasticity of the superhero genre" (2009, 17, 18).

Jenkins proposes a three-stage model to account for this persistence and elasticity. He begins with a first stage roughly equivalent to what is commonly dubbed the Golden and Silver Ages (late 1930s to mid-1960s), when superhero comics consisted of "relatively self-contained issues" with recurring characters that displayed little development and differentiation. This is followed by a second stage from the early 1970s to the 1990s characterized by "shifts towards more and more serialization." Here, the comics profit from a long-time readership that is knowledgeable about their history, seeks gratification through narrative continuity, and is cultivated by the professionals as well as encouraged by a reliable distribution system through which these interests can be satisfied. This culminates in a third stage, said to begin in the mid-1990s with the arrival of online communication and still ongoing today: a "period of multiplicity" where continuity is less crucial because it inhibits the superhero's transmedial spread and is unable to reflect the long and varied history of the genre. Today, the pleasures of reading superhero comics and pursuing characters across media result less from a producer's ability to control a story's place inside or outside the continuity of a specific series than from the invocation and recombination of the genre archive (Jenkins 2009, 20–21; Ford and Jenkins 2009, 307–8).[15]

How does this model and the (relatively loose) order it imposes mesh with an actor-network account of superhero seriality? From an actor-network perspective, genres are assemblages of actors that maintain their associations through constant reiteration and negotiation. Jenkins's notion of the interplay of standardization and differentiation also aligns with classic theories of genre evolution by film

15. Pearson, Uricchio, and Brooker speak of "multiple Batmen, in multiple timelines, universes and media [that] compete for attention" (2015, 1).

scholars like David Bordwell and Rick Altman. Bordwell speaks of "bounds of difference" (1985, 72) that exert standardizing pressures (the demand to follow formulas) as well as "countervailing pressures towards novelty, experimentation, and differentiation" on each new iteration (Jenkins 2009, 19). Altman therefore views genres as "the temporary *by-product* of an ongoing *process*" of cultural production instead of "a permanent *product* of a singular origin" (1999, 54). As Saige Walton holds, genres are cumulative and potentially unending. They constitute "the episodic realization of a perpetually deferred series" and perform "a perpetually unfolding signification, loaded with unexpected possibility," always "in pursuit of [their] own formation" (2009, 91, 86). Texts may thus be regarded as "uses of genre" (Frow 2006, 25) that depend on a sense of contractual agreement between authors and readers (Brown 2001, 2). While Altman thinks of them as blueprint, structure, label, or contract (1999, 14), Jason Mittell perceives of them as "simultaneously fluid and static, active processes and stable products" (2001, 11).

Genres therefore exist without really existing. They constitute evolving actor-networks that are inherently unstable and must be upheld, but also modified, changed, and developed, by recurrent genre practices. While they are not tangible institutions, they nonetheless exert authority (Frow 2006, 2). They signal that a text is addressed to a "discourse community" and "constructs a world which is generically specific" by invoking knowledge based on previous genre enunciations, "creat[ing] effects of reality and truth, authority and plausibility" (7, 2). And even though genres are not themselves organizations, they possess a concrete "organising force" that "gets a certain kind of work done" (13, 14). Like the social for Latour, genres must be assembled and reassembled through specific actions dispersed across human and nonhuman actors. Some of these actions become habitual, solidifying into readily mobilized practices that keep the genre going. They provide a sense of momentary stability through their ability to associate actors repeatedly, deriving authority from the relative security of accepted conventions. Ongoing popular genres are generally "stabilised-for-now" and "stabilised-enough" (Schryer 1994, 107).

All of this boils down to a deceptively simple insight: Genres evolve. But the concept of genre evolution is controversial, especially when it is associated with rigid notions of genre boundaries and the movement through predetermined developmental stages. In the con-

text of superhero comics, the availability of evolutionary accounts like Thomas Schatz's *Hollywood Genres: Formulas, Filmmaking, and the Studio System* (1981), which traces film from an experimental to a classic stage and on to stages of refinement and finally baroque self-reflexivity, is attractive because they readily accord with already popular periodizations (Golden, Silver, Bronze, Modern) (Walton 2009, 95). Peter Coogan's *Superhero: The Secret Origin of a Genre* accepts Schatz's model with genre-specific modifications, such as a prehistory consisting of a "Proto-Age" and an "Antediluvian Age" (2006, 116, 126). Another example is Paul Lopes's *Demanding Respect: The Evolution of the American Comic Book* (2009), which details "the evolution in the meanings and practices associated with the field of the modern American comic book" via Bourdieu's theory of the field of literary production. Lopes subdivides the history of comic books (including non-superhero comics) into a more or less teleological narrative according to which craftsmen rebelled against the conditions of comic book production and ushered in a shift from an "Industrial Age" to an autonomous and self-determined "Heroic Age" (2009, xii, xiv). The power of Lopes's account, which aligns with Jean-Paul Gabilliet's (2010) work on the shifting self-understanding and working conditions of generations of creators, lies in its attention to the interplay of technological and creative agencies, the languages of the comics collective, and the controversies that have shaped the medium in its evolutionary path. But this attention channels the serial logic of the genre's proliferation and consolidation through a Bourdieuian emplotment that at times shortchanges the accounts of the actors in favor of a specific sociological framework.[16]

Against such evolutionary conceptions, and especially against the critical conceit of consecutive ages, critics have proposed an understanding of superhero comics as a much more unruly corpus that cannot be subjugated to any succinct succession of stages. "The superhero's longstanding intergeneric dialogue . . . and its reconfigurations of the past frustrate enclosed, evolutionary approaches to genre," Walton notes. "All genres thrive on repetition but this is especially the case for the serialized adventures of the superhero. Reinterpretation has become nothing short of a practical strategy of survival for the comics, where the revisiting of origins, retroactive changes, and outright narrative reversals predominate" (2009, 95). Walton

16. Stevens (2015) offers another evolutionary account of superhero history.

rejects Schatz's view of genres as "closed, continuous systems that invariably pursue their own internal dictates," faulting it for relying on an "evolutionary model of genre (teleological, self-contained, utterly predictable) [that] has the unfortunate effect of belying its anthropomorphic basis" (96). Yet Walton's objections, shared by Marc Singer's critique of evolutionary models of superhero history (2018, 61–64), only make sense if we buy into reductive notions of genre evolution as a closed system with predetermined life cycles.[17] As Walton's reference to reinterpretation as "a practical strategy of survival" of the superhero indicates, evolutionary accounts do not have to betray their anthropomorphic basis to be useful as an organizing metaphor.

Brian Boyd's "On the Origins of Comics" (2010) illustrates the benefits of an evolutionary perspective. Boyd's suggestions are compatible with an actor-network approach in their interest in the intersections of human and nonhuman actors: "Far from reducing all to biology and then to chemistry and physics, [evolution] easily and eagerly plugs in more local factors—in a case like comics, historical, technological, social, artistic and individual factors, for instance—the closer we get to particulars," he maintains. "Evolution accepts multi-level explanations, from cells to societies, and allows full room for nature *and* culture, society *and* individuals" (2010, 97). I am intrigued by Boyd's subsequent definition of adaptation as a process of solving the recurrent problems faced by a species or culture. This process never delivers final solutions but follows a serial dynamic according to which every solution offers particular benefits and costs, "transform[ing] the problem landscape" by posing new problems that call for new solutions on a more evolved level (97).

If evolution is viewed in these terms as a process of incremental transformation within specific environments that are themselves evolving, then the general fascination in genre histories with momentous and monumental change instituted by individual publishers, authors, artists, or fan groups becomes suspect. Furthermore, this view encourages us to extend accounts of active fandoms and par-

17. Singer questions "the logic of the ages" (2018, 61) and the resulting evolutionary model that, as Woo argues, "proceeds from a conception of history that is simultaneously nostalgic and teleological" and according to which "the periods are elevated to an ontological status and ascribed a monolithic essence" (2008, 272, 273). Wandtke opposes his conception of revisionism to any "simple linear evolution of characters" (2007, 6).

ticipatory cultures into larger processes that involve more human and nonhuman actors. As Boyd holds, "new forms often emerge that could persist and proliferate, but die out because conditions are unpropitious or chance eliminates the novelties before they can spread" (2010, 98). The commercial success of DC's first Superman stories in *Action Comics* and *Superman* in the late 1930s (selling between 900,000 and 1,300,000 copies per issue) or Marvel's line of comics from *The Fantastic Four* and *Amazing Spider-Man* to *The Incredible Hulk* and *The X-Men* in the 1960s (selling about 60 million copies annually and 90 million worldwide by 1972)[18] may have been less the result of a calculated publicity stunt or clever audience manipulation than the outcome of a particular constellation of actors — describable as an actor-network — at a particular historical moment and environment (Boyd 2010, 103): an untapped interest in serial stories among young readers in the case of *Action Comics* and a demand for new types of superheroes that had itself evolved from earlier popular genres and narratives in the case of Marvel. If Shuster and Siegel based their first published Superman adventure (*Action Comics* #1, 6/1938) on a comic strip version they had done in 1934, and if DC located this version and sent it back to Shuster and Siegel so they could transform it into a comic book (Lund 2016, 2), it makes little sense to credit the invention of the character to a single person or action. Instead of speaking of "an evolutionary leap" from the "standard-bearers for justice in the pulp magazines and comic strips" (Cotta Vaz 1989, xi) to the superheroes, we should look more closely at the dispersed actions that account for the genre's emergence.

When we think about superhero comics in these terms, they become more than texts that share a common set of themes, character types, iconographies, and publication formats. Rather, as a serial artifact that results from and affords specific practices, each comic participates in the evolution of the genre with which it is allied and which it amends, complicates, refines, reinforces, or questions. While it is true, as Mittell (2001) has argued, that genre classifications are usually produced discursively, it is equally true that every new installment will both activate and redefine the total sum of genre enunciations — and will make certain classifications likely while rendering others impos-

18. Lund reports the numbers on *Action Comics* and *Superman* (2016, 1); Stan Lee comments on Marvel's sales in the 1960s (Bourne 1970, 101); Raphael and Spurgeon report the 1972 figure (2003, 137). *Marvel Comics* #1 (10/1939) sold almost a million copies (Fingeroth 2019, 22).

sible or at least implausible. As John Frow puts it, "neither authors nor readers act as autonomous agents in relation to the structures of genre, since these structures are the shared property of a community. Readers and writers negotiate the generic status of particular texts but do not have the power to make their ascriptions an inherent property of those texts" (2006, 109). Each story "'perform[s]' a genre, or modif[ies] it in 'using' it" (11). Therefore, each comic is not just an "intermediary" that merely "transports, transfers, [or] transmits" generic information without affecting it, but also a "mediator" that "creates what it translates" (Latour 1993, 77, 78). Every comic book is a nonhuman participant in genre evolution. It will "authorize, allow, afford, encourage, permit, suggest, influence, block, render possible, [or] forbid" (Latour 2005, 72) future installments, speech and writing about the genre, and transgeneric and transmedial adaptations, each of which will have a similar productive potential. Every comic book "*make[s] others do things* . . . not by transporting a force that would remain the *same* throughout as some sort of faithful intermediary, but by generating *transformations* manifested by the many unexpected *events* triggered in the other mediators that *follow* them along the line" (107). These transformations and mediations are confined neither to the actions of human beings nor to those of objects. Rather, they must be authorized again and again by interlocking human and nonhuman actors. They can be found in every part and at every level of the genre.

Authorization Practices

If recursive production and reception cycles shape all forms of popular serial storytelling, they have proven to be particularly productive for the proliferation and diversification of superhero comics. But proliferation and diversification only constitute the centrifugal side of the popular serial coin. On the centripetal side, we find practices of managing and organizing proliferating characters and narratives into a genre marked by specific production methods, narrative conventions, and modes of reception—of "managing multiplicity," in Sam Ford and Henry Jenkins's terms (2009). How do these practices come into existence? Who or what is acting when and where, and with which consequences? How can we grasp these actions as genre mediators? In order to tackle these questions, I condense Latour's list

of mediating activities—authorizing, allowing, affording, encouraging, permitting, suggesting, influencing, blocking, rendering possible, forbidding further action—to a notion of authorizing practices.

According to this notion, superhero comics facilitate "authorization conflicts" (Kelleter and Stein 2012), or what Latour calls "controversies." These conflicts or controversies pop up almost everywhere in the genre. They are not confined to active readers who publicly hope to have their wishes fulfilled in upcoming installments or to the diverse mechanisms through which creators, publishers, or series seek to authorize themselves as legitimate genre actors. In terms of production, we encounter additional conflicts over the nature and role of comic book authorship and artistic creation, the significance of brand promotion and product diversification, and the function of editorial control over individual series. In the texts themselves, each new installment must authorize itself vis-à-vis previous installments, genre conventions, and the expectations of diverse audiences. In the reception process, stories are interpreted, the legitimacy of new installments debated, and storytelling alternatives developed and negotiated. Authorization conflicts further structure extratextual practices that include legal and institutional forms of authorization from copyright and trademark litigation to fan clubs, comics conventions, specialty stores, and cosplay events, amateur and professional journalism, as well as official and unofficial (authorized and unauthorized) creative engagements with comic book superheroes.[19]

In this book, I identify crucial moments when authorization conflicts mediate new serial practices and when new serial practices enable the genre to evolve. I follow Wulf Oesterreicher, Gerhard Regn, and Winfried Schulze's (2003) heuristic distinction among *authority of form, authorization,* and *institutional authority,* developed as part of their research on the early modern period. According to this model, *authority of form* encapsulates semiotic and communicative phenomena, including the content and expressive structures of texts and the ways in which they seek to guide, regulate, or control

19. All of this complicates Fiske's sense of a "constant struggle between fans and the industry, in which the industry attempts to incorporate the tastes of the fans, and the fans to 'excorporate' the products of the industry" (1992, 47). Authorization conflicts usually entail less clearly defined, not always oppositional, forces that trouble Fiske's distinction between "socially and institutionally legitimated . . . official culture" (31) and a "popular culture which is formed outside and often against official culture" (34).

their reception, their access to and storage of knowledge, and the emotions, affects, and actions they initiate (Oesterreicher 2003, 13). Authorities of form have an inherent stabilizing function as they shape the production, reception, and preservation of knowledge within specific parameters (13–14) without fully controlling this process, since they allow a certain degree of flexibility and variation (13). "Reading comic books is a learned cultural practice that nevertheless incorporates a great deal of openness and ambiguity," Jason Dittmer notes, "and producers' expectations for clear transmission of narrative are often unmet, with the potential existing for readers to consume comics in any number of ways in large part because of comics' symbolic openness" (2010, 225–26). Furthermore, authorities of form emerge from aesthetic decisions and from formally ingrained notions of origin or descent (Oesterreicher 2003, 13–14). They appear in networked structures that unfold their authoritative effects in specific lifeworlds but also in theory- and knowledge-related contexts (14), and they affect the production and reception of individual texts and genres.

Superhero comics are closely involved with, and indebted to, a number of authorities of form, including the discursive traditions and genres, classificatory systems, argumentative structures, linguistic prescriptions, images, and media Oesterreicher lists as key formal features (2003, 14–16). They exert authority as intermedial, sequential, and serially organized narratives traditionally published in an affordable floppy format that can be owned, traded, collected, and archived. Over time, they developed a visual vocabulary of spectacular fight scenes, flashy splash panels, and flexible panel frames. We may also think of the iconography of the superhero itself, from the swinging capes, colorful costumes, massive musculature, and mysterious masks to the insignia on their chests, as well as of visually appealing accessories such as Batman's utility belt, Captain America's shield, Wonder Woman's lasso, Thor's hammer, or Iron Man's armor, all of which relate messages of heroism within and beyond the actual stories.

Superhero comics historically derived authority from existing forms of popular narrative, such as the (serially told) adventure tale, crime plot, science fiction scenario, or melodrama, which audiences had already encountered through dime novels, pulp magazines, and film serials. They further communicated moral authority by pitting good heroes as protectors of the common folk and saviors of the inno-

cent against villains out to destroy the fabric of American society— from Superman's fights against corruption and Captain America's efforts to eliminate the evils of Nazi infiltration to the more complex scenarios of a post-9/11 world filled with the threat of international terrorism and internal political division, as explored in Marvel's *Civil War* (7/2006–1/2007) and *Captain America: Secret Empire* (4–7/2017).

Comic books also quickly developed their own genre conventions. These include a mission legitimized through an origin story that captures the character's motivation, rationalizes the modus operandi, and reveals the secret identity behind the public superhero mask (Reynolds 1992, 12–17; Coogan 2006, 30–39). As time went on, these conventions increased in both number and complexity, and they were supported by the explanatory discourses suffusing the comics and their secondary and tertiary texts.[20] Company icons and trademarks announce the semiotic, narrative, and legal authority of the stories, while continued celebrations of authors and artists as "masters" and "geniuses" in the letter pages and republications of "classic masterpieces" from earlier decades added a sense of cultural authority based on the genre's past.

If *authority of form* concentrates on a narrative's or artifact's affordances, *authorization* relates to the processes through which something becomes authorized (Regn 2003, 119). Focusing on the early modern period, Regn observes pluralization across different fields of cultural production and suggests that this process created a need to secure and safeguard an increasing number of competing bids for prevalence (119, 120). These bids had to be implemented and prioritized, often by opposing the new against the old or by claiming greater cultural currency against rivaling bids (121). Authority was no longer stable but became processual. It had to be produced constantly and thus remained precarious (120). In my translation of Regn's words: "Precisely because stable orders and function-securing traditions cease to exist as frames of reference and precisely because each bid for prevalence has to be justified, instability becomes a rather typical structural feature of early modern authorization" (120).

20. In Fiske's model of widening circles of televisual intertextuality, copyrighted and trademarked cultural productions would be the primary text; officially authorized and copyrighted supplementary materials associated directly with a primary text, the secondary text; and unauthorized texts and noncopyrighted materials, the tertiary text (1987, 108–27).

It should not be too difficult to see the applicability of these observations to the superhero genre. Bids for prevalence are not only a staple of the stories, where superheroes battle supervillains for control over a city, country, world, or cosmos and where the forces of good seek to prevail over evil.[21] They also structure the competition between different series or media and especially between publishers. Of course, one could argue that the cultural currency of the genre rests to a significant degree on the sense of tradition—as an American monomyth (Jewett and Lawrence 1988; Lang and Trimble 1988; Lawrence and Jewett 2002; Romagnoli and Pagnucci 2013) or as a reminder of childhood experiences (Gibson 2018; Tilley 2018). Yet the closer we look the more obvious it becomes that this sense of authority through tradition is both contested and precarious, in need of constant reiteration and adaptation to new contexts.

In conjunction with *authorities of form* and processes of *authorization, institutional authority* channels social processes of differentiation and pluralization by managing the transition from old to new social orders (Schulze 2003, 235). Schulze describes institutions as normative structures that guarantee durability and possess the power to bestow externally sanctioned legitimacy on emergent social structures and cultural forms, which become invested with an aura of authority capable of regulating the production of new texts and guiding their reception (235–36). Transitions toward greater social differentiation and pluralization—what I call genre evolution—depend on the incessant iteration of authority (Regn 2003, 119). In superhero comics, such authority must negotiate the dialectical tension between a centrifugal thrust toward proliferation, diversity, and sprawl and the centripetal counterthrust toward consolidation, preservation, and conservation. This evolution is subject to ongoing authorization conflicts that involve actors with different interests and motivations. Authorization, in that sense, is a "dynamic structure that attains the status of a condition of possibility for the construction of epochally relevant patterns of order" (Regn 2003, 119; my translation).

If authority, however legitimized, is always precarious, it is necessarily contested. Authorization conflicts set in motion practices that produce divergent claims to authority that, in turn, produce the growing complexity of social structures and thus also increase the

21. Whereas superheroes tend to defend the status quo, supervillains irritate and challenge it (Reynolds 1992, 50–51; Peaslee and Weiner 2015).

need for different actors to legitimize divergent bids for prevalence. Referencing the impact of formal types of authority, Regn stresses the importance of rhetoric for the implementation and enforcement of that authority, which often seeks to distinguish itself through deauthorizing gestures that rank the new over the old and the self against the other (2003, 120–21). DC's "New Look" Batman of the 1960s and Marvel's self-distinction from the creations of rival publishers, denigrated as "Brand Echh," come to mind in this context. What is considered legitimate ultimately depends on its ability to appear authoritative, or at least more authoritative than competing bids for prevalence (119–20).

Institutional attempts to maintain authority by adapting it to new situations and thereby working toward the stabilization of differentiation and pluralization processes abound in superhero comics. I am obviously concentrating on a much more limited field—a single popular genre—than the social structures Oesterreicher, Regn, and Schulze discuss. But looking closely at the ways in which popular genres mobilize institutional power to create, enforce, and thus perform authority against the sprawling impulse of popular seriality can tell us much about how modern societies make sense of their present, past, and future. In the comics industry, institutional authority is written all over place, from company icons and trademarked logos to the formation of company-sanctioned fan clubs as early as 1939, when the Supermen of America club was advertised in *Action Comics* and *Superman* (Gordon 2017, 119). Think also of the EC Fan-Addict Club in the 1950s or the Merry Marvel Marching Society (M. M. M. S.) in the 1960s, a fan club that offered exclusive membership status and even a pledge of allegiance that fans and creators should recite as a public oath of loyalty.[22]

Institutional authority was further exerted through the discourse of collective ownership that dominated the letter pages and editorial columns at DC and Marvel from the 1960s onward, as well as through a sense of intimate institutional affiliation propagated by slogans like "Make Mine Marvel." Both Marvel and DC did much to create a three-dimensional image of the work processes and the people who produced the comics, creating fictionalized images of the com-

22. According to a report by Harvey Zorbaugh in the *Journal of Educational Sociology*, these clubs had significant memberships. The Captain Marvel Club, for instance, had 573,119 members in 1944 (1944, 200).

ics' construction sites and offering behind-the-scenes details about their making. Marvel included colorful discussions of the members of the famed bullpen, one of the most "beloved, sustaining myths of comic book culture" (Hatfield 2012, 78), portraying editors, writers, pencilers, and inkers as interacting with publishers, secretaries, and even imaginary characters, representing all of them as real people with idiosyncratic habits. DC used prozines like *Amazing World of DC Comics* (*FOOM* in Marvel's case) to showcase individual writers, artists, and editors, connecting the producers of the comics with their favorite characters to communicate a sense of authored-ness, and indeed authority, of their superhero roster.

Consider the following example: The cover image of *Amazing World of DC Comics* #2 (9/1974) by Kurt Schaffenberger shows Superman, Green Arrow, Green Lantern, The Flash, and Captain Marvel as they glance over the shoulders of two writers at work on what seems to be the next superhero script. These writers are Cary Bates and Elliott Maggin, and their thoughts are featured in an interview in the same issue, titled "The Men behind the Super-Typewriter." More often than not, in interviews such as this, new storylines, characters, or iconographies are attributed to the authorizing force of human acts of creativity and invention, even though the difference between empirical author, implied author, and the narrator of particular stories is routinely negated. But even here, nonhuman actors creep into the account, as the titular reference to the *typewriter* indicates, suggesting a growing interest in comics production facilitated by letter columns and fanzine production. For many, reading superhero comics not only means wanting to know who is producing the stories and yearning for access to privileged moments of creation. Different representations of these ostensibly authoritative moments also authorize specific figurations of authorship, including its technical aspects. They further propose particular author roles that distract from the actual working conditions and legal controversies surrounding the production of superhero comics yet also inform audiences about what kinds of stories to expect and how to read them.

"Series carry inbuilt expectations," Brian Boyd argues; they "reduce search time" (2010, 103) for readers who seek the continuing gratification of returning characters and the safe reentry into a treasured storyworld while also allowing for the mostly gradual diversification and pluralization of this world and its characters. The

pleasures of serial consumption lie to some extent in managing the eternal threat of disappointment and dissatisfaction that hovers over every ongoing series. Publishers like Marvel and DC have been able to provide a strong sense of durability that is difficult to maintain in a fast-paced, profit-driven industry. They have succeeded, with different degrees of success, to authorize the variation necessary for continued adaptations to changing environments. Thus, it is no surprise that the evolution of the superhero genre is so deeply dependent on authorization conflicts. But these conflicts must be accounted for, and this is what this book is all about.

Structure of the Book

As the citation from Latour that prefaces this introduction indicates, comics, and superhero comics in particular, can serve as a playground for investigating serial storytelling and its cultural work. Since this playground is so vast that it defeats any attempt at completion, I have chosen Batman and Spider-Man as the protagonists in my study of authorization practices and genre evolution. I realize that picking two traditionally white male superheroes out of dozens of equally intriguing and potentially more diverse candidates may appear as an overly pragmatic as well as potentially problematic decision indebted, at best, to the need to delimit a sprawling genre. Frederick Luis Aldama, for instance, urges us to "explore more deeply and systematically the storyworld spaces inhabited by brown superheroes in mainstream comic book storyworlds" (2017, xv), and more and more significant research on the genre's racialized, gendered, and sexualized complexities has appeared in recent years.[23] I remain, however, intrigued, at least for the purpose of this study, with the very fact that Batman (whose sexuality has vexed fans and critics for decades) and Spider-Man (whose whiteness has been challenged with the introduction of the Afro-Mexican Miles Morales) continue to serve as powerful representatives of a still predominantly white, straight, and male genre. As arguably two of the most popular and most enduring genre figures, these superheroes have managed to incorporate, in one way or another, the challenges that have been leveled against their

23. See, for instance, Austin and Hamilton (2019); Guynes and Lund (2020); Aldama (2021).

constraints, and they have been able to make productive their critical reception by authorizing a variety of superhero variations, including female, ethnic, and queer ones.[24]

As I argue elsewhere (Stein 2018b), what Winfried Fluck describes as a crucial issue in cultural studies, namely "developments of cultural dehierarchization that challenge established ways of assigning meaning and significance to cultural material" beyond "the authority of an (explicit) master narrative" (2009, 42), becomes even more problematic in superhero comics, which complicate established parameters of literary and visual analysis. In addition, if Americanists routinely struggle to answer "the question of the representativeness of [their] material" (39) as they attempt to make sense of American culture beyond convenient text-context distinctions, the massive superhero corpus—a multidecade, multiauthored, transmedial, transnational, and highly malleable yet surprisingly durable form of popular serial storytelling—becomes a particularly vexing problem.

What's more, I contend that the risk involved in the selection of materials—the thorny question of what to include and what to exclude—is worth taking as long as we follow the actors. Any attempt to focus exclusively on the two superheroes I have selected for my account would run into serious problems anyway. After all, Spider-Man was introduced in issue #15 of *Amazing Fantasy* (8/1962) as the exciting variation of an established character type that authors and readers had known from decades of storytelling and were discussing in letter columns, editorials, and fanzines. Batman and his sidekick Robin shared with Superman the cover of the *New York World's Fair Comics* book as early as July 1940, even though it would take more than a decade for them to actually interact in their first team-up story, "The Mightiest Team in the World" (*Superman* #76, 5/1952). Marvel's comic books of the 1960s were filled with references to the "world of Marveldom" and self-descriptions as the "House of Ideas" (Pustz 1999, 56). This imaginary world, or metaverse, as I will call it, incorporated the official producers and those who read the comics and composed letters to the editor, as well as the fictional universes of multiple superheroes. Marveldom connected primary, secondary, and tertiary texts, playing host to shifting actor-networks. In all of these scenarios, Batman and Spider-Man do not act alone but interact

24. I explore the racial complexities of the genre, and of comics more generally, in Stein (2020b; 2021).

with, and activate, many other actors, including other—and increasingly diverse—superheroes.

Even though my choice of Batman and Spider-Man is unapologetically pragmatic and self-consciously risky, it is sanctioned by my Latourian methodology, which posits that we can trace assemblages of human and nonhuman actors from many different vantage points as long as we follow their actions closely. Moreover, my choice follows from additional considerations. Batman and Spider-Man represent two of DC's and Marvel's flagship characters. They emerged in different periods (the Golden and Silver Ages, respectively, in the popular nomenclature), have attracted intense and long-lived fandoms, and have inspired countless television series, Hollywood blockbusters, and computer game adaptations. Of course, many of my observations could be made in one way or another about Superman, Wonder Woman, Batwoman, Spider-Woman, Captain America, the Fantastic Four, the X-Men, Daredevil, Deadpool, Captain Marvel, or any other seminal superhero. But these serial figures (Denson and Mayer 2018) operate according to specific conventions, which can be studied through paradigmatic examples. As Jason Bainbridge rightly notes, Spider-Man can be taken as a "template for Marvel's other superheroes" (2010, 164), and while the same cannot be said as easily about Batman, the point is still valid because Batman's difference is noteworthy only if viewed against the genre norm. Finally, neither Batman nor Spider-Man can easily be construed as a genuine original or the result of ingenious innovations. Popular seriality always operates in medias res, and Batman emerged as an intriguing variation of Superman, who had himself amalgamated popular precursors. Spider-Man appeared after decades of variations, but even he followed on the heels of Marvel's Fantastic Four, which had been a response to DC's Justice League of America.

Tracing the evolution of superhero comics thus involves more than analyzing individual characters and the stories in which they appear. It includes recognizing the specific materiality of the comic book (and increasingly the superhero graphic novel collection, as well as digitally produced and distributed narratives), assessing paratexts (advertisements, bulletins, editorials, letter columns), and relating texts and paratexts to their surrounding epitexts (fanzines, prozines, online sites, scholarly work)—all of which must enter the account as evolutionary f/actors. In order to create such an account, this book presents four chapters that follow a loose chronology from

the earliest projections of comic book authorship in the late 1930s and early 1940s to the genre's existence in the digital era. These chapters identify crucial moments in the 1960s, when authorization conflicts transformed the problem landscape and thus mediated evolutionary advancements. They combine a focus on comic book narrative with an analysis of paratextual and epitextual negotiations as key practices of popular serial storytelling. While I occasionally move beyond printed matter, my focus is the print culture that produced and continues to sustain the genre as the superhero's "most enduring home" (Gavaler 2015, 18).

Chapter 1, "Negotiating Paratext: Author Bios, Letter Pages, Fanzines," begins with the first appearance of superhero comics in the late 1930s and early 1940s and then turns to a key period of the genre, the 1960s, when a new public discourse about the authoring and reading of comic books began to change the nature of superhero storytelling. This is the moment when letter pages and editorial statements start to mediate authorization conflicts about the authorship of comics, the plotting of stories, their visual aesthetics, and a host of other issues. Letter writers questioned the official presentation of a singular creator figure like Bob Kane in the case of Batman. Kane's authorial and iconographically distinct signature had graced Batman comics since 1939, when the character first appeared, allegedly invented solely by Kane. By the 1960s, however, readers of the series had become so intimate with Batman's look and adventures that they recognized different writers and artists despite the fact that Kane himself mandated a homogenous style: "I feel a ghost's job is to emulate the cartoonist, as near as you can, instead of recreating what he already did in his own style" (qtd. in Uricchio and Pearson 1991, 188). A comics creator was no longer a singular person like Kane or a team of inventor figures like Shuster and Siegel, but an association of multiple actors involved in a series' production (writer, artist, letterer, colorist, editor). This new perspective implied that fans could express their appreciation of, and dissatisfaction with, these actors. They could praise artists for their style or fault writers for unimaginative storylines. They could point out directions into which the story should venture, among the most decisive being the wish to discontinue a character, to invent new characters, or to start a new series around a new superhero. These new author functions authorized a shift from linear to multilinear forms of serial narration (Kelleter and Stein 2012).

Chapter 2, "Stylizing Storyworlds: The Metaverse as a Collective," reconstructs the emergence of the "wonderful world of Marvel," as Marvel's chief commentator Stan Lee put it in one of his "Soapbox" editorials (2/1968). The chapter takes Bainbridge's claim that "the Marvel and DC universes constitute the two largest and arguably longest-running examples of world building in any media" (2009, 64) as a prompt for concentrating once more on the 1960s, in particular the *Amazing Spider-Man* series and the story in *Amazing Fantasy #15* that launched the Spider-Man storyworld. I argue that style in super-hero comics is at least in some ways coproduced by the discourse about these comics as much as it is determined by authorial and readerly practices that are deeply invested in the aesthetics and in the material properties of the comic book. While I am wary of excessively broad definitions of style that include all visual and verbal elements, I contend that an overly narrow conception as the idiosyncratic visual enunciation of a particular creator can be equally detrimental. As I will illustrate, the Marvel style is a much broader phenomenon that includes textually, paratextually, and epitextually mediated incite-ments to storyworld construction and collaborative world-building efforts, alongside a disposition Thomas Frank (1997) labels "hip con-sumerism" in a related context. Together, these elements shape what I call a metaverse, or Latourian collective, as a space that incorpo-rates all levels of narrative (text, paratext, epitext) and other forms of engagement with the publisher's properties.

Chapter 3, "Transmodifying Conventions: Parodies," centers on the authorizing functions and evolutionary significances of super-hero parodies. Despite their popularity and except for a few attempts to integrate them within existing genre models, parodies are rarely understood as an answer to some of the problems that have troubled superheroes from their inception.[25] As commercial products indebted to earlier types of popular storytelling, superheroes depend on narra-tive formulas and graphic tropes that can become problematic as the genre progresses. Think of the colorful costumes that earned them the nickname "long underwear characters," of the intimate relations between superheroes and youthful sidekicks (paradigmatically: Bat-man and Robin) that caused allegations of pedophilic and homoerotic desire, or of the overly sexualized portrayal of female characters

25. Groensteen writes, "La veine parodique traverse toute l'histoire de la bande dessinée" (2010, 5).

(most famously: Wonder Woman), as well as the ever-present threat of stale storylines. For these and other reasons, superhero comics exude a sense of ludicrousness that has enabled many an exciting story but has also threatened to undermine the seriousness of the genre. Parodies facilitate evolution because they counterbalance this threat, and they do so not just at a late moment in the genre's development (as theorists have argued in connection with film), but already early on. The first extended parodies ran in *MAD Magazine* in the mid-1950s, whose popularity spawned so many parody comics that Harvey Kurtzman and Wally Wood's "Julius Caesar" spoof in *MAD* #17 (11/1954) featured a "special announcement" by the narrator that lambasted these "many lampoon type comic books on the newsstands" (mentioned are *Bughouse, Crazy, Eh!, Flip, Get Lost, Madhouse, Nuts, Panic, Riot, Wild,* and *Whack*) and suggested that the only legitimate kind of parody would "lampoon . . . the lampoon comics" (Apeldorn 2009, 5). These publications were followed by magazines like *Sick* (Crestwood Publications, 1960) as well as DC's (*Inferior Five*, 1966; *Plop!*, 1973) and Marvel's (*Not Brand Echh*, 1967; *Spoof*, 1970) own superhero parody series in the 1960s and by nonauthorized spoofs in fanzines like *Alter Ego*. In the early 1990s, parodies had evolved to such an extent that Alan Moore's miniseries *1963* (1993) satirized the comics industry as a whole rather than a single character or series. I propose that parodies constitute a major authorization practice through which the genre manages its inherent instability and attains new meanings by transmodifying its narrative and iconographic techniques, incorporating unusual content into a growing archive of stories and creating new roles for new actors.

Chapter 4, "Collecting Comics: Mummified Objects versus Mobile Archives," understands digitization as an impulse that forces the genre to (re)consider, (re)construct, (re)consolidate, and (re)authorize its history to meet the challenges of the present. Instead of focusing on the serial proliferation and cross-media spread of the comic book superhero (which mark the centrifugal forces of popular serial storytelling), it examines processes of conservation and preservation (the equally significant centripetal forces) at a time when the original carrier medium, the printed comic book, "may become an endangered species" (F. Wright 2008, n. pag.). As I will show in my analysis of the museum-in-a-book format—*The Marvel Vault: A Museum-in-a-Book™ with Rare Collectibles from the World of Marvel* (Roy Thomas and Peter Sanderson, 2007); *The DC Vault: A Museum-in-a-Book™ Featuring Rare*

Collectibles from the DC Universe (Martin Pasko, 2008); *The Batman Vault: A Museum-in-a-Book™ Featuring Rare Collectibles from the Batcave* (Robert Greenberger and Matthew K. Manning, 2009); and *The Spider-Man Vault: A Museum-in-a-Book™ with Rare Collectibles Spun from Marvel's Web* (Peter A. David and Robert Greenberger, 2010)—as well as of Chip Kidd's *Batman Collected* (1996), different kinds of musealization practices (Huyssen 1995, 2003) have shaped the genre by enlisting digital technology to overcome the ephemerality of popular serial storytelling through various archiving, indexing, classifying, annotating, contextualizing, interpreting, and historicizing practices. These practices counterbalance the genre's tendency to secure its future as mobile archives that not only preserve the growing backlog of primary, secondary, and tertiary texts but also enable canonization processes vital to the continuation of the genre by combining a process of communal authorization—of certain characters, stories, and creators—with a process of strategic forgetting.

The book ends with a coda on the current state of superhero comics and accounts for the pervasive cultural work of the comic book superhero in the wider social and political sphere.

NEGOTIATING PARATEXT

Author Bios, Letter Pages, Fanzines

As Glen Weldon's inquiry into the "origins and growing pains" (2016, 11) of Batman's first decade indicates, questions of origination lie at the core of the superhero genre. Weldon walks his readers through the creative process behind the early Batman comics, detailing how Bob Kane swiped poses and panel designs from Alexander Raymond's *Flash Gordon* and other sources and how Bill Finger, his initially unacknowledged writer, borrowed liberally from the pulp hero The Shadow to fashion a superhero that has fascinated audiences since the late 1930s. Moving from the circumstances of Batman's inception to an interest in narrative functions, DC writer and editor Dennis O'Neil once noted in an interview with Roberta Pearson and William Uricchio: "The origin is the engine that drives Batman" (1991b, 24). Successful comic book characters, Uricchio and Pearson suggest, derive their narrative thrust and the necessary malleability to sustain decades of storytelling in changing media environments from the powers of their origin stories. In Batman's case, this encapsulates a "set of key components" that enable the figure's "impulse toward fragmentation" by retaining an iterative core in lieu of an "authorita-

tive repository" of fixed facts and static elements (1991, 184–85).[1] It is these components that sanction each new iteration of the superhero by preserving a minimal background against which these iterations are scrutinized as legitimate successors of a constantly growing body of narratives. Origin stories thus provide common ground for any communication about the superhero's past, present, and future, from officially copyrighted and trademarked narratives to semiofficial or unofficial productions, such as fanfiction and fanart or amateur and academic criticism of the genre, including trade books like Weldon's. Indeed, these stories authorize a discourse of origination in a genre whose standard operating procedures include repetition, variation, and adaptation.

As I argue in this chapter, the authorizing functions of origin stories are not confined to individual characters but extend to stories about their inception and ongoing production, supplementing intradiegetic myths of becoming a superhero with powerful controversies about comic book authorship. In his recent book on Superman, Ian Gordon notes that "the story of Superman's creation by Jerry Siegel and Joe Shuster almost rivals th[e] story" of the character's origins and holds that the popular tale of Siegel's and Shuster's struggle against DC Comics "often achieves the mythic proportions of Superman, with the heroic artists as creative individuals facing off against the monolithic corporation that denied them their rights" (2017, 12). Gordon's analysis of the conflict-ridden letter exchange between Siegel and DC business manager Jack Liebowitz and editor Whitney Ellsworth indicates that "attributing authorship for Superman is a complex matter" (93). As we will see, attributing Batman's authorship is equally complex. It depends on multiplying not only the number of human actors involved in the process—in Gordon's account: Siegel, Shuster, and their assistants; Liebowitz, Ellsworth, and other DC staff; and employees of the McClure syndicate responsible for ensuring the quality of the Superman newspaper strip launched at the beginning of 1939—but also the number of nonhuman actors, such as copyright and ownership regulations as well as the affordances and constraints of popular serial storytelling.

Taking a cue from Gordon's work, I propose that stories about authorship and comics creation are integral elements of the genre. They are crucial evolutionary mediators, serving as more than con-

1. See also Banhold's (2017) account of Batman's many iterations.

textual information for the interested few by constituting an essential body of knowledge for those identifying as readers and fans. This is particularly significant because the nexus of authorship and authority, *auctor* and *auctoritas*, especially in its indebtedness to modern notions of ownership and originality, has traditionally shaped what Andrew Bennett calls "the 'praxis' or 'pragmatics' of authorship: the social, historical, institutional and discursive limits on, and conventions of, the author" (2005, 5), which undergo decisive change in the realm of popular serial storytelling. "It is essential that we also consider the information which circulates around the primary texts," Jeffrey Brown notes, since "the readers are often well aware of the creative forces behind the texts and incorporate as much extratextual information as possible into their interpretation of the stories" (2001, 17). These interpretations tend to include "transtextual facts (e.g., the character's back story or similar events in other comic books) and extratextual facts (e.g., historical genre references, knowledge of the creative team . . .)" (91), which readers negotiate in search of what is taken as the correct, or most adequate, understanding of the text (123).

The historically most productive space in which such negotiated interpretations of comic book content and the transtextual and extratextual information circulating around it emerged were the letter pages, or lettercols, that were introduced in the late 1950s and early 1960s and were featured in nearly all mainstream comic books by the 1970s (Pustz 2007, 165). "Without the lettercols, there might not have been a comic book culture, constructed out of communities of readers united by their love of comic books," Matthew Pustz maintains (2007, 182). These columns authorized a discourse *about* the comics that was printed *in* the comics. They fostered public exchange between producers and readers, provided running commentary about ongoing series, and planted seeds for later forms of criticism, from fanzines and prozines to online commentary and academic scholarship. Privileging the agency of human actors in this development, Bart Beaty suggests that "the second wave" of organized comics fandom, comprising people like Richard Lupoff, Maggie Curtis, Don Thompson, G. B. Love, Jerry Bails, and Roy Thomas, "exerted the greatest influence on the general development of organized comics fandom, creating most of its important institutions including comic book specialty stores, comic book conventions, fan magazines, comic book price guides, and even publishing houses" (2012, 154). In keeping with

Latour's notion of mediation as "an event . . . or an actor . . . that cannot be exactly defined by its input and its output" (1999, 307), I understand neither the introduction of the letter pages nor the activities of so-called fans as the single input that shaped these developments but rather recognize both as mediators that made a difference in the history of the genre.

A good example is the following letter by Albert Rodriguez in *Captain America* #110 (2/1969), which complains about what this writer believes to be the superhero's hawkish and warmongering rhetoric as well as his false sense of patriotism:

> In #101, page 17, panel 6, and I quote, "And those who would grind us underfoot can never hope to keep us from reaching our eventual destiny!" Sure, I agree with this ideal, in the fact that tyrants are enemies to freedom, equality, and fraternity. But does he [i.e., Captain America] have to make it sound as if he and a few other glory mongers can decide what justice individuals may have or may not have? No! Today in America, there are many hawks who favor conservatism. Obviously, Cap is an upholder of this policy. In the above issue, page 18, panel 2, Cap says, "It's you who have outgrown the dream—You who are blind to the promise of tomorrow!" Ha! Look who's talking. He's just as blind.

Readers like Albert Rodriguez position themselves politically vis-à-vis their favorite characters and stories, but they also act as proto-scholarly authors, using verbatim quotations and, as evidenced by letters from Kenneth Burke in *Captain America* #114 (6/1969) and Paul Scott in *Captain America* #132 (12/1970), cross-referencing previous letters (Burke: "I quote from his letter") and suggesting further reading (Scott mentions Eric Hoffer's *The True Believer: Thoughts on the Nature of Mass Movements* from 1951) (Stevens 2011, 613, 623).

Letter pages thus served as mediators of genre evolution by enabling readers to refine their critical skills and by fostering public controversy, with Rodriguez's missive spawning a "letter feud [that] lasted almost eighty issues, long enough to involve seven comic writers and twelve different artists" (Stevens 2011, 606). These pages did so not only by providing discursive space but also by materially anchoring this space in a serially published print object, which could be owned and collected and which accrued a growing historical repertoire—a "serial historiography" (Bolling 2012, 210) or "extraordi-

nary archive" (Fawaz 2016, 101)—analogous to the accumulating backlog of stories. The very existence of this discursive and material space can be traced to intersecting human and nonhuman sources of action: to a relatively small number of industry professionals who decided, based in some cases on personal experiences with earlier science fiction fandom, to try out letter pages in the comics; to readers willing to pick up a pen and send commentary to the editors; and to postal regulations that required the inclusion of two pages of text that had initially been filled with only moderately appreciated short stories (Pustz 1999, 166).

Comic Book Authorship

In his much-cited essay "The Death of the Author" (1967), Roland Barthes "seeks to move authority away from the author, the author as the source of the work, the fount of all knowledge and meaning," as Andrew Bennett maintains (2005, 13). Authorship, according to Barthes, does not reside in the text but is attributed by readers and critics. This attribution has far-reaching consequences: "To give a text an Author is to impose a limit on that text, to furnish it with a final signified, to close the writing" (1977, 147). For Barthes, the finality of the authorially attributed, closed text privileges the role of the literary critic, who conquers a text by seeking to explain—and thus ossify—its otherwise fluid meanings. Instead of adhering to such an explanatory fixing, Barthes favors the open-endedness of intertextual signification and allocates the agency for meaning-making within the reader: "A text is made of multiple writings, drawn from many cultures and entering into mutual relations of dialogue, parody, contestation, but there is one place where this multiplicity is focused and that place is the reader, not . . . the author" (148).

There is much to be noted about Barthes's conception of authorship, from the political overtones of his antiauthoritarian debunking of authorial power and his empowering of the reader, to the revolutionary rhetoric that informs his conclusion that "the birth of the reader must be at the cost of the death of the Author" (1977, 148). Most relevant for my argument is his insistence on writing and reading as the product of multiple agencies and the understanding of authorial attribution as something that channels processes of textual interpretation. As I will illustrate, superhero comics resonate

with, but ultimately complicate, Barthes's assumptions: They thrive on practices of authorial attribution but resist any sense of finality or closed-off meanings. They produce ever more narratives and interpretations while, at the same time, creating new means of containment and control.

In "What Is an Author?" (1969), Michel Foucault responded to Barthes's suggestions and argued that perceptions of authorship result from "specific discursive practices." These practices erect "systems of valorization" that manage the "relationship . . . between an author and a text . . . [and] the manner in which a text apparently points to this figure who is outside and precedes it" (Foucault 2001, 1622, 1623).[2] Foucault does not speak specifically about popular culture, and he does not seem to have in mind multiauthored and decade-spanning narratives like superhero comics when he suggests that discursive constructions of authorship perform significant functions for serial texts. But when he notes that the author of serial texts "constitutes a principle of unity in writing where any unevenness of production is ascribed to changes caused by evolution, maturation, and outside influence," and when he adds that this "author serves to neutralize the contradictions that are found in a series of texts" (1630), he pinpoints the serial function of authorship discourse in comics: to stabilize the inherently unstable project of narrative continuation from installment to installment and to mediate between the desire for authorial unity and the heterogeneous author figures produced by sprawling and often contradictory styles and contents.[3] It is through this nexus of serial storytelling and authorship construction that superhero comics authorize competing bids for narrative and interpretive prevalence and enable the emergence of new roles for new actors—including readers whose activities go beyond the act of reading—in the evolution of the genre.

While Foucault largely ignored the role of the reader, Umberto Eco developed a model for analyzing popular serial narratives that distinguishes between two types of readers: the "naïve" and the

2. Williams and Lyons propose five ways of approaching comics authorship: as a brand, as an allegorist or interpreter of real-world events, as a self-contained artist or worker for hire, as a political actor, or as a literary author (2010, xii).

3. Gray suggests that Foucault's author function "allows a middle ground, wherein the author is denied outright authority, but exists as a discursive entity that channels and networks notions of value, identity, coherency, skill, and unity" (2010, 109).

"smart" reader. The naïve reader "is the victim of the strategies of the author who will lead him little by little along a series of previsions and expectations"; the smart reader "evaluates the work as an aesthetic product and . . . enjoys the seriality of the series" (1990, 92). Eco's distinction, while certainly useful, underestimates the fact that the repetition and variation that structures serial storytelling also structures the reading practices through which followers of superhero comics interpret the stories. As we can learn from the comic book letter pages, more often than not, serial readers can be naïve and smart at the same time, appreciating the repetitiveness of an ongoing series and enjoying the familiarity of characters, settings, drawing styles, and story structures while treasuring the variations, additions, and revisions necessary for a series to retain long-term interest.

In addition, Eco's readers tend to merely consume a series and have little impact on its continuing production: "The series consoles us (the consumers) because it rewards our ability to foresee: we are happy because we discover our ability to guess what will happen," Eco alleges, noting further: "We do not attribute this happy result to the obviousness of the narrative structure but to our own presumed capacities to make forecasts. We do not think, 'The author constructed the story in a way that I could guess the end,' but rather, 'I was so smart to guess the end in spite of the efforts the author made to deceive me'" (1990, 86). Aficionados of popular serial narratives are usually more ambitious than this, showing an awareness of the specific affordances and constraints as well as reflecting and commenting on their own roles as consumers and commentators whose actions have consequences for a series' continuation. Many readers of superhero comics are aware of their double position as self-reflexively naïve *and* smart readers, self-identifying as fanboys or fangirls who act as the kind of "amateur narratologists" Mittell (2006, 38) discusses in the context of American television and also as critical contributors to comic book discourse. Consumers of popular serial stories frequently seek to transcend the role of passive recipient, becoming "active audiences" (Fiske 1987; Hayward 1997) that intervene in a series' public reception to influence the narrative possibilities of its continuation while, at the same time, being trained by the narrative to act as competent consumers (Allen and van den Berg 2014a, 2).

In that sense, superhero comics motivate heightened degrees of authorial engagement *and* reader involvement. Discussing the sequential arrangement of comics and their amalgamation of images

and words, Jared Gardner underscores the "unique affordances" through which comics involve readers in meaning-making. Comics "privilege an audience not only projecting its own storytelling into the text but also always potentially picking up a pen . . . and creating the story themselves" (2012, xiii). Readers are conceived as always latent and sometimes actual authors and artists, which foregrounds the flexibility and availability of authorial and readerly roles to a range of actors. What goes unmentioned, however, is a particular space in comic books that has functioned as a prime mediator in the construction, negotiation, and authorization of comics authorship: the threshold between the comic book stories themselves (the text into which readers project their ideas by imaginatively filling in the gutter spaces between panels and by working the interface between words and images) and the world outside of the comic book, where readers consume, comment on, and even draw their own comics or write their own stories.

Gérard Genette proposes the term "paratext" to designate this space between the text and the extratextual world:

> More than a boundary or a sealed border, the paratext is, rather, a *threshold,* or . . . a "vestibule" that offers the world at large the possibility of either stepping inside or turning back. It is an "undefined zone" between the inside and the outside. . . . [I]ndeed, this fringe, always the conveyor of a commentary that is authorial or more or less legitimated by the author, constitutes a zone between text and off-text, a zone not only of transition but also of *transaction.* (1997, 1–2)

It is this transaction at the fringes of the text, at this diffuse space of uncertain authorial legitimization and ambiguously authorized expression, that functions as a mediator in the evolution of superhero comics.[4]

Paradigmatic examples from the superhero genre are the editorials and letter pages that stage controversies about how to create and how to read the comics. Such paratextual engagements enable "practices of orientation and mapping," Mittell notes, and the very "act of linking a text to a paratext, whether officially sanctioned or viewer cre-

4. See Gray: "Paratexts fill the space between . . . Text, Audience, and Industry . . . , conditioning passages and trajectories that criss-cross the mediascape, negotiating or determining the interactions among the three" (2010, 23).

ated, changes how we see the original" (2015, 261, 262). In superhero comics, these paratexts not only provide orientation, they also foster serial debates about plot developments, the gestation of complex narrative universes, the characterization of protagonists and antagonists, and themes from the simple good versus evil stories of the genre's early years to the morally conflicted narratives of the darker period since the 1980s and 1990s. They generate exchange between official comic book producers and recipients: between those who are institutionally sanctioned by the company logo, copyrights and trademarks, and authorial signatures to present authoritative stories and those whose engagement with and commentary on these stories must utilize alternative means of authorization. Paratexts not only authorize new author functions, they also foster competing enunciations of authorship, or author figurations, in a Latourian sense: "What is doing the action is always provided in the account with some flesh and features that make them have some form or shape" (2005, 53). These author functions and figurations impinge on the ways in which the comics are produced, promoted, and perceived.

Authorial Origin Stories: From Paratext to Epitext

American comic books suffered from low cultural esteem and a lasting association with cheap mass entertainment throughout the first decades of their existence. Jules Feiffer recalls working in "schlock houses," minor publishers that "operated as way stations for both the beginners and the talentless" (1965, 50) in the early years of comic book production: "Jobs were divided and subdivided—or, sometimes, not divided at all. . . . Everybody worked on everybody else's jobs. The artist who contracted the job would usually take the lead feature. Other features were parcelled out indiscriminately. No one cared too much. . . . They were all too busy" (51–52). But from the very beginning of the genre, when "nobody had any respect for comics" and when they marked "the lowest rung on the creative totem pole" (Raphael and Spurgeon 2003, 27), as Stan Lee recalled, publishers counteracted the assumption that what they were offering were merely formula stories told by anonymous hacks. When the first Batman story, "The Case of the Chemical Syndicate," appeared in *Detective Comics* #27 (5/1939), it signaled its authorial status through a "Rob't Kane" signature on the first page. *Batman* #1 (3/1940) already

communicated a more complex author figuration, indicating that the series addressed a readership specifically interested in this superhero, its growing history, and its creator. Here, the notion of comic book authorship solidifies, and the author begins to take center stage: A stylized "Bob Kane" signature is displayed on the cover of the comic. Inside, readers are introduced to Batman's origin story, which supplies the character with the childhood trauma—the murder of his parents—that will motivate his endless fight against crime.[5]

If serial characters are driven by successive retellings of their origins, comics authorship is indebted to its own tales of conception. In *Batman* #1, Kane is introduced as the "creator of THE BATMAN!" in the one-page biography "Meet the Artist!" (see figure 1.1). This biography is the first of many paratextual figurations of Batman's authorship. Kane's photograph shows him at work at the drawing board and indicates how and by whom the stories are created. Kane looks directly into the camera, intimating a personal relationship between creator and audience: "READERS, meet Bob Kane," the opening sentence declares. Here, the author, or creator, is not merely implied, but verbally described and visually captured, foregrounding the diffusely authorized and negotiated nature of authorship through the ambiguity of the implied author as either "an intentional product of the author in or qua the work or . . . an inference made by the recipient about the author on the basis of the work" (Kindt and Müller 2006, 8).

The author biography, most likely written by editor Whitney Ellsworth, emphasizes the originality of Kane's creation, seeking to preempt discussions of Kane as a copycat, for instance of Superman, or of comic books more generally as a mass-produced form of storytelling assembled from a smorgasbord of cultural sources:[6] "Bob is certainly not a copyist; his work shows a definite originality and freshness." The text mixes a romantic notion of inspired authorial creativity with the public acknowledgment of comics production as a skilled and speedy process that delivers a marketable product. Comic book creators are geniuses because they produce fascinating figures and riveting stories to supply readers with a steady entertainment flow. Even when the attribution of a character was to the company and not to any specific creator or creator team, the discourse of orig-

5. *Batman* #1 reprinted the origin story from *Detective Comics* #33 (11/1939), titled "The Legend of the Batman—Who He Is, and How He Came to Be."

6. See Gavaler's (2015) investigation of the genre's prehistory.

MEET THE ARTIST!

READERS, meet Bob Kane, creator of THE BATMAN! Realizing that people like to know something about the men who draw their favorite cartoon-strips, we induced Bob to sit down at a typewriter and dash off a few pertinent facts about his life. He complained that a drawing-board—and not a typewriter—was his natural means of artistic expression, but he did manage to hammer out a sort of synopsis about himself.

On top of that, we felt that we should have a picture of Bob to grace this page. We asked him to bring us one. "Sure," he said, "I'll take care of that." But as the days went by, and publication date came nearer and nearer, we still had no picture. Finally we had to sit Bob down at a drawing board, hold him there until a photographer could be called in from another floor of the building—and we finally got our picture!

Bob Kane was born twenty-four years ago in New York City, and has spent most of his life in the big town. As you might expect, his primary interest has always been in drawing. His work has appeared in a long list of national magazines. For some time Bob was a straight "comic" artist, specializing in drawings of a humorous nature. When the trend swung toward the adventure type of drawing, Bob was quick to see that therein lay his future, and though the abrupt change in drawing technique necessitated plenty of hard labor on his part, the phenomenal success of THE BATMAN is proof enough that Bob was capable of making the transition. It hasn't been easy, and it isn't easy even now. Anyone who thinks a comic artist has an easy life should take a look at Bob Kane's working-schedule. It's an unusual week which doesn't find Bob at the drawing board on seven consecutive days. The saving grace about it all is the fact that he enjoys his work, though he does admit that he might like to have a little vacation come summer—three days in a row, or something like that.

Bob has spent a good deal of time in the North woods, hunting and fishing (before THE BATMAN took up all his time, of course). He loves outdoor life in all its phases. For a time he worked as seaman on a boat plying South American waters, and he says that he feels that this contact with all sorts of people, plus the satisfaction of seeing parts of the world absolutely foreign to the environment of New York, has been of great help to him in humanizing the characters which he draws.

Bob is certainly not a copyist; his work shows a definite originality and freshness which has attracted many fervent fans. He studies constantly, striving always to improve his work. If he has a free hour or two, he is very likely to spend it at one of the local medical colleges studying anatomy, for he well realizes that only by a thorough knowledge of bone and muscle structure is an artist able to inject into his drawings the true expression of action and motion which is so necessary to this type of art.

Bob Kane has worked hard, is still working hard, and will continue to work hard to give you just the sort of thing which you have come to expect in THE BATMAN. We predict ever-increasing success for both the artist and the creation of his facile pen. And they both deserve that success!

—THE EDITOR

FIGURE 1.1. "Meet the Artist!" *Batman* #1 (3/1940) © DC Comics.

inality was strong, as an advertisement for Captain America and his followers from the early 1940s indicates:

> Since Captain America and the Sentinels of Liberty have attained such tremendous popularity, many imitators have tried to mimic our favorite hero—But all of them fall far behind the pace set by Captain America in originality, action, and good reading—Beware of these cheap imitators!—Captain America and the Sentinels of Liberty . . . cannot be copied! (Simon and Simon 2003, 43)

Such portraits of DC's and Marvel's original creators and creations, including a biography of Siegel and Shuster's in *Superman* #1 (6/1939), did little to change the broader understanding of comic book authorship, as John Kobler's article "UP, UP AND AWA-A-Y! The Rise of Superman, Inc." in the June 1941 edition of the *Saturday Evening Post* indicates. Even though Superman was already a trademarked sensation, Kobler described Siegel and Shuster as pathological fans rather than legitimate authors and artists: "The young creators of the Man of Steel would have been hailed by Doctor Freud as perfect clinical illustrations of psychological compensation," Kobler opined:

> For here are two small, shy, nervous, myopic lads, who can barely cope with ordinary body-building contraptions, let alone tear the wings off a stratoliner in mid-air. As the puniest kids in school, picked on and bullied by their huskier classmates, they continually moped off into what Doctor Freud termed "infantile phantasies," wherein they became colossi of brute strength, capable of flattening whole regiments of class bullies by a flick of their pinkies. (1941, 70)

Kobler struggles to reconcile his patronizing impression of Siegel and Shuster with Superman's commercial success. This is a serious case of intentional fallacy shortly before William K. Wimsatt and Monroe C. Beardsley (1954) would coin the term for the reductive reading of literature through the lens of an author's biography and intention. Kobler's solution is to narrate the story of the character's creation as a tale of multiauthorial collaboration (which is, ironically, closer to the historical moment than the popular myth), downplaying Siegel and Shuster's agency by emphasizing the impact of DC's corporate representatives (Major Wheeler-Nicholson, Harry Donenfeld, Whitney Ellsworth) and editors of the McClure syndicate. Kobler emphasizes the character's expansion into *The Adventures of Superman* radio serial (1940–1951) and Paramount Pictures' animated cartoons (1941–1943) with a rhetorical move that deauthorizes the ostensibly childish creators. This move is announced in the title of the article ("Superman, Inc.") and culminates in the section "The Air Wave of Prosperity": "With Superman, Inc.'s many extra-literary enterprises neither Shuster nor Siegel has any direct connection" (1941, 74).[7]

7. See Meier (2015) on Superman as a transmedial phenomenon.

In 1939, when DC ran the Siegel and Shuster biography in *Superman* #1, the fiction of authorial creativity and control over the character was still in operation.[8] But even there, despite the focus on Siegel and Shuster as inspired creator figures, the tone and narrative perspective complicate the image of singular authorial creation, as they did in the Kane biography. While Kane "did manage to hammer out a sort of synopsis about himself" for *Batman* #1, the bio was actually written by an "editor," who "induced" Kane to "dash off a few pertinent facts about his life" and then converted the material into a biographical text. This procedure mirrors the way in which the comics themselves were produced, with writers and artists hammering out serial stories and editors authorizing final versions for their "many fervent fans" (whose status as "fans" elevates them from the role of mere consumers to the status of dedicated followers).[9] While the notion of collaborative production is implied, the twin fictions of superhero origins and singular authorial creation remain intact, even though readers learn that comics creators are hired professionals who work fast to meet the expectations of their editors and audience.

Only a few years later, a second origin story extended these authorial projections, as the expanding genre called for an expanding sense of authorship. What had been a surprisingly successful product in 1940 had evolved into a mainstream genre appreciated by a substantial chunk of the American population by the mid-1940s, when, according to a survey conducted by the Market Research Company of America, "95 percent of all children ages eight to eleven read comic books regularly, as did 84 percent of those from twelve to seventeen years old" (Pustz 1999, 27).[10] While Batman's origins and Kane's biography had been presented as two distinct pieces in *Batman* #1 (the hero's textual origins supplemented with the author's origin story), "The True Story of Batman and Robin! How a Big-Time Comic Is Born!" in *Real Fact Comics* #5 (11–12/1946) synthesized them into a

8. On this biography, see Gardner (2012, 74–75). Gordon suggests that the "Siegel and Shuster" byline ended when Siegel unsuccessfully sued DC for the return of his copyright to the character in 1947 and DC decided that "ownership was more important than promoting creators" (2020, 106).

9. The distinction between reader and fan is important. Fans become active beyond reading by collecting comics, writing letters, organizing and attending conventions, producing fanzines, or hosting comics-related websites.

10. On the genre's early successes in the war years and beyond, see B. Wright (2001); Murray (2011).

single graphic tale of origin (see figure 1.2).[11] According to Genette's nomenclature, this origin story was part of the superhero's epitext since it was not materially appended to the Batman comics but was nonetheless part of Batman's wider textual cosmos. The extension from text (Batman's origin story) and paratext (the author biography in *Batman* #1) to the epitext of *Real Fact Comics* illustrates a central dynamic of popular serial storytelling, where proliferating stories, characters, and settings are accompanied by an increasing demand for author figures to contain the serial sprawl (Kelleter 2014b, 48). Long-running narratives may not only generate vast narrative universes; they also give rise to classificatory systems, critical terminologies, and powerful fictions of authorship through which they channel proliferation into manageable forms (Kelleter and Stein 2012, 283–84).[12]

"The True Story of Batman and Robin!" depicts Kane behind the drawing board. The comic shows one of the genre's many (simulated) public construction sites, offering insights into making-of processes that can shift attention from matters of fact to matters of concern (Latour's fourth uncertainty) and suggesting that instead of taking Kane's creator role for granted, we should investigate how popular notions of Batman's authorship emerged and how they were continuously debated. Kane is presented as an artist working in a specific setting and institutional structure, but the notion of collaborative production no longer remains implied. The narrative refers to the "expert editorial guidance" Kane had received when he first created Batman, and readers get to see the graphic rendition of an editor. While Kane had already been described as an employee of DC Comics in *Batman* #1, he is now more clearly shown as one creative element in a longer production chain, whose work must be approved by an editor. What's more, "The True Story of Batman and Robin!" is not an autobiographical comic. It was drawn by Win Mortimer, and the narrative perspective is explicitly authorial: "Let us drop in at the studio of talented young Bob Kane," the narrator proclaims, suggesting a physical copresence of author and reader facilitated by those who edit and publish Batman.

11. See also Schumer (2001).

12. As an example of "vast narrative," the comic book superhero involves sprawling narrative extent, world and character continuity, cross-media universes, procedural potential, and multiplayer interaction (Harrigan and Wardrip-Fruin 2009, 2).

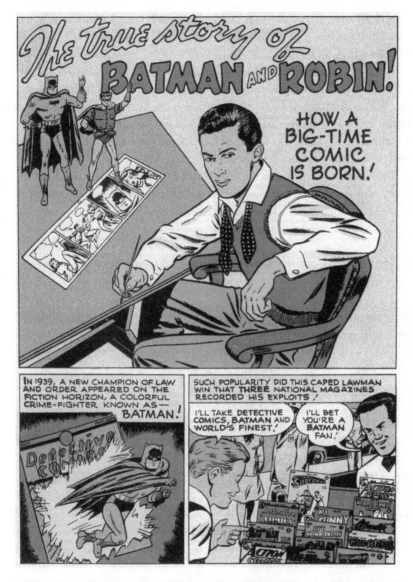

FIGURE 1.2. "The True Story of Batman and Robin! How a Big-Time Comic Is Born!" Win Mortimer. *Real Fact Comics* #5 (11–12/1946) © DC Comics.

In addition, the offer to collaborate in the storytelling becomes explicit in a scene that directly authorizes readers as potential comics creators. Here, we learn that the suggestion that had sparked the creation of Batman's teenage sidekick Robin had allegedly come from a fan who had expressed his desires in a personal letter to Bob Kane:

"I would like to see Batman have a partner . . . someone who can share the secret of his identity." Finally, Batman and Robin appear as characters on the story level but also as fictional comic book characters within this story. On the story level, they meet their creator, who leaves his extratextual position as an artist to become a character. When Batman and Robin thank Kane "for bringing us to life" and Kane thanks the fans "for your interest and wonderful friendship," the comic book paratext is publicly acknowledged as the space where authorial and readerly projections must vie for the legitimization of the whole discourse community involved in the production and reception of a superhero comic, a space where every decision concerning a series must come across as collectively authorized.

Letter Pages as Serial Paratexts: Authorizing Comics Authorship

As *Batman* #1 and *Real Fact Comics* #5 indicate, questions of authorship appeared early in the history of the genre. They attained a new dimension with the introduction of letter pages in the late 1950s and early 1960s. While letters had been printed on earlier occasions, DC began to feature them regularly in *Superman* #124 (9/1958) and *Action Comics* #245 (10/1958) and about a year later in *Batman* #125 (8/1959), with *Detective Comics* starting in issue #327 (5/1964).[13] Jean-Paul Gabilliet suggests that these pages created "a new type of proximity . . . between readers and publishers" (2010, 53) and that they were encouraged by DC editors Mort Weisinger, Jack Schiff, and Julius Schwartz. These editors had been part of science fiction fandom in the 1920s and 1930s, where letter pages were an established feature. They apparently realized that it made commercial sense to use letters to motivate a new generation of readers to embrace superhero comics as narratives whose present and future were worth discussing and whose past was worth preserving by amassing collections, creating archives, researching backstories, and reconstructing production histories.

In Foucault's terminology, one particularly significant mediating function of comic book authorship was the creation of a valo-

13. I will focus on the discourse in the letter pages of *Batman*, excluding (for the sake of space) *Detective Comics* and other DC publications. On letters to *Superman*, see Gordon (2012; 2017).

rizing system according to which particular styles and stories could be attributed to individual creators, criticized, and, over time, marginalized or canonized. In *Batman,* this system emerged from reader involvement amplified by the "Letters to the Bat-Cave" section, which reshaped Batman's author functions by authorizing new types of authorship. This page implemented the notion that readers could project their ideas from the extratextual world (Genette's "off-text") onto the material space of the comic by entering the paratextual discourse about their favorite series at a time when Batman stories still carried a "Bob Kane" signature. Will Brooker speaks of DC's "cultivation of [an] 'authorship' discourse" in the 1960s that promoted the notion that "the boundaries between comic author and fan, writer and reader, have always been thin and often dissolve entirely" (2000a, 252, 253).[14]

The first letter page in *Batman* #125 begins with a reader's comment. "I've been a BATMAN fan for many years," Larry Graff writes, "and I would like to make a suggestion. How about a page of letters for your readers?" Such a page "would give readers a chance to make suggestions of their own." The answer — "We agree with you, Larry, and so do many of your fellow BATMAN fans, who have suggested the same idea to us" — is supplied by a nameless editor who will, from now on, play the role of the moderator at the service of the audience. The fact that DC printed this letter as the opening salvo in the ensuing exchange between comic book producers and consumers underscores the evolution of the genre from the 1940s, when comic book communication was largely directed at readers, to the 1960s, when it begins to circulate from authors to readers and back again. As a long-running series, *Batman* now had a history that could be explored and discussed by followers whose long-term reading practices eventually aggregated into consolidated forms of comics fandom and whose activities no longer remained confined to the act of reading. Graff's letter thus constitutes a paratextually mediated authorizing gesture in a double sense. It transforms Graff from a reader into a published author (if only of a fan letter), and it announces an officially sanctioned notion of reader participation in DC's storytelling project.

Having Graff's letter kick off the column in *Batman* downplayed the commercial considerations that must have motivated DC's deci-

14. Lopes notes a "collective dialogue among fans, artists, and publishers in the comic book field" (2009, xiii).

sion to introduce lettercols, and it also fanned the increasingly pop-
ular appeal of reader participation. Yet the ease with which DC
attributed the beginning of the pages to the desires of the fan audi-
ence raises questions about the letters' veracity and their represen-
tativeness. It is true that some of them were written by DC staff,
especially when they fulfilled a strategic purpose. Pustz cites a 1985
interview with John Byrne, who confesses to having composed letters
when he was working on the *Fantastic Four* series (starting in 1979):
"I did, I guess, about three months' worth of letter columns that were
entirely fake letters. I took points from different letters, and I wrote a
letter that represented those points" (2007, 168). As early as July 1965,
Superman #178 printed a letter by Paul Emmett, the undisclosed son
of the head of Licensing Corporation of America, which was affiliated
with DC Comics and responsible for its merchandise. Proposing the
desirability of this merchandise, the letter stated: "I am a great Super-
man fan, I have seen several Superman products, such as the Aurora
model kit, which I built; but I'm interested in other Superman prod-
ucts" (qtd. in Gordon 2017, 143).[15] Solicited letters such as Emmett's
remind us that idealizing the columns as an authentic and democratic
space—as a "critical counterpublic" (Fawaz 2016, 97)—is problematic,
while Byrne's admission suggests that some fake letters at least took
prompts from actual letters. It makes sense, then, to read such letters
as competing attempts to exert agency and claim authority among an
array of diffusely authorized actors.

The fact that we know very little about the criteria of selection that
shaped the letter pages does not invalidate this reading. "Letters are
selected, and often for early editions solicited or ghostwritten," Mar-
tin Barker observes. "They are not produced by some 'natural sam-
pling' of readers' responses. . . . They are a part of the self-image of
the comic. They present that self-image, and help to encourage the
right kind of future response from readers" (1989, 47). The letters
nonetheless offered the comic book producers "an informal sam-
pling" of reader opinions, as Dennis O'Neil recalled in the early
1990s. He added: "We try to make the letters representative. . . . If
75 percent of our mail hated a story, we will reflect that in the let-
ter column" (Pearson and Uricchio 1991b, 21, 29). Barker's reference

15. Writing in the *New York Times,* Leonard Sloane reported not much later that
"the Aurora Plastics Corporation . . . is investing 10 per cent of its $1-million print
budget this year in the comics" (1967, 60). According to Sloane, National Periodical
Comics was reeling in half a million dollars in annual ad revenue.

to the "self-image of the comic" thus captures the serial agency of comic books in general and of the letter pages in particular. I do not mean to suggest that the people who wrote the letters and those who selected some of them for publication had no agency in the matter, but rather that the letters constitute a powerful example of interlocking human and nonhuman agencies.

Still, it is important to note the lack of information about the letters' scope. Gordon reports that DC's Paul Levitz once suggested that the company printed between 10 and 25 percent of the letters they received in the 1960s and '70s, while Mort Weisinger claimed in *Action Comics* #319 (12/1964) that readers were sending about 10,000 letters per month (a number probably inflated to hype the popularity of the comics) (Gordon 2017, 127) and Stan Lee even more incredibly suggested that Marvel received "500 letters a day" (Freedland 1966, n. pag.). Issue #32 (11/1964) of the *Fantastic Four* put the number of monthly letters at a more modest 3,000 for all of Marvel's comics (Kasakove 2011, 131). In their study of the letters to *The Amazing Spider-Man*, John A. Walsh, Shawn Martin, and Jennifer St. Germain cite a special segment called "The Anatomy of Fan Response" in issue #201 (2/1980), where the editor cites a total of 132 for that month, a number said to have been above the turnout for less popular Marvel comics. Based on this segment, Walsh, Martin, and St. Germain estimate an average of 110 letters for a typical *Spider-Man* issue and calculate that only about 4.15 percent of the letters sent to Marvel were printed (2018, 69). Due to slipshod archiving or willful neglect aimed at protecting claims such as Weisinger's, we have no access to those letters that were not printed and thus can gauge neither their extent nor the representativeness of those that were printed (Fawaz 2016, 96).

These caveats notwithstanding, letter columns offered a public forum for commentary about a series, and there is sufficient testimony of verified letter writers to suggest that they were mostly curated (Fawaz 2016, 99) rather than counterfeited. They prompted, and indeed authorized, readers to become active by writing to the publishers and investing themselves in the ongoing storytelling. While the whole discourse was controlled by the publisher (a point not specified in the editorial response to Graff's letter), it offered readers a sense of having a say in Batman's future. Graff's phrase "of their own" signals an expectation of shared ownership, or "shared complicity" (Regalado 2015, 14), earned through the purchase and

reading of comic books. This is supported by the editor's reference to the many fellow Batman fans who feel like Graff, which conjures up a social world of like-minded readers who can now converse with each other and seek to influence the makers of their favorite stories.

If letters transformed readers into critics, they also turned editors into readers of fan mail. Brooker notes that "the two concepts of comic book 'author' and 'fan' evolved in tandem from the early 1960s" (2000a, 249). Questions such as "what's your favorite, fans?" (*Batman* #150, 9/1962) and "what's your choice, readers?" (*Batman* #151, 11/1962) communicated a sense of collaborative stewardship by producers who publicly asserted that they would benefit from a mutual exchange of ideas that would shape much of the discourse on the letter pages. What's more, editors occasionally delegated their duties: "This is *your* department, with a minimum of editorial interference," we read in *Batman* #190 (3/1967); "make this page your own"; "what you would do if you were the editor of *Batman*"; "It's your right to write, . . . so don't muff out on this . . . chance to break into print," we learn in *Batman* #189 (2/1967).[16] These rhetorical gestures are part of a marketing strategy rather than actual transpositions of editorial power, but they have consequences: They authorize a reader who has a right to be a published author and potential editor—a right that, once granted, could and would be claimed and that was further supported by stories like "The Night of March 31st!" (*Superman* #145, 5/1961), which contained errors that fans could point out, like an actual editor, in their letters (Gordon 2017, 120).

The authorship discourse in the "Letters to the Bat-Cave" section began with relatively simple assertions, such as "Bob Kane must have had a job on that one" (*Batman* #163, 5/1964) or "a John Broome sounding title—right?" (*Batman* #167, 11/1964). But it quickly morphed into detailed discussions of individual styles and authorial voices beyond the official "Bob Kane" label that were sometimes informed by the writers' personal interaction with DC editors in the

16. We find the same discourse in Biljo White's "Batmania Philosophy," published in the fanzine *Batmania* a few months earlier: "The best way to 'break into' our pages is by a LOC (letter of comment) to the Batmanians Speak section" (1966a, 6). Gardner discerns the creation of a "virtual community" and a "notion of collaborate editorship" in science fiction pulps of the 1920s and '30s that prefigures developments at EC, DC, and Marvel in the 1950s and '60s (2012, 68). As the editor of *Astounding Stories* announced: "This department is all yours, and the job of running it and making it interesting is largely up to you" (qtd. in Gardner 2012, 68).

world off-text as well as within the pages of specific fanzines.[17] As a letter by Mike Friedrich in *Batman* #181 (6/1966) indicates, to distinguish themselves from less knowledgeable followers, expert readers displayed insider knowledge that only years of reading comics and investigating their production processes could garner:

> I'm sure a new writer has joined the *Batman* bullpen. The style of writing is completely different from either Fox, Herron, or Broome, the three mainstays. It might be the veteran Bill Finger, but I doubt it. The story had everything that *Batman* needs to have a story that clicks: (1) Plenty of action; (2) very good art; (3) practically a pun per panel; (4) very good supporting characters; (5) a good, though not outstanding villain. My guess for the authorship is Nelson Bridwell, our man on the inside.[18]

Friedrich speaks as a seasoned critic and chronicler, as someone who has written several letters and can tell a veteran writer not officially credited (Finger, in this case) apart from newer (also uncredited) writers like Nelson Bridwell. As Pustz maintains, printed letters communicated a status of official recognition that unpublished letters could not (2007, 163, 180). Having one's letter, or even multiple letters, published meant gaining a competitive edge over other letter writers, and it afforded special distinction in the comic book community, which charges Friedrich's catalogue of story elements with particular authority. In *Batman* #175 (11/1965), he had already correctly identified the author team behind the "June *Batman*," noting that "the script on this yarn was very good . . . [and that the] Kane-Greene (have you ever seen *green cane*? I haven't!) artwork was excellent. Sid Greene did a much better job of inking than he did on his first *Batman* assignment a couple of issues ago." The answer shows a willingness on the part of DC editors to supply readers with coveted information: "Let's not overlook author-credit for 'Robin's Unassisted Triple Play.'

17. The *Alter Ego* fanzine featured letters from writers like Otto Binder and Gardner Fox, artists like Kurt Schaffenberger, and editors like Mort Weisinger (Thomas and Schelly 2008, 138–39). Stan Lee also conversed with fanzine editors like Jerry Bails (Fingeroth 2019, 97–99).

18. Schelly calls Bridwell "a fan from Oklahoma who . . . moved to New York to work with [Mort] Weisinger" at DC and was one of "the many comic book professionals who came from the ranks of fandom" (1999, 84, 158).

Gardner Fox whipped that one up—while John Broome handled the writing end of 'Attack of the Invisible Knights.'"

Another letter writer, Ken Hodl, puts a name to the back-and-forth about the authorship of *Batman* in #181:

> Guess the author, eh? Well, I have some sneaky suspicions but I'll go about it in a scientific manner. Since it's not Fox, Finger, Broome, or Herron, it would have to be either Kanigher, Hamilton or Drake. I will rule out Arnold Drake for the reason that the story was a bit too wild, as far as violence is concerned. Mr. Drake also lacks the reality in his stories which this one had in tremendous proportions. Edmond Hamilton . . . and Robert Kanigher are both likely suspects, but with Kubert (who does most of his fine work for RK) doing some *Batman* covers now, I'd just have to put my money down on Robert Kanigher.

Friedrich's and Hodl's letters mark the beginnings of an authorship discourse that ventures beyond identifying specific creators, as Hodl's "scientific manner" recognizes individual drawing styles and authorial voices. Once the comics are no longer seen as products of "Bob Kane" but of a group of collaborators whose individual input can be recognized and judged on the basis of its merits, new practices of engagement become feasible. They include portraits of and interviews with individual writers and artists, lobbying for the assignment of particular writers and artists, and privileging certain styles and stories while disavowing others. In the 1960s, these practices facilitated a fan culture that eventually morphed into professionalized forms of comics journalism, including publications such as *Amazing Heroes* (1981–1992) and *Wizard* (1991–2011).[19]

The first stirrings of such criticism came in and through the letter pages, and they suggest a sense of increasing authority among those who read and wrote about the comics. "I consider myself to be a fairly good authority on *Batman*," Friedrich reveals in *Batman* #166 (9/1964). This claim is rewarded when he crosses the paratextual

19. Beaty maintains that fans of popular narratives and artifacts frequently authorize their affection for their desired objects by "mimicking the institutions that are seen to be more legitimate than fandom. To this end, the identification of an author for mass cultural texts that otherwise might be regarded as authorless . . . functions as an attempt to align fandom with the dominant cultural hierarchies" (2012, 75).

threshold from operating as a letter writer in the transitional zone between the world outside of the comic book and its textual inside by becoming the author of one of the stories in *Detective Comics* #387 (5/1969) and being featured as an expert in *Batman* #200 (3/1968).[20] This role reversal represents a serious case of wish fulfillment, an act of readerly empowerment prepared by years of stories depicting the metamorphosis from ordinary human being to superhuman hero. The fan is almost magically transformed here—not into a superhero, but into something perhaps even more powerful: an author of superhero stories. Friedrich was, in fact, hired by DC Comics in the late 1960s and became a writer for Marvel a few years later, and he was not the only fan-turned-pro. In 1966, the then-fourteen-year-old Jim Shooter was awarded with a writing position at DC, editor Mort Weisinger seeking to secure the young talent whose story suggestions for the *Legion of Super-Heroes* series promised a future in the business (Shooter would eventually become Marvel's editor in chief from 1978 to 1987) (Pustz 1999, 82). In other cases, DC bought stories from fans without offering them positions in the company.[21]

The career path from fan to pro remained the exception rather than the rule, but there was enough evidence that it was possible at least for some. "Comic book fans regularly become professionals, and professionals continue to identify as fans," Pustz states, discerning a "self-referential cycle" spurred by the serial agencies of the comic book (1999, 109). The successes of people like Friedrich and Shooter motivated others to invest their time and effort in pursuit of a prominent role in the storytelling. As Paul Decker, a fan of the Legion of Super-Heroes and one of the voters who felt empowered by the

20. Friedrich's transformation is mentioned in the author credits, in the last panel of "The Cry of Night Is—'Sudden Death!'" (*Detective Comics* #387), and on the final page of *Batman* #200, which features a "Dialogue between Two Batmaniacs upon Batman Reaching Issue 200" (Friedrich and fanzine editor Biljo White). He provides a detailed account of the writing and editing process and his communications with DC Comics in *Batmania* #19 (9/1974, 4–9).

21. Gordon tells the story of prolific letter writer Irene Vartanoff, described as "a legend in the comic world" in a letter by John Krzyston in *Action Comics* #397 (2/1971), who sold stories to DC, only one of which seems to have been published, and who was allegedly denied a job by Julius Schwartz and advised to seek a domestic married life instead (2017, 132–33). She appears in a 1975 photo gallery of the Marvel Bullpen as "Impish Irene Vartanoff" ("Bullpen Unleashed"; Thomas and Sanderson 2007, 128); John Romita recalls that she "was in charge of returning original art" to Marvel artists in the 1970s (Thomas and Amash 2007, 48).

annual elections of the Legion's team leaders staged by DC, wrote in the fanzine *Legion Outpost* #9 (1975):

> I think that one of the reasons so many of us really loved the Legion is that it was *our* feature. . . . I really felt a part of that Legion, when I knew that my vote had been counted, when [editor] E. Nelson Bridwell printed my letters and then my costume designs. I really felt that someday I was going to be another teen-aged Jim Shooter genius. (qtd. in Pustz 1999, 82)

As we can see here, Decker's activities beyond reading comics are quite extensive, ranging from written assessments to graphic suggestions for future installments.

The dream of transforming from fan to industry professional was feasible because long-running series pose a central problem to any author, whatever the official legitimation or institutional authorization may be: how to master accumulating plot developments and accruing character constellations, as well as the inevitable changes in style, tone, and setting, so as to produce authoritative new installments. Comic book creators have to be avid readers, if not fans, and even then, they will have a hard time competing with the collective knowledge of their readers, even though they are often guided in their narrative and aesthetic choices by so-called bibles that lay out the basic premises of a character and storyline and establish a blueprint for their momentary makeup.[22] In addition, the most dedicated readers will amass a serial memory over the years, with detailed knowledge about the most arcane elements of the series' past, and they may acquire skills that qualify them either as writers or artists of future stories or as perceptive critics of the ongoing serial storytelling.

With experts like Friedrich and the many others who wrote letters, published fanzines, and organized or attended comics conventions by the mid-1960s, it was no longer possible to tell simple

22. Earlier mechanisms were memoranda like Sheldon Mayer's "Note to Writers and Artists" (ca. 1940s) and letters to individual artists like Murray Boltinoff's missive to Gardner Fox from October 16, 1940, in which he provided "some helpful hints to you in writing your stories" (paying more attention to grammar and spelling, avoiding names that suggest specific nationalities or ethnicities, ways of keeping readers interested in the story) (Gilbert 2001, 38–40). DC's later "bat bibles" formulated the central parameters of the figure's character, setting, themes, and iconography (Pearson and Uricchio 1991b, 24).

episodic stories. The 1960s thus saw the emergence of a new serial form of storytelling. If earlier stories had largely taken place in an "oneiric climate" (Eco 2004, 153) in which previous stories had no or only little consequence for present and future installments, they now attained a serial memory, featured longer story arcs, and connected superheroes through shared fictional universes. This marked a transition from what can be called a linear form of seriality represented, in its ideal type, by professionally produced series with episodic structures seeking to close themselves off from acts of critical or creative appropriation ("Captain America and the Sentinels of Liberty . . . cannot be copied!"), to a form of multilinear seriality, understood as parallel and overlapping, often transmedially organized serial universes that possess narrative memory and are produced by professional and increasingly by nonprofessional actors (Kelleter and Stein 2012, 264). Examples of this transition are stories that draw upon the readers' knowledge of the series' history and their engagement with ongoing parallel series (including team-ups and crossovers), intersecting character constellations, and interlinked plotlines. "Gotham Gang Line-Up!" (*Detective Comics* #328, 6/1964), for instance, features butler Alfred because "Batman and Robin are on a case out of town with Superman"; in "Whatever Will Happen to Heiress Heloise" (*Detective Comics* #384, 2/1969), Batman fights alone because "Robin [is] off on a Teen Titans case."

By 1966, Batman did not just star in *Detective Comics* and *Batman*, where he had recently been subjected to a stylistic overhaul (the "New Look," in 1964), but also in comic book series like *The Brave and the Bold* and *Justice League of America*, in fanzines like *Batmania*, and in ABC's popular live-action television series (1966–1968).[23] Even though television was obviously less invested in the participatory dynamics of the letter pages, it turned Batman into a pop culture icon and brought the hero's exploits to the attention of an audience beyond the comics' readership. This mainstream popularity explains publications like *Bill Adler's Funniest Fan Letters to Batman*, a Signet paperback that offered a slice of "the thousands and thousands of letters that pour into Batman headquarters every day" (1966, 5). Adler's selection of letters is slanted toward the lighthearted and humorous, but a few letters propose new characters (the Kitten) and new

23. On the reception of the TV series, see Brooker (2000a, ch. 3); Weldon (2016, ch. 3).

or modified gadgets (a batplane, a revised utility belt), while others point out flaws in the stories.

Still, these letters provided only snapshots of a much larger and more consolidated discourse in *Batman, Detective Comics,* and other DC publications. In fact, by 1970, some fans were complaining about what they saw as DC's unjust preference for "intellectual" letters. Irene Vartanoff, one of the most prominent letter writers and one of the relatively few women active in comics fandom—the letter column in *Batman* #189 (2/1967) somewhat incredibly labels her a "femmefan"[24]—responded to this complaint in *Action Comics* #393 (10/1970) by emphasizing the effort and substance of those letters:

> We *work* on them. We take the time to be legible, coherent, polite, humorous, and, hopefully, intelligent. [But] . . . [p]lenty of "intellectual" letters never make the columns. If someone else happens to write a more thought-provoking letter that month, ours are rejected with the same indifference, as would be a smudgily penciled, unsigned "I hate your mag" card. Those are the breaks. (qtd. in Gordon 2017, 132)

Vartanoff plays the role of an expert fan who is diligent about the quality of her letters. She also recognizes the competitive nature of comic book fandom when she describes letter writing as a meritocratic system where the best people get published, and she proposes an evaluative distinction between the kinds of intelligent letters she envisions and the substandard scribblings of lesser qualified readers.[25] What we have here is a bifurcation between those who identify as actors on par with the people who make the comics and those identified as mere consumers, who lack the training and expert knowledge—and thus the authority—to be serious participants in the paratextual comic book discourse.

24. Schelly's (2010) profiles of ninety people active in 1950s and '60s comics fandom include only four women: Michelle Nolan (indexer), Pat Lupoff and Maggie Thompson (fanzine publishers), and Margaret Gemignani (writer). On the historical "invisibility" of female comic book readers and the increasing demand among female fans to be recognized and respected as visible actors in superhero comics, see Scott (2013). On the need for more diversity in comics studies, see the "In Focus" section "Gender Identity and the Superhero" of the *Cinema Journal* edited by Kirkpatrick and Scott (2015).

25. I draw on Gordon (2017, 132) here.

For publishers like DC, both groups were essential to sustain sales. On the one hand, the comics had to involve readers interested in adventure stories and in the types of participatory games cooked up especially for them. In the stories featured in *Detective Comics* and *Batman,* this group was invited to decode clues, encouraged to guess authors, and hailed to intervene in the ongoing plot. As a note beneath the final panel of "The Million Dollar Debut of Batgirl" (*Detective Comics* #359, 1/1967) reads: "Will the new Batgirl appear again? That depends on you, readers! Write and let us know!"[26] On the other hand, expert fans were vital because they could increase a series' cultural capital by treating it as a serious form of popular literature and because their activities tended to move beyond reading and letter writing into the realm of fanzine production. It was the members of the second group who could feasibly dream of becoming industry professionals.

In the *Batman* comics of the 1960s, new author functions emerged precisely as Bob Kane was being supplanted by new artists and writers under the artistic direction of Carmine Infantino. Infantino had asked editor Julius Schwarz to print his name instead of the Kane signature as early as 1964, indicating that fictions of authorial unity should no longer be hidden behind the official label (Brooker 2000a, 252). But not everybody was willing to let go of Kane as Batman's sole creator. The third issue (1/1965) of the *Batmania* fanzine printed a long letter from fan writer Paul Vizcarrondo, who contested the claim made by amateur researchers that Kane had stopped drawing the character. Basing his argument on his acquaintance with "many comic book pros," Vizcarrondo wrote:

> First off, I would like to clear up this business of who draws Batman now (excluding, of course, Infantino's bi-monthly stint in Detective Comics). Shocking as this might be to the most honored Jerry Bails, PhD, (see BATMANIA #2) it happens to be none other than Bob Kane. The layouts might look different to you, Jerry, but it is Kane's work. (15)[27]

26. In 1988, DC staged a phone-in poll where readers could vote about whether Robin would be killed or kept alive as Batman's sidekick. A slim majority favored his death; Robin was murdered by the Joker in the four-issue storyline "A Death in the Family" (Batman #426–29, 12/1988–1/1989).

27. Bails was one of the most prominent and most active writers, editors, and organizers in superhero fandom. For more information, see Schelly (2010, 20–26).

Vizcarrondo references discussions with DC artist Joe Giella and editor Julius Schwartz, both of whom allegedly reiterated that Kane was still drawing Batman, as well as meeting Kane himself, who had "several pages from a forthcoming Batman story . . . tucked underneath his arm" (15).[28]

Crossing the threshold into DC's actual workspaces and interacting directly with a famous figure like Kane may have given particular credence to Vizcarrondo's observations. But actual changes and a new consciousness among comic book creators and longtime readers, both of whom had begun to claim authority over interpreting the past, present, and future of the series, also involved new figurations of authorship. The letter pages constituted one form of collaborative mediation of the change at DC from the era of singular author fictions and the anonymous system of story production to an era of explicit authorial attribution, first on covers, then in the stories, starting with *Batman* #204 (8/1968). They took part in a broader assemblage of transactions between producers and consumers that affected the change from linear to multilinear storytelling and prepared the ground for the longer story arcs and more complex continuity demands of the coming decades.

A second authorization practice welded the paratextual letter discourse to Batman's adventures, as the stories began to thematize questions of authorship. In "The Perfect Crime—Slightly Imperfect" (*Batman* #181, 6/1966), Batman has to solve a case about a mystery novel written by an anonymous author. At one point, Commissioner Gordon exclaims, "No publisher would dare bring out a book under your [mystery author Kaye Day's] name if you hadn't written it." In another story, "The Million Dollar Debut of Batgirl," Barbara Gordon (Batgirl) looks at books in a library that carry the names Infantino and Greene (the creators of this particular story) on their spines. We can read such stories as instances in which previously anonymous creators announce their newfound prominence and launch their bids for authorial prevalence. In the early years of the genre, Batman and Robin had already appeared as readers of their own comics on the covers of *Batman* #8 (1/1942) and as artists and authors of their own stories in *Batman* #10 (5/1942) and *Batman* #35 (6/1946), respectively, and they would do so again in *Batman* #198 (2/1968) and #199 (2/1968).

28. In his "Open Letter to All 'Batmanians' Everywhere," Kane claimed: "I still draw about ninety percent of all Batman stories" (1967, 28).

But authorial self-inscriptions into the diegesis, rather than the super-heroes' metaleptic acknowledgment of their status as characters, took on more explicit forms when readers encountered instances in which the creators included themselves in the stories as a means of intradi-egetic self-authorization.[29]

A good example is "The Secret War of the Phantom General" (*Detective Comics* #343, 9/1965). The narrative is interrupted by a panel that shows "the writer of this story" (John Broome) at work at his typewriter, warning readers "that you're in for a startling surprise!" The writer reappears on the next page, having gotten "that flash-back out of the way." Both panels emphasize the fact that this story was written by a particular author, whose graphic avatar is looking at readers from the page and whose presence on the page is no longer confined to the paratextual realm. They further stress that creators labored under constant pressure: A note in the background of the first panel says "deadline 3/9/65," and an image of a deadline-enforcing editor on the wall is punctuated by darts in the second.

A later story, "The Strange Death of Batman" (*Detective Comics* #347, 1/1966), is even more elaborate. It introduces Gardner Fox at his workplace; he has finished a story and is thinking up a "what if" sce-nario, his "fingers fall[ing] from the typewriter keys" (see figure 1.3). Fox identifies himself as "one of the writers of the Batman stories," acknowledging the character's dispersed authorship while retaining a sense of creative origination. This visualization and intradiegetic depiction of authorship resonates with the comic book paratext since readers would have known Gardner's name from the letter pages. It also extends earlier depictions of comic book creators at the draw-ing board by showing the writer's desk with the typewriter as well as what the story calls "my 'what if' room," a place where Fox claims to dream up alternative story endings and encourages read-ers to contemplate the possibilities of multiple and conflicting sto-rylines: "But—what if—the bouncer knew what Batman and Robin were up to? How would that have affected the outcome of the story?" By showcasing a staple of serial storytelling—the what-if mode that

29. Infantino recalls that Irwin Donenfeld, editorial director and publisher of DC Comics, assigned him to Batman to save the series from cancellation, as Kane "was farming-out almost all of the Batman work to unknown, uncredited 'ghost' artists" who produced substandard work. Whereas Kane's *Batman* was doing poorly, Infan-tino's stories in *Detective Comics* had "print runs [of] up to 900,000 copies per issue" (2001, 66–67).

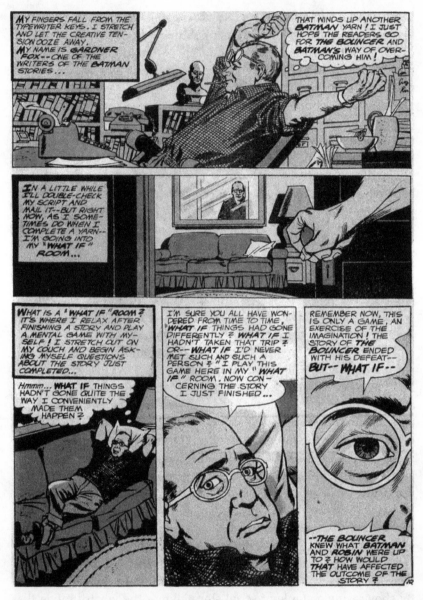

FIGURE 1.3. "The Strange Death of Batman." Gardner Fox and Carmine Infantino. *Detective Comics* #347 (1/1966) © DC Comics.

would be popularized by Marvel's series of the same title from the 1970s onward and had been present in DC's Imaginary Stories since the 1940s—Fox models an active form of reception that turns readers into amateur narratologists who enter his creative orbit (note the zooming-in effect of the final three panels) and become privy to his

thought process. Such metaleptic inscriptions of comics professionals into the diegesis not only followed publications like *Real Fact Comics #5*; they authorized later instances, like the cover design of *Superman #289* (7/1975), featuring employees Bob Rozakis, Cary Bates, Jack C. Harris, Carl Gafford, and E. Nelson Bridwell in a photographic scene with a drawn Superman (Gordon 2017, 35), or *Superman #411* (9/1985), showing editor Julius Schwartz at his desk, staffers promising a surprise and Superman hovering outside the window with a birthday cake.

One of the strengths of an actor-network approach is that it cautions us to assign clear-cut cause-and-effect relations between the letter pages and the evolution of the genre. I would not go as far as to assert that the pages caused the changes superhero comics underwent in the 1960s and '70s, when they moved from linear forms of serial storytelling to multilinear forms. I do maintain, however, that these columns acted as a mediator for this change because they authorized new author functions and figurations.[30] In addition, they themselves underwent a development from endorsing relatively simple, content-related questions to a more complex discourse and even proto-academic criticism. In fact, it makes sense to read the letter pages as a genre of its own that is located at the paratextual fringes of the comics and interferes with, and in some ways parallels, their gestation. Like the comics, these pages were produced under specific editorial guidelines, as evidenced by the editor's advice in *Justice League of America #115* (2/1975) to "keep your letters short and concise—say precisely what you want to and then stop. Write an interesting letter, one that you would enjoy reading in a lettercol if someone else had written it" (qtd. in Pustz 2007, 173). Like the comics, letter writing was presented as a meritocracy, where different styles and voices compete for the attention of the audience and seek to communicate with a particular sense of authority.

Fanzines as Serial Epitexts

Explicit representations of authorship sanctioned the growth of comic book fandom and the emergence of a fan discourse outside of, but in close communication with, the comics. Using mostly mimeo-

30. This complicates Yockey's "coincidental shifts occurring in comic book fandom at the time" (2017, 25).

graph machines, early fanzine producers "hijacked the machinery of modern office culture . . . and turned it towards endeavors that many would have considered wasteful, fanciful, and inappropriate" (Regalado 2015, 170).[31] In fact, the paratextual discourse spread into two directions: into the stories themselves and beyond the superhero text into the epitextual "world of fanzines" (Wertham 1973). These developments were generally supported by the publishers to secure the future of a serial genre hard-pressed to keep its readership involved and fulfill a consistent, if not always increasing, demand for stories. EC Comics had already spawned a vibrant, mostly young, white, and male, fan culture in the 1950s, popularizing a fan discourse and imagined community (Adler-Kassner 1997/1998, 103; Whitted 2019, 48) through letter columns and editorial statements as well as their National EC Fan-Addict Club, which disappeared when the company discontinued its horror anthology series (*The Vault of Horror, Tales from the Crypt, The Haunt of Fear*) in the wake of the comics scare.[32]

Nonetheless, EC's efforts to maximize the appeal of its products and the invitation to readers to recognize themselves as loyal followers of the company's publications are important. These efforts demonstrated the palatability of genre practices beyond the superhero tales and provided a model for DC and Marvel. Moreover, the disappearance of EC's most successful comics and, along with them, many of the fan practices that prefigured developments at DC and especially Marvel in the 1960s indicates that we are dealing with complex constellations of actors in specific historical moments. EC's activities included creative ways of involving audiences in the production of new stories. *Tales from the Crypt* asked readers to send in puns for upcoming story titles in 1953 (Pustz 1999, 37), and letter pages encouraged readers to consolidate their extracurricular endeavors by writing to each other or becoming fan club members (39). Letter writer Bob Oravec even called on fellow readers to join his budding fan club in *Tales from the Crypt* #35 (4–5/1953). Another practice was

31. For analysis of the controversies in comics fanzines of the 1960s and '70s, see Regalado (2015, chs. 5 and 6).

32. On the comics scare, see Nyberg (1998); Brooker (2000b); Hajdu (2008). On Fredric Wertham, see Beaty (2005); Tilley (2012). See Adler-Kassner: "The conventions of the E.C. books, correspondence between producers and consumers, and articles by anti-comic book critics . . . contributed to what those critics perceived as a new community of children and youth" (1997/1998, 102).

printing plugs for fanzines, for instance when Bobby Stewart promoted his "EC Fan Bulletin" in *Weird Science* #20 (7–8/1953) (Pustz 1999, 39; Schelly 1999, 17–18).

Following in the footsteps of fan clubs like DC's Supermen of America and the Junior Justice Society and Marvel's Sentinels of Liberty, EC's Fan-Addict Club offered its approximately 23,500 members (Beaty 2012, 110) an array of devotional material, from institutional insignia like a membership certificate, identification card, shoulder patch, and pin to a company-produced fanzine, the *EC Fan-Addict Club*. This fanzine "publishe[d] chitchat about the writers, artists, and editors, release[d] trial balloons on ideas for new comic books, list[ed] members' requests for back numbers and in general trie[d] to foster in the membership a sense of identification with this particular publishing company and its staff" (Warshow 2004, 67). As Pustz observes, EC was able to create a strong sense of "insiderism"—"making readers feel like they were part of an exclusive group" by "giv[ing] credit to creators, sometimes including extended biographies of writers and artists, providing readers a sense that there were real people behind the stories" (1999, 39)—that prepared the genre for the changes of the 1960s.[33]

Recognizing the commercial appeal of reader involvement, DC and Marvel picked up much of the slack left by EC Comics, with DC promoting fan clubs and fanzines like *Batmania* on letter pages by printing plugs like the following:

> HOT TIPS FROM BATMAN'S HOT-LINE: One of the Nation's largest *Batman* fan clubs, the BATMANIANS, has announced that it is issuing a new club fanzine called BATMANIA. A free copy and full club particulars are available for 10¢ postage from B. J. White, 407 Sondra Avenue, Columbia, Missouri. We highly recommend it. (*Batman* #169, 2/1965)[34]

As a later letter by Tom Fagan in *Batman* #180 (5/1966) indicates, the activities of these Batmanians created new authorization conflicts that

33. This sense of insiderism included socially conscious stories (so-called preachies) about racial segregation and discrimination and featured complex black characters (Whitted 2019, 18–19).

34. Roy Thomas had also plugged *Alter-Ego* in a letter in *Justice League of America* #8 (1/1962) (Pustz 1999, 44). Fingeroth writes that Stan Lee "studied EC's comics" (2019, 47).

followed the editor's recognition of a fellowship of Batman fans and the increase in readerly claims to legitimate serial knowledge:

> We *Batmanians* have grouped together to promote *Batman*. Our membership is presently close to a thousand persons. . . . Our slogan—*For Batman we accept nothing as impossible!* I would like to invite anyone wishing to join the *Batmanians* to write directly to Biljo White. . . . The *Batmanians* are going places and we want all *Batman* fans alongside us.

DC featured this advertisement even though it claimed a kind of authority over Batman's future that was no longer located exclusively in the publisher's hands. Appealing to strength in numbers, Fagan underscored the power of fans as new players whose will to challenge the decisions of official producers could make an impact. The permeability of the letter page as a paratextual zone that authorizes fanzines like *Batmania* is further illustrated by Bob Butts's related threat in *Batman* #186 (11/1966), which fantasizes about literally crossing the threshold between comic book reader and producer: "If you refuse to elaborate on *Poison Ivy's* 'perfect crime' I swear by the mighty *batmobile*, I'll come to your offices with half of fandom to picket and protest!"[35] It is, of course, ironic that Fagan and Butts employ a discourse of picketing and protesting at the height of the civil rights movement, when marches, boycotts, and protests possessed much more political urgency than the demands of comic book fans for entertainment more suitable to their needs as consumers of popular culture.[36] Within the comics world, Fagan and Butts act as "active textual participants . . . organize[d] into loosely structured interpretive

35. Butts wrote additional letters to *Batmania* (e.g., #6, 10/1965); he also wrote letters to DC and Marvel, several of which were printed (Schelly 2010, 171). Biljo White puts the number of Batmanians (i.e., subscribers to the *Batmania* fanzine) at 1,500 in "The Batmania Philosophy" (*Batmania* #12, 10/1966).

36. According to Schelly, organized Batman fandom was overwhelmingly white and male, so it is no surprise that questions of racial equality and changing gender notions remain largely outside of the fan discourse. The only African American among Schelly's profiles is amateur writer and artist Richard "Grass" Green. Schelly writes: "Given the quality of his work, one wonders why Green didn't make it into professional comics in a big way." As Green himself recalled about his failed attempts to be hired by Marvel, "it was always squashed by somebody higher up" (Schelly 2010, 153, 154). Even though Green attributes this failure to the lack of discipline in his art style, skin color might have been a contributing factor.

communities" (J. A. Brown 2001, 58), with Fagan eventually serving as an assistant editor for *Batmania*. They seek tighter communal organization by orchestrating their activities into a vocal fandom precisely because the comic books afford them with the means of doing so, not only by providing a forum for critical exchange with the official producers but also by creating discursive space where they can talk to each other and, once DC editor Julius Schwartz started printing their addresses along with their letters in the *Brave and the Bold* series in 1961 (Pustz 1999, 44), connect in the off-text world.

The question remains how the *Batmania* fanzine (and, by implication, other fanzines) might have contributed to the extension of the superhero discourse, the broadening of the spectrum of authorization practices, the emergence of new author figurations, and the genre's embrace of longer storylines, sprawling character constellations, complex narrative universes, and interacting trajectories among different series. *Batmania* presented itself as a response to the revamped Batman of the mid-1960s. Biljo White, a fireman from Columbia, Missouri, with a fondness for superhero comics, explained in the first issue (7/1964): "I decided now that Editor Julius Schwartz is presenting a 'new look' BATMAN, it would be a good time to start a genuine BATMAN movement. In order to promote my ideas on advancing this movement, I have prepared this first issue of BATMANIA—the fanzine especially for BATMAN fans" (3). The fanzine's objective was "to join together those who enjoy reading and collecting the stories of Batman" (3), with White's emphasis on fandom as a joint movement of emotionally invested readers and collectors once more evoking civil rights rhetoric to imply popular legitimization for a just cause. Explaining the stakes of fanzine membership in *Batmania* #3 (1/1965b, 21), White uses a more aggressive register: "As Batmanians, we crusade, not for monetary gain, but for the enjoyment of seeing our ideas materialize."[37] White matches this religiously grounded militaristic tone ("crusade") with a cover illustration a year later, for issue #8 (1/1966), where he traces a grim-looking Batman with his finger pointed at the reader underneath the caption "The Batmanians Want

37. White was among the most active early fans seeking a role as "enfranchised participants" in the superhero's serial evolution (Regalado 2015, 184). Rick Weingroff wrote in *Capa-Alpha* #4 (1/1965): "As Comic Book Fandom grows, the pro in the comic field will be faced with an increasing problem. Aside from his duties within the industry, he must also learn how to deal effectively with comic fans" (qtd. in Regalado 2015, 184).

You!!" (see figure 1.4). The image recalls James Montgomery Flagg's iconic World War I poster of Uncle Sam uttering "I Want You for U.S. Army." Next to this caption, White repeats the fanzine's motto, with the overall composition of the page suggesting that Batman is recruiting followers to the *Batmania* fan club in a way that recalls not only Flagg's poster (revived, in altered form, for World War II) but also the public service announcements and patriotic pleas that were a staple of early 1940s comic books.

The fanzine offered a public forum for those whose only previous outlet had been the letter pages. It marked a transition from these pages as an officially curated paratext to the less controlled and potentially competing space of the fanzine precisely when DC was trying to establish Batman's new look, that is, when a new version of the character was vying for authorization. This was perhaps not quite the kind of "counterpublic engagement" Fawaz associates with Marvel's more politicized readership "hold[ing] the creators accountable for their supposedly progressive social values" from the mid-1960s onward (2016, 103). But it indicated that fanzine producers like White sought to secure a say in the serial continuation of their favorite series by enlisting like-minded advocates who could be mobilized in future conflicts.

While *Batmania* presented itself as critical on occasion, it generally was not antagonistic. In the editorial "The Batmania Philosophy," White explained how he had solicited Schwartz's "blessing" and referred to his own role as that of a "faned" (fan editor) in an analogy to the professional editorship at DC (*Batmania* #12, 10/1966a, 4, 5). Moreover, the first issue of *Batmania* was explicit about its legally dependent status. It used copyrighted material on the cover and acknowledged National Publications (DC Comics) as the owner, announcing above another image: "Permission to publish and use the name 'BATMANIA' has been granted by NATIONAL." This largely symbiotic relationship between comic book and fanzine was rewarded with repeated references to "Batmaniacs" in the letter columns (*Batman* #189, 2/1967) and the comics (e.g., "Hunted or — Haunted?" in *Detective Comics* #376, 6/1968[38]), and even a reference to White himself when a character was named after him in "The Man

38. Note also how the language mimics the fanzine's rhetoric when a group of future Batmen band together: "We of the year 543 after destruct-day have organized ourselves as the Batmaniacs, our purpose being to prove Batman was man—not myth. . . ." The term "Batmaniacs" recalls the *Newsweek* article "Superfans and Batmaniacs" (1965); the difference here is between the pathological implications of that

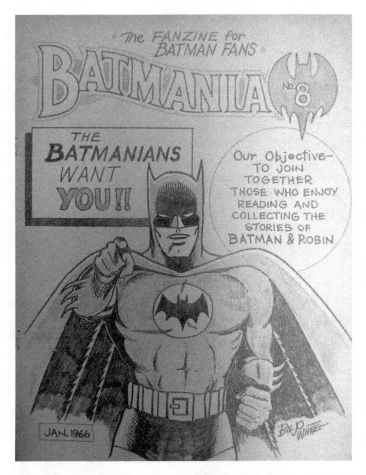

FIGURE 1.4. Cover illustration. Biljo White. *Batmania* #8 (1/1966) © Biljo White/DC Comics.

Who Radiated Fear!" (*Batman* #200, 3/1968). White's appearance as a comics character, his transition from the world off-text into the fictional world, was no isolated incident.[39]

Thus authorized, *Batmania* took its interest directly to DC. White's "Open Letter to Editor Jack Schiff" in issue #3 (1/1965d, 10) spoke from the position of a well-informed and well-connected fanzine

article (fans as maniacs) and the sense of communal identity in the fan discourse (being a Batmanian).

39. According to the DC Database, Tom Fagan appeared nine times in Earth-One series, including *Batman* and *Justice League of America*, as well as in seven Marvel Earth-616 comics, among them *Avengers* and *Thor*. For a more oppositional reading of fanzines as an expression of alternative culture, see Duncombe (1997).

writer who could appeal to public sentiment to make his case: "I've been informed by many fans that they have written you for more stories of this type"; "I would like to make known a few opinions of loyal Batmanians and myself." With "An Open Letter to Julius Schwartz," it was Fagan who once more addressed questions of authority: "Maybe to an editor the fans are annoying because of their constant demand for attention to detail and their frequent, sharp criticisms of poor story line and artwork. But let's face it. The fans are the outspoken vocal group of a far wider representation of readers than editors care to admit" (*Batmania Annual* 1967b, 16). The ratio between the vocal fans Fagan evokes and the larger readership is difficult to calculate. Beaty contrasts the number of subscribers to fanzines, which was usually in the hundreds, with the hundreds of thousands of comics sold each month. Focusing on an earlier moment, he notes:

> While perhaps 10 per cent of all EC readers subscribed to the company's official fan club, fewer than 1 per cent of all EC readers were significantly dedicated to pursue the fan-produced publications advertised in EC comic books. This small percentage constituted the elite fan base, self-conceptualized as connoisseurs and dedicated to the identification and explication of significant works in the EC tradition. (2012, 113)

White and Fagan act as representatives of this elite and as spokespersons for the wider range of Batman fans, defining their objectives and delineating the group's boundaries (Latour 2005, 31–33) by positioning fans and readers against DC's assertions of control over the character. In an effort to consolidate this group by mobilizing the persuasive power of an alternative institutional authority, Jerry Bails advocated the founding of the Academy of Comic-Book Fans and Collectors in issue #18 of the *Comic Reader*. Once founded, membership rose to 1,200 in 1965 and sought to empower fandom by hosting annual awards, publishing the *Comic Reader* as its official journal, establishing guidelines for trading comic books, creating a fan directory, planning conventions, and seeking to further the connections between industry professionals and fans (Pustz 1999, 45–46).

In addition to challenging the decisions of DC editors and demanding a say in all things Batman, fanzines also extended the functions and figurations of comic book authorship. The cover of *Batmania* #15 (5/1967) depicts Biljo White at a drawing board as an

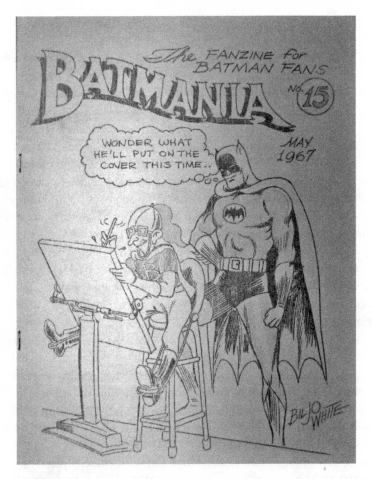

FIGURE 1.5. Cover illustration. Biljo White. *Batmania* #15 (5/1967) ©
Biljo White/DC Comics.

interested Batman looks over his shoulder, thinking: "Wonder what
he'll put on the cover this time" (see figure 1.5). Superheroes cannot
ignore what is going on in the fanzines, this cover suggests. More-
over, White is not just the cover artist of this issue but also a compe-
tent copier of Batman, as the visual rendition of the superhero behind
his graphic avatar indicates. The cover of *Batmania* #3 (1/1965) had
already visualized the desire of fanzine producers to be recognized
by the industry. It depicts Batman and Robin carefully opening a
door with the *Batmania* logo and an oversized drawing of Batman's
head on the inside. "Enter the Fascinating World of the Batmanians,"
the caption reads, marking the moment when the superheroes trans-

gress the threshold between their diegesis and the world of the fanzine.[40]

White thus acted as a spokesperson and recruiting officer in the Latourian sense, publishing not only *Batmania* but also *Komix Illustrated* (1962) as "the first fanzine to prominently feature amateur comic strips" (Schelly 1999, 47), the *Gotham Gazette* (1965), and *Capt. Biljo Comics* (1968). He was also active as a fan artist, drawing characters like The Eye and amateur strips like "Son of Satan," "The Fog," "Astro-Ace," and "The Lion," and he gained notoriety as Capt. Biljo because of his appearances as a comics character in his fanzines (47–48). White thus acted as a creator of amateur comics, an amateur critic and historian, and a fanzine producer (and in that capacity, as an editor and publisher of other amateur artists like Ronn Foss, as well as a profiler of other collectors). He received the silver Alley Award, a fan-based accolade that encapsulated fandom's growing institutionalization in the early 1960s and "began to create a small-scale star system for creators, which gave them greater professional leverage" (Regalado 2015, 185).

Batmania featured editorials, analytical essays, historiographic research, fan fiction, and visual renditions of Batman, which positioned fanzine editors, writers, and artists as legitimate actors in the expanding Batman cosmos. Examples include artwork by Bill Ryan in issue #1 that humorously explores what Batman might have looked like had he been drawn by other famous cartoonists as well as essays like Stephen Harrell's "What Has the 'New Look' Done for Batman?" (*Batmania Annual* 1967). Some of these pieces were collaborations, substantiating the sense that comic books favor shared authorial responsibilities and tend to disperse creative authority to different factions of authors and readers. The first story in *Batmania* #1, "The New Look," for instance, was authored "by BILJO WHITE and BATMAN FANS from COAST-TO-COAST" (7/1964, 4); *Batmania* #14 (2/1967) even proposed a line of special issues created entirely by readers: "You will be the editor!"[41] However, fanzines like *Batmania* rarely toppled the distinction between professionals and amateurs. Instead, they elevated comic books from a low type of youth entertainment to a revered form of cultural expression that offered differ-

40. The cover of issue #18 (7/1974) picks up this theme as Batman and Robin race toward the reader and Batman exclaims, "Let's go, Robin! — The Batmanians are calling!"

41. The fanzine also included a letter page called "Batmanians Speak."

ent actors a stake in its symbolic power. This was connected to the increasing prominence of an older generation of readers who could look back on a personal history of comics reading (and often collecting) and sought to distinguish themselves from younger readers by using their knowledge to solicit particular kinds of stories.

The bids for prevalence leveraged by these readers were supported by efforts to make sense of how DC's Batman comics were created and by whom. As George Pacinda wrote in "Those behind Batman" (*Batmania* #6, 10/1965, 4):

> With the advent of the "New Look" Batman there came praise for all concerned. There was praise for the editor, that fine genius who was mainly responsible for the change. There came credits to the writer, a master of scripting. The honor roll continued with the pencil-artist, a true craftsman of delineation. Next came praise and more praise for the inker, an able and talented artist. Since these people are so well known, especially here in the pages of BATMANIA, I have purposely avoided listing them. . . . But . . . there are others.

These "others" included those who lettered the comics, proofread them, and did the actual printing. "Suppose we trace a comic, a BATMAN comic, . . . to see how it comes into being" (4), Pacinda suggests and then provides a step-by-step description of the production process that complicates Beaty and Woo's assertion that "comics fandom . . . ha[s] long made use of a naïve version of auteur theory" (2016, 46).[42]

Pacinda's article appeared in October 1965, and it is remarkable that the authorship discourse, which had begun with the introduction of the letter pages only a few years earlier, had already moved far beyond the guessing-the-author game. In *Batman* #206 (11/1968), Joe Rusnak would write: "Figuring out authors of stories really isn't much fun now. The fad should soon be dying out because it's getting too easy." The DC editor responds: "The author-guessing fad has run its course; from now on we're giving author (and artists) credit along with each story." Uricchio and Pearson interpret this new editorial policy as reflecting an "increased valorization of comic book authorship, further encouraging the fans to take an auteurist perspective of

42. Pacinda anticipates Uidhir's distinction between production roles that serve mostly mechanical or technical functions and creative roles that impact which stories are told and how (2012, 54).

the production process" (1991, 188). Pacinda's article promoted the new role of the informed critic acting as a mediator between the fans and official comic book makers, someone who knows how comics are produced and offers his findings to the "better educated fans."

The authorizing functions of the paratext became more fully apparent once these "educated fans" were no longer satisfied with communicating vicariously and sought out writers and creators in person during conventions. Conventions were an extratextual manifestation of reader expectations and their projections of comics authorship. Yet they also underscored the industry's realization that courting fans and sampling their opinions could benefit their business objectives. In *Batmania* #7 (11/1965b), Fagan reported on the New York Convention of 1965 ("Con-Cave Coming?") and reconstructed the debate about the original authorship of Batman: "[Bill] Finger's comments filled in the history of Batman's success as a contin[u]ally popular comicbook character. Finger related how he had scripted the first Batman story, working in close conjunction with Bob Kane." The editor's note—"Tom Fagan has prepared an article on Bill tentatively entitled, 'Bill Finger, Man Behind A Legend,' which is based upon a personal conversation with the writer during the ComiCon" (11/1965, 12)—points to the increasing dispersal of author responsibilities. While this piece was never published, the quotations by Bill Finger it assembled eventually appeared (without attribution to Fagan) in Les Daniels's *Batman: The Complete History* (1999), and the whole article resurfaced on Marc Tyler Nobleman's blog *Noblemania* in the fall of 2012, having found its way into Nobleman's hands after Fagan's passing in 2008.

More important, "Kane" had come to stand for the contributions of many different writers and artists in the character's history whose work was only now being recognized and whose efforts had been written out of Batman's past through earlier author portraits such as Kane's biographies in *Batman* #1 and *Real Fact Comics* #5. As Fagan's later report ("Con-Cave '66") about the New York Academy Convention of 1967 in *Batmania* #14 (2/1967) illustrates, questions of authorship were at the forefront of this discourse: "Why aren't artist and writer credits given in the Batman comic book sagas, asked a Batmanian. Schwartz explained he had been giving these recently in letter-page paragraphs. He also stated Bob Kane's contract with National might stipulate Kane's name appear on Batman stories since Kane

was the originator" (1967a, 6).[43] While Kane's legal authority seemed more or less certain, Finger's remarks about his own role in the history of the series undermined the common authorial origin story: "Finger, when called upon, told how he came up with the name of Robin for Batman's youthful companion when the strip was only a few month's [sic] old. On the start of Batman from the beginning, it was Finger's suggestions that added cowl, cape and gauntlets to the Batman costume" (6).

Finger's remarks and their dissemination throughout the world of fanzines garnered responses from various sources, all of which laid claim to an authoritative authorial voice. One of these responses was Jerry Bails's "If the Truth Be Known or 'A Finger in Every Plot!'" in *Capa-alpha* #12 (9/1965). Like Fagan's piece in *Batmania,* this exposé did not just raise the question of who had authored the initial Batman character, it also challenged who was able to make his case in which form and forum. If DC had presented the myth of solitary creation in the 1940s, fanzine writers like Fagan and Bails now acted as investigative journalists and amateur historians, presenting their findings in settings they themselves controlled. Bails left little doubt about the collaboration he believed had led to Batman's creation: "Bill is the man who first put words in the mouth of the Guardian of Gotham. He worked from the very beginning with Bob Kane in shaping and reshaping Comicdom's first truly mortal costumed character." As we can see here, rather than reducing the complexity of comic book authorship, authorization conflicts produce more author roles. They diversify authorial practices and increase the pool of actors who can claim authorship status as much as they instigate new ways of managing the proliferation of author functions by enriching older figurations of comic book authorship with new stories of creative origination.

Bails's exposé triggered Bob Kane's "An Open Letter to All 'Batmanians' Everywhere," which Kane sent out to be printed in *Batmania.*[44] Kane wrote: "Now, Biljo, I'd like to emphatically set the <u>record straight</u>, once and for all, about the many '<u>myths</u>' and '<u>conjectures</u>' that I read about myself and my creation, 'Batman,' in your 'Fanzine'

43. Fagan identifies artists Gil Kane and Murphy Anderson and writer Nelson Bridwell as "key men behind Batman" (1967a, 6).

44. The letter was dated September 14, 1965, and appeared in the *Batmania Annual* 1967.

and other publications. . . . I, Bob Kane, am the <u>sole creator</u> of 'Bat-man'" (1967, 25). And then:

> <u>The truth</u> is that Bill Finger is taking credit for much more than he deserves, and <u>I refute much of his statements</u>. . . . The fact is that I conceived the "Batman" figure and costume entirely by myself, even before I called Bill in to help me write the "Batman." I <u>created the title, masthead</u>, the <u>format</u> and <u>concept</u>, as well as the <u>Batman figure</u> and <u>costume</u>. Robin, the boy wonder, was also my idea, not Bill's. (26)

Kane speaks as the institutionally authorized creator of Batman. He acknowledges Finger's cowriting of early stories but locates the act of origination before their first encounter, which makes Finger a hired gun rather than an originator: "In all fairness to Bill, I will admit that he was influential in aiding me in shaping up the strip, and there are certain characters Bill created, aside from my main characters" (26), Kane half-heartedly conceded, remaining vague about the exact extent of Finger's ostensibly limited impact (only some side characters) and removing him from the act of origination ("influential in aiding me"). The wording of the letter repeatedly betrays Kane's claim to clearing up creative responsibilities, as we can see in the following passage:

> Although Bill Finger literally typed the scripts in the early days, . . . he wrote the scripts from ideas that we mutually collaborated on and that <u>many</u> of the <u>unique concepts</u> and <u>story twists also came from my own fertile imagination</u> and that I was not just a puppet cartoonist alone, following the writer's script and contributing nothing more than the art work. (27)

Kane is waffling between denigrating Finger as a mere typist and elevating him to a mutual collaborator, and while he emphasizes his own uniqueness and imaginative prowess, his explicit rejection of the role of the puppet cartoonist who merely visualizes the writer's stories reads more like an acknowledgment of Finger's authorial significance than an effective denunciation.

Furthermore, Kane had to make this claim plausible for a readership that had become aware of various forms of creative collaboration and was becoming increasingly critical of traditional author

fictions.[45] This marks a shift in interpretive authority and the emer-
gence of new actors with new competences. Batman fans were no
longer passive readers, and neither were they mere letter writers.
They became authors of critical essays and used their knowledge to
complicate Kane's authorial status in what Patrick Parsons describes
as "an ongoing dialectic relationship between consumers and cre-
ators" that established an "evolutionary link . . . between Batman and
his audience" (1991, 67). A writer like Bails could now retroactively
inscribe Finger's authorship into the historiography of the series and
establish himself as an authority on comics history. Once instituted,
such authority was difficult to contain. Kane tried to control his
author image but was forced to do so by appointing another fanzine
writer as its protector, authorizing yet another author and creating
yet another author figuration. Referring sarcastically to Bails as "the
self-appointed authority on Batman" (1967, 26), Kane acknowledged
the agency of the fanzine writer, which could no longer be denied
but only reined in by appointing White as the "unofficial guardian
of pertinent Batmania folklore" (30). Yet it remains unclear how an
"unofficial guardian" could overrule the verdict of a "self-appointed
authority." If authority is bestowed by a higher power and would
then be more or less official, which White's authority is explicitly not
despite the fact that he is ordained by Kane, or earned on its own
strength, which would mean that authorities can be self-appointed
but must legitimatize themselves within a discourse community, then
neither White's nor Bails's views are necessarily more authoritative.
The reason for this unresolved tension is implied in Kane's statement:
If Batman's existence is equated with folklore, then any attempt to
pin down original authorship is moot from the start. At least in the
original sense of the word, folklore is a prominent example of serial
storytelling, but its imperatives run counter to romantic notions of
individual authorship and the modern legal conceptions that under-
gird Kane's claim to being the sole creator of Batman.[46]

Thus, when fans and hobby historians like Bails and Fagan pre-
sented their thoughts on Batman's authorship, they embraced a
more inclusive notion of comic book folklore than Kane. Fagan's

45. Kane and Andrae's autobiographical *Batman & Me* attempts to retain his
image as Batman's originator, including sketches of the character dated January 17,
1934, that may have been done later than alleged (1989, 34).

46. On legal concerns, see Gaines (1991); Gordon (2013); K. Barker (2015); Adams
(2020).

unpublished article on Finger's role in the creation of Batman used phrases such as "Comicdom legend holds" and "Comicdom lore relates" (1965a, 4) to foreground the discursive construction of this largely unofficial history. Fagan placed his activities in a long line of celebrations of heroism in which he was only the latest recorder of "mankind's heritage of folklore" (1). He also recognized the serial authorization of comic book history: Finger figured as the "man behind the scene" whose "legend has evolved over a quarter-century and bids to continue in the years to come" (2).

The new author roles and dispersed authorizing practices that came about in the 1960s were an asset and a liability for the official producers of superhero comics. They indicated that the comics were mobilizing audiences to immerse themselves in the storytelling. But they also challenged the authority of the comics industry to decide which kinds of stories they wanted to tell and how they could tell them.

Conclusion

In an early *Batman* letter column (#126, 9/1959), reader William Tauriello writes: "In a recent story, entitled 'THE SECRET OF THE FANTASTIC WEAPONS,' you show BATMAN and ROBIN in a Mexican village, trying to arrest a criminal. According to International Law, no United States officer can arrest a criminal in Mexico because the officer has no authority there." Tauriello struggles to connect Batman's fictional universe with the off-text world, expressing irritation about their apparent incongruity. The editor's answer goes beyond providing a plausible explanation, adding story elements by supplying previously unknown information after the fact: "True, under the International Law, an officer of one country can't make arrests in another country. However, BATMAN and ROBIN, being world-famous lawmen, have been deputized by the police forces of many nations, including Mexico." Letter columns apparently provided an opportunity to smooth over unintended crevices and fill in the gaps resulting from multiauthored and fast-paced serial entertainment, where narrative decisions are frequently made in haste and where commercial considerations can trump questions of narrative plausibility.[47]

47. Mittell calls this process "paratextual extension" (2015, 262).

Directly beneath this exchange follows a letter by Shirley Singer, one of the relatively few female letter writers, who doubts the plausibility of the Batman universe by comparing it to her own experience.[48] To apply assumptions from the reader's lifeworld to the world of the superhero can seem like a naïve form of reception, a particular kind of affective fallacy unable to entertain the fantastic conceits of the genre. But this type of reception had been encouraged by decades of public service announcements that explicitly addressed readers as historically situated individuals and urged them to align their real-world actions with the advice of favorite characters. "Gotham City is such a big place," Singer notes in her letter, "yet when the police need help, they flash the BAT-SIGNAL, and right away, BATMAN and ROBIN know where to go. How is this possible?" Like Tauriello's inquiry about Batman's international legitimization, this letter documents a readership that replicates Batman's role as a master detective by devoting its own deduction skills to the story logic (or lack thereof) of the superhero's exploits. The response specifies elements of the fictional universe by elaborating on the technicalities involved with Batman and Robin's communication system: "Both the BATMOBILE and the BAT-PLANE are equipped with police radios, which broadcast the details to BATMAN and ROBIN, as they take off in response to a BAT-SIGNAL." The result of this exchange, and of the serial logic from which it emerges, is a fictional world evolving into a more tightly organized and more elaborately imagined one than that of the previous installment. Increasing diegetic complexity is not merely the result of story logic, artistic ambition, or commercial concerns. It also follows from the paratextual interaction of letter writers and comic book producers, which authorizes particular reading strategies that "mak[e] storyworlds accessible and inhabitable" (Gray 2010, 21).

This increased complexity possesses an inherent binding power. While every storytelling decision enriches the fictional universe, it also delimits further narrative choices. One cannot easily undo what has been narrated, and future installments will have to make sense

48. There is no way to ascertain whether the underrepresentation of female letter writers, with an average of about 15 percent to 25 percent based on a cursory sampling of *Batman* letter pages in the years 1960 and 1966, was due to the overall lack of letters by women or the result of editorial decisions. In 1960, every *Batman* letter page carried at least one letter by a female reader; in 1966, as organized fandom had consolidated, several pages feature only male letter writers, with Irene Vartanoff being the most frequent female contributor.

vis-à-vis existing plotlines, character traits, and iconographic features. One of the central challenges for these stories is to fill in gaps in the narrative while retaining enough wiggle room for new storylines. The interest of many letter writers in Batman's utility belt underscores this observation. The belt was conceived as a device that completes Batman's and Robin's costumes, but it also provided writers with endless plot options. Whenever Batman and Robin are trapped, they whip out a surprising tool from their utility belt (like choking gas capsules or the batarang) and manage to escape. As early as the second letter page in *Batman* #126 (9/1959), a reader asks for "a list" of all of the "terrific gadgets in his [Batman's] UTILITY BELT." By reducing narrative uncertainty, such a list would grant readers greater control over the series by closing one gap in the fictional world. While they would not necessarily know which gadget Batman and Robin would use in a future story, they would at least be aware of the possibilities. Managing expectations in such a way is not the same as achieving closure, but it speaks to a readerly desire for increased influence on story development. The answer to the query tries to be diegetically satisfying while retaining a narrative device that is vital for a popular series based on formulaic storytelling, and thus on repetitive scenes with varied outcomes:

> There's no standard set of items in the UTILITY BELT. When BAT-MAN and ROBIN go out on a case, they equip themselves with weapons they expect to use. Also, they are continually designing new, secret gadgets for future use. The best way to learn about the contents of the UTILITY BELT is by following BATMAN and ROBIN in all their adventures.

Designing new gadgets for future use is not merely an example where the tricks of the serial trade impact the content of the stories. It also enlightens readers about the comic's narrative construction, like a manual that teaches users a lesson about the serial dialectic of repetition versus variation, control versus freedom, and containment versus sprawl. In addition, it speaks to a commercial interest in securing readers eager to buy magazine after magazine to witness new utility belt surprises.[49] Finally, the discussion about the utility

49. See also "The Secret of Batman's Utility Belt" in *Detective Comics* #185 (7/1952). The eighty-page giant *Batman* #203 (7/1968) devotes a full page to the contents of Batman's, Robin's, and the Joker's utility belts.

belt authorizes merchandising: the action figures, vehicles, and gadgets that constitute material instantiations of comic book characters for generations of consumers.[50] Such manifestations of superheroes as commodity items are captured by the title of Gary H. Grossman's *Superman: Serial to Cereal* (1977), which foregrounds the ephemerality of serial stories and characters in their constant search for new material vessels that will insert a character into quotidian spaces like the breakfast table, where they are literally imbibed by their fans.

50. Meehan reads Batman merchandise as part of a corporate intertext (1991, 48–49); Boichel speaks of "an array of bat-paraphernalia" (batgyro, batarang) that facilitates Batman's commodification (1991, 9).

CHAPTER 2

STYLIZING STORYWORLDS

The Metaverse as a Collective

In *The Great Comic Book Heroes* (1965), one of the first extended treatments of superhero comics, cartoonist Jules Feiffer writes about his youthful engagement with the medium: "I studied styles" (1965, 16). For Feiffer, style was a key element of superhero comics and one of the main reasons for their commercial success. Discussing Joe Shuster's work on Superman, he recognized an "old-style comic book drawing" that was notably different from the iconographic variations popular in the 1960s, the time of his writing. "[Shuster's] work was direct, unprettied—crude and vigorous; as easy to read as a diagram," he observed. "No creamy lines, no glossy illustrative effects. . . . He could not draw well, but he drew single-mindedly—no one could ghost that style. It was the man. When assistants began 'improving' the appearance of the strip it promptly went downhill" (19–20).

Feiffer's assessment represents an early exercise in stylistic analysis that looks beyond the content of the stories by acknowledging the importance of graphic style as a meaning-making element. While Feiffer resisted the temptation to celebrate Shuster as a master artist to nobilitate comics as a legitimate art form, he nonetheless differ-

entiated between Shuster's stylistic idiosyncrasies and the ostensibly less authentic work of his assistants, who soon into Superman's serial life took over substantial drawing responsibilities. This perceived authenticity, or stylistic integrity, according to Feiffer, is inextricably connected with the person of the creator, with Shuster as "the man" from whose pen the stories flourished.

Feiffer did not confine his analysis to Shuster. Turning to another one of DC's early successes, he noted:

> Kane's strength, as did Shuster's, lay not in his draftsmanship (which was never quite believable), but in his total involvement in what he was doing (which made everything believable). However badly drawn and crudely written, *Batman*'s world took control of the reader. If Kane said so, men *did* pose stroking their chins whenever they weren't fighting, running, or shooting in such a way that hand and chin never quite made contact. . . . Kane . . . set and made believable the terms offered to the reader. (1965, 28)

Classifying Kane as a mediocre draftsman, Feiffer echoed his point about Shuster's "single-minded[ness]" with Kane's "total involvement." Instead of detracting from the content of the stories, Shuster's and Kane's less-than-stellar artistry is compensated by their personal investment in the storytelling and the believability of their creations. For Feiffer, the imperfection of the writing and the crude visuals created entry points into the superhero's world for readers, who recognized the constructedness of the narrative (stilted poses, unrealistic fight scenes) but suspended their disbelief to embrace the overall ethos (Kane's believable terms) of the depicted world. Rather than polished works of art, the comics were ongoing narratives involving authors and readers alike.

It is this connection between a personally attributed graphic style and the expanding immersive and interactive serial world that interests me in this chapter. Feiffer maintained that style in comics possesses narrative functions that depend on the reader's recognition of an artistic intention, of a creator figure, behind the stories, the equivalent of which on the reception side is a willingness to immerse oneself in the fictional world and willingly interact with, or even participate in, it: "*Batman*'s world [taking] control of the reader," as Feiffer puts it, evoking Latour's claim that "it's never clear who and what is acting when we act" (2005, 46). Is it Shuster, Siegel, or

Kane whose actions create the comic? Is it their writing and drawing styles and the authorial presence these styles evoke? Is it the serial agencies of mass-marketed popular storytelling? Is it the immersive world that emerges from the stories und draws the readers in? Is it the readers who create their own storyworlds based on what they see and read? If action "is not a coherent, controlled, well-rounded, and clean-edged affair" but "should rather be felt as a node, a knot, and a conglomerate of many surprising sets of agencies that have to be slowly disentangled" (Latour 2005, 46, 44), then the answer may very well be: all of the above. But how the actions of these human and nonhuman actors intersect, and when and how they become mediators in the evolution of the genre, is far from clear. This chapter traces these intersections by connecting questions of style with notions of storyworld construction and world-building practices that Feiffer's account implies but does not fully explore.

In "Storylines," Jared Gardner speaks of "the narrative work of style" and adds that "when narratology addresses issues of style it is often to collapse questions of style into the less technically . . . specific issue of discourse" (2011, 58).[1] Taking a cue from Gardner, I comprehend the narrative work and the (story)world-building powers of style—graphic and otherwise—as a crucial element in the evolution of the superhero genre. I propose that the graphic style of Stan Lee and Steve Ditko's *The Amazing Spider-Man* (issues #1–#38, 3/1963–7/1966) and the story that launched the series in *Amazing Fantasy* #15 (8/1962) authorized discourses and practices that shaped the development of Spider-Man's fictional world and contributed to the emergence of what I call Marvel's hip metaverse. This proposition does not conflate style and discourse but seeks to reconcile the division between visual and verbal analysis, including textual, paratextual, and epitextual elements. Graphic style in superhero comics is coproduced by discourse as much as it is determined by authorial and readerly practices invested in both the aesthetic and the material properties of the comics. It functions as a mediator in the Latourian sense: as something that authorizes new practices of comic book production and reception, including the extension of single fictional worlds into extended universes and ultimately into a company-wide metaverse, or a collective, in my Latourian nomenclature.[2]

1. On narrative style in comics, see Grennan (2017). For cognitive approaches, see Cohn (2013); Kukkonen (2013).

2. Bainbridge suggests that Marvel's relationship with its readers went "beyond the creation of an integrated fictional universe for consumers" by constructing "a

My understanding of the metaverse is related to Richard Reynolds's concept of the metatext as "a summation of all existing texts plus all the gaps which those texts have left unspecified" (1992, 43), but it goes beyond a textual understanding to include discourse about and nontextual practices of serial engagement.[3] The term "metaverse" was coined in Neal Stephenson's science fiction novel *Snow Crash* (1992), where it described "a 3-D virtual environment . . . [as] a place where your identity was what you made it, and where your story was determined by your interactions with people you would probably never meet in a physical setting" (Ludlow and Wallace 2007, 30). In superhero comics, the metaverse is mainly associated with DC Comics as a framework that encapsulates all of the company's fictional universes (or "worlds") and timelines, but I believe it has an untapped potential to shed light on the genre's evolutionary processes. In my understanding, the metaverse is the realm in which fictional worlds and extended universes conjoin with metacommentary, including all paratextual and epitextual statements, about the comics.[4] As I will show in the following, the Marvel metaverse is characterized by a particular style—graphic and verbal elements as well as a particular attitude—that suggests coherence and continuity in an often incoherent and discontinuous business.

Many discussions of graphic style begin with Robert C. Harvey's definition of style as "the highly individual way an artist handles pen or brush (or draws a face or composes a panel or lays out a page or breaks down a story)" and as "the visual result of an individual artist's use of the entire arsenal of graphic devices available, including the tools of the craft" (1996, 9, 152). As Kai Mikkonen objects, this definition is "relatively broad" (2015, 111), and it is hampered by the fact that Harvey deems style "illusive" and "too individual a matter to provide a basis for evaluation" (1996, 152).[5] Descriptions of graphic style, Gardner holds, are always in danger of becoming verbal approximations of visual impressions haunted by "what is lost in a paraphrase" (2011, 58). But the graphic style of comics like *Amazing*

larger community between the producers and consumers of Marvel Comics" (2010, 170).

3. There is also an echo of Genette's "metatext," a "type of textual transcendence" defined as "the relationship most often called 'commentary'" that "unites a given text to another, of which it speaks without necessarily citing it . . . , in fact sometimes even without even naming it" (1997, 4).

4. See also Emilsson (2016).

5. See also Miodrag's understanding of style as "the distinctive ways particular artists manipulate the medium as a whole" (2013, 197).

Fantasy #15 and *The Amazing Spider-Man* encouraged debates about the effects specific stylistic choices may have had on individual reading experiences. This, I believe, is what is gained in the paraphrase. I have already traced the critical discourse that evolved in and through editorials, letter pages, and fanzines and afforded the actors involved in DC's *Batman* with different roles, expressive channels, and a language through which they could authorize some serial developments while challenging others. In this chapter, I concentrate on the triadic movement from Spider-Man's graphic style to the emergence of expanding fictional worlds and finally the Marvel metaverse as a collective of human and nonhuman actors.

Gardner's call "to see the graphic line in *narrative* terms" instead of merely as "marks on a flat surface" (2011, 57) provides the starting point for my analysis. In comics, "the act of inscription remains always visible, and the story of its making remains central to the narrative work" (57), Gardner suggests. "We *cannot* look at the graphic narrative and imagine that the line does *not* give us access to the labored making of the storyworld we are encountering (and participating in crafting)" (64). Gardner is aware that the readerly belief in what Jan Baetens calls the moment of "initial graphiation" (2001, 147), the moment in which the story was first rendered visually, results from the medium's affective abilities, acknowledging that graphic narratives "will not give us unmediated access to the scene of composition, to the materiality of the act of putting pen to paper" (Gardner 2011, 62). Nevertheless, recognizing the felt closeness of production and reception, the graphically evoked sense of reexperiencing the initial moment in which a story was drawn, can deepen our understanding of the investment and involvement of different actors in superhero comics.

Referencing Philippe Marion's French-language analysis of graphic narration and citing from Baetens's work on the subject, Gardner alleges that "the self-reflexive opacity of the line necessarily invites the reader 'to achieve a coincidence of his gaze and the creative movement of the graphiateur'" (2011, 66; Baetens 2001, 149). He concludes: "Such identification with an imagined original scene of graphic enunciation is *necessary* to the reader's comprehension of the story" (2011, 66; see Baetens 2001). These ideas evoke Mikkonen's reminder that what we encounter on the page is often "seen as a kind of signature of the story's creation, the image bearing the signs of its making" (2015, 101). We need to "understand . . . the ways in which

we as readers attribute immediacy to drawings and realize the con-structedness of the comics page," Lukas Etter notes, "and how we negotiate this impression of immediate, subjective proximity versus constructedness in relation to both the main characters depicted and the cartoonist whose 'mark on the page' we believe to experience" (2017, 93).[6]

Building on these observations, I understand graphic style as the visible trace of presumed authorial activities that stimulates a felt coincidence of the initial graphiation, or creative movement, of a cre-ator's pen or brush over a sheet of paper, and the moment in which the reader gazes upon this trace. Part of this reception is an identifi-cation with an imagined original scene of graphic enunciation that serves as a constant reminder of the labored making of the storyworld (Gardner 2011) and is altered but not entirely erased by the increas-ing prominence of digital writing and drawing tools. This identifi-cation affords a simultaneous sense of immediacy and detachment, or immersion in the storyworld and a meta-consciousness about its constructedness, and it transcends Wolfgang Iser's suggestion that it is "the convergence of text and reader [that] brings the literary work into existence" (1974, 275). If superhero text and reader must converge in order to bring the comic into existence, stylistic analysis indicates that this convergence is authorized by a particular sense of authorial presence that manifests itself in the visible traces of what is taken to have been the production of storylines and drawn images. But it also conjures up a sense of readerly presence, manifested in the letter pages and the near-constant references to fans and followers in editorials, as well as, occasionally, in the stories themselves.

As Iser's work shows, the unfolding of a narrative necessitates an ongoing "process of anticipation and retrospection," of gradually concretizing a fictional world about which the reader is progressively making assumptions by means of what has already been narrated (1974, 280). Narrative sense-making further depends on a particular horizon of expectation (Jauß 1982) that arises from personal disposi-tions, genre conventions, and the material affordances of the medium. In this process, gaps inevitably emerge, as readers must derive their interpretation of what has been read and their expectation of what is yet to come based on incomplete information. Postclassical narratol-

6. See Hatfield's definition of the "idiographic" as "the individual graphic sig-nature of the work, meaning its personal, handmade quality" (2012, 44). For further analysis, see Etter (2021).

ogy proposes the concept of storyworld as a way of distinguishing between the diegetic setting of narratives, whose gaps and omissions readers fill by making assumptions, and a less text-centered notion of mentally modeling a world that results from the readers' cognitive engagement with the text. As noted, in superhero comics, storyworld constructions seep into the paratextual and epitextual communication about the expanding fictional world and ultimately shape what I call the metaverse.

In order to trace the emergence of comic book storyworlds at a crucial moment in the history of the genre—the early 1960s, when Marvel recharged the genre against DC as "the comic-book industry's gold standard" (Raphael and Spurgeon 2003, 75)—and to account for the emergence of the metaverse, this chapter analyzes graphic style in *Amazing Fantasy* #15 and selected issues of *Amazing Spider-Man*. I explore how this graphic style is coproduced by narrative and discursive figurations that, acting as mediators, enabled the extension of serial fictional worlds through shared world-building activities. After tapping into narratological theories of storyworlds and world-building, I focus on moments of initial graphiation in a double sense: on controversial accounts of Spider-Man's conception by Steve Ditko, Jack Kirby, and Stan Lee, and on how this initial conception sanctioned debates about origination, creativity, and imitation. I also consider imagined original scenes of graphic enunciation to gauge how style is connected to certain artists in the comics themselves and in their paratextual and epitextual surroundings. Then, I explore how the rudimentary setting of the first issues of *Amazing Spider-Man* evolves into a serial universe ostensibly cocreated by industry officials and readers. Finally, I suggest that this universe authorizes Marvel's hip metaverse, a multilevel constellation of practices that unites "Marvelites" and "True Believers" into a larger collective characterized by an ethos of "hip consumerism" (Frank 1997, 121).

Style, Storyworld, Metaverse

Superhero comics have produced many prominent settings, from Superman's Metropolis and Batman's Gotham City to Wonder Woman's Paradise Island/Themyscira (in DC Comics) to the comic book version of New York City populated by Marvel's superheroes. Following Gérard Genette, these settings anchor the diegesis of the

superhero narrative, serving as "the universe in which the story takes place" (1990, 17). Superhero universes, however, are visual-verbal constructs that have morphed into multiverses and now comprise many worlds and timelines, which can become so convoluted over time that they are subjected to occasional cleansing, retcons and reboots being key mechanisms of curbing such serial sprawl.

The concept of the storyworld that informs my analysis involves more than the notion of diegesis or fictional universe. David Herman writes:

> More than reconstructed timelines and inventories of existents, story-worlds are mentally and emotionally projected environments in which interpreters are called upon to live out complex blends of cognitive and imaginative response, encompassing sympathy, the drawing of causal inferences, identification, evaluations, suspense, and so on. (2002, 16–17)[7]

If followers of superhero comics do more than simply "reconstruct . . . what happened" (13) in a given story when they imagine the action within a larger environment made up of particular spatial and temporal relations as well as of a particular philosophical stance, then narrative sense-making is a processes of imaginary invest-ment that includes readerly and authorial activities. Interpreters of stories, Herman suggests, tend to "reconstruct a sequence of states, events, and actions not just additively or incrementally but integra-tively or 'ecologically'" (14). They mobilize "processing strategies . . . [to] determin[e] how the actions and events recounted relate to what might have happened in the past, what could be happening (alternatively) in the present, and what may yet happen as a result of what already has come about" (14). On a historiographical level, this includes retrospective considerations of what might have happened, such as when Mark Evanier reprints cover artwork by Kirby with handwritten copy by Lee that was intended for the *Fantastic Four* #20 (11/1963) but never made it into print (2008, 121).

7. Proposing a multifaceted storyworld concept that encapsulates various approaches and definitions, Thon "distinguish[es] between the medial representa-tion of a storyworld as part of a narrative work, the mental representations of that storyworld that recipients build during the reception process, and the storyworld itself as an intersubjective communicative construct" (2019, 376).

Storyworld construction requires recipients who "try to understand a narrative by figuring out what particular interpretation of characters, circumstances, actions, and events informs the design of the story" (Herman 2002, 1). This is essentially a reciprocal practice of narrative production and reception: "Story recipients, whether readers, viewers, or listeners, work to interpret narratives by reconstructing the mental representations that have in turn guided their production" (1). The power to coax readers into immersing themselves in the storyworld follows from a narrative's "ability to transport interpreters from the here and now of face-to-face interaction, or the space-time coordinates of an encounter with a printed text . . . , to the here and now that constitute the deictic center of the world being told about" (14). This "deictic shift" (Segal 1995) from the real world outside of the narrative and thus the lifeworlds inhabited by those involved in the production and reception of particular stories to the diegesis can be described as a process of recentering or imaginative transport where "consciousness relocates itself to another world" (Ryan 2001, 103).

In superhero comics, processes of recentering and transport are not merely part of storyworld constructions once a story has been published. As serial narratives, these comics entice readers to prolong the deictic shift over extended periods of time, filling the temporal gaps between installments with activities that keep them continually recentered, from rereading and collecting issues to letter writing and fanzine production, fan club involvement, and convention attendance. In addition, relocation and transport are some of the superhero's central actions and formally authorize their extension into the readers' consciousness. Think of Superman's relocation from Krypton to earth or of the Silver Surfer's space explorations, but also of the most basic forms of transport: from ordinary person to superhero through accident or trauma-induced physical and metal training, and from private identity to superhero disguise and back.[8] Or, perhaps, from "normal" reader to exceptional Marvel fan: "The minute someone gets hooked on Marvel, he stops being normal," as the editor of *The Fantastic Four* #45 (12/1965) declared.

Imaginative transport can take place in two ways: immersion in, and interaction with, a storyworld. For Marie-Laure Ryan, "the aes-

8. Yockey speaks of Marvel's "diegetic and extra-diegetic engagement with tropes of transformation" (2017, 10).

thetics of immersion implicitly associates the text with a 'world' that serves as environment for a virtual body [whereas] the aesthetics of interactivity presents the text as a game, language as a plaything, and the reader as the player" (2001, 16). As a heuristic, this distinction works for superhero comics, and especially the Marvel comics of the early 1960s, because it allows a differentiation between processes of storyworld construction that draw readers into the fictional world evoked by the comics and their more distanced interaction with this world when they turn to letter writing and related forms of communication. According to Ryan, a "marriage of immersion and interactivity" (19) may occur in a single encounter with a text, but the contrast she establishes between the modes is nonetheless stark: "Immersion is a corporeal experience, and . . . it takes the projection of a virtual body, or even better, the participation of an actual one, to feel integrated in an art-world." Interactivity, by contrast, is "the appreciator's engagement in a play of signification that takes place on the level of signs rather than things and of words rather than worlds, it is a purely cerebral involvement with the text that downplays emotions, curiosity about what will happen next, and the resonance of the text with personal memories of places and people" (21).

One of my objectives is to complicate Ryan's distinction by suggesting that readers' immersion in the "world of Marvel" may result from virtual as well as physical forms of bodily projection into the storyworld and that their interaction with this world can be emotional and cerebral, sparked by a strong curiosity about the continuation of the narrative and filled with deep resonances of personal (serial) memory. Since fictional narratives can never create a world in all its facets, they must provide "cues as scaffolding for world-construction" by authors and readers alike, whose mental work entails adding the details necessary for comprehension (Herman 2009, 123). Karin Kukkonen observes about the DC multiverse: "Whereas the images of . . . comics provide cues for constructing both the spatial and the temporal dimensions of the storyworld, they are more like blueprints than photo-ready copies of the mental models that inform the design of the storyworld" (2010, 44). As a blueprint, "the storyworld is not a reproduction of the visual information the story represents, but a model of what the interpreter takes to be relevant for understanding the story" (46). As I will show, what was deemed relevant in Marvel comics of the 1960s became a matter of curated controversies in letter columns, bulletins, and editorials, pub-

lic spaces where different actors sought authorization for particular storyworld constructions.

If storyworlds result from the construction of readerly and authorial mental models based on the fictional world(s) evoked in a comic, world-building is the collaborative practice through which producers and recipients of the superhero's diegetic environment expand this environment into an increasingly detailed metaverse. This process begins with public statements that locate readers and authors in a shared world in which their engagement with the comics takes place. "We never thought of ourselves as separate and distinct from our audience. We are our audience," Stan Lee once proclaimed (Van Gelder and Van Gelder 1970, 22). If those who write, draw, and edit the stories profess to have the same attitude toward the comics as their readers, they can model an ideal immersive and interactive relationship with the Marvel world. "We BELIEVE in our swingin' superheroes! We created them—we live with their adventures—their hang-ups—almost 24 hours a day. We know 'em as well as we know our families," Lee explained in an early edition of "Stan's Soapbox" (10/1967; Cunningham 2009, 8). Elaborating on his own storyworld constructions as the self-professed architect of the Marvel universe, he stated decades later: "I was writing virtually all of those comics myself, and, by writing them all myself, it was easier to hold them all together" (Cangialosi 1999, 171).

It would be difficult to make rigorous distinctions between immersion and interaction here, as it was precisely the promise of collaboration that intensified the readers' sense of immersion in the "world of Marvel." The actors' "world-making activities" and their "world-building enterprise[s]," Latour reminds us, "consist . . . in connecting entities with other entities" (2005, 24, 103), and as such they shape the Marvel collective. Latour describes a collective as those who subscribe to "a shared definition of a common world" (247). The task in following the actors assembling this collective is "to learn from them what the collective existence has become in their hands, which methods they have elaborated to make it fit together, which accounts could best define the new associations that they have been forced to establish" (12). A collective, in that sense, is "a movement in need of continuation" that depends on constant acts of "group formation" (37, 31). In order to create stability, collectives "have constantly to be made, or remade" (34). They need "recruiting officer[s]" and "spokespersons which 'speak for' the group existence" and "are constantly

at work, justifying the group's existence, invoking rules and precedents and . . . measuring up one definition against all the others" (32, 31). The boundaries of these groups "are marked, delineated, and rendered fixed and durable," Latour concludes: "Every group . . . requires a *limes*" (33).

The task in following the actors engaged in storyworld constructions and world-building activities lies in tracing how they establish connections that foster the emergence and maintenance of the collective, "an imaginary world that activates and is activated by a reader" (Bukatman 2016, 197) and stretches across texts, paratexts, and epitexts to simulate a sense of "share[d] authorizing agency" among writers, artists, and fans "by confirming agency within [the] collective" (Yockey 2017, 4, 2).[9] Comics like *The Amazing Spider-Man* activate authors and readers to fashion mental models of the fictional world by transforming printed artifacts into a storyworld filled with action and suspense. While this is generally true of any comic book, the style of Marvel's comics in the 1960s activated particularly effective and affective kinds of immersion and interaction.

Initial Graphiation and Scenes of Graphic Enunciation

The cover and the opening splash of *Amazing Fantasy* #15, the issue that introduced Spider-Man's origin story, are good places to start thinking about how these comics induce a sense of their createdness, of encouraging their reception as authored narratives and enticing storyworld constructions. The cover—inked by Ditko, penciled by Kirby—shows a muscular superhero in a red-and-blue costume with a spider logo on his chest, webbing covering his outfit, a mask enveloping his face (see figure 2.1). Spider-Man is swinging from a rooftop, his left hand clasped around a rope while his right hand is grabbing, seemingly without effort, what looks like a criminal trying to escape. Arrested in the middle of his gliding trajectory, Spider-Man makes a melodramatic statement that is graphically separated into two speech balloons. "Though the world may mock Peter Parker, the timid teenager . . . / . . . it will soon marvel at the awesome might of . . . Spider-Man!"

9. See also Fawaz's understanding of (queer) world-making (2016, 14–15).

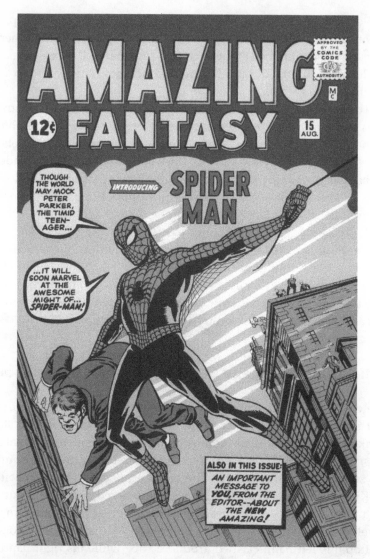

FIGURE 2.1. Cover illustration. Steve Ditko and Jack Kirby. *Amazing Fantasy* #15 (8/1962) © Marvel Comics.

This statement cries out for verbal analysis—it uses alliteration for dramatic effect, condenses the narrative structure of the series, slyly drops the publisher's name—but its visual style is even more significant. Bob Batchelor suggests that Spider-Man on this cover "is off-center, frozen in a moment, as if a panicked photographer snapped a series of frames" and that the rendition might have made readers

wonder whether "this [was] a man or a creature from another world" (2017, 79). Adding to this potentially otherworldly effect are the speech balloons, which are filled with a bright yellow background, a highlighting effect that must have made them stand out on a magazine rack amidst other comics, vying for the attention of potential buyers. As Stan Lee recalled, "We treated our covers like posters or billboards. They had to be able to be seen and understood at a glance, and they had to be colorful, and inviting, and attractive. . . . No matter how good the book was, the cover had to grab the reader first" ("Stan Lee Talks 2" 2007). This complicates Peter Mendelsund's description of readers' transition into a storyworld: "When you first open a book, you enter a liminal space. You are neither in this world, the world wherein you hold a book . . . nor in that world (the metaphysical space the words point toward)" (2014, 61).[10] In Marvel Comics, this liminal space begins before readers open the comic, while the metaphysical space that waits inside, as we will see, often points outward to the off-text world.

The words on the *Amazing Fantasy* cover are rendered in bold black letters, which underscores "the awesome might of . . . Spider-Man" and adds to the weighty effect of the balloons' thick outlines. They do not sound like they are spoken by Spider-Man, even though they are attributed to him through the speech balloons, but by an editor promoting the superhero's arrival. Finally, the conflict announced on the cover between timid teenager and mighty superhero aligns Peter Parker more closely with the world of the readers than the wealthy playboy Bruce Wayne, the alien Kal-El, the Amazonian Diana of Themyscira, or the Wakandan T'Challa. That his "awesome might" will turn out to be a burden as much as a blessing is captured by the statement's separation into the two speech balloons: one reserved for the timid teenager, the other for the powerful superhero.

Indeed, the character split between superhero and secret identity that defines the genre also determines the cover design, and it is echoed in the structure of the opening splash page (see figure 2.2). Here, we see a group of high schoolers mocking Peter as a "bookworm" or "wallflower" in the foreground and a downcast teenager shadowed by his new Spider-Man identity in the background. This is a second instance of foreshadowing the character's transformation through the radioactive spider bite (after the speech balloon on

10. See also Bukatman's (2016, 140–41) discussion of Mendelsund's argument.

FIGURE 2.2. Opening splash. Stan Lee and Steve Ditko. *Amazing Fantasy* #15 (8/1962) © Marvel Comics.

the cover). Moreover, the content of the second speech balloon from the cover is projected onto the wall behind the students. It bifurcates the page into a depiction of "the world" that will mock Peter and shows the social outsider who will transform into a superhero. The scene transports, or deictically shifts, us from the more or less realistic setting of the diegesis to Peter's expressionistically rendered sense

of alienation, promising unprecedented access to the superhero's interiority.

Remarkably, this deictic shift is doubly coded. Not only does it invite readers to construct a mental model of Spider-Man's story-world, it also introduces an editorial voice that speaks about the comic book as a material artifact, commercial product, and genre narrative. As the narrative caption in the opening splash announces, superheroes may be "a dime a dozen," but readers (apostrophized as "you") "may find our Spiderman just a bit . . . different!" The wording of this passage signals a safeguarding of the risky innovation (a new type of superhero), offering a reassuring sense of expectability (only "*a bit* . . . different"), even though Spider-Man did go against the grain of many previous superheroes. Here, the teenager becomes a superhero rather than a sidekick, but he is also the lone hero of the tale, "a 'poor' boy with powers," as reader Dan Fleming noted in *Amazing Spider-Man* #5 (10/1963). "Spidey didn't usually save the universe . . . [but] largely lived in his own world, an unpleasant place full of rotten people with personal grudges and ungrateful peers" (Raphael and Spurgeon 2003, 101).

More than a decade later, in *Origins of Marvel Comics*, Stan Lee expanded on the notion of Spider-Man's difference when he claimed that the originality of Marvel characters stemmed from their "unique quality, the imaginative interpretation, and the stylistic departure from all the superhero strips which had gone before [them]" (1974, 18). Here, it is the quality of the product, its wrenching of a new inter-pretation from an existing formula, and a change in style rather than substance that legitimizes Marvel's claims to having started a "New Wave of Comics" (Cavett 1968, 15) and ushered in "the new Marvel Age" (Leguèbe 1978, 83). Moreover, the serial dialectic of repetition and variation is captured by the cover's interpictorial reference to the cover of *Batman* #1 (3/1940), where Batman and Robin are swinging on ropes toward the viewer. On the cover of a later issue, *Amazing Spider-Man* #19 (12/1964), Spider-Man aims directly at the reader in a suggested movement out of the diegesis and into the world off-text. The comic is advertised as "brimming" with guest stars, the wording suggesting animated stories that cannot be contained by the printed page and will spill over into the readers' lifeworld. This is indeed a *bit* different from what readers had come to know and appreciate.

A note at the bottom of the cover of *Amazing Fantasy* #15 promises readers "an important message to you, from the editor—about the

new amazing [Spider-Man]!," introducing a strain of editorial comments and self-reflexive remarks that will accompany the narrative. Apart from its verbal content, these comments and similar remarks have a visual function. Over the course of the series, they move rather seamlessly through all sections of the comic book, refusing to stay confined either to the space of the stories, where they often add meta-commentary to the narrative, or to their surrounding paratexts. They suggest a permeability between text and paratext that invites mental constructions of storyworld models and the sharing of commentary about these models. The note on the cover ends with "amazing!," while the final word "Spider-Man" is supplied in oversized red letters on the opening splash. This transition underscores the comic's accessibility by making sure that the Spider-Man name, colors, and costume (note the drawn Spider-Man next to the letters) have maximum effect, reinforcing the iconicity of a figure called a "new teenage idol" at the end of the story.

Let's return to the notion of graphic style as connected to an author's signature, the "leaving [of] a personal trace on paper or other surfaces" (Etter 2017, 92) and the "kind of signature of the story's creation, the image bearing the signs of its making" (Mikkonen 2015, 101). At the bottom of the opening splash, over the gray pavement of the high school surroundings, we spot two names, "Stan Lee + S. Ditko," in different handwriting. These are presented as Lee's and Ditko's signatures and thus as authorial inscriptions that readers might have recognized from earlier series like *Amazing Adult Fantasy*, where they had graced several covers and stories. Marvel's comics, these signatures insinuate, are created by specific people, who will be portrayed in editorial remarks and columns, background stories, and fanzine reportage. Once we have seen these two signatures, we will probably view all other lines of the comic as traces of Lee's voice and Ditko's pen. We will imagine original scenes of graphic enunciation as authorizing gestures that are particularly important in popular serial genres, where authorship is usually dispersed and where a distinction between authors and readers is often difficult.[11]

11. That the discourse of creative origination did not always match the realities of comics production is acknowledged in the editorial response to a request by letter writer Gerry Johnson to include the signature of the artist on Marvel covers in *Amazing Spider-Man* #6 (11/1963): "The reason we don't usually have artists sign the covers . . . is that they often represent the work of MANY men. One might do the

Many of the readers whom *The Amazing Spider-Man* transformed into letter writers acted on the permeability of the boundary between text and paratext by commenting on style, celebrating or criticizing Ditko's artwork. Some of them wished he would incorporate more of his "weird" style from his work in *Amazing Adult Fantasy* (Buddy Saunders, *Amazing Spider-Man* #3, 7/1963); others also labeled this style "weird," recalling the pulp magazine *Weird Tales* as well as EC Comics' early-1950s *Weird Science* (Dan Fleming, *Amazing Spider-Man* #5, 10/1963; John Page #9, 2/1964; Ken Landgraf #11, 4/1964). This is the beginning of a discourse that traces the stylistic past and present styles of the genre, with single references to the weirdness of Ditko's style becoming a familiar trope. Significantly, this weirdness is interpreted as a sign of Ditko's valuable idiosyncrasies, with Dan Fleming speaking of "a very good, but weird style that is hard to copy" (*Amazing Spider-Man* #5, 10/1963) and John Favereau suggesting that Ditko "just can't copy Jack Kirby's style (Jack Kirby can't copy Steve's work either)" (*Amazing Spider-Man* #10, 3/1964).[12] Authorization conflicts loom large, as controversies over style suggest a sense of creative competition and legitimization that associates specific artists with particular superheroes—Ditko's Spider-Man, Kirby's Fantastic Four—and foregrounds a discourse around issues of invention versus derivation, original versus copy. Legal implications notwithstanding, from a genre perspective the question is not who originated Spider-Man. It is rather how the evolution of this character and the competing narratives about its contested origins authorized debates about authorship and ownership, about form and content, style and substance, that served as mediators for a new critical discourse and for the eventual conglomeration of individual storyworlds into an overarching style-driven metaverse.

Ditko's later attempts to position himself as Spider-Man's originator clashes with Kirby's public pronouncements and Lee's recollections. In "An Insider's Part of Comics History: Jack Kirby's Spider-Man" (1990), Ditko traces the steps from the initial idea and name for the character to its first appearance. He acknowledges Lee's

rough layout—another the pencilling—then, we might decide to change a figure or two and still another artist might make the correction—ditto for the inking."

12. See Hatfield's retrospective assessment: "Kirby's mannerisms—his geometric forms, slashing lines, squiggles, dots, bursts, and so on—become symbolic of the artist himself and his legacy. . . . Kirbyism can be aped; indeed these mannerisms are often used by others to invoke the very idea of Kirby" (2012, 47).

conceptual impulse and Kirby's aborted attempt to draw a Spider-Man story but still claims creative ownership of the character. This claim is difficult to sustain because Ditko has to demonstrate that his contribution to Spider-Man is more substantive than Lee's and Kirby's. In order to achieve this, he makes three basic distinctions. First, he distinguishes between the idea for the character, which he attributes to Lee, and the finished creation, which he claims for himself. Second, he differentiates between Kirby's "five unused penciled pages of an unfinished story," which he labels "a fragment, of some undisclosed whole" (57), and his own first story, printed as "Spider-Man" in *Amazing Fantasy* #15, as "a valid comic book creation (character, hero, costume, etc.) . . . that . . . is actually brought into existence, a finished whole, a complete creation" (59).[13] Third, he argues that Lee's and Kirby's rudimentary suggestions and partially discarded story elements—"a name, a teenager, an aunt and uncle" (57)—do not constitute an "original creation" (57) but that his design of the superhero's costume and his initial cover illustration (which was rejected and supplanted with a Kirby drawing inked by Ditko[14]) make him the originator of the character: "I am the creator of [the cover] and the published Spider-Man costume is my creation" (58).

Ditko traces the uncertainties about who and what was acting during Spider-Man's inception: "Is it to be believed/held that a name or its 'idea' could 'cause' the originator to 'create' a rejected 'creation' and 'cause' others to 'create' a complete, accepted, and successful one?" (57), he asks, excessive quote marks troubling the very notion of originality undergirding the statement. Ditko further describes his contribution as the transformation of a few diegetic dregs into the building blocks of the actual fictional universe: "One of the first things I did was to work up a costume," he recalls. "A vital, visual part of the character, I had to know how he looked, to fit in with the powers he had, or could have, the possible gimmicks and how they might be used and shown, before I did any breakdowns." Ditko's mental model of the character shaped his decision to cover

13. Comics, of course, are an essentially fragmented medium, a medium that builds its narrative apparatus through and from fragments (Postema 2013).

14. Kirby drew an earlier version of the cover that differs from Ditko's version in style and composition. Kirby's cover features a more muscular Spider-Man from a worm's-eye perspective that foregrounds physical prowess and agility to a greater extent than Ditko's bird's-eye perspective. Both versions are reproduced in David and Greenberger (2010, 12, 18).

Spider-Man's face with a mask against conventional wisdom: "I did it because it hid an obviously boyish face. It would also add mystery to the character and allow the reader/viewer the opportunity to visualize, to 'draw,' his own preferred expression on Parker's face and, perhaps, become the personality behind the mask" (56). Apart from its diegetic necessity, Ditko emphasizes the immersive potential of the mask as a stylistic device.

Ditko's essay reminds us of the larger Marvel metaverse to which actors must relocate to legitimize their claims. For one, he contributed his essay to Robin Snyder's *The Comics* (5/1990), a fanzine that featured first-person accounts of comics history, and he challenges Kirby's authority of Spider-Man by noting that Kirby's cover may have been chosen for *Amazing Fantasy* #15 but that his own initial cover illustration "has been reprinted" in the fanzine *Marvelmania* #2 (1970) (1990, 58). In addition, he begins his recollection by referring to "my series of essays, 'Avenging the Issues,'" which is "now in the draft stage" and will "deal more deeply with the aspects of ideas, creators and creation, definitions and other relevant concepts (collaboration, art ownership, rights and justice), their various contexts (Marvel, Marvel's success, division of labor)" (56).[15] Like Bob Kane, who appointed Biljo White as the "unofficial guardian" of his work on Batman and sent his claim to creatorship to *Batmania*, Ditko wants to debunk "numerous confusions, errors, and fallacies" (1990, 56) and casts himself in the superheroic role as an avenger in order to authorize this endeavor. Finally, he acknowledges the genre-shaping powers of comic book discourse when he cites from a *Comics Journal* interview where Kirby had stated: "I created Spider-Man. We decided to give it to Steve Ditko. I drew the first Spider-Man cover. I created the character. I created the costume. I created all those books, but I couldn't do them all" (Groth 1990a, 82). Ditko's rebuttal—"I am the creator" (1990, 58)—not only echoes Kane's claim to creating "the title, masthead, the format and concept, as well as the Batman figure and costume," but also reverberates with Lee's grand assertion, made in the company prozine *Foom* #17 (3/1977), that he was "writing virtually all of them" (Marvel's superhero comics) and that he was "creating my own universe" (63).[16]

15. See Ditko's *The Avenging Mind* (2008).

16. Hatfield concludes that "any simple assignment of creative credit to Kirby's or anyone else's single authorship" (2012, 81) is impossible. But Lee was often portrayed as "the author of the Marvel Universe" (Raphael and Spurgeon 2003, 159).

Ultimately, Ditko's claim to being the main creator of Spider-Man rings hollow, as do Kirby's and Lee's, because they all insist on attributing the crucial charge in the character's convoluted history to specific human actors, namely themselves. Lee at least acknowledged the impact of nonhuman actors in a radio interview when he confessed that new developments "aren't always planned" but "grow" and "evolve," with "all the characters get[ing] ahead of us" and "writ[ing] their own stories" (Hodel 1967, 166). Ditko, in turn, aims to resolve the conflict over who and what was acting by maintaining that "a creation is actually a re-creation, a rearrangement of existing materials in a new, different, original, novel way" (1990, 58), seeking to salvage the idea of origination in a popular genre that privileges derivation and variation. But in order to discredit Kirby and Lee, he must disavow any sense of radical innovation or personal origination, including, by implication, his own: "Every comic book hero . . . is the result of some prior 'idea' or 'ideas,' names or words, some prior position or 'creator' from some previous position or 'creator,' ad infinitum" (58).

The issue of Ditko copying Kirby's style that triggered my excursus on Ditko's creation theory came up in letter pages because issue #1 of *Amazing Spider-Man* (3/1963) featured a crossover story in which Spider-Man meets the Fantastic Four. This meant that Ditko had to draw characters usually handled by Kirby. Readers thus had a chance to compare the graphic styles of these artists and gauge the interaction of Lee's "verbal stamp" and Kirby's/Ditko's "visual imprint" on the characters (Raphael and Spurgeon 2003, 97). To suggest, as John Favereau did, that both artists are unable to copy each other's styles is to invest their artwork with an aura of individuality that may have been intended to compensate for the fact that readers only had access to mass-produced reproductions of the original black-and-white drawings.

How much of this discourse about style in general and stylistic competition in particular was initiated and channeled by Marvel is difficult to say. References to "Another Marvel Masterpiece in the fabulous Marvel style" appeared as early as *Amazing Spider-Man #6* (11/1963) in advertisements for an upcoming Captain America story in *Strange Tales* and for an Ant-Man adventure in *Tales to Astonish*.

Essays like Lee's "How I Invented Spider-Man" (1977a) downplay the ambiguities of collaborative authorship. See also Wells (1995); Fingeroth (2019, 112–17).

Marvel's special announcements sections frequently evoked the "now-famous Spider-Man style" (*Amazing Spider-Man* #12, 5/1964) or simply "the Spider-Man style" (#14, 7/1964), promising a consistent look that privileges corporate identity while reaffirming the value of individual achievements. The work of Joe Orlando, for instance, who was taking over the *Daredevil* series from Bill Everett after the first issue, was described in *Amazing Spider-Man* #14 (7/1964) as "really in the Spider-Man style." The editors "hope you'll get the same kick out of it that you do out of Smilin Stevie's" (Ditko's). This promotional patter suggested coherence behind, and also a sense of corporate control over, a fluctuating process of assigning artists to specific titles and issues.

The Bullpen Bulletins, where Marvel announced new publications from December 1965 onward, declared about artist Bill Everett: "His style is as exciting as KIRBY's, as different as DITKO's, and as unforgettable as AUSTIN's" (*Amazing Spider-Man* #35, 4/1966). The bulletins of the following issue (#36, 5/1966) even surmise that Everett may "prove to be another STEVE DITKO—with an inimitable style all his own, just as sturdy Stevey has." The similes in the first quotation capture the tension between standardization and differentiation, using Kirby, Ditko, and Austin as benchmarks to hype Everett's individual artistry while casting his work as congruent with the Marvel house style. Graphic style functions as a descriptive category and an authorizing agent in a discourse aimed at selling comics. But it has another, more normative, function: It reveals an editorial policy and hiring practice that enforces particular styles for artists compelled to exchange idiosyncrasies for a streamlined company style. As such, it impacts the range of available graphic styles. "The entire Marvel line revolved around the Kirby style," Bob Batchelor asserts (2017, 105), and Chris Gavaler suggests: "Becoming the Marvel house style seems to have required Kirby to regularize his layouts, presumably so they could be more easily imitated" (2016, n. pag.).

That the style of Marvel's artists was not as inimitable as frequently insinuated is acknowledged in the Bullpen Bulletins in *Amazing Spider-Man* #49 (6/1967): "We've just enough space left to welcome Dandy DAN ADKINS to the blusterin' Bullpen. Dan's the fellow who drew the cover of X-Men #31, as well as the Sub-Mariner yarn for ASTONISH #92. . . . If his style reminds you of another former Marvel-man, it's because Dan has worked with him, sometimes anonymously, for quite a while." Offering inside scoop and behind-the-

scenes access, such statements enticed readers to take a leap of faith from their own off-text world into Lee's depiction of the bullpen as an actually existing place. Adkins's transition from anonymous collaborator to official bullpen member shows how graphic style can foster identification with an imagined original scene of graphic enunciation. Once Adkins is part of the bullpen, readers can imagine him at the drawing board, working on a new Marvel adventure.

Indeed, readers were also able to spot writers and artists at work in stories like "How Stan Lee and Steve Ditko Create Spider-Man!" in the *Spider-Man Annual* #1 (11/1964), which fictionalizes Lee and Ditko's personal rapport and locates their collaboration in a concretely rendered visual space (see figure 2.3). The story "Something Fantastic?" in *Amazing Adult Fantasy* #12 (5/1962) had already depicted Lee and Ditko dealing with a case of writer's block, while "At the Stroke of Midnight!" in *Daredevil Annual* #1 (9/1967) featured a humorous depiction of a plotting session between Lee and artist Gene Colan where Lee adds one incredulous plot point after another for a befuddled Colan. In both cases, the off-text world of comics creation enters the fictional world of the comic book and triggers a particular storyworld for the readers. "Entering the storyworld and meeting its participants" (Kukkonen 2013, 19) in these narratives meant encountering comic book representations of names and voices readers would have recognized from the letter pages. There is also a bit of self-reflexive humor in "How Stan Lee and Steve Ditko Create Spider-Man!" when Lee's inspiration for new plots is stereotypically depicted as a nighttime epiphany or when Ditko contrasts his workload with Lee's merely "signing [his] name all over." But several panels depict Ditko as he is sketching, penciling, and inking an image of Spider-Man, walking readers through the process of initial graphiation that brings a comic book into being. They visualize a step-by-step account of his workflow as the panels variously depict Ditko's point of view at his work and the reader's more distanced view of him producing this work (not to mention the humorous contrast between Lee's frantic work ethic and Ditko's ostensibly more relaxed routine on the opening page).[17]

Letters to the editor do not create a temporal coincidence of initial graphiation and the act of reading in any strict sense of the term.

17. Expressing a different ethos, Frank Miller noted in 1981, when he was working on *Daredevil*: "One thing I can't stand is when the artists and writers of comic books put themselves into the story. That really bothers me—it's reminding the reader that he's reading a piece of paper with pictures on it" (Decker 2003, 23).

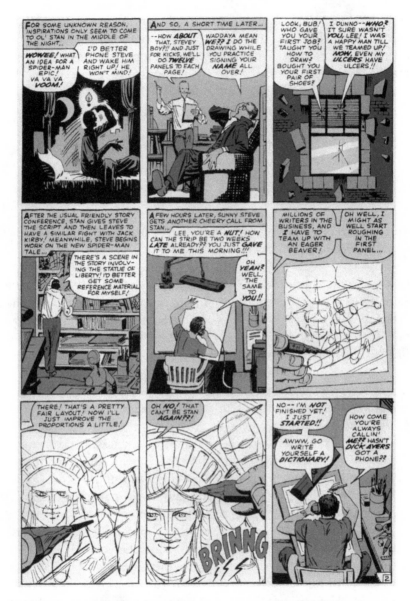

FIGURE 2.3. "How Stan Lee and Steve Ditko Create Spider-Man!" Stan Lee and Steve Ditko. *Spider-Man Annual* #1 (11/1964) © Marvel Comics.

Nevertheless, they narrow the time between production and reception. Stories were often produced quickly, with little advance time, rushed to the printer, delivered to newsstands, and sometimes bought on the day of publication. Some of these readers might have been so enthused or angered by a story that they would write to the

editor that very same day. Robert Cox's letter in *Amazing Spider-Man* #42 (11/1966) illustrates the sense of urgency that accompanied the purchase and perusal of the comics and outlines how the act of opening the comic book starts the process of storyworld immersion:

> Spider-Man #39 just couldn't hold me back from writing. I'll tell you what I thought of it in a minute, but I've got to say, when you walk to your favorite newsstand, you're just you, you look for Spider-Man and when you lay your eyes on it, your pulse jumps, and you've got to buy it. Why? Because you have a soap opera going and you have to find out what happens next! It's just a magazine when you open it, but as you read, your interest mounts, you're swept into your own world, and when you finish it, you're just you again—till the next ish come out, that is!

Cox's wording indicates the affective lure of the serial ("you have to find out what happens next") and the resulting urge to own the artifact ("you've got to buy it"). His verbal style also simulates the breathless excitement of buying and reading the comics (oral phrases like "you're just you, you look"; the quick enumeration in "when you lay your eyes on it, your pulse jumps, and you've got to buy it"). Cox is swept into *his* own world by the comic; the relocation is to a personally constructed storyworld rather than to a world owned by Marvel, but the immersion ends ("you're just you again") as soon as the narrative stops. It is exactly the time "till the next ish come out" that readers like Cox bridge by writing letters, which may not always keep them immersed but at least keeps them engaged.[18]

While superhero comics are certainly "vast narratives" (Harrigan and Wardrip-Fruin 2009), as Cox's testimony of his immersion in the superhero soap opera indicates, they are also "*fast* narratives" (Kelleter 2017, 13)—so fast that letters could be printed only with a temporal lag of a few issues because they outpaced production.[19] A "Personal Message from Spider-Man" in *Amazing Spider-Man* #1 (3/1963) seeks to bridge this gap as the superhero breaks the fourth

18. On the affective lure of Marvel's 1960s superheroes and the simulation of "affective authenticity and intimacy" through reader address, see Yockey (2017, 14).

19. In a fast-paced industry, the seven-month gap between *Amazing Fantasy* #5 and *Amazing Spider-Man* #1, which necessitated a recap of Spider-Man's origin story, underscores the initial uncertainty about the character's commercial potential (Fingeroth 2019, 103–4).

wall by looking directly at the reader from the fictional world into the off-text world and announces that issue #3 will contain a letter page "called THE SPIDER'S WEB." Evoking spirited responses that would sustain storyworld immersion, Spider-Man asks for "knocks and boosts," soliciting controversial statements that will keep readers coming back month after month for the stories as well as the paratextual discourse.

Marvel's promotional rhetoric ramped up this sense of pulse-raising urgency and temporal proximity, prodding readers to buy the comics immediately to secure their reading pleasures. The Mighty Marvel Checklist of *Amazing Spider-Man* #27 (8/1965) predicts that readers "will make [*Tales to*] *Astonish* the fastest Marvel sell-out of the month!" *Amazing Spider-Man* #34 (3/1966) commends readers for "hav[ing] made our capricious comics the most popular, most talked-about, fastest-selling mags of their type in the free world!" These statements create a sense of speed that mirrors the suspense-ridden narratives, the "fast-paced, action-packed, suspenseful, drama-charged epic[s]" one reader celebrated in *Amazing Spider-Man* #21 (2/1965). They were designed as self-fulfilling prophecies and tied again and again to paratextual depictions of scenes of graphic enunciation and initial graphiation. Consider this statement from *Amazing Spider-Man* #12 (5/1964): "By the time you read this, our newest mag, DAREDEVIL, should be on sale. Putting that thing out was like a comedy of errors! We lost some pages of the script, we missed our first deadline, we couldn't decide on his costume till the last minute, and we did the cover over a zillion times!" The stylistic and narrative choices concerning this issue become welded to a discourse that stylizes Marvel into a company different from a conventional publishing house in the same way in which their superheroes diverge from the genre norm. It evokes a world beyond the comics page, a world that extends what happens in the stories to riveting depictions of story creation.

Indeed, the overall setting evoked for Marvel productions was one of hasty efforts to fulfil an incessant, reader-driven demand for more and better stories: "Never let it be said that we merry Marvel madmen don't listen to all you frantic fans. Our tale this ish was specially produced in answer to a flood of mail demanding more adventures of Spidey fighting either with or against our human matchstick [i.e., the Human Torch]," the special announcements section in *Amazing Spider-Man* #21 (2/1965) declared. One cause for Marvel's hectic work

environment were the "hundreds of letters a day" (Conan 1968, 43) that, according to Lee, "inundated" (Kraft 1977, 63) or "swamped" (Suid 1976, 49) the Marvel offices in response to the company's spell-binding stories.

That readers were interested in the "merry Marvel madmen" and in moments of initial graphiation as fodder for storyworld construction can be seen in various letters describing the style of *Amazing Spider-Man*. Take Ken Landgraf's comments in *Amazing Spider-Man* #11 (4/1964): "The Ditko art for years has been my favorite type of illustration (The flat out-of-shape feet, the oversized glasses, and the unfilled-in ears.) This weird style that I like above any artist makes him appear young. By his drawings I can imagine how he looks. He no doubt is rather thin and wears glasses. I'd like to see how close I came!" Ditko's stylistic quirks and his ability to evoke more than he shows inspires Landgraf to create a mental model of Ditko's physical appearance. In this reader's storyworld, the style of the comic triggers a visual sense of authorial presence.

The letter transforms Landgraf from a reader into a writer, a transformation that many others underwent as well and that created the critical mass for fanzines and, later on, academic criticism. Early examples of this discourse tend to focus on the creator as the source of Spider-Man's graphic style, and they often take sides in debates about Ditko's artistic merits. Roger Post writes in *Amazing Spider-Man* #33 (2/1966):

> It's evident to me from reading your past letter columns that many readers don't like the style of Spider-Man artist Steve Ditko. Well, I'm not going to say he's the best cartoonist there is, but he has a quality that everyone seems to overlook. Most artists try to make their characters look noble and graceful at all times. . . . Mr. Ditko dares to break the mold. If at any time Spidey is falling down, he doesn't strike a ballet pose—he falls flat on his face; arms and legs flailing wildly. If he gets conked on the noggin . . . , he doesn't sprawl out gracefully—he crumples into a heap.

Style and characterization are integrally connected, Post suggests, and they shape the language readers employ about their favorite superhero and its creator, with ekphrastic formulations such as "fall[ing] flat on his face; arms and legs flailing wildly" and "get[ting] conked on the noggin" approximating Ditko's visuals as well as Lee's diction.

About Ditko's successor, Dave Serene comments in *Amazing Spider-Man* #44 (1/1967): "John Romita has modified his style greatly since DAREDEVIL #12. In that issue, ol' Hornhead was all muscle—his whole muscular structure was very exaggerated. Fortunately, John can really portray girls realistically; Betty Brant looks better than ever." Serene lauds the "story, plot, and script" and supports Marvel's decision to feature stories that continue over several issues: "You will get letters from guys who will proclaim you should have ended it in one mag, but disregard them. The length was what gave the story elements of suspense." Equally motivated by Romita's style, Jon C. Skillman introduces notions of page layout and realism in *Amazing Spider-Man* #48 (5/1967): "There is smoothness and grace in the art. The layout is filled or 'crowded,' but this is done in such a way as to be natural and well organized. It is realistic as well as artistic." These assessments cover a substantial range of stylistic observation, from realism and artistic skillfulness to narrative structure and layout, and they correspond with Romita's self-fashioning as a master realist who worried about details (including the depiction of female characters) that previous writers and artists had neglected.[20] In *The Art of John Romita*, a collection of his sketches and artwork, he notes:

> Stan and Ditko would do things like have Peter Parker become Spider-Man and go across town. . . . [H]e changes his clothes, leaves them either behind the house or in an ashcan somewhere, he goes across town, maybe miles away, and he goes to a rooftop, he goes down the building and becomes Peter Parker. And I would say, "Stan, where the hell did he get his clothes?" "Oh, you're too worried about those things," he'd say, "you're too technical." I could not rest with that. I devised the dumb web sack that he has on his back to keep my sanity. (qtd. in David and Greenberger 2010, 39)

Romita's storyworld is defined by a maximum degree of realism. As the artist who followed Ditko, he entered a fictional universe not of his making by creating a mental model of Spider-Man's habitus and habitat, discovering gaps he felt needed filling to make the stories more believable for himself and the reader. His different approach

20. Female readers like Sandee Griffith had complained about the lack of a feminine perspective during the Ditko years. Griffith wrote in her letter in *Amazing Spider-Man* #23 (4/1965): "Most of the letters I've read in Spider-Man's mag have been from boys. I thought I'd write to give you my point of view from the female angle. I don't think you are giving Betty true-to-life female characteristics."

found expression in a different style, as the juxtaposition of facsimiles of Ditko's rough pencils for a page of *Amazing Spider-Man* #38 (7/1966) with Romita's pencils for #51 (8/1967) indicates. The stylistic differences are clear: Ditko's pencils are lighter and looser than Romita's tighter and detailed drawings (Thomas and Amash 2007, 41); Romita places his characters in a more concrete environment and uses fewer but larger panels to structure the narrative; Ditko's rudimentary faces and almost stick-figure-like characters differ from Romita's finely chiseled facial features and his attention to body postures and clothing choices (see figures 2.4 and 2.5).

The introduction of a realist sensibility is generally considered one of Marvel's major contributions to the genre. In two particularly noteworthy cases, however, it caused major controversy, first when *Amazing Spider-Man* #96–98 (5–7/1971) presented a cautionary tale about drug abuse that did not get approval from the Comics Code Authority and was discussed in the *New York Times* (Van Gelder 1971), and a few years later in issues #121–122 (6–7/1973), which told the story of Peter's girlfriend Gwen Stacy's tragic death. Exchanging what Lee called the "cardboard figures" of conventional narratives (Van Gelder and Van Gelder 1970, 21) with "more three-dimensional" (Feiffer 1998, 131) superheroes like the suffering Spider-Man enabled new ways of interaction and immersion. "The big formula . . . was just saying to myself, suppose a real, flesh and blood human had thus and such a super power," Lee recalled in the early 1980s. "What would his life be like anyway? What would happen to him in the real world" (Pitts 1981, 88). Lee discussed Marvel's realism frequently and asserted a sense of closeness between the characters, their creators, and their readers. "We try to set our stories in the real world . . . [and] treat our superheroes as real people," he told Lawrence and Lindsey Van Gelder (1970, 20–21): as people losing a loved one, for instance, as Spider-Man did more than once (Uncle Ben, Gwen Stacy), and undergoing a period of grief. Marvel's comics, he claimed, "were to be completely realistic except for the one element of a super power which the superhero possessed, that we would ask our reader to swallow" (21). In addition to being part of Marvel's style, this conceit aligned those who officially produced the comics with those who consumed them: "We writers and artists and editors . . . live in the same world as our readers, and certainly what our readers are concerned with, we are concerned with" (22). For Lee, this shared residence in the off-text world ensured "stories that will tell [the readers] something about the world they are living in now" (29), while his

own engagement with the fictional world increasingly projected a shared fictional universe: "It made the characters more real to me by having them meet each other. I used to imagine that the characters lived in their own world. They lived in the Marvel universe!" (Cangialosi 1999, 171).

Locating stories in a single universe where events in one story impact all other stories and where characters pop up in different series privileged a readership willing to follow multiple "crossovers, guest appearances, and ongoing narratives" (Bainbridge 2010, 169). Previews for a wide range of series in the bulletin sections "contributed towards the idea of a cohesive whole, a community of characters and titles that could collectively be thought of as 'the Marvel Universe'" (169). In this universe, "stories interpenetrate and revise each other to such an extent that they often cannot be distinguished as individual stories," Carl Silvio noted in the mid-1990s. Silvio speaks of "serialized link[s]" connecting stories through "web-like patterns" that require an "interpretive and aesthetic matrix with which the reader apprehends the text [and that] expands with each successive title" (1995, 43). The fact that this universe was modeled on New York City connected Spider-Man's world with a concrete geographical and cultural space and manifested itself "both textually and extratextually in Marvel's relationship with its readers" (Bainbridge 2010, 164).[21]

Such serialized links and weblike patterns and the immersive reading experiences they fostered were not confined to Marvel's stories. They also shaped the paratextual discourse in bulletins that advertised the company's whole roster of publications and centered the production of the comics in the fictionalized bullpen. Moreover, addressing readers in a characteristically jocular manner, editors like Lee "curat[ed] letters in such a way as to highlight substantive differences of opinion on both aesthetic and political concerns" (Fawaz 2016, 99), redefining "the relationship between creators and fans as a form of creative camaraderie" (100). Substantiating this sense were

21. Foregrounding the made-ness of this universe, "Marvel's depiction of New York City also serve[d] as a constant reminder of the artists who produced it. . . . New York is simultaneously the diegetic place where the Marvel Universe is located and the extradiegetic place where the Marvel Universe is created. . . . New York . . . connotes not only a general 'realism' for the Marvel Universe but also some more specific understanding of how its creators feel about the city in which they often lived and worked. Kirby's New York and Ditko's New York are as much signatures of the artists as any panels which bear their names" (Bainbridge 2010, 175). On Spider-Man's allegiance with New York as an evolving setting, see Flanagan (2012). On Batman's Gotham, see Uricchio (2010).

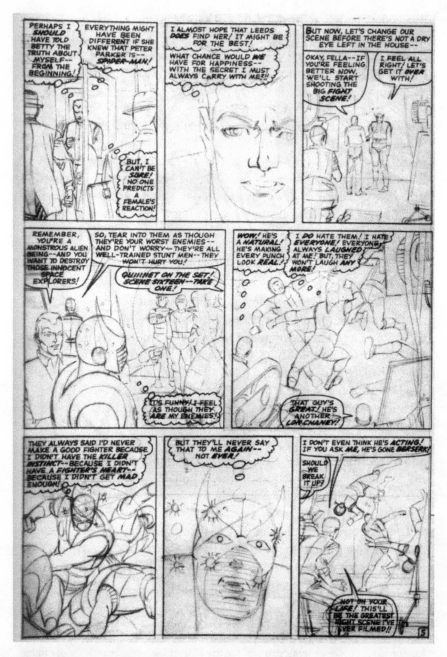

FIGURE 2.4. Steve Ditko, pencils for *Amazing Spider-Man* #38 (7/1966). Roy Thomas and Jim Amash, *John Romita . . . and All That Jazz!*, 2007 © TwoMorrows Publishing.

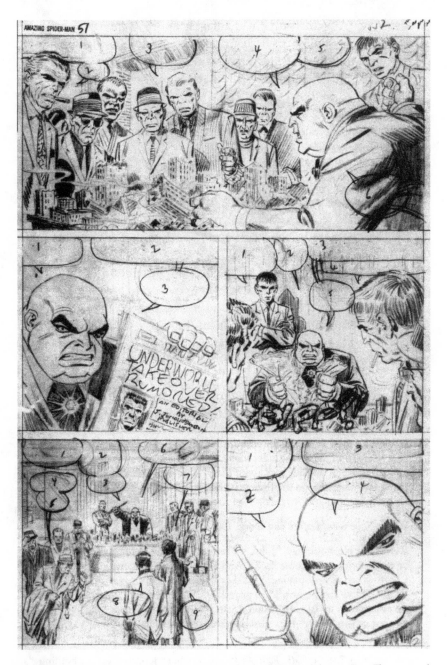

FIGURE 2.5. John Romita, pencils for *Amazing Spider-Man* #51 (8/1967). Roy Thomas and Jim Amash, *John Romita . . . and All That Jazz!*, 2007 © TwoMorrows Publishing.

stories like "A Visit with the Fantastic Four" (*Fantastic Four* #11, 2/1963), where Sue Storm is dismayed by negative fan letters about her limited role in the superhero team.[22] Fawaz maintains that this story "feature[d] readers as visible actors in the production of the Fantastic Four mythos" (2016, 107). It responded to, and thus retroactively authorized, one letter writer's demand to excise Sue from the Fantastic Four because "she never does anything" (*Fantastic Four* #6, 9/1962), which triggered not only "A Visit with the Fantastic Four" but also a barrage of letters on behalf of the character. According to a poll initiated by Lee and Kirby, the overwhelming majority favored her continuation as a member of the team and even demanded a more active role (see Fawaz 2016, 102–3). Within a little over a year, Sue became a more powerful character, and while Fawaz reads "the evolution of Sue's powers" (104) as a direct result of the readers' responses, I would suggest a more uncertain distribution of agencies, from the serial setup of the storyworld and the paratextual powers of the letter pages to the commercial incentives behind the storytelling and the general political climate (including early second-wave feminism). Fawaz is right, though, to detect "a movement from questions of visual representation . . . toward questions of world making that addressed the series' broader political commitments and the formal tools through which it made claims about the 'real' world[,] . . . a general shift in . . . scale . . . that reflected the expanding imaginative locus of the Marvel Universe" (102).

Once readers felt authorized to act publicly as critics, offering their expertise to improve the stories and their style, they became eligible as industry professionals through a particularly powerful form of relocation or transport. Marvel famously hired fan writers like Roy Thomas or industry outsiders like Gary Friedrich, as addressed in the "Marvel Bullpen Bulletins" of *Amazing Spider-Man* #46 (3/1967):

> Roy was originally supposed to lighten the work load for poor Smiley [Stan Lee]; but now that the Rascally One [Roy Thomas] is so busy, we hadda hire *another* budding Shakespeare to take the pressure off *him!* So, lets hear it for GARY FRIEDRICH, whom

22. See also *The Fantastic Four* #5 (7/1962), where Johnny Reed is holding "a great new comic mag" that looks like *The Incredible Hulk* #1 (5/1962), which had appeared a few months earlier. Staring at the Thing (Ben Grimm), he exclaims: "I'll be doggoned if this monster [the Hulk from the comic book] doesn't remind me of the Thing!" Angered by this comparison, the Thing takes the comic away from Johnny, who then transforms into the Human Torch and burns it in retaliation.

we snatched away from an editorial job on a Midwest newspaper to help bring culture and enlightenment (Marvel style!) to all you Keepers of the Flame!—Pretty soon, we'll haveta start issuing score cards so you'll know who's who—and then maybe you'll be able to tell *us!*

When Marvel had hired Thomas a year earlier, the decision was announced with equal fanfare in the "How About That Department" of *Amazing Spider-Man* #33 (2/1966):

You'll see the name ROY THOMAS popping up here and there in our ever-lovin' editions. Roy's a fan who's made it! Although employed as a school teacher in St. Louis (his subject was English!), Roy never lost his love for comic mags—Marvels, to be exact! So, after a lot of correspondence back and forth, we decided it would be cheaper to hire him for the bullpen than to keep shelling out money for those air-mail stamps! Now that Roy's aboard, we're betting our syntax will be sensational, and there won't be a split infinitive for miles around!

The familiarity expressed in these statements implies a close connection between the nicknamed members of the bullpen and their readers. This discourse community ("Keepers of the Flame") shares an attitude toward the comics, a devotion to the "Marvel style" that turns readers into "Marvelites" whose expertise might surpass that of the official producers. The playful reference to score cards and the followers' ability to keep track of who is who evokes additional forms of storyworld engagement. Speculating that fans may soon be "able to tell *us*" (the makers of Marvel comics) who is working for Marvel is an assignment for readers to preserve the company's cultural memory, perhaps in pursuit of careers like Thomas's, the fan who transitioned from high school teacher to comics author.

The Labored Making of the Storyworld

"In the beginning Marvel created the Bullpen and the Style" (Lee 1974, 7). Thus begins *Origins of Marvel Comics,* Stan Lee's first anthology of Marvel superheroes published by Simon and Shuster.[23] Lee's

23. Sequels include *Son of Origins of Marvel Comics* (1975), *Bring on the Bad Guys: Origins of Marvel Villains* (1976), and *The Superhero Women* (1977b).

description of the book and its sequels as "comics on slick paper" (Gold 1976, 45) registers what he often celebrated as the "elevation" of the medium (T. White 1968, 11). The book capitalized on this new sense of legitimacy, but it also connected Marvel's most popular characters with narratives of their making. It did so by reprinting "classic" stories and contextualizing them with Lee's creation myths, which countered the popular notion of comics as mass-produced, assembly-line entertainment with colorful accounts of the Marvel Bullpen and the publisher's interactive storytelling approach. "Marvel's genius was to make that 'assembly line' seem personal rather than mechanical," Hatfield notes (2012, 96). According to Lee, this personal element resulted from

> a uniquely successful method of working. I had only to give Jack [Kirby] an outline of a story and he would draw the entire strip, breaking down the outline into exactly the right number of panels replete with action and drama. Then, it remained for me to take Jack's artwork and add the captions and dialogue, which would, hopefully, add the dimension of reality through sharply delineated characterization. (1974, 16–17)

This account of the so-called Marvel method—which Lee had discussed in "Soapbox" columns from January to July 1970 and which indeed recalls "the labored making of the storyworld" (Gardner 2011, 64)[24]—has been widely contested, including by Kirby himself, about whom Lee stated elsewhere:

> Jack has his own perception of these things. . . . It's really a semantic difference of opinion, because it depends what you mean by "creating" something. . . . Jack did create the characters in the sense that he drew them. I didn't draw them. I wrote them. He created the way they look. . . . [I]t seems to be that the person who says, "I have this idea for a character," that's the person who created it. (Pitts 1981, 91)

Indicating the controversial nature of the Marvel method, Kirby begged to differ when he told Will Eisner:

24. The Marvel Bulletin Page featured an explanation of the Marvel method as early as 1966: "All Stan has to do with pro's like JACK 'KING' KIRBY . . . is give them the germ of an idea, and they make up all the details as they go along, drawing and plotting out the story. Then, our leader simply takes the finished drawings and adds all the dialogue and captions" (*Amazing Spider-Man* #34, 3/1966).

Stan Lee wouldn't let me put in the dialogue. But I wrote the entire story under the panels . . . so that when he wrote that dialogue, the story was already there. In other words, he didn't know what the story was about, and he didn't care because he was busy being an editor. . . . [F]rom a professional point of view, I was writing them, I was drawing them. . . . Stan Lee wrote the credits. (Eisner 2001, 220–21)

Rather than picking sides and privileging one claim over another, it is the evolutionary effects of the controversy that interest me. While official publications like *Origins of Marvel Comics* allowed Lee to cast himself as the creative force behind Marvel's superheroes and the mastermind of the Marvel universe, they relegated Kirby to the role of the dispossessed artist struggling to get his due.

Through books like *Origins of Marvel Comics*, Lee instituted information on the conception of the characters that placed himself at the center of the storyworld's labored making. He describes, for instance, his convoluted collaboration with Kirby and Ditko as well as the negative reaction of publisher Martin Goodman to his initial Spider-Man pitch and the realization of the first story (1974, 131–38). Suggesting a glance behind the curtain at backstage banter and production processes, Lee implies an author figure as well as a specific type of reader: someone who is not just a fan of the characters and their adventures but is interested in everything Marvel, including paratextual and epitextual discourses, and who is willing to act as a participant in the Marvel metaverse.

A few years earlier, Lee had already modeled the attitude with which Marvel approached the comics and that cast readers on par with industry professionals. In his first "Soapbox" column, which appeared across series starting in May 1967, Lee extended the paratextual discourse from the letter pages and Bullpen Bulletins into another avenue of communication, deepening the connection between storyworld and metaverse. Offering his ideas as a manifesto on Marvel's style in an editorial voice that glued the publisher's comic books together,[25] Lee proposed a particular stance toward the comics and the off-text world:

25. See Kasakove: "Stan Lee's editorial voice—at once frantic, comic, self-deprecating, tongue-in-cheek, good-natured, wildly self-congratulatory and (sometimes) moralistic—was . . . the glue that held the Marvel Age of Comics together" (2011, 130). Fingeroth finds "one consistent, singular—call it *omniscient*—voice tell-

We believe in our cavortin' characters a lot more than we believe in some people we know, and we do have a motive—a purpose— behind our mags! That purpose is, plain and simple—to entertain you! We think we've found the best formula of all—we merely create the type of fanciful yarns that we ourselves like to enjoy—and, if we like 'em, you oughtta like 'em, too: after all, you're our kinda people! Now then, in the process of providing off-beat entertainment, if we can also do our bit to advance the cause of intellectualism, humanitarianism, and mutual understanding . . . and toss a little swingin' satire at you in the process . . . that won't break our collective heart one tiny bit! (Cunningham 2009, 5)

Lee frames this "philosophy" as a matter of faith: as a belief in the lifelikeness and real-world significance of the characters. This faith corresponds with a wish to do good by promoting a better world. However, he is explicit about the primary incentive: to entertain for profit. He is, indeed, "selling a participatory world for readers, a way of life for its true believers" (Pustz 1999, 56).[26] The claim to social and political significance, softened rhetorically by phrases like "toss a little swingin' satire at you" and "merely create the type of fanciful yarns," presents Marvel as a politically progressive company that might educate readers about intellectualism, humanitarianism, and mutual understanding (hardly controversial causes) but will not antagonize them by becoming overly political. The abundance of personal pronouns—mostly "we" and "you"—reiterates the close bond with the readers by casting Marvel creators as regular folk who enjoy the same fanciful stories as those who buy their magazines. What comes across is a sense of style, an attitude toward the company's properties, a lighthearted political disposition, and an image of a reader-friendly group of enthusiastic writers and artists rather than corporate cogs in a machine. Many letters from the 1960s affirm this ideal of an intimate connection between creators and consum-

ing you the stories and, as importantly, welcoming you into the world of Marvel" (2019, 138).

26. We find a similar discourse in the pages of *Batmania* #12, where editor Biljo White employs religious rhetoric to outline his "Batmania Philosophy": "Mr. Schwartz gave me his blessing, and the 'Bible for Batmanians' was officially born"; "we like to feel we converted several non-Batman fans"; "For Batman We Accept Nothing as Impossible is not an idle boast. We say it, we believe it, we preach it. Batman Forever" (1966a, 5).

ers and imagine Marvel as a collectively shared space of storyworld creation. Lee had encouraged this ideal in the letter page of *Fantastic Four* #10 (1/1963): "Hi, fans and friends! Look—enough of that 'Dear Editor' jazz from now on! Jack Kirby and Stan Lee (that's us!) read every letter personally, and we like to feel that we know you and that you know us! So we changed the salutations in the following letters [i.e., to "Dear Stan and Jack"] to show you how much friendlier they sound our way!"

That this was more than a playful gesture becomes clear when we consider the cover of this issue, which announces "The Return of Doctor Doom" and inserts a drawing of Lee and Kirby at the bottom of the image. They are standing with their backs to the reader, looking at and commenting on a scene involving Doctor Doom, Sue and Johnny Storm, and the Thing, with Reed Richards leaving the fray and looking back in anger. "How's this for a twist, Jack," Lee's avatar says. "We've got Doctor Doom as one of the Fantastic Four!!" To which Kirby's avatar replies: ". . . and Mr. Fantastic himself is the villain!! Our fans oughtta flip over this yarn." This setup is less intriguing for its seeming reversal of genre conventions, with the intimation that the villain may become part of the superhero team (it is labeled as a "yarn" and thus to be taken with a grain of salt), than for its visual and verbal representation of the creators. For one, as the text that fills the red arrow pointing at the creators indicates, readers will "actually meet Lee and Kirby in the story!!" The promise is that readers who have appreciated the work of these figures will now get to know them, that they will enter the fictional universe of the comic in order to be able to connect with their fans. Of course, this is a facetious promise, as it is only a graphic approximation that readers will meet. But the gesture is nonetheless significant, as the comic will visualize the labored making of the Fantastic Four's storyworld.

Second, the short exchange between Lee and Kirby on the cover does not read like a dialogue but rather as a single voice speaking for both creators at once. Here, readers encounter a paradoxical and highly complex narrative situation. In the diegesis, they are seeing Lee and Kirby as two distinct individuals speaking to each other. On the level of narrative transmission, however, they see what may amount to Kirby's image (a single artist for both figures) and Lee's text (a single writer for two speakers), but even this is complicated by the fact that the cover was the work of at least four people: Kirby, who did the pencils; Dick Ayers, who did the inking; Stan Gold-

berg, who did the coloring; and Lee, who wrote the words and also approved of the cover in his role as Marvel's editor. The story itself continues the breaking with conventions when a caption in the first segment interrupts the narrative to switch from the fictional universe of the Fantastic Four to a fictional representation of an office shared by Lee and Kirby, where the two men struggle to find a good villain for the story. They lament the fact that they had disposed of Doctor Doom in issue #6 but are interrupted by this very supervillain, who surprises them with his presence and asserts agency as the prime storyteller of the comic.[27]

Responding to, and perhaps also motivating, these kinds of authorial self-fashioning and metaleptic playfulness, reader Doug Austin notes in *Amazing Spider-Man* #10 (3/1964):

> I'm sure the rest of your readers and I feel the same way toward your personal message in Spider-Man #6. Many of us are probably collectors or followers of many different magazines, but no successful magazine has ever given us the pleasure or experience which we get from seeing you and Steve match wits in creating the unusual Spider-Man adventures. Your reading of every letter . . . I'm sure has gained a great impression on your readers. I know you enjoy creating Spider-Man's adventures because you show it not just in printing it but also in your fine outstanding art. I admit Peter Parker's growing success is partly [due] to us, but our suggestions and criticisms are only words. It is your job to put our words to work which sometimes can be very difficult since we all have different opinions, but since you're doing a great job, you don't have to worry.

On the surface, this is a typical praise letter, with Austin celebrating Lee and Ditko for their work. But Austin presents his missive as a direct response to an earlier special announcement in *Amazing Spider-Man* #6 (11/1963):

> A personal message to our readers, from Stan and Steve: We've been in the business of creating comics for many years. During that time we've had quite a few hits (and our share of duds, too!) But no successful mag has ever given us the pleasure, or the THRILL, which we get from seeing how you, the magazine readers, have made

27. For related analysis, see Batchelor (2017, 76–77).

Spider-Man the success story of '63! Just as he seems to appeal to YOU, he appeals to US the same way! We really ENJOY writing and drawing his adventures, and we want to repeat that your letters mean a lot to us—we read every single one—and we feel that a great deal of Peter Parker's growing fame is due to your intelligent suggestions and sincere criticism.[28]

Austin's response suggests a serial dialogue, and it is filled with personal pronouns, or "collecting statements" (Latour 2005, 231), that, very much like Lee's messages, create a sense of intimacy between Spider-Man enthusiasts on both sides of the paratextual vestibule, "upend[ing] the producer-consumer relationship between Marvel and its readers" by shifting the readers' communication with company employees to a mode of "engaging in an interactive communication with a couple of friends" (Fingeroth 2019, 151). Such collecting statements, Latour argues, propose "theories of what it is to connect"; "they perform the social in all practical ways" and "provide a second order description of how the social worlds should be formatted" (2005, 232). Note Austin's attempt to present himself as more than a casual reader—as a laborer in the shared storyworld—when he identifies himself as part of a larger group of "collectors or followers of many different magazines." As an expert reader whose intake is not confined to a single series and whose collection represents a reservoir of knowledge, Austin wants a stake in the making of Marvel comics; he offers his labor to ensure stories fans will appreciate: "Peter Parker's growing success is partly due to us." While he acknowledges Lee and Ditko's nominal power over the property—"our suggestions and criticisms are only words"—he conceives of himself and other fans as cocreators and of Lee and Ditko as professionals who translate suggestions and criticisms: "It is your job to put our words to work." That he praises Lee for "reading . . . every letter" indicates a sense of

28. Lee held less favorable views on fanzines, which he deemed "highly repetitive" and often "just interested in peddling their own wares" and which "generally express the opinions of the fanatical fans while the mail expresses the opinion of the average fan." Nonetheless: "I read all the mail given to me and I read all the fanzines that cross my desk. . . . I pay attention to the fanzines in the sense that I believe in brain-picking" (Hurd 1969, 78).

significance toppling conventional notions of active authorial creation and passive reception.[29]

Laboring in a shared storyworld, as evoked in Austin's account and Lee's editorial statements, was a central comic book fantasy. A case in point is the cover of *Origins of Marvel Comics,* where two hands hover over a typewriter from which the Marvel superheroes Thor, the Human Torch, Namor, Spider-Man, the Hulk, Dr. Strange, and the Thing emerge. Reinforcing the promise of participatory creation, the image places the reader into the position of the writer-at-work, whose hands (presumably Lee's, or ours, depending on how we place ourselves vis-à-vis the space evoked by the cover) we see illustrated and who begins the fable of Marvel's origin stories with a rewriting of the *Book of Genesis.* The genealogy implied by the book's opening statement—"In the beginning Marvel created the Bullpen and the Style" (1974, 7)—moves from the publisher's godlike powers to the bullpen as the world in which Marvel Comics are made, to style. Style, here, relates to the form, content, and context of Marvel's productions: to the idea that Marvel is a "wild and wondrous world," "a special state of mind," "a mood, a movement, a mild and momentary madness" (9).

If readers wanted to enter this state of mind, they had to come to terms with the stories and with the comic's gestalt, as they were hailed by the cover and beckoned by paratexts, from covers and letter pages to bulletins, service announcements, and advertisements.[30] As Bukatman maintains, "world-building is not only a function of rich narratives or detailed backstories; it also derives from aesthetics and style" (2016, 27). This entails

> the quality of line, the use (or nonuse) of color, the slickness of the production, the number and regularity of panels on the page, the acceptance or rejection of the grid, the size of the page, the legibility

29. The first *Merry Marvel Messenger* newsletter of the M. M. M. S. (1966) put fans in charge of creating content: "We're gonna give all you madcap marchers a chance to tell us—and all the rest of Marveldom—what's cooking with your local chapters! You send us the news, and we'll do our best to print it—right on the pages of this, your exclusive club bulletin!" (facsimile reprinted in Thomas and Sanderson 2007, 97). Prior to 1966, the Biljo White's *Batmania* fanzine had already instituted its own newsletter called *Gotham Gazette.*

30. Sullivan argues that Marvel offered "a gestalt experience, a universe whose interconnectedness implied the inclusion of the knowledgeable reader" (qtd. in Pustz 1999, 56).

of panel transitions, the presence or absence of text, the placement and style of text, and the overall sense of unity or disjunction that the comic imparts. (30)

In other words, "different visual styles create different aesthetic experiences and different worlds" (29). Early on, "the parameters of the universe begin to be established; reading protocols and horizons of expectations begin to emerge," with "the first pages . . . address[ing] the reader and creat[ing] a world almost through aesthetic choices alone" (31, 39). Readers enter a "graphic space" as much as they enter a "fictional world" (197) to engage in storyworld creation, with "narrative beginnings as prompts for worldmaking" that induce "interpreters to take up residence . . . in the world being evoked by a given text" (Herman 2009, 109, 112).[31]

In *The Amazing Spider-Man*, the parameters of this fictional world/graphic space were indeed established early on, as my discussion of Ditko's "weird" handling of Peter Parker's physique and Spider-Man's movement through space has shown. I have noted that this handling may have been less appealing through a superior quality of the artwork than through a quirky style, a rather unpolished approach that translated Peter's oddness and Marvel's self-professed oddball status into an entertaining reading experience, making good on the claim that Spider-Man was a *bit* different. In terms of color, Spider-Man's first appearance in *Amazing Fantasy* #15 is visually striking, as is his red-and-blue costume, scattered across each page after Peter's transformation, as well as Ditko's unusual choice of background coloring, which oscillates between different shades of green, yellow, orange, blue, gray, and red. These choices do not follow any real-world logic—the wallpaper in Peter's room changes from light blue to orange to yellow to green on a single page. The colors rather set a mood and give each page a dynamic feel, while the backgrounds contain little detail. The focus is usually on Peter or Spider-Man, perhaps to ensure the readers' identification with the character, and it gives rise to "Peter Parker's Ditkonian world," marked by outdated clothing styles and an antiquated look of the urban scenery (Fingeroth 2019, 111).

31. This recalls Hatfield on "Kirby's graphic mythopoesis" as "world-building *through drawing*" (2012, 153).

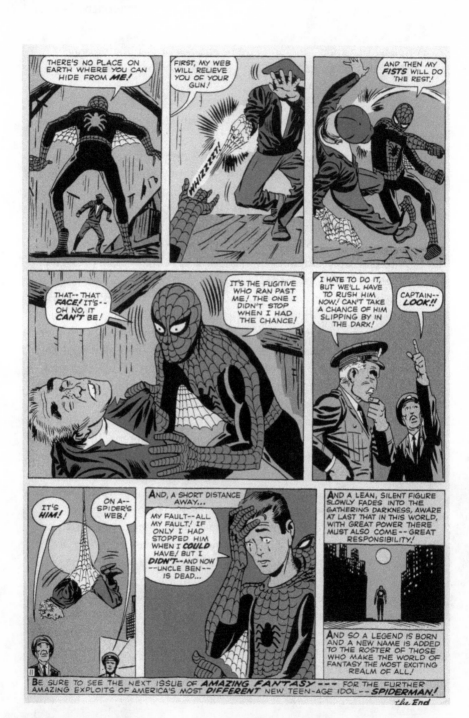

FIGURE 2.6. "Spider-Man." Stan Lee and Steve Ditko. *The Amazing Spider-Man* #1 (3/1963) © Marvel Comics.

The story is rather text-heavy, with few narrative captions but plenty of monologue and dialogue. Ditko uses fairly thin and sometimes frail lines that contrast the bold outlines and lettering of the speech balloons on the cover of *Amazing Fantasy* #15 and underscore both Spider-Man's self-doubts and Peter's vulnerability as a teenager whose powers can be overwhelming (see figure 2.6). Upon realizing that the criminal he had allowed to escape had killed his uncle, Peter exclaims: "My fault—all my fault! If I had only stopped him when I could have! But I didn't—and now—Uncle Ben—is dead. . . ." He speaks these lines in the penultimate panel, before the narrator utters the memorable sentiment that "with great power there must also come—great responsibility!" This lament is followed by an advertising pitch: "And so a legend is born and a new name is added to the roster of those who make the world of fantasy the most exciting realm of all!" Peter is still wearing his Spider-Man costume, but he has taken off the mask, expressing his grief through two teardrops running down his cheeks, his right hand clasped to his furrowed forehead.[32]

That the storyworlds afforded by these images are based on the labor of specific individuals is signaled by the authorial signatures on the opening splash page as well as by the "important message . . . from the editor" announced on the cover and delivered on the fan page later in the comic. Here, an unnamed editor introduces the magazine's "new editorial policy," claiming to take "our valued readers . . . into our confidence" and promoting Spider-Man as "one of the most unusual new fantasy characters of all time." The labor that went into this magazine is described as a collaboration, the editor repeatedly citing the influence of fan mail on the new policy and soliciting more responses: "We are most anxious to have your opinions, and will be waiting eagerly for your letters. Rest assured that . . . we carefully read each and every one, and are guided by your desires when we edit our magazine!" The storyworld being collectively constructed here enlists a number of builders, and it banks on their ability to create intense immersion experiences, enticing authors and readers to interact again and again. Immersion and interaction are not mutually exclusive types of engagement, but integrally connected through

32. Hultkrans identifies anxiety as the "dominant emotion in Ditko's pre-'66 work." Examples are the "quivering pen strokes" that shape the *"tingle lines"* visualizing Peter's "spider-sense" (2004, 223).

the complex combination of storyworld construction, world-building activities, and the collaborative production of the metaverse.

In Spider-Man's origin story, the deictic shift into the story-world is aided by a series of visual choices that are part of Ditko's graphic style. Peter repeatedly faces the reader as he is turning his back to his surroundings, allowing insights into his private thoughts and sentiments. This invitation to Spider-Man's interior world turns readers into confidantes rewarded for their willingness to immerse themselves in the story by a protagonist whose personal problems prove highly relatable. The frequent use of thought balloons when Peter ponders the implications of his superpowers, not even sharing his transformation with his aunt and uncle, heightens this impression. Moreover, Ditko frequently uses subject-to-subject panel transitions (McCloud 1994, 71) that present Spider-Man's visual impact on the unbelieving world around him.[33] These transitions serve as guideposts for the reader, underscoring the amazing-ness of Spider-Man—his actions leave mouths agape and eyes glued to his body—and thus create an image of an unbelieving public as a reception model for the comics' predominantly young readers who might have empathized with what Bukatman calls the superhero's embodiment of "social anxiety, especially regarding the adolescent body and its status in adult culture" (2003, 49).[34] As one of the captions in *Amazing Fantasy* #15 exclaims: "Yes, for some, being a teenager has many heart-breaking moments!"

The cover of *Amazing Spider-Man* #5 (10/1963) amalgamates messages that, in conjunction with the opening splash, launch the deictic shift by mobilizing multiple paratextual elements (see figure 2.7). The shift evolves from a layering of different temporalities and spatialities that start with the left-hand corner, which displays the Spider-Man trademark and thereby equates the character with the title of the comic and thus with the publisher that owns the product. Below Spider-Man's iconic head, taken directly from the stories, we find the publisher's name, Marvel Comics Group, as well as the price for this comic. Legal ownership and corporate control thus frame the story;

33. He does so in *Amazing Fantasy* #15, in *Amazing Spider-Man* #1, and in later issues.

34. I have commented on the intensely gendered superhero body elsewhere (Stein 2018a), where I follow José Alaniz's view "of the *super-body* as a site of elaborate, overdetermined signification" (2014, 5–6). See also Bukatman (2003); A. Taylor (2007); Avery-Natale (2013); Ormrod (2020).

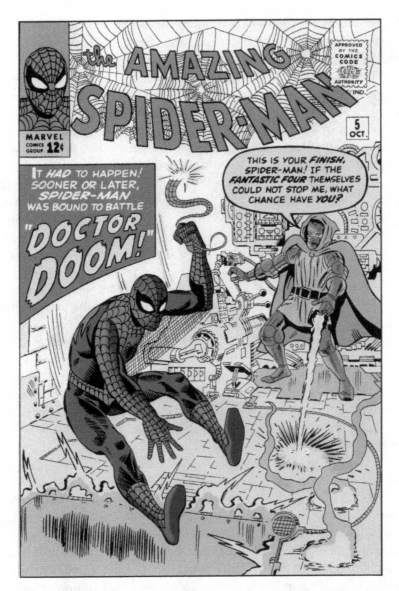

FIGURE 2.7. Cover illustration. Steve Ditko. *Amazing Spider-Man* #5 (10/1963) © Marvel Comics.

as an "undisguised commodit[y]" (Kelleter 2017, 10) intended to activate audiences, the comic's commercial nature is acknowledged and the reader is addressed as a consumer. In the center top third, we find the logo *The Amazing Spider-Man* in the color of Spider-Man's costume (red, undergirded by Spider-Man's webbing), flanked by the

"Approved by the Comics Code Authority" stamp that was carried by all superhero comics at the time and signified restrictions on content and style.

The left-hand side of the cover features an announcement in a blue-colored box. Its tone and register recall the editorial statements from *Amazing Fantasy* #15 and thus insinuate serial continuity. The announcement—"It had to happen! Sooner or later, Spider-Man was bound to battle Doctor Doom!"—introduces an element of drama and suspense: How will the battle unfold? Will Spider-Man emerge victorious? The villain's telling name heightens the tension, suggesting scientific expertise that may outmatch Peter and foreshadowing evil intentions that may spell Spider-Man's demise. Its sense of inevitability ("had to happen"; "bound to battle") raises questions of narrative agency. Possible answers based on the cover and the opening splash are the Marvel Comics Group as the publisher of the comic, the creators whose names are given, the logic of the superhero genre (superhero defeats supervillain), or the seriality of the storytelling (superhero must not die). This multiplicity may have taunted readers, whose recognition of the seriality of the narrative—indicated by the issue number and the phrase "sooner or later"—offered them a role in determining the series' unwritten future. Especially readers with knowledge of this comic's short serial history, who would have known that Doctor Doom stood in a line of increasingly menacing antagonists (Vulture, Doc Ock, Sandman), may have felt empowered to play that role when they were incited to send letters.

The shape and increasing size of the lettering as well as the exclamation marks on the cover convey the drama of the situation by mimicking the sound of voice-overs known from cinema and television. The editorial announcement, we must assume, is not audible in the fictional universe but can be heard in the storyworld as a message from the creators, who speak to readers about the comic book they are holding in their hands. The sinister tone of Doctor Doom's speech is visualized through the speech balloon's blue background. In opposition to the editorial announcement only grasped by the reader, the content of the speech balloon is meant to be heard in the fictional universe (by the characters) and read outside of the storyworld (by the reader), which suggests a subtle transition from diegetic to storyworld communication.

The cover recalls previous events from another series, creating the foundation for the increasing interconnection of different Marvel con-

tinuities into one company universe. Appealing to the readers' rec-ollection of stories like "Prisoners of Doctor Doom" (*Fantastic Four* #5, 7/1962) and "The Return of Doctor Doom" (*Fantastic Four* #10, 1/1963), the supervillain exclaims: "If the Fantastic Four themselves could not stop me, what chance have you?" While he addresses the question to Spider-Man, it also warrants an answer from the read-ers, activating their knowledge of previous stories to speculate about the present conflict. The cover further enlists readers in the act of problem-solving, asking them to mobilize a particular horizon of expectations: Spider-Man's hubris as well as his sense of duty, but also Doctor Doom's evil ingenuity, may have gotten the superhero into this situation; his quick thinking, physical prowess, and web-shooters will probably get him out again.

Amazing Spider-Man #5 condenses the central confrontation of the story into a single cover image, but the scene does not appear in the story. It functions as a multilayered message designed to "hook" readers into mentally modeling a storyworld: "We were look-ing for something to hook some new readers," Lee recalled (White 1968, 4). From a diegetic perspective, the scene promises spectacular action and an appealing antagonist. The static nature of the image works like a freeze frame, arresting the action immediately before the impending climax. Doctor Doom is about to electrocute Spider-Man, who is hurtling toward an electrified metal plate. His web-bing has just snapped, motion lines visualize his fall, the tension is heightened through the two temporalities of the image. On the one hand, the image works like a photograph of a single moment, a frac-tion of a second captured by the exposure of the film. On the other hand, Doctor Doom's speech must take several seconds to complete, which slows down Spider-Man's fall, as if he was descending in slow motion. Spider-Man is falling both fast and slow in a "dialectic of exuberant motion and a legible stasis" (Bukatman 2003, 194), suggest-ing the need for a last-minute rescue and perhaps creating an urge in the reader to brace the superhero's fall.[35]

The only way to figure out what will happen is to open the comic and read the story. Yet upon turning the page, readers encounter another paratextual threshold, the opening splash page, in a second step in the immersion process. The splash delivers the dramatic title

35. The cover of *Amazing Spider-Man* #6 (11/1963) creates a similar effect. It shows a head-down Spider-Man about to fall into a well as he is fighting the Lizard.

of the story, "Marked for Destruction by Dr. Doom!," and provides creator credits—"written by . . . Stan Lee / Drawn by . . . S. Ditko / Lettering . . . S. Rosen." The credits are reminders that what readers are about to consume was produced by actual people whose names are written in a cursive font that simulates handwritten signatures, evoking once more the moment of initial graphiation. In addition, the splash carries editorial announcements, including a banner declaring "Spider-Man and the Arch-foe of the Fantastic Four, Face-to-Face for the First Time!" and thus reiterating the intersection of Spider-Man's diegesis with that of the Fantastic Four. Later, Doctor Doom recalls an earlier bout with this superhero team through a flashback that visualizes his recollections and retroactively adds a Ditko-drawn facet to a published Kirby comic—the worlds of Spider-Man and the Fantastic Four merging into a shared universe.

The splash frames the central image of Spider-Man facing off against Doctor Doom with portraits of characters who will become key players in what Hatfield calls Marvel's "huge, looming world" (2012, 153) and what Sean Howe describes as the company's potentially "infinite" universe (2012, 72): newspaper owner J. Jonah Jameson, his secretary Betty Brant, classmates like Flash Thompson and Liz Allan. This portrait gallery enables an easy entry into this world especially for new readers while reminding more knowledgeable followers of the series' four-issue history. Instead of merely taking stock, the gallery introduces another element of suspense, creating wonder about "the other Spider-Man!" shown on the right side of the gallery (it turns out to be Flash Thompson, Spider-Man's biggest fan and Peter's greatest nuisance, who dresses up as the wall-crawler to prank Peter but is captured by Doctor Doom and eventually rescued by Spider-Man). From a less content-oriented perspective, this mysterious double, cropping up as early as the fifth issue of the series, registers the processes of character proliferation to which Spider-Man is indebted and that will shape his future—he will appear as an animated character on ABC by 1967, become a merchandising figure by the mid-1960s, and star in several comic books by the 1970s.[36]

The bottom of the page features an address to the reader by an editor:

36. Ryan and Thon usefully conceive of "storyworlds as representations that transcend media" (2014, 2).

> Have you ever noticed, when you start reading a comic mag, the opening caption tells you that you're about to read the most exciting story ever written . . . with the most dangerous menace, and the most suspenseful plot?? Well, we're going to try to be honest! This may *not* be the greatest story ever written! You may have read about more exciting villains! And you may have thrilled to better plots! But, y'know something? We can't see *how!*

This tongue-in-cheek message displays the faux modesty readers would come to expect from Marvel. Not only does it break the fourth wall; it also launches a discussion about the comic in the pages of this very comic. Text and paratext; fictional world and world off-text; narratorial, authorial, and editorial functions intersect to create the Marvel style.

The story itself begins with media coverage of Jameson's campaign against Spider-Man, with television images of the superhero swinging through the cityscape and Jameson calling him a "public . . . menace." Despite Jameson's gall, which will become a running theme linking stories across issues, the TV program emphasizes the sense of moral uncertainty that has shaped Spider-Man's life from the beginning: "A force for good or evil?" Spider-Man's mistreatment by Jameson's *Daily Bugle* also models a position for the readers, whose identification with Spider-Man, and thus also with Marvel, transforms them into underdogs—"hailed as self-made outsiders and maladjusts to the norms of social acceptability through a rhetoric of alternative belonging" (Fawaz 2016, 79). Switching from the sentimental tone of the ending in issue #9, where Peter and Betty are "each feeling the first pangs of that emotion we call—love!," to a more exuberant register, the announcement underneath the final image promises "more fascinating details about the life and adventures of the world's most amazing teen-ager—Spider-Man—the superhero who could be—you!" Not only is Spider-Man presented as a relatable character—"Please don't change Spider-Man. He seems so human right now. . . . I have the same problem so I feel akin to Spider-Man," Jodene Green Acciavatti writes in a letter printed in *Amazing Spider-Man* #12 (5/1964)—but readers are hailed to believe that they could actually be Spider-Man if they were bitten by a radioactive spider. In terms of world-building, Peter is as important to the narrative as Spider-Man, as readers are promised more information about the character's life and his adventures.

Page 2 of *Amazing Spider-Man* #5 presents Peter as a social outcast among his high school peers who are, ironically, fans of Spider-Man. This torn identity, visualized in the split facial image of Peter/Spider-Man in panel 6, offers an entry point into the fictional world. Only the readers can see the Spider-Man half of Peter's face. This discrepancy between Peter's private problems and his public success as Spider-Man is encapsulated through the frequent use of thought balloons. A few pages later, when Spider-Man "practices his agility with his web, in the privacy of his room," readers are again invited to share the superhero's intimate space. They also get a close-up of Spider-Man operating his webshooters and, later on, witness a "safety check" of his outfit and arsenal: "Plenty of web fluid . . . Spider-Man light beam okay . . . mask on securely. . . ." Detailing the curious physics of Spider-Man's existence as a superhero in an otherwise realistically rendered world, this checklist aids storyworld construction by grounding the action in concrete circumstances.

The world in which the events unfold depends on such depictions and on a limited number of spatial references. A closer look at the first few pages of issue #5 illustrates Ditko's sparse but effective contextualization, suggesting a knack for storyworld construction. The tale begins with an image of Spider-Man flying through the air in an urban environment. As noted, readers encounter this image via the drawn representation of a television screen. They see a mediated version of a superhero whose pursuit by the malicious Jameson not only mobilizes an emotional investment with the hero's plight. Readers are meant to root for Spider-Man, but they are also nudged toward taking a stand for him by the narrative commentary in the second panel, which notes that "the whole world knows of Spider-Man's existence! But the world doesn't know his true identity, or his real motives!" This effect is heightened by the fact that Jameson endorses the exact opposite of Marvel's official editorial policy when he counters Peter's allegation that he is attacking Spider-Man for dubious reasons and rejects Betty's suggestion that he is jealous: "That's enough! I'm still the publisher here, and I'll decide our editorial policy!"

The fourth panel on page 2 of this story reveals the location of the television screen, a "local bowling alley" where Peter and his classmates follow the program. The final panel moves the scene to "another part of town," where Doctor Doom's armor-covered right hand is reaching into the frame. On the following page, details about the supervillain's lair emerge (we also learn that he can fly using a

jet-powered belt), and one page later, we see Spider-Man move from his room through an unmarked cityspace to Doctor Doom's hideout. Within just three pages, Ditko evokes a world that includes public spaces like the bowling alley and the city at large as well as private spaces like Peter's room, where the teenager practices his fighting skills, and Doctor Doom's lab, the locus of his criminal activities. The rest of the story stays within these spatial coordinates, providing further snapshots of the city—a bridge and a harbor suggesting that Spider-Man may be living in New York City—and additional glimpses of Doctor Doom's hideout.[37]

Ditko frequently depicts the superhero's traversal of this environment and his fights with the villain from above, taking the reader up in the air and offering a bird's-eye view unattainable for any onlooker in the diegesis. The reader becomes Spider-Man's invisible companion: deictically shifting into the comic by animating its storyworld to experience the superhero's "costumed extravagance, muscular absurdity, and hyperkineticism" (Bukatman 2003, 189).[38] In the fight scenes, we witness bodies in motion, a sense of speed, agility, and three-dimensionality simulated through the use of motion lines, body postures, and shifting points of view.[39] "Superhero narratives are sagas of propulsion, thrust, and movement through the city" (189), and the perspectives change accordingly, zooming in on details and out to panoramic views of characters and positioning the reader in the middle of the action in shot/reverse-shot fashion, sometimes sharing Spider-Man's and sometimes Doctor Doom's point of view.[40] Doctor Doom whips out weapon after weapon—a spinning machine, heat rays, electric shocks, which Spider-Man calls "kookie gadgets"—making it harder and harder for the wall-crawler to fight him off. Soon, Spider-Man seems outmatched: "Another inch and

37. Early visual hints at New York include the Statue of Liberty in a Spider-Man and Human Torch story in *Strange Tales Annual* #2 (10/1963). The story verbally references "Long Island's South Shore," "Madison Avenue and 63rd Street," and "New York's Bowery."

38. Hatfield speaks of the "kineticism of [Kirby's] style" (2012, 36). Ditko's style may be less physical, but it is no less kinetic. Flanagan suggests that Spider-Man "is placed *within* the city as well as above it" (2012, 43).

39. See Molotiu on Ditko's "sequential dynamism" as "the formal visual energy, created by compositional and other elements internal to each panel and by the layout, that in a comic propels the reader's eye from panel to panel and from page to page, and that imparts a sense of sustained or varied visual rhythms" (2012, 89).

40. On zooming and storyworld construction, see Horstkotte (2015).

I'm done for," he admits, the narrator noting that he is "exerting every last bit of power contained in a super-human body" in hopes of "executing one last maneuver." Both characters are speaking to each other throughout the scene, suggesting multiple temporalities for these images, as speech prolongs the action whereas Spider-Man's lightning-speed movement speeds it up.

In addition, readers become privy to Spider-Man's thinking, as thought balloons reveal his assessment of the ongoing fight. When, earlier in the story, Peter is torn over whether or not to heed his aunt's prohibition to leave the house, he faces the reader directly in a close-up that displays his split facial image, half-Peter/half Spider-Man, followed by the admission, "Some superhero I am! I've got to find some way to get my aunt to let me out of the house!" The discrepancy between the superhero's thoughts—often voiced through "character-driven soliloquies" (Raphael and Spurgeon 2003, 101) or habitual "monologuing" (Bukatman 2009, 121)—and his exterior banter with Doctor Doom once more suggests an interiority shared between character and reader, evoking an inclusive community of knowledgeable insiders in a world of callous antagonists. In combination with the comic's melodrama—Peter's romantic interest in Betty Brant, domestic life with Aunt May, high school conflicts—the building blocks for productive storyworld constructions are all there.

Finally, the comic extends the editorial spiel from the cover to the story. Eleven pages into the adventure, a narrative caption that looks like the message from the editor on the cover of *Amazing Fantasy* #15 declares: "Let's face it! You've struggled through one of the longest introductions you've ever read! But we think you'll find it well worth it, because now the fireworks begin in earnest!" On the next page, another editorial comment: "And now, settle back and prepare to witness the gol-dangest, ding-bustedest, rip-snortin'est super-characters fight you've ever seen!" This meta-commentary culminates in a third comment at the end of the story: "Thanks to your overwhelming response to Peter Parker's off-beat adventures, Spider-Man is now published monthly! Don't be a Johnny-come-lately! Reserve your copy of the sensational issue #6 at your newsdealer now! You won't want to miss the new super-villains, super-adventures, and super-surprises in store for you!" From the acknowledgment of genre conventions (introduction, fireworks, offbeat adventures) and the slangy promise of spectacular action to the superlative-laden advertising of Spider-Man's contents and its publication schedule, this commentary

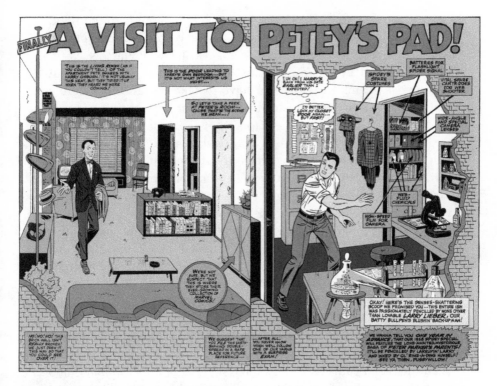

FIGURE 2.8. "A Visit to Petey's Pad." *Spider-Man Annual* #4 (11/1967) © Marvel Comics.

narrows the distance between producers and readers and models an intimate, confidential rapport between "Stan and Steve" and readers like David Coleman, who, in his letter in the same issue, declares that he wants to start a nationwide fan club with "an opinion page, a Spider-Man Fan Club book, and a member sheet."

It may very well have been the relative scarcity of contextual information that made Spider-Man's world intriguing for readers, whose interpretive activities may have been jump-started by the mixture of hints about the setting, editorial verbosity, and Ditko's suggestive style. But Marvel also used the affordances of serial storytelling to reveal more information to "thicken" (Herman 2009, 130) Spider-Man's world. The *Spider-Man Annual* #4 (11/1967) features a double-page spread titled "A Visit to Petey's Pad!" that offers a panoramic view of Peter's apartment and its contents (see figure 2.8).

While Harry Osbourne, Peter's roommate, is standing on the page to the left, occupying a living room that includes a sideboard where "we suspect . . . they store their ever-growing collection of Marvel

comics," according to an editorial note, Peter's room is to the right. It reveals his gear and gadgets with more yellow-boxed captions. Another comment at the bottom "suggests[s] you file this earth-shaking spread in a safe place for future reference," joking about "a surprise exam!" readers may have to take but also insinuating that the layout and contents of the apartment are fixed elements of Spider-Man's world that, once displayed, will impact future stories as well as readers' mentally modeled storyworlds. Moreover, the depiction plays with the tension between private and public, diegesis and metaverse, when the editorial voice on the bottom of the left page exclaims: "This brick wall isn't really broken! We just drew it this way so that you could see over it!" Another metaleptic comment further conflates extratextual with diegetic space: "It's not usually this neat, but they tidied it up when they heard we were coming."

The next *Spider-Man Annual* (#5, 11/1968) even carries a map of the storyworld in a segment called "Where It's At," featuring "a slightly garbled guide to help you locate some of Spidey's most familiar havens and haunts": the Coffee Bean, the *Daily Bugle*, Empire State University (ESU), his city apartment, his boyhood home, and so forth. About a decade later, *Annual* #13 (11/1979) offered another glimpse at "Peter Parker's Pad!" as well as interior shots of the *Daily Bugle* and an exterior shot of Empire State University. These "Mighty Marvel bonus page[s]" are presented as responses to reader requests: "Everybody in the world seems to be writing to us, demanding that we present the never-before published schematic on all of Peter Parker's hangouts," an editorial statement claims. "As Pete's horizons expand, so does his supporting cast. Here are just some of the folks you'll be getting acquainted with in the months to come!" reads a caption at the bottom of the ESU page. These are prime examples of world-building as described by Mark J. P. Wolf: "For works in which world-building occurs, there may be a wealth of details and events (or mere mentions of them) which do not advance the story but which provide background richness and verisimilitude to the imaginary world" (2012, 2). The view of Peter's apartment may not have much significance for the ongoing plot, but it gives Spider-Man's world fuller texture. "Sometimes this material even appears outside of the story itself, in the form of appendices, maps, timelines, glossaries of invented languages, and so forth" (2), Wolf adds, which is true for the "slightly garbled guide" orienting readers in Spider-Man's world. Finally, the *Annual* itself represents material that stands outside of

the serial continuity, includes "making of" elements (Wolf 2012, 223), and generally "encourages an encyclopedic impulse in both readers and writers" (Jenkins 2007, n. pag.).

Within a few years, Marvel instituted a new forum for highlighting the making of the comics and playing with the encyclopedic impulse: the Bullpen Bulletins, a section in each comic that informed readers about upcoming titles and fictionalized the Marvel bullpen as the locus of comics creation. The bullpen presented a collective author figuration by stabilizing the unstable—hasty, hectic, haphazard—production process that was evoked again and again in paratextual and epitextual statements, such as when Lee explained in an interview: "We have trouble just keeping our balance and meeting all our deadlines. It's a mad scramble. . . . It's just panic all day long. We don't know from day to day what we're gonna do tomorrow. It's just whatever hits us" (Bourne 1970, 102). This enabled readers to picture original scenes of graphic enunciation: the place where writers and artists were producing the comics. It projected an imagined space of interaction between official producers and readers of these comics, offering an escape from the two-dimensional, sequentially structured and serially segmented storylines into a wider network of interaction "from one Marvel Madman to another," as the bulletin in *Amazing Spider-Man* #32 (1/1966) declared. "Imagine this voice, in this intimate medium, . . . adding narratively unnecessary but fun-as-hell verbiage and wordplay—extending your time reading the comic, so also adding to its value as entertainment time purchased," Danny Fingeroth observes (2019, 141).

The bullpen became part of the larger Marvel metaverse by connecting the storyworlds evoked in and across individual series with the off-text world. This outside world included newspaper coverage like Nat Freedland's "Super Heroes with Super Problems" in the Sunday Magazine section of the *New York Herald Tribune* (January 9, 1966), which opens with Lee's directions to "production man" Sol Brodsky and ends with a contrived dramatization of a "summit meeting" with "veteran comic book artist" Jack Kirby, in which Lee acts out a new Silver Surfer story for Kirby (n. pag.).[41] As soon as Marvel began to credit inkers and letterers (first in *The Fantastic Four* #9, 12/1962), a cast of bullpen characters emerged. Following verbal ref-

41. When Kirby was asked in 1986 to recall the "legendary story conferences" with Stan Lee "jumping up on the desks and so forth," he replied: "It wasn't like that at all" (qtd. in Fingeroth 2019, 284).

erences to the bullpen were visual depictions of Marvel's staff. Under the banner "Meet the Gang in the Merry Marvel Bullpen," the *Marvel Tales Annual* #1 (1/1964) displayed a photo spread of bullpen staffers from publisher and "guardian angel Merry MARTY GOODMAN" and "writer/editor [and] bullpen boss Smilin' STAN LEE" to "corresponding Secy. [and] Gal Friday Fabulous FLO STEINBERG." A few years later, the *Fantastic Four Annual* #7 (11/1969) ran another series of photographs of employees and added in comic lettering: "Because You Demanded It! Here's a veritable rogues' gallery of candid photos, featuring just about everybody in the whole blamed bullpen!" As in the *Marvel Tales Annual,* the employees have nicknames that capture their role in the production process and their relationship with their characters while playfully painting the overwhelmingly male creators as heroes: Lee is "Marvel's Madcap Monarch," Neal Adams is "X-Men Artist X-Traordinary," Sal Buscema is "Honorary Avenger," Marie Severin is "Our Princess of Pencilling."[42] Marvel's comics may be beholden to a model of labor division and dispersed production, as Lee acknowledged many times, but the bullpen affords this model with a veneer of familiarity and intimacy. "Who were the people who actually created and produced America's comics books?" (1974, 14), Lee asks in *Origins of Marvel Comics.* "Comics have always been primarily a piecework business. . . . The more pages you could grind out, the more money you made. . . . [T]here were no royalty payments at the end of the road . . . no residuals . . . no copyright ownership" (14). Still, these comics are celebrated as the outcome of an organic process of creative collaboration where acts of inspired innovation are the norm. As Lee described Marvel's "hip familiarity" in his autobiography: "I wanted to give our fans personal stuff, make them feel they were part of Marvel" (Lee and Mair 2002, 150).[43] In an earlier conversation, he noted: "We tried to bring the readers into the whole Marvel world with us so they weren't just fans. They were friends. I tried to talk to the readers as if I was sitting right with them and they were sharing the excitement with me" (Pitts 1981, 89).[44]

The bullpen enabled readers to imagine this workspace as a storyworld with concrete settings, specific characters, and expanding

42. Out of the forty-one portrayed employees, only five are women.

43. I take the phrase "hip familiarity" from Jacobs and Jones (1985, 70).

44. Fawaz discerns "a kinship of strangers and intimates that mirrored the ever expanding familial bonds of the characters . . . (and the real-world associations among Marvel staffers)" (2016, 98).

storylines, all of which are evoked in the Bullpen Bulletins and by appearances of bullpen members as characters in some of Marvel's most popular series. Lee and Kirby, for instance, make a short appearance in *The Fantastic Four* #10 (1/1963), and they get full exposure in *What If the Original Marvel Bullpen Had Become the Fantastic Four?* #11 (10/1978). This is another example of the incitement to turn fictional universes into storyworlds that feed into a larger metaverse of comic book production and reception, the "world of Marvel" where identification with the "House of Ideas" is tied to original scenes of graphic enunciation. That many artists worked from home and that the bullpen was a myth that downplayed the conflicts over creator credits and ownership rights does not erase its significance for the extension of the readers' storyworld immersion into an interactive mode of engaging with the comics and their creators. From an evolutionary perspective, Kirby's and Ditko's criticisms of Lee's role at Marvel, with Kirby alleging "it was a caste system, pure and simple" (qtd. in Sadowski 2002, 123), and the conflict over Marvel's refusal to return Kirby's original artwork (Beaty 2012, 88–91), are significant because they underscore central authorization conflicts in the genre and mark important changes in the discourse about these conflicts.[45]

Lee once claimed that he "began to feel I wasn't even the editor; I was just following orders" (1974, 73) when fan mail began to appear. He credits many of the comics' improvements to letter writers who sent story suggestions and details, alleging that the letters indicated "that there were actually real live readers out there . . . [who] . . . wanted to talk to us about our characters, about our stories" (73). But according to the first installment of "The Merry Marvel Bullpen Page" in *Amazing Spider-Man* #27 (8/1965), these readers should primarily buy merchandise. The page is essentially one big advertisement for a Spider-Man T-shirt. It is covered with captions whose visual appearance recalls the editorial comments from the stories and whose rhetoric replicates the paratextual self-appraisals readers would have known from covers, opening pages, and letter pages (and mentions twenty-five members of the M. M. M. S. fan club as a gesture of public recognition, acknowledging these followers in the pages of the comic book). The T-shirt is pitched as Spider-Man's

45. *The Comics Journal* published special issues on Kirby (#167, 4/1994) and Lee (#181, 10/1995) that address these conflicts. See also George (2002); Howe (2012). John Romita recalls "getting probably two out of every five stories I ever did" back from Marvel (Thomas and Amash 2007, 48).

physical extension into the readers' personal space: "Just wait'll you slip into these snug-fitting, brightly colored, guaranteed T-shirts . . . you'll be a sensation." In the same way that Peter turns from bookworm to superhero whenever he slips on his costume, wearers of this shirt will feel "spectacular." This physical immersion in the world of the comic was accompanied by an arguably less spectacular sense of physical interaction with the comic book. Readers had to cut out a coupon and send it to Marvel to receive the shirt (or, as was suggested later on, send a copy of the coupon if they wanted to preserve the page).

If wearing their fandom (J. A. Brown 2012) brought Marvel followers closer to the character in physical terms, the "The Secrets of Spider-Man" segment in *Spider-Man Annual* #1 (11/1964) presents "inside facts about Spidey's powers, his problems, and his personal life." This *Annual* revisits the superhero's origin story and explains elements established in Spider-Man's still short serial past: "Spidey's Spider Senses!"; "The Secret of Spider-Man's Mask"; "Spidey's Costume"; "Peter Parker's Favorite Heel and Heart-Throb." Once taken out of the comic and pinned up on the wall, the poster of "Peter Parker as Spider-Man" (its Spider-Man signature echoing Lee's and Ditko's signatures on the opening splash of *Amazing Fantasy* #15) will become part of the reader's real-world environment. Striking about these features is the ironic self-consciousness with which they are presented as historically relevant items, simultaneously taunting and flaunting the dominant high/low distinctions of the time. *Annual* #4 (11/1967) includes a double-page spread of "The Coffee Bean Barn," the place that serves as "the unofficial cultural center of ol' E. S. U.," and appends a

Special Note for Future Historians: The unvarnished explanation for why we included yon seemingly unrelated double-page spread in this never-to-be-forgotten issue is: while working on the rest of the mag, we began to develop a king-sized thirst, and kept wishing we had some cups of java! Well, one thing led to another, until . . . here we are . . . gulpin' with the gang!"

These *Annuals* and the serial continuities they annotate encouraged readers to "develop . . . a very detailed encyclopedia of costumes and visual attributes, an iconography that provides shortcuts into [their] knowledge structures" (Kukkonen 2010, 42). More important, how-

ever, was the alleged closeness among the Marvel staff, the readers, and the characters insinuated in the special note: the sense that they could all be hanging out at the Coffee Bean Barn.

Marvel's Hip Metaverse

Marvel's ability to simulate nonhierarchical communication with readers established the basis for the collective production of the company's metaverse, which emerged once paratextual and epitextual projections of the world of Marvel subsumed individual storyworld constructions into a broader sense of communal belonging. I understand the metaverse as a collective that shares a common sense of style, conceived as a continuum from specific elements of graphic storytelling to an overarching state of mind.

The storyworld constructions and world-building practices that shaped Marvel comics from the 1960s onward evolved into a metaverse connecting immersive reading experiences with heightened forms of interaction. A drawing by Marie Severin that accompanies Chris Claremont's editorial in *Foom* #13 (3/1976) captures this sense of immersive interaction (see figure 2.9). The image shows Daredevil swinging through the air in front of two houses and evokes a sense of perceptual depth as the blind superhero is in the foreground and the houses are in the background. In addition to these two spatial layers, in front of Daredevil, also in midair, is a writer scribbling on his notepad, with a worried look on his face as Daredevil has grabbed him by the neck and carries him along through the air, perhaps because the action is slipping away from him, the joke being that the pace of authorial creation is outmatched by the demand for stories. While Daredevil's body is aimed toward the left-hand side of the image, indicated by the motion lines, which implies that he is swinging through the image but will stay within the diegesis, the writer's body (and thus also his flight pattern) is directed more toward, but not directly at, us and thus aimed outside of the diegesis into the real-world space beyond the page. Moreover, the writer's pen and pad overlay a tiny portion of Daredevil's body, suggesting a location on a spatial layer even closer to the reader's off-text world. Now we have three layers: the houses in the background, Daredevil in the remote middle ground, and the writer in the close middle ground. The image is completed by what seems to be another rendition of the writer—

FIGURE 2.9. Untitled drawing. Marie Severin. *Foom* #13 (3/1976) © Marvel Comics.

perhaps Chris Claremont, who had worked on Daredevil, the pencil now stuck behind his ear—looking at the scene from outside of its frame. He is located at the right-hand side of the image and thus on the fourth spatial layer, the foreground of the image.[46]

The scene at which this author is gazing is situated within a particular kind of frame: a window, with blinds on top and a pane at the bottom. This recalls Kukkonen's notion of the comics panel as a window, which suggests that the metalepses inscribed into this image may simulate a "transgression of the boundary between the fictional and the real world" (2011, 216). "The real world is . . . shown to intervene with the fictional world when conventions of representation, such as the drawing style, are brought to the fore" (214). Accordingly, panels function "as windows into the fictional world" (215), and "the 'real' world in comics is either the location of the author and the readers on the other side of the imagined window pane which is the surface of the comics page or it is represented in the space between the panel images" (217).[47] But this particular scene shows a window within a panel bordered by a black line surrounding the image as a whole, and thus a window-within-a-window (and in front of houses full of windows). While Daredevil is depicted in the conventional Marvel style (minus the coloring, as *FOOM* was a

46. On spatial construction in comics, see Lefèvre (2006).
47. See also Greg Smith's distinctions among panel, frame, and window (2015).

black-and-white publication), the writer outside of the window and the writer inside are rendered in a similar, though not identical style. They seem to share the same ontological world, but since the outside writer is rendered more realistically, we may surmise that he has imaginatively transported himself into the image beyond the window to report on Daredevil's doings.

The proliferation of spatial layers in this image visualizes the movement from fictional world to storyworld to metaverse. For one, it implies that Daredevil is a character but that he is acting on his own or, rather, is always on the verge of escaping the creator, an apt metaphor for the tendency of serial popular figures to elude authorial and otherwise institutionalized forms of control. It also suggests that Daredevil is acting in a comic book world imagined by his creators, who must immerse themselves in this world to follow his exploits. This recalls the permeability of text and paratext, only that here the threshold is the window screen that supposedly separates the world of the creator (connoted as real: as the place where things are made) from the world of the character (were the made things appear). Second, the image places viewers in an ambiguous space, positioning them in the room with the writer and sharing his glance through the window. They are, however, situated on a slightly higher level than the outside writer, not directly looking over his shoulder (and thus not sharing the same view) but looking both at the writer and through the window. Viewers are therefore both outside of the panel (and thus not in the room, though privy to some of its content) and separated from the action on the other side of the window. Being twice removed from the action affords an encyclopedic perspective that includes the comic book content and the process of comics creation, extending the "illusion of a penetrable space" (Ryan 2001, 3) to fold the reader into the metareferential frame. The fifth layer of the image is the flat material surface of the page itself, where all other layers are evoked and which constitutes its own ontological plane, identifying *FOOM* as a window into the workings at Marvel Comics where, according to Jim Steranko's editorial "Once upon a Foom" in issue #1 (2/1973), the Marvel staff are "comic fans ourselves" and where the fans "will have a hand in shaping the future of the Comic Marvel Age."

The metaphor of the window proves particularly productive for thinking about these complex processes. Silvio maintains that panel frames make for a reading experience that resembles the act of looking through a window. "If an individual novel functions as

a complete alternate world within which the reader can lose him or herself," he writes,

> then a comic book's function is more that of window or aperture through which the reader selectively views and orders the hetero-cosm. . . . Like the voyeur, the comic book reader stands somewhat outside the scene under observation, yet is still implicated within it, in a position that aspires to power. He or she is not a passive receiver of the story, but an active creator of it. Because there is no absolute or permanently set order in which the Marvel Universe's composite narratives must be experienced, the reader is free to con-trol and shape the text-world by selecting which narratives will be followed and in what sequence. (1995, 46)

These observations evoke Severin's image and, as such, under-score the intersection of immersion and interaction. Voyeurs almost immerse themselves in a storyworld, watching people and actions from a safe space that is not part of, but is located close to, the pri-vate world they are watching. But they also interact with this world by creating mental models that elaborate on the limited information their gaze provides.

Yet selecting narratives and shaping reading sequences fall short of what Silvio calls the "process of repositioning the reader as co-producer" of the text (1995, 46). This necessitates a shift from story-world constructions to the metaverse. It is true that readers depend, at least to some degree, on "the text-world [to] reassert its author-ity. Not only does this authority manifest . . . itself by presenting the reader with fixed linkages within the narrative web, the text's coer-cion of the reader to follow multiple titles serves to undermine the autonomy engendered by the text." But instead of merely creating a "comic heterocosm [that] requires its readers to follow multiple titles because . . . each new title read expands the diegetic space within which the reader operates" (48), the text world is always already an interactive world marked by porous boundaries between text, para-text, and epitext that enable the readers' transformation from voyeurs into active agents in the Marvel metaverse.

When the boundaries between Spider-Man's diegetic world, the storyworlds modeled by authors and readers, and the world off-text dissolve, this metaverse becomes a shared space of immersion and interaction. It would be too simple, therefore, to suggest that Marvel's stories are immersive and that the paratexts and epitexts

provide space for interaction. While it is not necessarily wrong to distinguish between "the text [as] a 'world'" (immersion) and "the text as a game" (interaction) (Ryan 2001, 16), Marvel's fictional worlds offer immersive reading experiences as much as they afford an interactive relationship with the text, while the metaverse conjoins these practices into interactive forms of immersion. The no-prizes Marvel awarded readers if they spotted mistakes in the stories combined the need for immersion in the accumulating storyworld—how else could one recognize inconsistencies or contradictions?—with a playful attitude toward comic book storytelling as a game, where publicly pointing out mistakes allowed readers to "assert their own mastery over Marvel producers and compete with one another" (Yockey 2017, 11). As early as *Fantastic Four* #4 (5/1962), Lee offered readers rewards if they could explain away mistakes (Yockey 2017, 11). Marvel upped the ante in the 1970s, when *FOOM* included adventure board games, crosswords, word searches, word pyramid puzzles, and trivia questions but also solicited readers in issue #1 to submit their concepts for a superhero or supervillain, the best of which would be reprinted in upcoming issues.

The *Marvelmania* fan club magazine, edited by Mark Evanier and Steve Sherman, had already pulled punches to offer readers an interactive immersion experience: what the editorial in *FOOM* #1 calls being "infected with the tempestuous FOOM Bug" (2/1973, 2). This included an introductory note in *Marvelmania* #1 (4/1970) that carried the voice and rhetorical style of the letter pages and bulletins into the prozine and offered "members who have shown an interest in the club, above and beyond mere mortal membership," to join a "Special Advisory Board for future MARVELMANIA projects." An advertisement for a bullpen foto kit ("You asked for it!" / "start your collection now") and a "Meet the Marvelmania Madmen" column with biographies of Marvel staff are matched by a "Marvelmaniac of the Month" segment celebrating a particularly loyal fan each month. In issue #6 (1/1971), *Marvelmania* became even more self-referential when the editorial characterized the magazine as "a halfway house between prodom and fandom. Not only in printing works of both, but in being a forum for fan opinion," a statement that is followed by a "Behind the Scenes at Marvelmania" article that documents the production of the magazine.

How to Draw Comics the Marvel Way (1978) by Stan Lee and John Buscema is the logical consequence of such labored storyworld making and metaverse construction, as it motivates—readers to try their

own hands at drawing Marvel-style comics. It not only narrowed the gap between professional artists and amateurs but allowed readers to imagine themselves reexperiencing moments of initial graphiation in a double sense: in terms of their own activities as budding artists and in terms of retracing—and thereby personally animating—lines previously drawn by the acclaimed John Buscema, who used "artwork from Marvel comics as primary examples" (back cover) to illustrate Lee's narration.[48] The tongue-in-cheek "pandemonious puffery from the publisher" on the back cover advertises the book as "an encyclopedia of information for creating your own superhero comic strips" and claims that it "belongs in the library of every kid who has ever wanted to illustrate his own comic strip." The book breaks down the composition of typical Marvel panels, introduces readers to the terminology and drawing techniques necessary to execute a superhero comic, and provides blueprint sketches that readers can use to draw their own Spider-Man story and cover design. Readers are invited not only to imagine themselves but actually to become the type of comics artist depicted on the book cover, where many of Marvel's most popular characters (Captain America, the Thing, Thor, the Hulk, Spider-Man, Dr. Strange, Doctor Doom) gather around a pencil sketch of Spider-Man on a drawing board, watching a creator at work. We only see the creator's hand, but the perspective of the image places the viewer in the position of the artist, visualizing the attractive premise of the book: that they may become comics artists and that Lee and Buscema are there to help them master the Marvel style. They are positioned as professionals in the making, as the kind of "apprentice pro" the young Jules Feiffer imagined when he studied the styles of Kane and Shuster (1965, 12).[49]

48. The later *Official Marvel Comics Try-Out Book* (Shooter and Romita 1983) walks readers through the various aspects of comics creation (coloring, inking, scripting, plotting, penciling), challenges them to "prove yourself under simulated 'combat conditions'—as close as possible to actual, professional working conditions," and encourages them to submit their work, as Jim Shooter's foreword explains. Lee's *Secrets behind the Comics* (1947) prefigures such publications as it "revealed such insider details as how to recognize an artist's style . . . and included several blank pages that comic-book wannabes could use to draw their own stories" (Raphael and Spurgeon 2003, 33–34). Writing guides by industry professionals include O'Neil (2001); Moore (2008).

49. The book identifies its audience as "everyone who's ever thrilled to the sight of a dazzling drawing and longed to be able to copy it, or better still, to create an

But style in the Marvel metaverse entails more than graphic design. As Ralph Gershovich writes in a letter printed in *Amazing Spider-Man* #6 (11/1963):

> I find your comic simply perfect. . . . I don't mean your stories are all perfect—I mean your style is perfect. First of all, I like the idea of your letter column being at the end of the story, not in the middle. I like the idea of Spider-Man being a teenager. . . . I like the idea of his costume being completely different with not one thing being a take-off from some other hero. Last, but not least, I like his personal style which is his alone. I very seldom write to a comic but I couldn't resist this letter because of all of the perfectly original ideas you have come up with.

Gershovich locates style neither exclusively on a story level nor on the level of graphic enunciation. In his storyworld, style incorporates the whole material artifact: the character and look of the hero, as well as the overall structure of the comic book, with no hierarchical distinction between text and paratext. Moreover, the letter delineates Gershovich's transformation from appreciative reader ("I like") to critical commentator who writes more than one letter ("I very seldom write") because the comics make him act ("I couldn't resist"). Interestingly, Gershovich buys into Marvel's discourse of originality, replacing Marvel's legitimization of Spider-Man as "just a bit different" with a reference to the "completely different" costume.

The success of comics like *Amazing Spider-Man* depended on their ability to evoke in readers a relatively concrete understanding of what the moment of original graphic enunciation may have looked like, regardless of how close this understanding was to the realities of this moment or to its publicly promoted image. In Gershovich's letter, this is highlighted by a personal attribution of Spider-Man's originality to Lee and Ditko—*your* comic, *your* stories, *your* style, *your* letter columns—matched by the reader's equally persistent reference to his own role in Marvel's storytelling—*I* find, *I* don't mean, *I* mean, *I* like, *I* write, *I* couldn't resist. What we see here is a kind of "fan-based community-building" (Pustz 2007, 163) where all participants share a common sense of purpose. "It is wrong to think of the Marvel

original! In short, to everyone and anyone who's ever wanted to be—a comic-book artist" (Lee and Buscema 1978, 5).

Universe as somewhere else, somewhere governed by different rules, different causes and effects," Dwight Halberstam wrote in 1984. "The Marvel universe is OUR universe. Those heroes live HERE, on OUR earth. It is OUR lives they protect, our values they represent" (qtd. in Pustz 2007, 168). A decade earlier, the editors of *Amazing Adventures* had already assured the readers of issue #25 (7/1974): "It's a great honor to become a part of your world" (qtd. in Pustz 2007, 172). Such affirmations of imaginative transfer and shared worlds are not surprising once we realize that they had long been authorized by the comics, which modeled a fictional universe for creators and readers alike that resembled their real-life interactions. "Marvel Universe Looks Almost Like a Real Social Network," one study of collaboration in Marvel's storylines finds (Alberich, Miro-Julia, and Rosselló 2002); the "discursive community" fostered by the letter pages modeled "rudimentary social networks" among readers, Gordon notes accordingly (2012, 120).

It would be easy to romanticize this sense of community and the sense of identification with a larger collective that M. M. M. S. stickers with slogans such as "I Belong" promoted.[50] It would be equally easy to classify the Marvel metaverse as merely a clever means of marketing the company's products. After all, Lee talked openly about the commercial incentives behind his editorial decisions: "We need those sales," he stated during a discussion at Vanderbilt University. "If something can make money for Marvel Comics, it is good. What's good for Marvel Comics is good for . . . Stan Lee's country" (Vanderbilt 1972, 34–35). A few years earlier, he had explained the rationale behind the nicknames of Marvel staff to radio host Mike Hodel: "We sort of think of the whole thing as one big advertising campaign, with slogans, mottos, and catch phrases, and things the reader can identify with. And besides just presenting stories, we try to make the reader think he's part of an 'in' group" (1967, 164). M. M. M. S. catch phrases like "Make Mine Marvel" are as much an expression of consumer choice as they are publicly declared affiliations with a

50. For some scholars, the urge to belong extends to their involvement in comics studies. See Jenkins: "We want a homeland where comics geeks of all disciplines can come together—perhaps a return to the treehouse where we used to talk about the latest comics with our buddies, or perhaps something which is one part local comics shop and one part university bookstore, where our conversations can go up a notch from the usual debate about whether the Hulk can beat up the Thing" (2012, 2). For a critical assessment, see Singer (2018, 5–7).

certain lifestyle. Consuming Marvel comics and participating in the metaverse was a commercial act as well as an act of personal identification. Becoming a "dyed-in-the-wool Marvelite" meant spending money on the company's products, but the metaverse ensured that the investment could be perceived as a personally, communally, and culturally significant act.

Marvel's commercial exceptionalism is the comic book version of the "new aesthetic of consuming" and "advertising style" Thomas Frank describes as a particular kind of 1960s "hip consumerism" (1997, 68, 95, 121). Frank interprets this new type of consumerism as the response to the widespread "revulsion from artificiality and packaged pleasure" (54) that "recognize[d] the alienation, boredom, and disgust engendered by the demands of modern consumer society, but . . . [made] of those sentiments powerful imperatives of brand loyalty and accelerated consumption" (231). This "hip style was fully established by 1965" and suggested that "the solution to the problems of consumer society was—more consuming" (133, 55). If the comic books of a previous generation in the early 1940s had connected the act of buying *Captain America* comics and enlisting as one of the Sentinels of Liberty with being a good "consumer-citizen" (Yockey 2017, 8) and "loyal believer in Americanism" gung-ho on joining "the gallant crusade against the spies and traitors who attempt treason against our nation," as an advertisement from *Captain America* #5 (8/1941) proclaimed, hip consumerism transformed the consumers' allegiance to the nation to a company pledge, where they became "true believers" in the Marvel style (Yockey 2017, 8, 14).

Considering Lee's self-professed interest in advertising, it is not surprising that the Marvel metaverse represented the epitome of hip consumerism. "I love writing advertising copy," Lee confessed to David Anthony Kraft (1977, 68); "as much as I may have contributed to Marvel's success with any stories, editing, or creating characters, I think equally as valuable was the advertising, promotion, publicity, and huckstering that I did," he told Roy Thomas (1998, 149).[51] Part of the attractiveness of the world of Marvel was its compatibility with a shift in American consumer culture that encapsulated the comics industry and made Marvel's self-proclaimed Otherness hardly rad-

51. Lee appears as a Barnum-type huckster on the cover of *The Comics Journal* ("A Circus of Celebration/A Carnival of Criticism," #181, 10/1995). He referred to himself as a huckster in several "Soapbox" columns (10/1977, 5/1978, 8/1979, 9/1979, 12/1979).

ical. This shift also raises questions about who or what was acting when Marvel introduced its advertising style—visionary individuals, as popular lore would suggest, or an assemblage of mediators that included the logic of capitalism and a new style in American advertising?

This new style was couched in a sense of "commercial antinomianism," a kind of "anti-advertising" that saw consumers as "canny beings capable of seeing through the great heaps of puffery cranked out by Madison Avenue" (Frank 1997, 56, 55, 63). Marvel, of course, was no stranger to self-serving ironic puffery, as the reference on the back cover of *How to Draw Comics the Marvel Way* to the "pandemonious puffery from the publisher" indicates. The Marvel discourse was indeed shaped by a "self-effacing . . . style" peppered with "faux-confess[ions]" (Frank 1997, 69). Consider how the special announcements section of *Amazing Spider-Man* #19 (12/1964) commented on the introduction of a new supervillain (The Scorpion): "We'll also have enough surprises, complications, and bonehead mistakes to satisfy those of you who just don't dig Scorpions." Note also the editor's faux confession at the end of *Amazing Spider-Man* #7 (12/1963): "We admit it! This isn't a typical ending for a typical super-hero tale! But, we've never claimed that Spider-Man was a typical super-hero! In fact, next issue, he does some very untypical things!" The opening splash of "Once upon a Time, There Was a Robot . . . !" in issue #37 (6/1966) declares: "We hate to brag, but . . . this one's a doozy!"

The resonances between the advertisements Frank discusses as expressions of hip consumerism and the Marvel rhetoric are remarkable. The line "Who says a good newspaper has to be dull?" from a *New York Herald Tribune* television campaign in the mid-1960s (Frank 1997, 86) predates the byline of Marvel's first parody series, *Not Brand Echh* (1967–1969), "Who Says A Comic Book Has To Be Good?" The oxymoronic declaration "This car is for people who don't like cars" from a 1964 Volvo advertisement (Frank 1997, 147) anticipates Marvel's pitch that *Sgt. Fury and His Howling Commandos* (1963–1981) was "the war mag for people who hate war mags" (*Amazing Spider-Man* #24, 5/1965) as well as the advertising of *Not Brand Echh* #1 (8/1967) as "The Comic Magazine for Non-Believers Who Hate Comic Magazines!" The fake contest included in an ad for Booth's House of Lords Gin in 1966—"I hate conformity because _____. . . . [F]ill in the blank spaces and we won't send you this Booth's House of Lords

'Protest' tie. . . . All comments will be totally ignored. Not a chance of winning anything" (Frank 1997, 139)—reads like it was directly inspired by Marvel's no-prizes.

But this is not all. What unfolded in the 1960s as an encounter between Coca-Cola and Pepsi known as the "cola wars," with Coca-Cola seeing its "near-universal hegemony" challenged "by an ad campaign that made skillful use of the subversive, anarchic power of the carnivalesque and of the imagery of youth rebellion" and that offered "a vision of its consumers as impudent insurrectionaries, sassy upstarts flouting the dull, repressive mores of the past" (Frank 1997, 169), found its counterpart in Marvel's self-positioning against market leader DC. "Have you noticed the way Brands X, Y, and Z have been knocking themselves out trying to imitate the now-famous Marvel style? All of a sudden, we find watered-down versions of our own pulsating plots and devastating dialogue all over the place," the bulletin page asked in *Amazing Spider-Man* #34 (3/1966) in an effort to establish Marvel as a trendsetting, hip underdog. Three issues later (#37, 6/1966), the editors wrote:

> We don't resent competition—indeed, we welcome it. But, we DO resent shabby, carelessly-produced, badly-written and -drawn, conscienceless IMITATIONS of our Marvel mags—imitations which are callously lacking in quality, and which are produced for the sole purpose of making a fast profit in the very field which they themselves are helping to keep at the bottom of the artistic totem pole! We have been flooded with indignant letters from readers who have bought issues of the various Brand Echhs now on sale and have been shocked at the undisguised effort these opportunists have made to confuse the public into believing that their titles are the same as Marvel's!

Such statements are exercises in group formation as they delineate the limes between Marvel and other publishers. They convey a sense of maturity, emphasizing Marvel's creativity and artistic quality and accusing others of commercialism. The editor is writing from a position of power, suggesting that Marvel is making the most original, trendsetting, and relevant comics, part of their appeal being their carnivalesque style and impudent rhetoric. As Lee writes about "the ever-continuing Marvel-Brand Echh rivalry" in his November 1967

"Soapbox" column: "Let them continue catering to the bubblegum brigade. . . . The public needs SOME sort of pablum till it's grown up to Marvel!" (Cunningham 2009, 8).

Rather than determine whether the advertisements Frank discusses influenced the Marvel discourse or whether this discourse shaped these advertisements, it is more productive to acknowledge the "uncertainty about the origin of [the] action" (Latour 2005, 46) these resonances create. At the very least, they should help us embed Marvel's achievements of the 1960s more thoroughly in the aesthetics and practices of postindustrial consumption. A Buick ad from 1967, for instance, championed the wishes of the consumers in ways that any Marvel reader at the time would have easily recognized: "Now we're talking your language. . . . [W]e gave [the new model] a whole new look simply because we believe you want a car like this." Three years later, Buick presented "the cars you've been asking us to make" (Frank 1997, 151). In conjunction with celebrations of the consumer's creativity—Polaroid's "express yourself" (1969) and Tappan's "Suddenly you're not just cooking. You're creating!" (1968) (Frank 1997, 137, 138)—these advertisements extended a participatory and egalitarian promise, a form of "consumer populism," that "turn[ed] public skepticism into brand loyalty" (Frank 1997, 70, 72) and that Marvel had offered their readers since the early 1960s.

Conclusion

Asked about the careers of Marvel's characters, Lee responded: "These things aren't always planned. They grow. . . . [T]hey evolved" (Hodel 1967, 166). The following year, he told Ted White: "It's a little difficult . . . to stay with a definite theory for each [comic] book . . . because we're always in a state of flux" (1968, 13). One way to make sense of this evolutionary flux is to view it negatively as a consequence of the "the tyranny of the serial" that Jason Dittmer associates with a "fundamental conservatism" in the superhero genre, where plots and characters must vary but where serial continuity makes true change unlikely (2007, 253). Another way would be to see this flux positively by emphasizing the superhero's seriality as an asset along the lines of Fawaz's notion of the superhero's fluxability (2016, 11). Fawaz discerns a radical imagination in and around Marvel comics that stems from collective world-making practices and counter-

narratives that "facilitate a space of public debate where dissenting voices can reshape the production and circulation of culture and, in turn, publicize counternarratives to dominant ideologies" (14). "A Marvel comic is the magazine for everybody—every character is equal. A villain or hero can be any race or creed," Tom Salazar noted in a letter printed in *Amazing Spider-Man* #42 (11/1966), which sounds like a fairly progressive statement at the height of the civil rights movement.[52] But the answer to the letter misses the opportunity to comment on the political context, and the "Birth of a Superhero" story that precedes the letter column introduces Mary Jane Watson as a new, and phenotypically safe, love interest for Peter. In that sense, Marvel's "imaginative worlds" did not always deliver the basis for "an affective counterpublic" emerging from the interdependencies of "open-ended political projects" and "open-ended serialized narratives" (Fawaz 2016: 14, 19, 15, 18).[53]

As this chapter has shown, both of these readings of the superhero—as a conservative figure suffering from the tyranny of the serial and as a fluxible figure of the radical imagination—are possible. In the 1960s, Marvel avoided taking strong positions on controversial political issues, but editors were nonetheless willing to foster debates about the conflicts of the day, and readers certainly commented on them in their letters. What's more, Marvel began to introduce black superheroes, most notably Black Panther (*Fantastic Four* #52, 7/1966), but shied away from using them too overtly as critics of racial discrimination and other forms of marginalization. Viewing these comics as expressions of hip consumerism and noting their entanglement of commercial and stylistic concerns, my analysis complicates both conservative and radical interpretations.

I conclude this chapter with thoughts on Marvel's discourse of "true believers," which invested serial consumption with a higher authority and is not easily classified as conservative or radical. There is certainly no dearth of occasions on which this discourse materi-

52. See also Russell Zoller's letter in issue #48 (5/1967): "I'm from Mississippi and there are many prejudiced people down here, but I'd like to let you know that I'm not one of them. I am not a Mississippian, or a rebel, or a Southerner, but an American, and I'll fight and die for my belief that a man is a man, not matter his race, color, creed, or whatever they come up with next."

53. J. A. Brown develops a related approach to Batman as a "cultural nexus" and "connecting point" for controversies concerning "familial relations, sexuality, ethnic representation, violence and morality" (2019, 2).

alized. References to "true believers" crop up repeatedly in Bull-
pen Bulletins and letter pages in the second half of the 1960s (for
example in *Amazing Spider-Man* #43, 12/1966), along with phrases
like "defender of the faith" (*Amazing Spider-Man* #43, 12/1966) and
"Keeper of the Faith" (*Amazing Spider-Man* #45, 2/1967). Some letters
read like religious conversions—"But I have seen the light and I have
faith" (Russell Zoller, *Amazing Spider-Man* #48, 5/1967); "reconverting
a lost pilgrim, returning him to the religion he had once been a part
of" (George D. Edwards, *Amazing Spider-Man* #36, 5/1966). Particu-
larly striking is a 1973 *FOOM* poster that assembles Marvel's super-
heroes and reached members of the fan club as part of their sign-up
package. Located at the bottom is the club seal with the motto "E
Pluribus Marvel." Surrounding the seal is a statement signed by
Lee: "Thou hath joined Marveldom Assembled! Thy name hath been
inscribed, now and evermore, in the blessed book of FOOM! Come
take thy place, believer, within the hallowed ranks. The eyes of
FOOM are upon thee. . . . Thou hath chosen a creed, a code, a way
of life" (Saffel 2007, 103).[54] The first issue of *Foom* substantiates this
discourse, addressing readers collectively as "Foomdom Assembled"
and extending a sense of belonging, of sanctification even, to those
who have seen the light:

> Greetings, O Seeker of Truth thou hast found thy true Nirvana! Here
> in the hallowed circle thou art truly amongst thy peers—thou art
> truly welcome—thou art truly safe and secure within the fabled, far-
> flung Fellowship of Foom! From this moment on you are no longer
> a lonely wanderer on the twisting treadmill of life. Ever at your side
> stand the rapturous ranks of Foomdom Assembled. Your days have

54. The statement references John Winthrop's "A Model of Christian Charity"
(1630) or, perhaps more plausibly, its most famous and lasting metaphor of the
"city upon a hill," the full quote reading: "For we must consider that we shall be as
a city upon a hill. The eyes of all people are upon us. So that if we shall deal falsely
with our God in this work we have undertaken, and so cause Him to withdraw
His present help from us, we shall be made a story and a by-word through the
world." Also note the closing statement of the letter column in *Amazing Spider-Man*
#33 (2/1966): "Remember, when you're a Marvel madman, the eyes of the world
are upon you." Marvel fans are identified as the chosen ones, while Lee's words
also convey a sense of messianism. The popular fan club slogan "The M. M. M. S.
Wants You!" represents a more secular sense of American civil religion at work in
the Marvel discourse.

found new meaning; your nights have been enriched; your world
has gained new lustre.

Both statements are obviously hyperbolic, written in Lee's exagger-
ated style, expressing a self-reflexive, hip attitude. Yet they also sub-
sume Marvel's heterogeneous readership into a quasi-religious cult,
or collective. Writing about the serial constitution of the nation as an
imagined community, Benedict Anderson suggests that "the obsoles-
cence of the newspaper on the morrow of its printing" turns the act of
reading the paper into a "mass ceremony: the almost precisely simul-
taneous consumption ('imagining') of the newspaper-as-fiction,"
where the reader, "observing exact replicas of his own paper being
consumed by his subway, barbershop, or residential neighbours, is
continually reassured that the imagined world is visibly rooted in
everyday life" (2006, 35, 36). Marvel's religious rhetoric turned the
consumption of the comics into a mass ceremony, but it did not end
with purchasing and reading the stories. It authorized more active
forms of reception by connecting ceremonial immersion with reli-
gious interaction—religion in the double sense of spiritual fulfillment
and repeated enactment. Rather than instill in consumers the "confi-
dence of community in anonymity" (Anderson 2006, 36), the Marvel
collective offered intimacy with Lee as the patron saint of the con-
verted, doubling as the godlike creator of the Marvel universe.

Religions often institute hierarchies and nomenclatures, and so it
is not surprising that we find similar structures in the Marvel col-
lective. Mark Evanier's letter to Marvel, reprinted as part of "Stan's
Soapbox" in *Amazing Spider-Man* #50 (7/1967), which featured the
iconic "Spider-Man No More" story, is a case in point. Complaining
about what he saw as the descent of the M. M. M. S., whose member-
ship included 50,000 college students in the mid-1960s,[55] into "disor-
ganized chaos," Evanier wrote:

I suggest we have some officers. By buying his first Marvel mag, a
fan is automatically entitled to the rank of RFO (Real Frantic One).
His first published letter elevates him to QNS (Quite 'Nuff Sayer). A

55. This number is given in Weingroff (2011, 94). Freedland's article in the *New
York Herald Tribune* reinforces the company's popularity with college students:
"From the Ivy League to the Pacific Coast Conference, 125 campuses have their own
chapter of the 'Merry Marvel Marching Society.' The M. M. M. S. is at Oxford and
Cambridge, too" (1966, n. pag.).

no-prize raises him to TB (True Believer). Each additional no-prize raises one level: From JHC (Junior Howling Commando) to RH (Resident Hulk) to AAT (Associate Assistant Thing) and finally to the penultimate, the utmost a fan can attain: MM (Marvelite Maximus)! Naturally, the artists all have the rank of DDD (Definitely Dizzy Doodlers), the editorial assistants are IPR (Illiterate Proof Readers), art associates are VOD (Victims of Doodlers), and the letter[er]s are IWP (Indefatigable Word Placers), and Stan himself is at the summit—MEO (Marvel's Earthbound Odin). Each person would use his title at the start of his name—as I've done. (Signed—) RFO Mark Evanier.

This letter exemplifies the tendency of actors in group formation to "actively, reflexively, obsessively . . . produce typologies; they . . . design standards; they . . . spread their . . . organizations, their ideologies, their states of mind" (Latour 2005, 149–50). Evanier's suggestions were eventually adopted. Starting with *Amazing Spider-Man* #55 (12/1967), Marvel set out to introduce one rank each month, "the first, officially-approved Marvel moniker, to be used by any frenzied fan who buys at least three Marvel titles per month, with unfailing devotion," being R. F. O.: "You, O hallowed hero, have now attained the first rung of the towering ladder of Marveldom!" The hierarchical structures that were demanded and implemented here were not grounded in an us-versus-them rhetoric pitting loyal followers of Marvel's superheroes against the official comic book makers. Instead, Evanier imagined their relationship as a fluid continuum, where the threshold between consumers and producers was permeable. Upward mobility from the initial purchase of a magazine to becoming a professional member of the Marvel staff was distinctly possible in this model. Readers could rise in rank if they were willing to dedicate themselves to promoting Marvel comics and were willing to go beyond the call of duty by performing feats of heroism (e.g., through clever letters) that would earn them Marvel's tongue-in-cheek equivalent of the military medal: the no-prize for reporting holes in the story logic in any of Marvel's publications.

CHAPTER 3

TRANSMODIFYING CONVENTIONS

Parodies

Looking back on the *Batman* live-action series that had aired on ABC between 1966 and 1968, Bob Kane wrote in his autobiography, *Batman & Me*:

> I've received many letters from comic book fans who didn't appreciate Batman being parodied in the TV series. . . . My own opinion is that it was a marvelous spoof, . . . but it certainly wasn't the definitive Batman. Since the seventies, those who have worked on the series have returned to my original concept of Batman as a lone, mysterious vigilante. (Kane and Andrae 1989, 135)

Kane's words sound the judgment of an author whose status as Batman's original creator had withstood decades of contestation and whose autobiography was published to coincide with the release of Tim Burton's much-anticipated movie version of the caped crusader, *Batman* (1989). If the television series had already raised questions about authorial intention, narrative continuity, and transmedia storytelling, Batman's appearance in a blockbuster film set off a debate among those who claimed institutional authority over the figure,

those who identified as fans of the comics, and those who were ultimately responsible for turning Batman into a global franchise. Burton featured Kane as a production consultant to promote the film as an authoritative adaptation, but he also disclaimed any responsibility to ensure the film's fidelity to its comic book sources. As he told a reporter of *Time Out*: "This is too big a budget movie to worry about what a fan of a comic would say" (qtd. in Uricchio and Pearson 1991, 184).

Despite Burton's dismissive disposition, questions of authorial intention and fidelity never went away, as actor Christian Bale's statements about *Batman Begins* (2005), the first film in Christopher Nolan's trilogy, revealed more than a decade later.[1] Promoting this new release as a work that differed from earlier screen adaptations, Bale tried to tie the darker, more mysterious protagonist of *Batman Begins* to Kane's supposedly original vision. He may have done so in order to emphasize a departure from the campy aesthetics for which the ABC television series and its spin-off movie (1966) had come to be known and which Joel Schumacher's two *Batman* films of the 1990s had reinvigorated for a new generation of (mostly dissatisfied) viewers.[2] *Batman Begins*, Bale told reporter Bob Strauss, "is what Bob Kane intended when he first created the character. . . . I spoke with his wife, and she said that he was appalled when the (1960s) TV series spoofed what he had intended. But then you had the great revivals in the comic books" (qtd. in Gordon, Jancovich, and McAllister 2007, viii). Since Kane had passed away in 1998, Bale delegated interpretive authority to his wife. While Bale's statement contradicts Kane's characterization of the TV series as a "marvelous spoof," it reiterates the idea that DC's revisionary superhero narratives (Klock 2002) of the 1970s and 1980s, notably works by Dennis O'Neil and Neal Adams but especially Frank Miller and Lynn Varley's *The Dark Knight Returns* (1986), Miller and David Mazzucchelli's *Batman: Year One* (1987), and Alan Moore and Brian Bolland's *The Killing Joke* (1988), had brought back the old comic book hero in a new shape and form. These revisionary narratives—as well as "reconstructive" comics (Coogan 2006, 197–98) like Kurt Busiek and Brent Anderson's *Astro City* (1995–) that toned down social critique in favor of "recovering forgotten pieces of comics lore" (Singer 2018, 67)—supplanted the colorful depictions of

1. On the Nolan trilogy, see Brooker (2012).

2. *Batman Forever* (1995); *Batman & Robin* (1997). On the reception of the TV series and its connection to the comics, see Weldon (2016, ch. 3).

the 1950s and 1960s with a more violent and ambivalent character-
ization of their legendary protagonists, and they rejected the campy
aesthetics of the TV series. "If your only memory of Batman is that of
Adam West and Burt Ward exchanging camped-out quips while clob-
bering slumming guest stars Vincent Price and Cesar Romero, I hope
this book will come as a surprise. For me, Batman was never funny,"
Miller wrote in his afterword to the graphic novel version of *Batman:
Year One* (2005, 134).[3] "Whatever changes may have been wrought in
the comics themselves, the image of Batman most permanently fixed
in the mind of the general populace is that of Adam West deliver-
ing outrageously straight-faced camp dialogue while walking up a
wall thanks to the benefit of stupendous special effects and a camera
turned on its side," Moore complained in the introduction to the Brit-
ish edition (1986).[4]

Kane's distinction between his "definitive" Batman and the ABC
series as a "marvelous spoof," Bale's understanding of the series as
a spoof that violated Kane's intentions, and Miller's and Moore's
rejection of its campy humor are discursive interventions that seek
to canonize a particular version of the superhero but also highlight
the authorizing functions of parodies in the evolution of the super-
hero genre.[5] They speak to the power of parodic engagement to alle-
viate the tensions between alleged originals and supposed copies that
follows from the serial dialectic of repetition and variation. Parodies
of comic book superheroes, this chapter proposes, remind us that
claims to original status always seek to authorize specific versions of
a superhero. In popular serial narratives, originals are never really
originals, and copies are never just copies. What may seem securely
authorized can be challenged by competing bids for prevalence.[6]
What used to be serious can be inscribed with humor through paro-

3. Miller did, however, claim that he "was having great fun with parody"
while working on *The Dark Knight Returns* (Sharrett 1991, 38).

4. Medhurst notes: "Batman in its comic book form had, unwittingly, always
been camp—it was serious (the tone, the moral homilies) about the frivolous (a man
in a stupid suit)" (1991, 156). See also Bukatman's understanding of superheroes as
"flamboyant, performative" figures (2003, 216). On camp in Batman comics and the
1960s television series, see Brooker (2000a, ch. 3); Durand (2011b).

5. See Durand: "All of these are questions of *canon*, of what is the authoritative
Batman" (2011a, 81).

6. Today, most film productions are accompanied by trailers, making-of fea-
tures, and similar kinds of media paratexts that occupy an overlapping cultural
space with unauthorized productions, including parodies (Gray 2010; Stein 2012).

dies that transport characters, images, and stories into the comedic realm and remake the mood, makeup, and messages of ostensibly original texts. Parodies therefore function as a mediator of genre evolution by transmodifying the superhero's conventions.

Parody as Transmodal Transformation

Parodies perform authorizing functions by offering meta-commentary that is both humorous (and thus potentially affirmative) and critical (and thus potentially reformative). "Battyman, Begone!" from *MAD* #455 (Devlin and Richmond 7/2005), a spoof of *Batman Begins,* illustrates this double function. Battyman and Henri Retard (Henri Ducard) are fighting on top of a train when Spider-Man sweeps in to stop it from derailing. The announcer explains:

> Welcome aboard the Action Movie Monorail, making all expected stops. Hero finally overcomes his doubts and avenges his previous losses . . . check! Villain dies in such a way that he could conceivably be resurrected for a sequel . . . check! Plotline resolved with garish special effects explosion . . . check! Please remember to park your disbelief someplace else, and have a nice day! (110)

This scene lays bare the formulaic structure of *Batman Begins,* but it also acknowledges the commercial viability of company crossovers. If all superhero narratives essentially reproduce the same trite storyline, the scene further suggests, the ensuing boredom can become pleasurable once it is offered as the butt of a joke that banks on the reader's willingness to laugh about the exposure of genre conventions. The spoof ultimately derives its legitimacy from the formal and cultural authority of *MAD,* a magazine whose satirical stance toward the commercial outgrowths of comics and film and parodic missiles aimed at superheroes had been a prominent part of popular culture since the 1950s.[7] Moreover, it capitalized on the palimpsestic double-voicedness of parody, where "the audience . . . is . . . meant to hear

7. I use "parody" and "spoof" interchangeably, recognizing what Gehring calls the "semantic ambiguity" of the terms in his discussion of film critic Pauline Kael (1999, 23). Clear distinctions frequently depend on a questionable notion of intentionality; Dentith suggests that "spoof can . . . denote a mocking imitation which is deliberately meant to deceive" (2000, 194).

both a version of the original utterance of its speaker's point of view
. . . *and* the second speaker's evaluation of that utterance from a dif-
ferent point of view" (Morson 1989, 65).[8]

On that view, parodies perform authorizing functions for the pro-
liferation and diversification of the superhero genre. Indeed, parody
is itself a serial practice invested in genre politics. It is always an act
of doing something to, or with, something that has preceded it. It
is serial in the sense that it is a continuation of, or another—though
often unauthorized—installment of, a previous text that releases this
text from its status as a self-contained work. If this previous work,
or precursor text (Dentith 2000, 6), is already part of a serial genre,
the parodic possibilities multiply. Parodies tend to move a series
sideways, rather than forward. They open up a palimpsestic strain
of narrative continuation that competes with the styles and contents
of ongoing stories by challenging them from the vantage point of
the what-if, the comic book variant of parody's "ironic inversion"
(Hutcheon 1989, 87). What if Batman was a funny rather than a seri-
ous character? What if he was a bumbling idiot rather than a master
detective with perfect fighting skills? What if he was a closet homo-
sexual rather than an asexual vigilante? Parodies do not simply fill
the gaps in existing narratives; they use them as anchor points for
retellings of, and reflections on, whole stories, series, and genres.

These suggestions go against the grain of classic genre studies.
John Cawelti, for instance, suggests that the proliferation of parodies
indicates a genre's stage of final exhaustion:

> One can almost make out a life cycle characteristic of genres as they
> move from an initial period of articulation and discovery, through a
> phase of conscious self-awareness on the part of both creators and
> audiences, to a time when the generic patterns have become so well
> known that people become tired of their predictability. It is at this
> point that parodic and satiric treatments proliferate and new genres
> gradually arise. (2012, 296)

Cawelti's remarks seem applicable to superhero comics. The "initial
period of articulation and discovery" could be equated with forms
of linear seriality, while the "phase of conscious self-awareness on

8. Morson bases his observations on Bakhtin's *Problems of Dostoevsky's Poetics*
(1973).

the part of both creators and audiences" might correspond with the emergence of multilinear serialities. New genres would then arise from the proliferation of parodic treatments of all too predictable generic patterns. Yet parodies have played a much more vital role at various moments in the genre's evolution. They have participated in the broad-scale authorization of the comics at least since the 1950s, when the genre was still relatively young. And while they may eventually aid the creation of new subgenres—such as the video spoofs I analyze elsewhere (Stein 2012)—they have also contributed to the dissemination of superhero narratives into various forms of cascading serialities (Kelleter and Stein 2012, 283), where no clearly delineable set of cultural practices and media conventions dominates.[9]

Cawelti's model can be squared with Linda Hutcheon's understanding of parody as a "modeling process of revising, replaying, inverting, and 'trans-contextualizing'" (1985, 11). This modeling enables a "range of intent . . . from the ironic and playful to the scornful and ridiculing," achieved through forms of intertextual and intermedial engagement, or "repetition with critical distance" (6). Harvey Kurtzman and Bill Elder's "Woman Wonder!" (*MAD* #10, 4/1954), for instance, begins by acknowledging the repetitiveness of the narrative: "This story is the usual super type story! . . . Main character has superhuman powers . . . runs around in very tight-fitting tights! . . . Same old stuff, you say?" (n. pag.). But it immediately advertises a distance from the usual superhero fare: "Don't go 'way, boys, cause this character in tight-fitting tights is a woman!" (n. pag.). The critical potential of this distancing depends on how we decode this opening gambit. It certainly anticipates Marvel's promotion of Spider-Man as "slightly different" from the genre norm, a welcome divergence from the "same old stuff." In that sense, Woman Wonder (known in her civilian identity as Diana Banana) is like any other superhero, with the exception that she is a woman. The introductory patter further insinuates that the "tight-fitting tights" worn by male superheroes are somewhat ridiculous and perhaps more appropriate when worn by a woman, and the story continues by playing (while not necessarily undermining) traditional 1950s gender roles. A romantic love scene set at night in front of a full moon depicts a dainty and presumably female figure in silhouette who is crushed by the strong arms of

9. Denson distinguishes between "a linear form of serial progression, continuation, and development" and "a non-linear form of serial 'concrescence,' snowballing accumulation, or compounding sedimentation" (2011, 536).

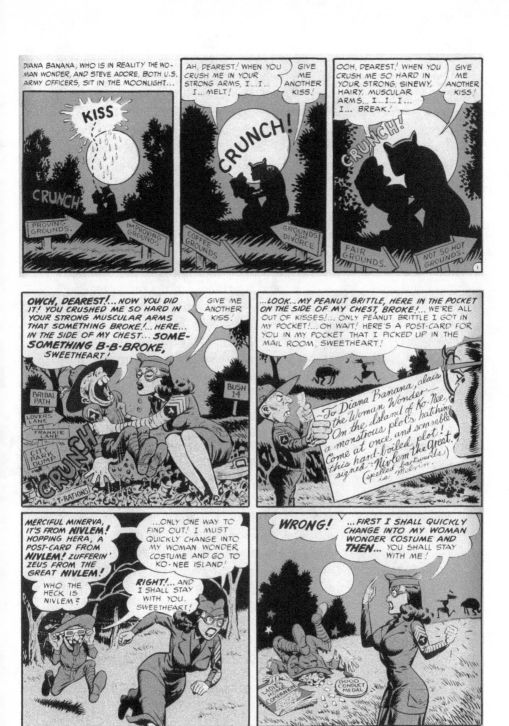

FIGURE 3.1. "Woman Wonder!" Harvey Kurtzman and Bill Elder. *MAD* #10 (4/1954) © DC Comics.

what seems to be a male pursuer (see figure 3.1). But as the next page reveals, it is Woman Wonder who is strong-arming the smallish Melvin, who in the next scene stumbles over an issue of the *Ladies Home Companion* magazine (an allusion to the *Woman's Home Companion*). At the end of the story, Woman Wonder tries to use her "feminine charm and beauty" to beguile the villain (Melvin, now named Nivlem), but he smashes her face with his "hob-nailed boot" and beats her "to a bloody pulp" (n. pag.). Woman Wonder then gives up her life as a superheroine. The last panel shows her with a baby in her arm and cooking dinner as her husband is reading the paper. The caption reads: "Diana Banana is now content with the normal female life of working over a hot stove!" What we have here is both a repetition of the clichéd gendered conclusions of many popular narratives and, given the mayhem and irreverence of the preceding pages and the ironic tone of the final panel, a critical (though no less sexist) comment on the boring conventionality of such narratives. As "Woman Wonder!" shows, rather than limit the authorizing functions of parody to the late stages of the superhero genre, we can read it as a "cultural practice which provides a relatively polemical allusive imitation of another cultural production or practice," but we must also ask "what cultural work . . . [a] parody [is] effecting" (Dentith 2000, 9, 188).

This chapter argues that parodies work neither simply as subversive responses to official series by fans hijacking content to produce their own meanings (although that can be the case), nor merely as the kind of poaching and raiding of official texts by the "rogue readers" and "textual poachers" from Jenkins's (1992, 2006) participatory culture model (although this, too, happens).[10] More important, they act as mediators of genre evolution by making productive the willing suspension of disbelief that many superhero conventions (double identity, superpowers, costumes, gadgets, grotesque villains) demand and that "Battyman, Begone!" wants viewers "to park . . . someplace else." As parodic reformulations of existing superhero stories, they at once reify the authority of these stories and create discursive space for willing expressions of comic disbelief. By offering their

10. See also Hills's (2002) taxonomy of tensions in fan cultures between consumerism and resistance, community and hierarchy, knowledge and justification, fantasy and reality. On fandom and (digital) media, see De Kosnik (2016); Booth (2017); Gray, Sandvoss, and Harrington (2017). For a gender-based critique of fan culture historiography, see S. Scott (2019).

own claims to narrative and discursive authority, parodies can serve as a stabilizing force in genre evolution, acting as mutations that aid adaption to new environments while reinforcing basic conceits. But they can also act as irritations or provocations (Hutcheon 1989, 101), undermining these very conceits by satirizing not only individual works or particular genres but also the audiences of such works or genres (Morson 1989, 63). Connecting Bakhtin's notion of the carnival with parody, Hutcheon speaks of "the paradox of its authorized transgression of norms" where "the recognition of the inverted world still requires a knowledge of the order of the world which it inverts and, in a sense, incorporates" (1989, 99). Indeed, "in Bakhtin's terminology, parody can be centripetal—that is, a homogenizing, hierarchicizing influence. But it can also be a centrifugal, denormatizing one. And . . . it is the paradox of its authorized transgression that is at the root of this apparent contradiction" (102).[11]

My analysis begins with close readings of parodies from the late 1950s and 1960s published in *MAD,* followed by DC's *The Inferior Five,* Marvel's *Not Brand Echh,* and the fanzine *Alter Ego.* I am interested in how *MAD* performs the "superimposition of an external order upon a work that is presumed to be original" (Hutcheon 1985, 4) and how DC's and Marvel's own parody series respond to that challenge. My subsequent reading of Alan Moore's metareflexive six-issue miniseries *1963* (4/–10/1993) reveals a satirical sensibility toward the growing historical self-awareness of superhero comics as a genre with an extensive—and frequently contested—history.

That *MAD* Spirit

In *Superhero: The Secret Origin of a Genre,* Peter Coogan broaches the topic of early parodies, picking up Schatz's assertion that successful parodies do not necessarily signal the end, but rather the consolidation of a genre. Coogan claims that the first appearance of a superhero parody was Sheldon Mayer's "Scribbly" in National Periodical Publications' *All-American Comics* #20 (11/1940). In this story, the housewife Ma Hunkel became the stock-pot-wearing, flannel-underwear-donning Red Tornado. For Coogan, this was "a parody of the superhero generally, not . . . a specific parody of Superman," which

11. Hutcheon builds on Bakhtin's *Rabelais and His World* (1968).

"suggests that the superhero genre clearly existed and was perceived as a genre by 1940" (2006, 28). Other early parodies were the comic book stories featuring Koppy McFad, known as "the kid with the most comics in America," who imagined himself as a superhero character named Supersnipe (published between 1942 and 1949 by Street and Smith). Here, the parody extended from protagonists and storylines to readerly practices like storyworld construction and comic book collecting (Coogan 2006, 196–97).

While these early parodies reinforced the idea of superhero comics as a genre that could be cited, criticized, and parodied almost immediately after its emergence, they seem to represent relatively isolated instances. If we understand genre parody as a more concerted "metadiscursive" engagement (Hutcheon 1989, 89) with precursor texts, we can pinpoint the first sustained superhero spoofs to the early 1950s, when the conventions of the genre had been firmly established. As we know from letter pages and fanzines, authors and especially older readers knew they were dealing with stories that followed formulas and strained to keep narratives interesting for new and old audiences. Launched in 1952 by William Gaines and Harvey Kurtzman, *MAD* appealed to this older demographic and became the flagship of EC Comics, selling half a million copies per issue (Pustz 1999, 36). The company had to discontinue its horror and crime comics (*Tales from the Crypt, Haunt of Fear, Crime Suspense Stories*) in the wake of Fredric Wertham's anti-comics campaign and the Senate hearings on comics and juvenile delinquency in 1954.[12] But *MAD* appeared as a magazine and not as a comic book and thus escaped control by the Comics Code Authority, which was founded in 1954 by American comics publishers to signal an end to the lurid and violent narratives of earlier years.[13] Free from such censorial constraints, *MAD* turned on superhero comics almost from the start, following parodies of the company's own comics, such as Al Feldstein and Wally Wood's "EC Confidential" in *Weird Science* #21 (9–10/1953), with its depiction of EC staffers as aliens from Venus (Pustz, 1999, 39), with parodies of DC's caped crusaders. In *MAD* #4 (4–5/1953), Harvey Kurtzman and Wally Wood parodied the first and most iconic of all superheroes, Superman ("Superduperman"); in issues #8 (12/1953–1/1954), #10

12. Wertham had lobbied against the graphic depiction of sex and violence in comic books (superhero, horror, crime) in lectures, on the radio, and in print. See especially Wertham (1954).

13. On the history of *MAD*, see Reidelbach (1991); J. Lee and Bird (2014).

(4/1954), and #14 (8/1954), they spoofed Batman and Robin ("Bat Boy and Rubin!"), Wonder Woman ("Woman Wonder!"), and Plastic Man ("Plastic Sam!").[14]

The eight-page "Superduperman" ridicules a range of verbal and visual elements from Superman's fictional universe. The opening splash announces the larger point behind the parody. It depicts a flying Superduperman punching an old man, in violation of the superhero's "prosocial and selfless" mission (Coogan 2006, 31). Superduperman and his nemesis Captain Marbles possess a ludicrous physique. Their muscle-packed torsos are grotesquely hypertrophied versions of the already bulky bodies presented in the official Superman and Captain Marvel comics. Superduperman's disproportionately thin bowlegs add to the comical appeal, as do his simpleminded look and limited facial expressions. This depiction follows a common parodic strategy: deflating the hero through exaggeration and caricature. There is also an element of critique that recasts Superman as an intellectually unassuming figure (much muscle and little brain), suggesting that superheroes were stuck in the simple formulas of their infancy.

Kurtzman and Wood replaced Superman's S-insignia with the words "approved by Good Housebreaking," which ridicules the seal of approval issued by the *Good Housekeeping* magazine. Superduperman is subject to female control; he is a housebroken puppy rather than the ferocious embodiment of spectacular masculinity comic book readers might have expected. Again, the story can be decoded in different ways, enabling at once a reactionary reading (lamenting the superhero's inhibited masculinity and identifying women's meddling in the comics business as part of the problem) and a more progressive understanding (depicting the ideal superhero as a nonconformative figure). In addition, the reference alludes to the debate about the dangers of comics for young readers (who might not yet be fully housebroken in the sense that they still rely on parental supervision), anticipating the Senate hearings and the Comics Code. Ironically, the hearings and the code effectively ended many of EC's

14. For reprints of these and other *MAD* superhero parodies, see Meglin and Ficarra (2006); Ficarra (2010). *Plastic Man* was written and drawn by Jack Cole, first appeared in 1941, and lasted until 1956 (initially published by Quality Comics, then DC). It was already a comical variation of the comic book superhero: Plastic Man's hyper-elastic body lent itself to the depiction of many funny incidents; he also had a stocky, simple-minded sidekick named Wolfgang "Woozy" Winks.

properties and thus supported the development of *MAD*'s irreverent style and humor.

"Superduperman" claimed authority by comically renaming all central characters: Superman becomes Superduperman, Clark Kent becomes Clark Bent, Lois Lane becomes Lois Pain. The all-American (albeit alien) Clark Kent is reimagined as a member of an exploited workforce (a creature bent by his workload, suffering from abusive bosses) and chronically rejected by a woman uninterested in getting involved with a creep like him. Shuster and Siegel's Depression-era idealism gives way to the postindustrial disillusion of white-collar office routines and the unmasking of juvenile fantasies of women as damsels in distress waiting to be rescued by a male member of the species glorifying himself as a superhero.[15] As "an incredibly miserable and emaciated looking . . . assistant to the copy boy" at the *Daily Dirt* (*Daily Planet*) newspaper, Clark Bent further recalls Herman Melville's "sub-sub-librarian." But unlike Melville's custodian of world knowledge, he ogles ladies in the powder room, is bossed around and exploited by the tenacious office boy, and suffers constant humiliation from the love of his life.

The comedy of these scenes derives from parody's palimpsestic power. Readers familiar with Superman would have been able to decode the discrepancies between the officially sanctioned characters and the spoofed versions presented in *MAD*. The spoof complicates its precursor texts not just by upstaging them with wacky characters and a plot liberated from the restraints of formulaic storytelling, but also through strategically placed intermedial references. One such reference follows the logic of Hutcheon's "repetition with critical difference" by revising Superman's slogan "It's a Bird! . . . It's a Plane! . . . It's Superman!," which had been introduced in the opening credits of the popular television series (ABC, 1952–1958). In the opening panel, the slogan reads, "It's a Bird! . . . It's a Plane! . . . It's Superduperman!" Later in the story, it is spoofed again when gangsters look at the window and exclaim, "Look! Up there in the sky! It's a bird! It's a plane! It's a bird!" (an anticlimactic bird appears). While these are small changes, they connect the parodying with the parodied text and reiterate parody's need for double-decoding. They attain some of their revisionary energy from the fact that slogans of popular series

15. On Depression-era ideology in Superman comics, see Brod (2012); Lund (2012); Gordon (2017, ch. 2).

frequently become trademarks: legally protected and endlessly circulating verbal and/or visual designators of series, characters, and styles.

Other significant changes include a poster on the opening splash that depicts a young man or child at the drawing board and proclaims: "When better drawings are drawn . . . they'll be drawn by Wood. He's real gone." The claim is that Wood's drawings are better than their precursor texts and that *MAD* offers a hipper and more sophisticated — "gone" — superhero. That this claim avoids connecting Wood's work with a bourgeois discourse of high art is crucial because it indicates the position *MAD* inhabited as a popular commentator operating within the realm of popular culture instead of an outside critic of mass entertainment. If Stan Lee peppered his discourse at Marvel with literary allusions — he mentions Ernest Hemingway, Bernard Shaw, Charles Dickens, Victor Hugo, Franz Kafka, Paddy Chayefsky, O. Henry, and François Rabelais, as well as *Frankenstein, Dr. Jekyll and Mr. Hyde,* and *The Hunchback of Norte Dame* in *Origins of Marvel Comics,* and Shakespeare multiple times in his Spider-Man bulletins — Kurtzman and Wood's parody is too far "gone" to claim the comic's upward mobility into the realm of canonized culture.

The last panels of the parody deflate the sensationalist ending of the first Superman story from *Action Comics* #1 (6/1938). They supplant the announcement "And so begins the startling adventures of the most sensational strip character of all time" with a return to Clark Bent: "once a creep always a creep!" What had begun with the promise of serial storytelling — the infinite longevity ("of all time") of continually exciting narration ("startling adventures") and character development ("sensational strip character") — is reassessed fifteen years later as the repetitive presentation ("once a creep, always a creep!") and mediocre illustration of a comic outmatched by *MAD*'s "gone" comics. The competitive thrust encapsulated in the statement "when better drawings are drawn . . . they'll be drawn by Wood" validates superhero parodies as the work of artists seeking to rise above childish fantasy. Yet this bid for prevalence necessitated a basic familiarity with the spoofed material, and the creators of *MAD* were very much aware of the genre conventions they were spoofing. *MAD* was therefore authorized by the superhero genre itself. It derived its legitimacy from the very material at which it aimed its comical critique.

"Superduperman" did not just raise questions of narrative authority, about who could draw better images and tell more compelling

stories. It also highlighted questions of legal authority. As Maria Rei-delbach observes, National Periodical Publications threatened *MAD* with a lawsuit over copyright violations, even though they did not follow through (1991, 23). "Superduperman" thus had no direct legal consequences, but it established a precedent that sanctioned the spoofing of copyrighted material. Its popular appeal prepared the path for further parodies, turning a single spoof text into a serial subgenre that would soon transcend the pages of *MAD.* Consider the second superhero parody published in *MAD,* Kurtzman and Wood's "Bat Boy and Rubin!" Here, the caricatured rendering of the superhe-roes is more pronounced, probably to ensure that it was recognized as a parody beyond reasonable doubt to avoid legal trouble, while the story itself is even more outrageously incongruent with the pre-cursor text (see figure 3.2).

Batman appears as the smallish "Bat Boy." He is unable to per-form even the simplest feats of superheroism and is finally revealed as a vampire feeding on Robin's blood, in a nod to EC's vampire com-ics. Rubin is a geeky teenager with a less-than-heroic fighting stance who is constantly bugging Bat Boy about the right course of action. As he asks on the opening page, where the dynamic duo is attacked by a sprawling mass of criminals launching a seemingly endless array of weapons against the goofy-looking crimefighters: "Bat Boy! Bat Boy! The whole gang of crooks is getting ready to charge! Should we: (a) Fight 'em with our fists? (b) Fight 'em with our weapons? (c) Run?" Being a quintessential antihero, Bat Boy chooses the third option, but this constitutes only the superficial layer of this parody. On a meta-level, this multiple-choice approach spoofs the formulaic structure of superhero comics (predictable plot options), its visual codes, and the interactive and participatory rhetoric of EC's earlier horror and crime comics, where readers were asked to contribute story suggestions to invest in a series' future.

"Bat Boy and Rubin!" undermines the superheroic status of its title characters, alleging a lack of plausibility when Robin exclaims: "Poor fools! Don't you know us comic book characters are always missed when we run at the guns?" The story also displays a num-ber of disclaimers that hark back to the legal issues "Superduper-man" had evoked, beginning with a reference to the precursor texts it claims not to spoof (but obviously does): "You have heard of these two masked, bat-like, crime-fighters of Gotham City [. . .]. This story, then . . . has absolutely nothing to do with them! . . . This story is about two different people. . . ." The story is filled with signs and

FIGURE 3.2. "Bat Boy and Rubin!" Harvey Kurtzman and Wallace Wood. *MAD* #8 (12/1953–1/1954) © DC Comics.

notices that identify it as a parody: "Notice! This story is a lampoon! If you want to spend your dime on cheap, rotten lampoons like this instead of the ever-lovin' genuine, real thing . . . Go right ahead, boy!" Here, the genre-shaping conflict between material perceived as original and material designated as derivative resurfaces in the guise

of ironic deflation. By superimposing itself over the source text, the parody insinuates a new aesthetic hierarchy, turning established discourses upside down: *MAD*'s "cheap, rotten lampoons" claim intellectual and aesthetic superiority over the "ever-lovin' genuine, real thing." This superiority, we learn on the next page, undermines expressions coded as all-American ("ever-lovin'") with a Yiddish twist: "Note: We repeat! Lampoon! Bat Boy mit a Boy! Rubin mit a u!"[16] What's more, around mid-story, the dialogue between Bat Boy and Rubin takes a metareflexive turn when it acknowledges the legal dispute between National Periodicals and EC Comics over copyright infringement: "Now! Onto the window sill! Faster than a speeding bullet, kapweeng! Up. . . . Up . . . Up and away!," Bat Boy yells, and Rubin remarks: "Wait a minute, Bat Boy! That 'faster than a speeding bullet' is another character's routine! . . . It may be copyrighted! Want to get us sued?" Wood, however, did not get sued but was hired by DC, where he contributed to series like *Captain Action, All Star Comics,* and *Wonder Woman,* and he also worked for Marvel on *Daredevil, Avengers,* and *Astonishing Tales.* Instead of excluding *MAD*'s parodic agencies from the genre, enlisting Wood meant diversifying its central tenets.[17]

The parody missiles launched by *MAD* targeted both the "structural *énoncé*" of specific series and the "entire *enunciation*" of superhero comics (Hutcheon 1985, 23): their texts, paratexts, and epitexts. They spoofed names and slogans, the characterization of central figures, the repetitive structures and simple morals of the stories, their counterintuitive claim to narrative originality, the neglect of their creators' Jewishness, and the legal threats to competing superhero material. What had begun as occasional genre spoofing morphed

16. There are six such references altogether. Abrams notes: "*Mad* used parody to criticize a predominantly Protestant culture from the perspective of the Jewish outsider"; its "humor was grounded in Yiddishisms, sarcasm, and self-mockery, all defining features of Jewish humor" (2014, 112, 114). *MAD*'s Yiddish inflections foreground the irony that Jews like Shuster and Siegel but also Jack Kirby (Jacob Kurtzberg) and Stan Lee (Stanley Lieber) were central to American superheroes. William Gaines and Harvey Kurtzman were also Jewish. For further analysis, see Weinstein (2006); Fingeroth (2007); Lund (2016).

17. The historical connections between Marvel and *MAD* were more substantial than readers may have thought. Al Jaffee worked as a freelancer for Lee in the early 1940s, when he drew a story called "Squat Car Squad" in which the characters faulted him for going off Lee's script. Harvey Kurtzmann did work for Lee in the late 1940s (Fingeroth 2019, 28–29, 42).

into a transmedial spoofing game that soon included lampoons of ABC's Batman.[18] Notably, the serial nature of *MAD*'s parodies was not so much rooted in an ongoing story told in installments. Rather, it appeared as a continued practice of spoofing superheroes across media that produced recurring features like Sergio Aragones's "A MAD Look at . . ." and a series of comical graphic novel reviews.[19] It also contributed to Batman's mutation from comic book to television when *MAD* featured a parody by Lou Silverstone and Mort Drucker titled "Bats-Man" (*MAD* #105, 9/1966).

Silverstone and Drucker's "Bats-Man" raises questions about the adaptive process from print to moving image, about the television series' camp aesthetics, and about its authority (or lack thereof) vis-à-vis its precursor texts. "Bats-Man" approaches these questions by refocalizing the story from Bruce Wayne ("Bats-Man") to Dick Grayson ("Sparrow") and transmodifying heroic characters from a fictional make-believe world into quotidian circumstances. Announcing the process of refocalization as a what-if scenario, the opening statement asks: "Has anyone ever wondered what it would really be like as the side-kick of a 'Caped Crusader'?" The answer follows after a few more questions: "Would a typical red-blooded teenager boy really be happy dressing in some far-out costume and spending all of his free time chasing crooks? Or would he much prefer dressing in chinos and go-go boots and spending all his free time chasing chicks? We at *MAD* think the latter!"[20]

The first few panels of this parody establish the troubles of "Boy Wonderful" when his date complains about being abandoned during her last tête-à-tête with Gray Dickson (Dick Grayson): "Ditching me for a middle-aged lady! I saw you sneaking off down the back stair-

18. Such lampoons endured past their immediate environment. Bruce Timm references "Bat Boy and Rubin" in a section titled "Mad Love Commentary by Bruce Timm" in the 2009 graphic novel edition of his and Paul Dini's *Batman: Mad Love and Other Stories*. On *MAD*'s TV parodies, see Ben-Porat (1979).

19. See "A *MAD* Look at Batman" (#106), "A *MAD* Look at Superheroes" (#177), "A *MAD* Look at Spider-Man" (#418), "A *MAD* Look at the San Diego Comic-Con" (*MAD Comic-Con Special* 2008), etc. Graphic novel reviews include "Batman: When Worlds Contrive" (#479) and "The Amazing Spider-Man: Irreversible Terminal Demise, Vol. 1" (#485).

20. A sentence like "We at *MAD* think the latter" illustrates the compatibility of *MAD*'s parodies with the Marvel discourse as reflected in statements such as "We here at Marvel are especially anxious for your opinions" (*Amazing Spider-Man* #5, 10/1963) and "we at the Marvel bullpen" (*Amazing Spider-Man* #10, 3/1964).

case with her!" For initiated comic book readers, the reference to the "middle-aged lady" might have rung a bell. As Sparrow's thought balloon in the next panel reveals, it was Bats-Man with whom he had snuck off to pursue a criminal. Yet the fact that Sparrow's date mistakes Bats-Man for a middle-aged lady and thinks that there may be something sexual going on between the two (as the phrase "sneaking off" suggests) recalls earlier debates about Bruce Wayne's homoerotic relationship with Dick Grayson.[21] Parodies thus also function as a form of historical memory, preserving older discourses by weaving them into the contemporary superhero fabric.

In terms of the transition from comic book to television, Silverstone and Drucker harp on the unheroic appearance of the caped crusader's smaller-than-life TV version by presenting a caricature of Adam West as a lanky, pot-bellied, and rather nutty Bats-Man accompanied by a bratty, querulous Sparrow. This marks the transmodification of these superheroes into television characters as an act of comic deflation ultimately inferior to *MAD*'s own parodic deflations, such as when the reference to the "Aide-de-'Camp' Dept." at the beginning of the parody ridicules the show's self-description as "camp." The TV series may have been trying to spoof the comic books, but *MAD* could arguably spoof them better—and also spoof the television series. When Bats-Man appears in his underwear in the opening panel, the message is clear: The original proprietors of camp are the writers and artists at *MAD,* whereas television is a latecomer to the spoofing game. Without the editorial restraints of the comic books and TV show, *MAD* could be outrageous with its target material. The opening panels (see figure 3.3) transform the long-underwear character Batman into the short-underwear character Bats-Man (who wears boxers with his own bat insignia like a fan who has purchased Batman merchandise) and ridicule Superman as a competing superhero when Neuman (Alfred) holds up a Superman costume and states: "You'd sure look ridiculous fighting crime in this outfit."

The structural commentary of this spoof prefigures later parodic engagements. On the third page, the police commissioner calls Bats-Man on the hotline to let him know that he is "bored out of his mind! He said we've been on the air 15 minutes and we haven't had one fight, seen one weird villain, or scaled one wall!," Bats-Man informs

21. On homosexuality in Batman, see Medhurst (1991); Wilde (2011); J. A. Brown (2019, ch. 3); Stein (2018a).

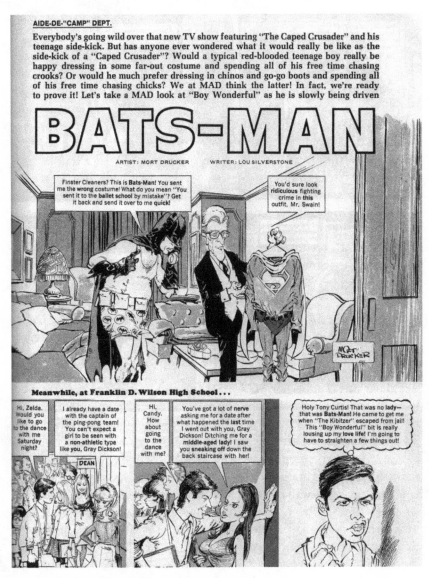

FIGURE 3.3. "Bats-Man." Lou Silverstone and Mort Drucker. *MAD* #105 (9/1966) © DC Comics.

Sparrow. The commissioner stands in for a viewer unimpressed with the narrative structure and content of the episode, demanding better entertainment according to the expectations raised by the show's own promise of suspense. Bats-Man and Sparrow even know that they are actors on TV: "I tried all the conventional TV weapons and nothing

worked," Sparrow remarks at one point. Moreover, they comment metacritically about the quality of the script. "But how were you able to make that phone call to the Commissioner? I was with you all the time! And how were you able to change into that costume so fast?," Bats-Man asks, and Sparrow replies: "A lesson I learned from you in one of your many boring speeches! Remember the one about logic and TV writers? You were right! They have none!"

Moving beyond spoofing the structural *énoncé* of the television series, Silverstone and Drucker turn to its public reception and the ways in which television producers and broadcasting corporations market their shows. Toward the end of the strip, Sparrow complains, "All my hip friends [are] laughing at me." Bats-Man's retort presents what the parody takes to be the perspective of the television industry: "What difference does it make if they laugh, as long as they watch the program!" After more sophisticated programs had failed to attract large audiences, he explains, "The industry made a revolutionary discovery. Give the 'in' group garbage—make the show bad enough and they'll call it 'camp' and stay glued to their sets!" To be hip in the *MAD* sense meant flying above the garbage of mainstream entertainment, not by becoming high culture, but by creating more biting entertainment.

"Bats-Man" and other *MAD* parodies did more than afford established characters and conventions a fresh look as viable alternatives to officially authorized stories. Through the palimpsestic powers of parody, they inserted new meanings into known character histories and story conventions as well as into the genre's iconographic makeup. They highlighted the ludicrous strain of the superhero by spelling out what was often only indirectly acknowledged. In doing so, they balanced overly dark interpretations of a character like Batman (who was actually quite colorful in the 1950s) with counterinterpretations that tended to diversify images of the lone vigilante many creators before and afterward (Kane, Miller, Moore, Nolan) embraced as the "original" nature of this crime fighter. Readers of these *MAD* parodies would have returned to the genre with a new genre awareness that would not just shape their future encounters with a particular series but had the power to retroactively shift the meanings of published stories.

Furthermore, *MAD* facilitated the entrance of major comic book publishers into the parody field. Under *MAD's* sway, DC launched its own superhero parody, *The Inferior Five,* in 1966, while Marvel started

Not Brand Echh a year later. Earlier attempts to enter the parody game had been confined to individual stories like "Batman Meets Fatman" in *Batman* #113 (2/1958), where Batman and Robin are aided by "a clumsy, overweight Batman" who turns out to be "Fatman the circus clown in his popular act that lampoons the real Batman." The parody was visual—Fatman's figure is the antithesis of Batman's muscular body, and he repeatedly trips over his own feet—as well as verbal: "Who is the caped crime-fighter who makes felons shake? Who is the mantled man-hunter who makes hoodlums quake? Who? Nobody but Fatman," the opening panel declares. But this was a rather isolated effort, perhaps meant to defuse fundamental questions about the viability of the superhero concept posed by *MAD*'s parodies.

Fanzines versus Authorized Parodies

MAD was followed by magazines like *Panic, Whack, Unsane, Bughouse, Crazy, Eh!,* and *Nuts* (Reidelbach 1991, 24). While none of these magazines stayed in business for long, they sustained the parodic mood and secured its role in the discursive and creative conflicts over the superhero's past, present, and future. By allowing readers to balance their willing suspension of disbelief with a dose of comic relief, they acted as mediators for emerging amateur comics and parodies in fanzines from the early 1960s onward.[22]

Fanzines frequently published amateur parodies like Roy Thomas's "The Bestest League of America" in *Alter Ego* #1–3 (3–11/1961). "Bestest League" was inspired by *MAD*'s early superhero parodies (Thomas and Schelly 2008, 21) and captured the wacky iconography that turned muscular superheroes into bumbling antiheroes and promoted the comical corruption of slogans—the Cash (i.e., the Flash) "can run as fast as the speed of a vanishing paycheck" (21)—and names: The Green Arrow becomes the Green Trashcan, Aquaman is Aquariuman, Superman is Superham, Batman is Wombatman, Wonder Woman turns into Wondrous Woman (21, 27, 40).[23] Indicating

22. See also Wally Wood and Roy Thomas's "The Old, Un-Mod Blunder Woman" and "Sub-Marine Man" in *Alter Ego* #10 (1/1969).

23. A later story from *Alter Ego* #6 (3/1964), titled "The Inimitable (who'd want to?). Bestest League of America meets . . . Da Frantic Four," references *MAD*'s Yiddishisms when a sign says "Down mit der BLA" (= Bestest League of America). It is reprinted in Thomas and Schelly (2008, 75–83; the sign appears on page 82); it

that *MAD*'s parodies were as much part of the history of the genre as the officially authorized comics, the story picks up the standard narrative resolution from *MAD*. Wombatman is the mysterious villain who has turned against his colleagues just as Rubin had betrayed Bat Boy and as Sparrow had tried to kill Bats-Man. Finally, "The Bestest League of America" referenced its target texts by spoofing the cover of *Justice League of America* #3 (3/1961) in its third installment, which shows the members of the team traveling to Disneyland on a makeshift space boat.

Anticipating the trajectory from linear to multilinear storylines and intersecting universes, issue #6 of *Alter Ego* contains a spoof of DC's *Justice League of America* and Marvel's *Fantastic Four* called "The Inimitable (who'd want to?). Bestest League of America meets . . . Da Frantic Four" (see figure 3.4). Written by Roy Thomas, drawn by Richard "Grass" Green, and published in March 1964, it complains about the pricing of comic books ("12¢ and still going up!"), pokes fun at the Comics Code Authority ("Approved by the Comics Clod Atrocity"), and addresses copyright control and creative ownership ("Featuring characters copied-right 1963") (Thomas and Schelly 2008, 75).[24] As such, it channeled conflicts from the letter pages and other sections of the fanzine into comics form. The story appeared two years after *The Fantastic Four* had been introduced by Marvel, underscoring the relative rapidity with which fanzines turned a parodic gaze on the genre. It preceded the format of the intercompany crossover story, exemplified by *Superman vs. the Amazing Spider-Man* (1976) and later spoofed by *MAD*'s "Battyman, Begone!," by more than a decade. What we see here is an experiment with a new story format that first appears in a semiauthorized forum, a fanzine acknowledged by DC but with no overt commercial objectives and a relatively small readership that acts as a mediator by preparing the ground for official crossover narratives. Issues #7 (4/1968) and #10 (10/1968) of DC's *The Inferior Five* pick up the crossover narrative when the Inferior Five fight spoofed versions of Marvel characters like the Fantastic Four (Kookie Quartet), Sub-Mariner (Sub-Moron), and Spider-Man (Cobweb Kid).

also spoofs *The Fantastic Four* #5 (7/1962), the issue in which Johnny Reed reads a comic book that looks like *The Incredible Hulk* #1 (5/1962). This is a good example of serial proliferation, where Marvel first humorously refers to one of its own series in a comic book and fanzine publications like *Alter Ego* then spoof such metareferential storytelling: "Here we go again" (Thomas and Schelly 2008, 80).

24. See also Schelly (2006).

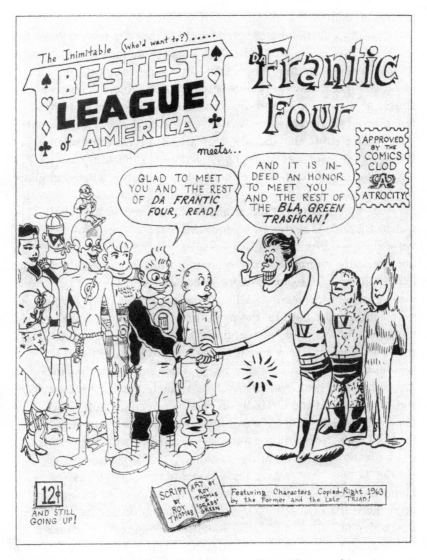

FIGURE 3.4. "The Inimitable (who'd want to?). Bestest League of America meets . . . Da Frantic Four." Roy Thomas and Richard "Grass" Green. *Alter Ego*, 1964 © TwoMorrows Publishing.

Additional spoof elements in Thomas and Green's parody reflect Marvel's increasing success with *The Fantastic Four, The Incredible Hulk,* and *Amazing Spider-Man* by turning on Stan Lee's commercialized patriotism: "Da Frantic Four!—an enemy of mankind!—a menace to flag!—to country!—to sales" (Thomas and Schelly 2008, 78). They do so by evoking Marvel's pithy attitude toward their com-

petitors in editorials and bulletins—DC becomes "Defective Comics" (80)—and by questioning the plausibility of new characters. Renamed the Hunk, the Hulk is a "ridiculous-looking character" and has the Bestest League wonder: "How could anyone possibly believe in a guy like this?" (80). Even Lee's alliterative editorial voice ("you acetylene abuser of alliteration!") and the economic constraints of story production ("these silhouette shots sure save a messa drawin'") are spoofed (81, 79). Yet while this parody is aware of recent reformulations of the superhero, such as Marvel's flawed and conflicted protagonists, it identifies as an amateur production humorously challenging genre conventions.

From an industry perspective, one way to defuse such challenges was to acknowledge them by producing parody comics as a form of "preemptive self-parody" (Morson 1989, 78). Yet DC and Marvel did not explicitly reference such amateur productions, despite the fact that industry professionals were in contact with fanzine producers and soon-to-be professionals like Thomas. Rather than openly connect with fanzine culture, the professional parody comics expanded the publisher's market reach and diversified their image. Since *MAD* remained successful, its threat to the narrative authority of DC and Marvel had to be addressed, more so than that of the fanzines. DC did so by launching *The Inferior Five,* written and drawn by E. Nelson Bridwell and Joe Orlando, in *Showcase* #62 (5/1966).[25] The series appeared as an attempt to ensure the readers' loyalty at a time when the publishers' institutional authority competed with a growing network of alternatively authorized actors.

The Inferior Five was deeply indebted to *MAD*. As the little blond kid running DC in *The Inferior Five* #6 (2/1968) exclaims: "We need more life in that magazine! Put in more of that MAD spirit!" The order is followed by additional *MAD* references: "Potrzebie," "Fershlugginer," "Alfred E. Neuman," "What, me worry?" These references suggest that the authors and readers of *The Inferior Five* were familiar with *MAD,* and so it comes as no surprise that competitor Marvel advertised its own parody comic *Not Brand Echh* as "the maddest magazine of all" (*Amazing Spider-Man* #50, 7/1967). The cover of *Showcase* #63 (8/1966), in which the second Inferior Five story appeared, further indexes the *MAD* influence, depicting patched

25. The first three stories of *The Inferior Five* appeared in *Showcase* #62 (5/1966), #63 (8/1966), and #65 (11/1966); issues #1 to #10 of the independent title appeared throughout 1967 and 1968, and the final two issues as *The Inferior* #5 in 1972.

underwear on a clothesline, a note reading "Clue No. 2," and a love-stricken chicken sitting on the character The Feather. Patched-up costumes, comical notes, and funny animals were staples of *MAD,* and they were now officially sanctioned as legitimate genre elements by DC, which further enacted elements from *MAD's* playbook by inventing funny names for their new superheroes (Merryman, Awkwardman, Dumb Bunny, White Feather, the Blimp) and by investing them with preposterous physiognomies and a cowardly attitude that are contrasted with the iconographic norms represented by the company's regular superheroes (Superman, Batman, Robin, Green Lantern, Green Arrow, the Flash, etc.) on the cover of issue #6 (2/1968): Awkwardman is overly clumsy, the Blimp looks like a bloated balloon, Merryman is scrawny and cross-legged, Dumb Bunny evokes the sexualized Playboy bunnies of the 1960s and simultaneously spoofs the sexualized superheroines of mainstream comics (see figure 3.5).

Additional *MAD*-related elements include supplanting famous superheroes with cowardly antiheroes of little apparent fan appeal. The cover of issue #5 announces "our disgusting combo gets itself beheaded—you hope" and promises readers "this month's apathetic adventure," while the cover of *Showcase* #62 introduces "the greatest group of <u>rejects</u> in comics history!" This group will stumble through adventures and solve cases by accident, expressing a repetition-induced fatigue with conceits like Batman's deduction skills, his physical prowess, and his ability to defeat the villains not matter how super they may be.

More significant, however, was the metareflexive perspective that *The Inferior Five* (to a lesser degree) and Marvel's *Not Brand Echh* (to a greater degree) popularized. Both series aimed their parody at themselves, their competitors, and the genre at large. Both spoofed superhero groups such as DC's Justice League of America and Marvel's Fantastic Four. *The Inferior Five* inflated the number of the members of *The Fantastic Four* and deflated the powers of Marvel's mutants through their self-declared inferiority. In a similar vein, the title *Not Brand Echh* distinguished Marvel's supposedly superior superhero fare from the inferior works of other publishers, denigrated as "Brand Echh."

In *The Inferior Five,* the comic's self-awareness of its status as a parody takes deceptively simple forms. Recalling Silverstone and Drucker's parody of the Batman television series, Awkwardman complains about the length of the prologue in issue #6: "They're already

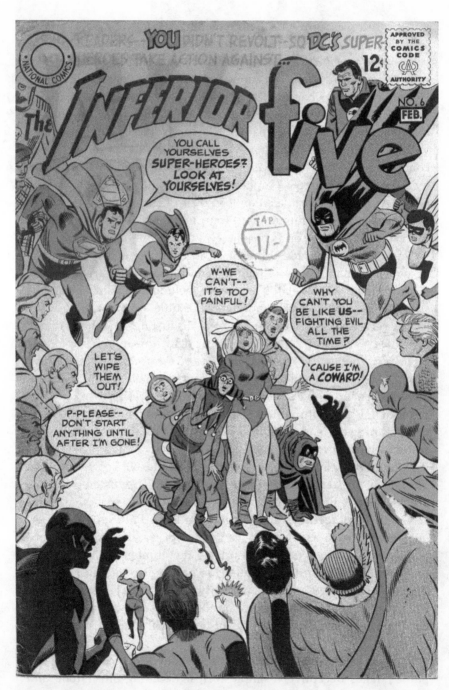

FIGURE 3.5. *The Inferior Five* #6 (2/1968). Cover by Mike Sekowsky and Mike Esposito ©
DC Comics.

at the bottom of page 5 and they haven't even started this issue!" The characters are also aware of being characters. Dumb Bunny notes: "Where are those little pictures of us with the introductions saying how I'm Dumb Bunny?" To which the Blimp responds: "They always have those introductory bits on the splash page!" What comes across as a few characters' funny reflections on what is conceived as a substandard story in fact anticipates potential reader responses—to this story, obviously, but also to nonparodic stories in the DC lineup. Therefore, the shift from serious superhero storytelling to parodic revision enables the inscription of imagined storyworld constructions into the serial multiverse: Dumb Bunny and her associates ventriloquize implied readers as they are perusing the story and simultaneously evaluating the quality of the storytelling. In doing so, and in voicing dissatisfaction within the pages of a comic book, they recognize potential weaknesses of their stories and display a knowingness about how these stories may be received to elevate DC from a mere seller of commercial entertainment to a critical—and arguably hip—assessor of their own products.

These are not the only metareflexive moments in *The Inferior Five*. Issue #6 provides a comical behind-the-scenes look at comics creation that recalls earlier (and more earnest) comics like "The True Story of Batman and Robin!" and "How Stan Lee and Steve Ditko Create Spider-Man!" The actual boss at DC, readers learn, is a pugnacious kid who pummels writers with a lollypop and orders them to write the next issue. The reaction of the employees says much about the public discourse in fanzines and on letter pages: "He can't," one of them explains. "He has to do a rewrite on a Lois Lane story and write three letter columns!" Another employee chimes in: "Besides that, he has to give me a full month's Direct Currents and edit the next Batman Giant!" A third one asks: "Do you think maybe I can get paid for this one?"[26] The following pages walk the reader through the production process, from writing the script ("The Inferior 5 battles the Blue Beagle, the Scarlet Wench, the Green Hairnet and the Black Belt!") and brainstorming for a cover (for which the artist pulls the Blimp across panel borders for a model) to inking and lettering the story and coloring the material. So much goes wrong that the writer does not want his name in the credits. Such depictions respond to, and

26. "Direct Currents" was a rubric under which DC (starting in the mid-1960s) advertised upcoming stories; "Giant" editions were special issues that reprinted classic stories.

also poke fun at, Marvel's bullpen fictions, acknowledging the growing public awareness of comics production and the attendant stratification of authorial authorities, something that Jason Dittmer calls "the author-ity of narrative" (2013, 4).

The Inferior Five #6 addressed authority issues in two ways. First, it raised questions about the tension between original and copy by referring to the advertising slogan "Accept no Substitutes." This slogan was popularized by Coca-Cola in the early decades of the twentieth century to assure customers they were buying the superior original brand instead of inferior imitations; "Demand the Genuine" was another slogan from the soda company. As the name of this parody indicates, however, readers were ironically dealing with an inferior substitute for DC's "original" superhero stories. But this substitute also claims the high ground and thereby an advanced level of intertextual engagement with its target texts. When DC's kid boss is introduced by the narrator as "the Boy Wonder," the actual Boy Wonder Robin swings into the next panel and intercedes: "Hold it! I, Robin, am the original, 100%, genuine, certified Boy Wonder! Accept no Substitutes!" The slogan is picked up again when the kid's attempts to make the comic book more like *MAD* are undermined by a sign in the background that reads, "Need a Super-Hero? Call the Original Superman! Accept no substitutes!" These claims to originality are immediately ridiculed when the kid demands, "Get out of this story or I'll have Bob Kane draw you so you look like an idiot!" To which Robin responds: "For 25 years he's been drawing me in this stupid red-and-green costume! What more can he do?" The story faults Kane for his aesthetic choices but does not register that he was no longer the major artist working on Batman and Robin. It makes sense, then, to read this scene as acknowledging the change from linear to multilinear forms of serial storytelling, where officially authorized stories compete with more and more—and more and more complexly authorized—narratives. Instead of one official Robin, controlled by a single author and publisher, readers were dealing with different Robins by various authors, including those working for DC, but also *MAD*'s Rubin and Gray Dickson/Sparrow and similar parodies.

A second type of authority claim involves snide comments and in-jokes about DC's main competitor, Marvel.[27] One placard at the

27. The rivalry between DC and Marvel resulted in DC's depiction of Marvel's Avengers as the Champions of Angor and Marvel's spoofing of DC's Justice League

entrance of DC's headquarters states, "M. M. M. S. Members will be brainwashed!"; the kid boss also speaks of "a competitor named Stanley" (Stan Lee) and his "monster . . . the Ridiculous Husk" (the Incredible Hulk). The letter page of issue #5 mentions "a letter every editor dreams of getting—a 14-pager filled with more superlatives than you'll find in the dictionary," whose enthusiastic writer, a Mr. Lee, had mistaken DC's *Inferior Five* with his own *Fantastic Four*. In these instances, the parody is not limited to specific Marvel series but extends to the metaverse sustaining these publications as well as the company's rhetorical strategies of self-promotion.

Cross-company jabs such as these indicate the kinds of readers parody comics targeted. While these readers sometimes remain implied, they are addressed directly in a familiar, knowing, and self-deprecating tone in other instances. Several covers of *The Inferior Five* hail them as "fanatical fans" (#1 and #5), while others leave little doubt about their spoof intentions: "Readers—you didn't revolt—so DC's superheroes take action against . . . The Inferior Five" (#6); "Buy it at your own risk! No refunds!" (#3). These forms of address simulate a sense of producers and consumers sharing a laugh about the parody and its playful prodding of genre conventions. They tell us much about the ways in which these parodies were straining to (re)position their readers while, at the same time, seeking to reflect as well as deflect these readers' critical responses to the regular series.

The phrase "fanatical fans" is picked up in the title of the letter page in *The Inferior Five*, "The Fanatical Fans Squawk!" It suggests a readership engaged in various types of fan practices, including letter writing, but one that was also aware of its potential impact on the stories. The statement that readers did not revolt against *The Inferior Five* and the warning that disappointed readers would not be refunded indicate that fan revolts and requests for refunds had been a factor in previous authorization conflicts. Recall Bob Butts's playful threat in *Batman* #186 (11/1966) that he would "come to [DC's] offices with half of fandom to picket and protest!" unless his demands for specific plot developments are met. It is unlikely that readers of parodies would have identified with stereotypically geeky fans, who are called "juveniles" by one of the editors and depicted as visitors to the DC offices in issue #6 (2/1968), where they exclaim: "This is my 57th time here"

as the Squadron Sinister in the 1960s and 1970s (Wolk 2013). Examples are *The Avengers* #69 (10/1969) by Roy Thomas and Sal Buscema and *Justice League of America* #87 (2/1971) by Mike Friedrich and Dick Dillin.

and "I'd grab some original art and run like crazy . . . only I can't move" (because the place is too packed). Such exclamations reflect the hierarchical structures that came along with fandom's increasing institutionalization, authorizing more mature and expert fans like Butts who can shake their heads with industry professionals about such immature fanboys.

Shortly after DC had launched *The Inferior Five,* Marvel followed with *Not Brand Echh* (8/1967–5/1969).[28] This move recalled the founding of Marvel as Timely Comics in the wake of DC's early successes and the creation of the Fantastic Four as a response to DC's Justice League of America. *Not Brand Echh* was a new actor in the parody game, and it provided new input. The name of the magazine derived from the advertising term "Brand X," which was used to refer to competing products and had already been transformed to "Brand Echh" as a designator for DC and other competitors in bulletins and letter pages. Considering the popularity of *MAD*'s parodies, it is feasible that Marvel's introduction of *Not Brand Echh* was not just a reaction to DC's parody comics. The cover of *MAD* #105 (9/1966, the "Special Summer 'Camp' Issue" featuring Silverstone and Drucker's "Bats-Man") by Norman Mingo had depicted an Adam West–inspired Batman looking in disgust at Alfred E. Neuman, who is dressed up as Robin. Batman makes a regurgitating gesture and utters a disgusted "ecch!"

Not Brand Echh combined the comic irreverence and wacky humor of *MAD* with the more conservative appeal of DC's *Inferior Five.* What we see here is a process of evolutionary differentiation, with the niche *Not Brand Echh* claimed being one where acts of authorized self-deprecation counter the challenges of unauthorized parodies. The slogan that introduces all *Not Brand Echh* issues acknowledges controversies over comic book authorization: "Who <u>Says</u> A Comic Book Has To Be Good?" While this joke signals self-irony and ridicules the comic book's apparent lack of quality while utilizing a hip consumerist aesthetic, it also raises veritable questions: Who has the power to determine whether a comic is good or not? Are "good" and "bad" the appropriate categories to measure a comic's appeal? Can pleasure be derived from reading "bad" comics that, according to mainstream opinion, are throwaway entertainment for dumb readers? And what

28. These comics were recently reprinted in Stan Lee et al., *Not Brand Echh: The Complete Collection* (2019).

role can parodies play in increasing the pleasures of comic book readers and attracting critical followers?

A big announcement on the cover of the first issue addresses these questions by advertising *Not Brand Echh* #1 as "The Comic Magazine for Non-Believers Who Hate Comic Magazines!" This hip statement promises a new kind of magazine that can be perceived as more sophisticated than the usual Marvel products and appeals to readers who might look down on comic books. That these readers were called "non-believers" in apparent opposition to Marvel's "true believers" indicates the complex narrative situation of *Not Brand Echh*. Rather than merely vying for new readers, the series also spoke to Marvel's regular audience but addressed it in unusual ways by experimenting with a new narrative mode. Yet the series also diversified established modes of storytelling. By employing an ironic undertone that only playfully undermined and thus in fact affirmed the basic "beliefs" of Marvel's comics, it allowed the more doubtful readers of the company's regular titles to remain "believers" in the metaverse.

Overall, the transmodification of superhero stories into *Not Brand Echh* followed three basic principles. First, the series presented an editorial voice (especially in paratexts such as opening splashes and letter pages) that differed from the "regular" voice of Marvel's nonparodic titles only in that it spoofed its own rhetoric and thus underscored—ironized, insulated, stabilized—Marvel's marketing hyperbole.[29] Second, popular characters like Spider-Man, the Fantastic Four, the Incredible Hulk, Thor, Iron Man, Captain America, Namor the Sub-Mariner, Daredevil, Wolverine, and the Silver Surfer were recast as comical antiheroes in a process that differed from DC's introduction of parodic characters (which were also spoofed in *Not Brand Echh*: Batman and Robin, Green Lantern, Superman). Since Marvel's superheroes were already flawed and melodramatic figures whose superheroism was frequently thrown into question when it clashed with everyday problems, they offered more room but also constituted greater challenges for spoofing than the more serious DC characters. Third, like DC's *Inferior Five*, the Marvel parodies contained in-jokes and satirical jabs at their main competitor, compelling readers to align themselves with their favorite publisher.

29. See Hutcheon: "The parodic text is granted a special license to transgress the limits of convention, but . . . it can do so only temporarily and only within the controlled confines authorized by the text parodied—. . . within the confines dictated by 'recognizability'" (1989, 100).

The editorial voice sounded loudest in the opening paratexts of *Not Brand Echh*. On the cover of the first issue, statements from Marvel employees offer mock endorsements. "Absolutely the funniest, most satirical humor, I ever read or wrote," Stan Lee exclaims; Roy Thomas quips: "Funny, that's just what I was gonna say"; Gary Friedrich announces in typical Marvel alliteration: "It's a rip-roarin' riot . . . I almost smiled once or twice"; Sol Brodsky concludes: "They said it couldn't be done!——So we didn't do it!" These obviously fake quotes lampoon Marvel's discourse of self-appraisal and acknowledge its commercial incentives, positioning Lee and his colleagues as hucksters peddling a product to an audience that likes this product precisely because it is aware of, and very much okay with, its hip consumerist style. They do so in a way that is both chatty and dialogic. These initial quotes use the authoritative powers of paratextual discourse to begin a funny conversation, inviting commentary and drawing readers into the Marvel metaverse. This continues on the contents pages and spreads into the actual stories. On the contents pages, we find comments like "if you think this page is a mess, wait'll you see what's comin'" (#2, 9/1967), "you bought it! So you've only yourself to blame!" (#4, 11/1967), and "didn't think we'd make it this far" (#5, 12/1967). In "Peter Pooper vs. Gnatman and Rotten" (Peter Parker vs. Batman and Robin) in issue #2, a sign on the wall recalling *MAD*'s visual gags defines the story as "another messed-up milestone in this, the Marble Age of Madness."[30] On the bottom of the page, the credits refer to the story as "wretchedly written by and pathetically perpetrated by Smilin' Stan Lee and Merry Marie Severin" (#2); in issue #6, the credits to "The Wedding of Spidey-Man, or . . . With This Ring, I Thee Web!" read: "Stan Lee devoutly wishes this is one story he didn't edit! And . . . Gary Friedrich and Marie Severin don't want the blame for it, either! But Al Kurzrok unabashedly admits he lettered it—because he didn't know any better!"

30. *MAD*'s influence shapes the cover illustration of Spider-Man in issue #2, which reveals a JJJ tattoo on his right wrist, insinuating that he is in love with J. Jawbone Junkton (J. Jonah Jameson). Instead of Peter's spider insignia, Aunt May's head appears on his chest. The hole in Spidey-Man's sock in the opening splash is classic *MAD*; one sign reads "Alfred lives!!"; Batman and Robin's depiction recalls Kurtzman and Wood's "Bat Boy and Rubin." Note also the Yiddish inflections on the cover of #6 ("a meshuguna mess of . . . off-beat oddballs!") and in the letter page of #5 ("this meshugina mag"). In the wedding story, one bystander speaks of "those furshlugginer flower people!" Spidey-Man's physique also recalls *MAD*'s style of caricature.

If such parodies embrace a self-deprecating tone, they do not drown out the regular Marvel discourse. In fact, by exaggerating this discourse, they reaffirm it. As already noted, there is an element of self-parody in Marvel's regular comic books. Yet this self-parody rarely undermines the integrity of the characters but pursues a strategy of self-affirmation through preemptive self-deflation. For readers familiar with this discourse, the network of references to the Marvel Age of Madness, to Lee's promotional spiel and the instant canonization of Marvel publications as "milestones," and to the company's efforts to create an image of the Marvel bullpen as an actual place with actual people working together (and not always wretchedly or pathetically) is certainly not attacked or revoked, but reinforced through the humorous, self-consciously hip perspective.

Like many spoofs and parodies, *Not Brand Echh* recast Marvel's superheroes as antiheroes and frequently reversed genre conventions. Issue #4 announces this reversal on the cover: "The Bad Guys Win!" In issue #6, Peter Pooper/Spidey-Man is a love-stricken teenager whose bedroom is filled with embarrassing objects: Aunt May's tonic for sickly boys, a trophy for being his high school's "boy voted most likely to be bugged," an anti–spider breath perfume bottle. To make matters worse, Aunt May is constantly worried: "Keep your hot water bottle on your little tum-tum—and don't let your tootsies stick out from under the cover," she advises. Spidey-Man wants to fight "baddies" but thinks "the Comical Code [Comics Code] should like me better as a lover." The plot changes from the usual mixture of action-driven adventure and melodrama to the comical exploration of an imaginative scenario: What if Spidey-Man got married? Like a true antihero, Spidey-Man does not want to battle supervillains like Doctor Octopus, the Vulture, Doctor Doom, the Green Goblin, Kraven the Hunter, or the Lizard and invites them to the wedding. Heroes and villains operate in the same fictional universe, but their conventional antagonism gives way to an image of character constellations as intimate family relations. These characters, whichever side of the good versus evil axis they may represent, sustain each other and secure the continuation of the series.

The only real suspense in the story is finding out who Spider-Man's wife will be: Peter's first love, Gwen Stacy, who first appeared in *Amazing Spider-Man* #31 (12/1965), or Mary Jane Watson, debuting in *Amazing Spider-Man* #42 (11/1966). Counting on the reader's knowledge of the Spider-Man universe, the story frustrates expecta-

tions with an anticlimactic revelation: Peter marries the tiny Wisp, a scantily clad creature who fits into the palm of his hand and is eventually crushed by Aunt May's flyswatter. This ending kills off the narrative possibilities of this what-if scenario, at least for the time being. But the genie was out of the bottle. It may have taken another two decades before the wedding scenario resurfaced in the canonical Spider-Man story "The Wedding" by Jim Shooter, Davis Micheline, et al. (*Amazing Spider-Man Annual* #21, 1987).[31] Yet as later stories like "What If . . . the Amazing Spider-Man Had Not Married Mary Jane?" (*What If?* vol. 2, #20, 12/1990) and "What If . . . the Amazing Spider-Man Had Married the Black Cat" (*What If?* vol. 2, #21, 1/1991) illustrate, parodies, what-if scenarios, and canonical stories are subject to the flux of serial narration.[32]

Besides depicting the clumsy efforts of familiar superheroes turned antiheroes, *Not Brand Echh* revived a character Lee had introduced in another one of Marvel's answers to *MAD,* a magazine called *Snafu* (three issues between late 1955 and early 1956): Forbush-Man, "The Way-Out Wonder!" References to the imaginary Irving Forbush had popped up in Bullpen Bulletins and letter pages from *Amazing Spider-Man* #25 (6/1965) onward.[33] Considering his status as a recurring character, it seems only logical that he would eventually transform from a verbal construct into a comic book antihero. Whatever the actual impetus may have been behind this transformation, it was presented in the Bullpen Bulletins of *Amazing Spider-Man* #48 (5/1967) as Marvel's eagerness to please the fans:

> We need help! You've got to give us the answer to the most burning question of the day! We get a zillion letters a week asking about Honest IRVING FORBUSH, the world's most famous non-entity! Now, our problem is this—would you like to see a picture of Honest Irv—or is it more fun to let him remain an unknown enigma? Your letters alone will give us the earth-shaking answer! (We kinda hope you'll decide that he should remain a mystery—because if

31. DC played with this plot option in "The Marriage of Batman and Batwoman" (*Batman* #122, 3/1959), where Batman's marriage to Batwoman is part of a dream.

32. Durand speaks of "a canon in flux" (2011a, 81).

33. For a succinct overview, see the YouTube video "The Origin and History of Forbush-Man" by Strange Brain Parts (2019).

we should ever actually have to dig up a picture of him, then we'll already be in a jam!)

Marvel readers apparently opted against keeping Forbush a mystery (if this ever was intended as an actual poll), so Forbush-Man made his debut in the first issue of *Not Brand Echh*. His looks, behavior, and background story could have been conceived by Kurtzman and Wood. He wears woolen underwear and a pot as a helmet, stomps around in oversized galoshes, and generally misreads what is going on around him (see figure 3.6). Instead of using his disguise "to strike terror into [the criminals'] hearts" (*Detective Comics* #27), as Batman does, Forbush-Man aims "to strike fear into the hearts of arch-fiends, super-villains, and head-waiters" (*Not Brand Echh* #5). He even receives his own origin story ("The Origin of . . . Forbush Man") in *Not Brand Echh* #5. Yet his overall conduct and appearance, however ridiculous, were not so far out of step with the company's regular characters that readers would necessarily have been discouraged from placing him in the same fictional universe. Appreciating Forbush-Man may have meant reappreciating established superheroes precisely because of their ability to authorize this hilarious antihero and vice versa. On the cover of issue #1, Spider-Man, the Fantastic Four, and other superheroes gaze at the new addition to the Marvel roster and exclaim in mock, Superman-inspired, awe: "It's absurd! It's insane! It's Forbush Man!" (#1).[34] Framing Forbush-Man thusly signaled the extension of the Marvel metaverse into the parodic mode and made this mode an integral part of the company's style.

Forbush-Man sought to control as well as capitalize on the disruptive potential of *MAD*'s parodies. That Marvel readers were aware of *MAD* magazine can be seen in a letter in issue #4 of *Not Brand Echh*, which praises several panels from the first issue as "rank[ing] with the best MAD ever did," recognizing the magazine as an ongoing benchmark for Marvel's parodies. Even after the demise of *Not Brand Echh*, Marvel continued to reference *MAD*, for instance in the new parody magazine *Crazy* (1972–1983), whose first issue brought back the notorious antihero, whose announcement on the cover, "Support peace, you super-baddies—or we'll clobber ya!," encapsulates

34. The Superman slogan is spoofed again in issue #5: "He's absurd!" "He's insane!" "He's Forbush Man!"

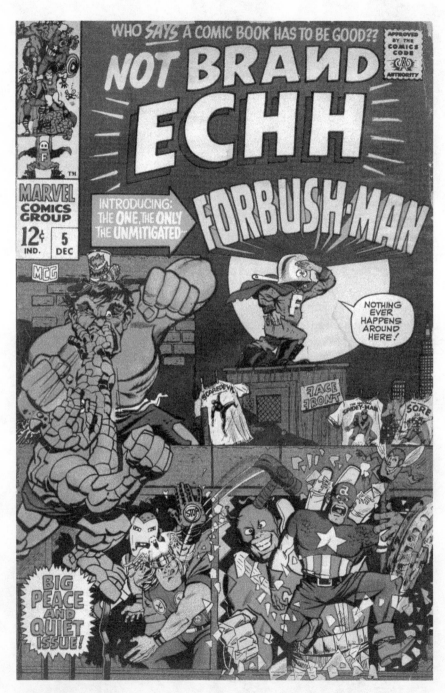

FIGURE 3.6. *Not Brand Echh* #5 (12/1967). Cover by Stan Lee, Jack Kirby, Tom Sutton, and Artie Simek © Marvel Comics.

the superhero's vigilante violence and the hypocrisy of US foreign policy (the peace symbol Forbush is holding up acknowledges the antiwar movement at the height of the Vietnam War).[35] The cover further brags about "starring the most far-out foul-up in all of Comicdom—Marvel's own Forbush-Man!" Voiced in the typical superlative rhetoric, it sought to authorize the parody via *MAD*: "Look out, world—Marvel Goes Mad!"[36]

The way in which Forbush-Man was initially introduced defused competing parodic interventions—by other publishers, by fanzines— because it defanged biting spoof responses to Marvel's regular superheroes. One example is the lampooning of the company's overblown rhetoric of fan influence on the opening splash in issue #5: "At last!! In response to virtually no requests at all, the Mighty Marble Comics Group perfidiously presents—." Another example is the spoofing of Marvel's alliterative slogans and laudatory labels: Forbush-Man is the "Pixilated Pride of Marbledom" as well as a third-rate superhero "Available for Weddings, Graduations[,] Bar Mitzvahs." In the letter pages, phrases like "masterpiece of mirthful mediocrity" and "your Bullpen's battiest book" (#4) connect Marvel's exceptionalist rhetoric with its hip devotion to self-parody. A third example is Forbush-Man's civilian identity as Irving Forbush, who does odd jobs in the Marvel basement and is a fan of comic book superheroes as well as a passionate autograph hunter—he appears as not just a parody of Clark Kent, but also of *MAD*'s abused office boy Clark Bent. A fourth example is his origin story, a wacky alternative account that signals an ultimately superior—knowing, self-aware, metareflexive—stance toward *MAD* and other parodies.[37] Forbush-Man is a cheap copy, albeit a funny one, of Spider-Man as he has been modeling himself after Peter Parker: "If only I could be a Super-hero! . . . I've already got a loving aunt—just like Spidey-Man!" (#5).

The objectives behind such parodies are discussed in the letter pages. In *Not Brand Echh* #5, Mark DeBellis writes: "The ultimate pur-

35. On the complex relationship between comic books and the Cold War era, including the Vietnam War, see Costello (2009); Goodrum (2016).

36. See also the *MAD* variant *Plop!* (DC, 1973–1976), which was edited by Joe Orlando and featured artists who had worked for *MAD*, like Sergio Aragones, Wally Wood, and Basil Wolverton.

37. The cover of issue #7 exclaims: "Wouldja believe. . ? A Nutty New ORIGIN issue!! The ORIGIN of the Fantastical Four!! The ORIGIN of Stuporman!!" The appearance of Stuporman evokes *MAD*'s Superduperman in a rewriting of another publisher's already spoofed character.

pose of N. B. E. (besides to make money!) is to make fun of the characters of your competitors' comic books, whether you asserted it or not." While this statement emphasizes commercial considerations, it also points to the rivalry between DC and Marvel as a factor for genre evolution. This rivalry becomes particularly productive through parodic variations such as "Peter Pooper vs. Gnatman and Rotten." Running in *Not Brand Echh* #2, it uses the cross-company crossover format that dedicated followers would have known from "Bestest League of America meets . . . Da Frantic Four" to upstage DC's Batman series as well as *The Inferior Five*. The opening splash depicts an upside-down Spidey-Man reading a comic book called *Defective Comics,* the name Roy Thomas had given to DC in his *Alter Ego* parody. Rather than read the competition between these companies solely as an antagonistic struggle over readers, we can also recognize these spoofing practices as means of managing the superhero's centrifugal sprawl.

This and many other humorous jabs in this story—jabs that are directed at DC, and at Batman in particular, but also inward, against Marvel and Spider-Man—reveal that comic book readers must have been aware of a broad array of superhero stories. They were probably less exclusively devoted to the comics of one company and more inclusive in their reading habits than the "true believer" label insinuates. The range of humorous references—renaming Batman as Gnatman and the excessive visual humor that follows: a gnat insignia on Gnatman's chest, a gnat at the end of Gnatman's gnaterang, the gnat signal lighting up the sky, the gnat gas in Gnatman's utility belt—can only be decoded by readers familiar with Batman's expanding selection of gadgets. Readers would have to have been aware not just of the basic storylines and character constellations of both DC and Marvel comics to fully appreciate the story. They were also offered more obscure and more rewarding references. For example, Rotten is a tiny cross-eyed boy with dark-rimmed glasses who reads a comic book named *Tales of Suspense: Captain America and Iron Man,* and when Gnatman and Rotten sign a contract with J. Jonah Jameson to get rid of Spidey-Man, they enlist the help of DC's lawyers. These references imply a reader immersed in Batman's and Spider-Man's fictional universes as well as in their metaverses. They range from a specific form of intertextuality, such as when a member of DC's superhero roster prefers Lee and Kirby's *Tales of Suspense* (1959–1968), to references

beyond text—think of DC's reputation as a company bent on suing
for copyright infringement.[38]

That Batman and Robin are recast as antiheroes and cowards
(Jameson: "The contract's already signed! . . . So cut out! Go make
like heroes!") and that Spidey-Man falls victim to his hubris when
he fails to attach his webbing, hobbling away with broken bones,
would not have surprised most readers. Gnatman is obviously ridi-
culed. He wears a jester's hat instead of a bat mask, Rotten jumps
into his arms when he learns that they have to go against Spidey-
Man, and he seeks to distract Spidey-Man by confessing, "I'm a fan
of yours." Spidey-Man, though exaggerated, largely stays within his
conventional character mold. Marvel's regular comics, the story sug-
gests, are funnier and more complex than DC's because they include
multilayered characters like Spider-Man, who can be tragic, melodra-
matic, or comedic and thus surpass DC's ostensibly one-dimensional
characters.

The intertextual web of references established in "Peter Pooper vs.
Gnatman and Rotten" and similar parodies suggests a series of nar-
rative complexities (Mittell 2006, 2015) that appeared relatively early
in the genre's history. In fact, we can detect the kinds of in-jokes that
Jason Mittell finds in later television series in comic book parodies
from the 1960s onward. They range from the more or less obvious,
like a Batman figure pinned to a building and labeled "The Blechh
Knight" in "The Origin of . . . Forbush-Man," to the more challeng-
ing, such as a footnote in "Peter Pooper vs. Gnatman and Rotten" that
explains Rotten's thoughts about "Ol' Mort Wienieburger" (DC edi-
tor Mort Weisinger) and is marked as an "In joke! If your name isn't
Wienieburger, forget it!—Sly Stan." They also highlight a metarefer-
ential perspective. In "The Wedding of Spidey-Man," Peter wonders
whether Aunt May is having a heart attack when she learns about his
plans to get married, and she retorts, "I'm not gonna kick off, stu-
pid—this is a comic book!"

This kind of metareferentiality is more pronounced in the letter
section of *Not Brand Echh*, titled "<u>This</u> is a Letters Page?" As noted,

38. In a letter in issue #6, Robert Zaragoza asks, "Can Marvel be sued for this?"
The answer is: "What the heck, even Brand Ecch must have a *sensahumor*! (Just
'cause we've never *noticed* it doesn't mean they haven't *got* one, y'know!)." In issue
#4, an ironic disclaimer in the opening splash ridicules copyright disputes: "Any
similarity to actual characters, living or dead, is actually just dumb luck!"

letters in superhero comics can be dubious, and exchanges between readers and editors in the parodies are even more contrived. But if we read these exchanges as practices through which parodies reflect on their own textual status, then authenticity is less important than questions of authorization. Two letters underscore the functions of letter pages as a company-controlled forum even in *Not Brand Echh*. The first letter by Norman Elfer, printed in issue #5, reads in part: "The entire purpose of our beloved N. B. E. is satire, and it cannot be appreciated for its richness unless the reader is aware of the rest of comicdom. You do not try to fake it out for the more ignorant with a plot they can grasp without knowing more. We, your readers, thank you for not insulting our intelligence." Elfer distinguishes between experts familiar with comicdom at large and ignorant readers unable to grasp the "richness" of Marvel's parodies. He claims authority by speaking as an intelligent representative of Marvel readers who appreciates a complex and thus "real" plot instead of a "fake" one.

The answer to Elfer's letter sanctions this position and offers a deal that promises readers quality entertainment and Marvel steady revenue:

> You can sure write a whole kaboodle of letters, for one thing, Norm! We can't remember any other new mag ever receiving as much enthusiastic fan mail as N. B. E., as you call it! As you've all guessed by now, it seems that mixed-up Marvel has another halcyon hit on its greedy little hands! So we'll hang in there trying—if you'll hang in there buying! Izzit a deal?

As this exchange indicates, letter pages define the relationship between comic book producers and readers, encapsulated in a collective "we" responsible for the successful stewardship of the series. They offer discursive space for the production and promotion of Marvel's style as part of the company's hip consumerism.

A letter by Anthony Roche in *Not Brand Echh* #6 satirizes the knowledgeable and intelligent readers Elder describes. While it does not refer directly to his letter, it points to a logical flaw in his argument: the assumption that one can distinguish between intelligent readers (capable of appreciating the richness of the parody) and ignorant readers (incapable of getting the humor) and then claim discursive authority on behalf of all readers. Roche offers a theory of comics

readership that troubles Elfer's assumptions as well as Eco's distinction between smart and naïve readers:

> Taking my portable tape recorder into the streets, I asked different comic fans their reaction to this new menace [i.e., *Not Brand Echh*]. Melvin T. Schnook, fanzine editor: "Aaargh! What is it?" Dr. Freddy F. Bales: "This is truly a masterpiece of literature and is a good example of the heights to which graphic art can attain. It plumbs a pseudo-theological world and plunges the reader into a phantasmagoria of mind-staggering memorabilia." Then I told him it was supposed to be funny! I learned that Stan Glee had been promptly kicked out of a comicon when the fans had read BRECHH, and Zack Kurvy had been unceremoniously dismissed from the Cartoonists Union.

The object of this ridicule is a pretentious, pseudo-academic fandom that seeks to elevate comic books to the status of literary masterpieces and is too infatuated with its own eloquence to appreciate the zany humor of *Not Brand Echh*. This type of fandom publishes quirky fanzines—Dr. Freddy F. Bales invokes Dr. Jerry G. Bails, the founder of *Alter-Ego* and *The Comicollector*. Moreover, it is so opinionated that it banishes creators like Lee (Stan Glee) and Kirby (Zack Kurvy) from fan-organized events like comic book conventions. Whether this letter was written by a witty reader as a means of deauthorizing competing conceptions of fandom or whether it was composed by an editor poking fun at fanzine culture by reiterating the company's institutional authority through benign ridicule is ultimately beyond the point. More important is that the increased awareness of the superhero genre did not only allow, but demanded, parodic revisions to thrive in an environment of networked fan practices.

Not Brand Echh and *The Inferior Five* were relatively short-lived publications, running for only thirteen issues between the summer of 1967 and spring of 1969 and for twelve issues (and three appearances in *Showcase* in 1966) between 1967 and 1972, respectively. Why Marvel and DC stopped producing them remains unclear, but it seems that they had served their evolutionary purpose and were no longer selling sufficient numbers to warrant continuation. They had allowed the companies to reassert creative and discursive authority at a time when readers sought outlets for genre critique, most prominently in letters and fanzines. Moreover, they had diversified the spectrum of

storytelling options and narrative modes through which superheroes could reach new readers while keeping long-term followers involved.

Revisionary Parodies: The Case of *1963*

Marvel had tried to capitalize on *MAD*'s popularity by publishing "three short-lived imitators" in 1953 and 1954 called *Crazy, Wild,* and *Riot* (Fingeroth 2019, 61). While these early ventures failed from a commercial standpoint, parody become a staple of the genre in the 1960s, marking a paradigm shift whose significance Grant Morrison acknowledged in *Animal Man* (1988–1990). Morrison featured members of the *Inferior Five* and caricatured versions of DC superheroes like Batman and Superman and also recalled some of *MAD*'s earlier depictions in stories like "Crisis" (#23, 5/1990) and "Monkey Puzzles" (#25, 7/1990). Instead of merely spoofing established superheroes, as earlier parodies had, he used allusions to the history of the genre, including its parodic elements, to authorize his (still ongoing) project of revising some of the genre's core concepts. This project, which was part of a larger trend toward revisionary narrative (Klock 2002) and references the genre's past in a palimpsestic rather than nostalgic fashion (Singer 2012, 8–9), entailed a metareflexive turn to the historiography of superhero comics and constituted an attempt to reimagine characters for a new readership.

In addition, publications like *What the—?!*, Marvel's self-described "Mag of Mirth and Mayhem," extended the parodic mode into the late 1980s and early 1990s. What was changing, however, were the controversies that spawned the parodies. Issue #3 (10/1988) featured "Peter Porker, The Spectacular Spider-Ham: Nevermore," a story whose title alluded to Edgar Allan Poe's "The Raven."[39] "Nevermore" utilizes parody's meta-potential by showing a comically distorted version of Marvel's offices, where an angry Spider-Ham complains about the scriptwriting: "Do you call this literature? Do you call this art?" The scene registers a wish to elevate superhero comics to a respected form of graphic literature. Taking matters into his own hands, Spider-Ham writes a new script: "Now here's a saga—suitable for 'Dark Kni—er, bookshelf format.'" The aborted reference

39. Spider-Ham had been introduced in the first issue of *Marvel Tails* in November 1983 and then appeared in the bimonthly parody series *Peter Porker, the Spectacular Spider-Ham*. The character was inspired by Dave Sim's *Cerebus*.

is to Frank Miller's *The Dark Knight Returns* and its publication as a graphic novel (DC's "Prestige Format"), which cemented Miller's celebrity status and allowed DC to market their publications as "serious" literature. Once the story is accepted, Spider-Ham hopes that "Frank Muler" and other celebrity creators will get to work on it, but when he eventually finds out that lesser-known professionals have adapted it into a cliché-ridden comic, he rants: "Taking a sensitive pig's story of love, honor and redemption and transforming it into this—this travesty of art? I wanted to be in a graphic novel in the worst way—this sure was it!" The parody thus targeted DC's attempt to sell superhero comics as artful storytelling and elevate their creators to the status of visionaries.[40] Its punch line symbolically crushes such aspirations when Spider-Ham gets his head snapped between the pages of a book titled "Spider-Ham Graphic Novel" (a narrative denouement that recalls Marvel's unsuccessful forays into graphic novel publishing). Marvel would continue to advertise their series as comic books, and not as graphic novels like DC, as this punch line suggested, but the spoof carried a deeper message: that DC's successful use of the graphic novel format brought a new level of cultural prestige to the publisher and increased the popularity of creators like Miller (who used to work for Marvel), a development that garnered ridicule because Marvel's own line of comic book trade paperbacks, published since 1982 (Jim Starlin's *The Death of Captain Marvel* being the first), had failed to attract much recognition.[41]

If Miller's *The Dark Knight Returns* and Moore and Bolland's *The Killing Joke*, two texts that were repeatedly spoofed in *What the—?!*, can be described as revisionary narratives, we may think of Moore's six-issue miniseries *1963* (4–10/1993) as a revisionary parody that counted on readers willing to accept what Eco describes as an "invit[ation] to play upon one's encyclopedic competence" (1990, 89). *1963* was written by Alan Moore (art by Rick Veitch, Dave Gibbons, Don Simpson, Steve Bissette, et al.), who had worked for DC (*Batman, Swamp Thing*) and launched a career as a freelance writer. It was published by Image Comics, which had been founded a year

40. See the appropriately named *Vertigo Visions: Artwork from the Cutting Edge of Comics* (Kwitney 2000), a collection of work published as part of DC's Vertigo imprint. On Vertigo as a provider of "mature" comics, see Round (2010); Dony (2014).

41. On Marvel's early attempts to establish itself as a publisher of graphic novels, see Clarke (2014).

prior to its release and directly challenged the authority of both Marvel and DC.[42] As its title suggests, *1963* spoofs Marvel comics of the early 1960s, especially their paratextual packaging, style, and stance. Moore's parody speaks to a "dynamic in the exchange between producer and audience, one based on the sophistication of both parties, each possessing knowledge formerly (and allegedly) accessible only to the semiotician," as Jim Collins notes about Batman's transmedia appearances in the late 1980s (1991, 170).

Each issue of *1963* responds to a Marvel series from the early 1960s. Issue #1 (*Mystery Incorporated*) recalls the *Fantastic Four*, issue #2 (*No One Escapes . . . The Fury*) is based on *Amazing Spider-Man*, issue #3 (*Tales of the Uncanny*) references Captain America and Iron Man, issue #4 (*Tales from Beyond*) evokes *The Incredible Hulk*, and so forth. The stories reproduce the graphic style of their precursor texts and contain a relatively low degree of visual parody. One could argue that the use of footnotes that refer to nonexisting texts, the telling of origin stories through flashbacks, and the tongue-in-cheek inclusion of self-reflexive references (the Mystery Incorporated team reads fan mail and Marvel comics) reward the reader's knowledge of early 1960s Marvel comics more than they attack, criticize, or cajole them. Rather than retroactively demolish the content and style of these works, *1963* revives and pays homage to them, perhaps to rank their relative sophistication over the flashier and more bombastic superhero comics of the present. In the process, they mobilize the authorizing powers of stories broadly classified as Silver Age enunciations of the genre and might thus be conceived as stylizations rather than parodies in the Bakhtinian sense, as rooted "in the different relation that obtains in each between the first utterance and the second," as Gary Saul Morson argues. "In parody, the two utterances are antithetical, in stylization corroborative" (1989, 66). As Bakhtin puts it: "Stylization stylizes another style in the direction of that style's own tasks," whereas parody "becomes the arena of conflict between two voices . . . [that] are not only detached and distanced . . . [but] hostilely counterposed" (1973, 160).

It is the paratextual repackaging of the early Marvel comics as revisionary parodies that turns *1963* from a work of stylization into an extended, and occasionally hostile, parody. This repackaging

42. Image released other parody publications that year: the two-issue *Splitting Image* by Don Simpson (3–4/1993) and Hilary Barta and Doug Rice's one-shot *Stupid* (5/1993).

begins with the cover of issue #1, which is drawn in the style of the Fantastic Four and characteristically announces "America's most exciting comic book!" It extends to the promotional spiel about forthcoming publications on the inside cover, spoofing Marvel as "the Bower of Brilliance," and it concludes with fake advertisements on the final pages and back cover: "An Amazing Invention—'Magic Art Appropriator'/Swipe any drawing in one minute! No talent! No lessons" (#2, 5/1999); "Shamed by You [sic] English?" (#1, 4/1993).[43] These advertisements reinforce the status of the comic as a commercial artifact consisting of texts as well as paratexts: of stories about superheroes as well as advertisements about fantasies that may come true, for instance, when readers learn to swipe artwork as a shortcut to fame. But it is the spoof versions of the "Bullpen Bulletin" (the "Sensational Sixty-Three Sweatshop Section!"[44]), "Stan's Soapbox" ("Al's Amphitheater!"), and the letter pages that most effectively display Moore's revisionary transmodification.

Around the same time, Marvel addressed questions of paratextual authenticity in their own parody comics but resolved them in a much more playful manner than Moore's 1963. Consider the following letter by Alex. Good-Malloy, printed in issue #26 (fall 1993) of What the—?!: "Do you ever make up letters?" The answer, cast in a faux French accent, undermines interest in the veracity of Marvel's paratextual discourse by projecting the debonair superiority of a pretentious art critic: "Yes, we do make up lettairs—all of the ones saying zat zey like WHAT THE ?! comics are fake!" In issue #6 of 1963 (1/1993), the answer to a letter by Durable Doug Winter had already confessed: "Doug, we hate to disappoint you, but . . . we're afraid that you're actually one of the readers that we made up. What we do is we get names out of the phone directory, switch the addresses around a little and BINGO! Another letters page finished!" While such exchanges were likely invented for humorous purposes, all the letters in 1963 are obviously fake. Ironically, they often come across as more authentic than the actual letters from the 1960s when they bring up issues that rarely made it into the earlier letter pages.

These fake letters and their editorial responses constitute an example of "counterpointed double-voicing" as they "call . . . attention to the presence of both author and reader positions within the

43. MAD had introduced the spoofing of advertisements in the 1950s.

44. Frank Miller associates early superhero comics with "a sweatshop atmosphere" (Sharrett 1991, 35).

text and to the manipulating power of some kind of 'authority'" (Hutcheon 1985, 88). The producer of the parody (Moore, in this case) is the "controlling agent" (88) of the textual discourse, whose authority supersedes that of the precursor texts and their authors. Readers are invited to reconstruct the intention of the parody and accept the authority of this controlling agent by acting as an ideal audience pre-positioned by the critical discourse of the fake letters. Even more so, the answers refashion Marvel's editorial voice into a series of hypocritical attempts to hide the exploitative working conditions of the bullpen, which is renamed Image Comics' "Sixty-Three sweatshop" and is led by Affable Al Moore (Marvel's "Smilin' Stan Lee," whom Kirby once satirized as "Funky Flashman"[45]). Ironically, the "critical distancing" (Hutcheon 1985, 41) inherent in parodic engagements with precursor texts emerges through the identification of Moore with Lee and Image with Marvel, an identification that feeds on a series of palimpsestic incongruities that knowledgeable readers would have appreciated.

The palimpsestic nature of Moore's parodies requires a sophisticated reader with near-encyclopedic competence (Eco 1990, 89) and a hyperconsciousness (Collins 1991) about the superhero's paratextual and epitextual backlog. This backlog resurfaces in a series of letters by a fictitious Ralph J. Hutty, an avid reader of *The Comics Gazette* (that is, *The Comics Journal*), who keeps pestering the editors of *1963* about the working conditions behind the façade of the Sixty-Three sweatshop. The allusion to *The Comics Journal* is part of the overall anachronism of *1963*; the stories and visual aesthetics of the miniseries may be modeled on Marvel's publications of the early 1960s, but the issues addressed in the exchanges between readers and editors relate to current controversies. In the first issue, Hutty reports that he has read an interview in *The Comics Gazette* with artist Roarin' Rick Veitch, who actually worked on the *1963* parodies:

> I have to admit that I'm kind of troubled by some of the things that
> Rick said, especially about everybody in the Sixty-Three sweatshop
> having to sign contracts that make Affable Al the sole owner of any

45. Kirby created Funky Flashman for DC's *Mister Miracle*, where the character made its first appearance in issue #6 (2/1972) and attacks Lee as a spineless, self-serving huckster who abuses colleagues like Roy Thomas (dubbed Houseroy) and who runs a "plantation" called the Mockingbird estate with "*Happy* slaves singing for the *family*" (qtd. in Fingeroth 2019, 233).

characters they create. . . . I admit there was a lot of stuff in the interview that I maybe didn't understand, like for example what does "Work for Hire" mean?

This faux-naïve question about the creators' working conditions and the faulty intimation that Lee owned the characters he claimed to have created point to the significance of the independent comics press, which offered authors and artists a forum for voicing their opinions outside the channels controlled by DC and Marvel and increased their authority as critics of exploitative industry practices.

Questions of creative ownership and copyrights were at the forefront of comics discourse in the early 1990s. This was doubly problematic for Marvel and DC. For one, this discourse created negative press about the industry's history of disenfranchising artists.[46] But it also strengthened the position of publishers like Fantagraphics or Dark Horse, which granted their artists creative ownership of their work more often, and it supported the founding of Image Comics, a substantial contestant to DC and Marvel's market leadership. In the context of these developments, the fictional editorial response to Hutty's fictitious letter is intriguing:

> Roarin' Rick's rib-tickling rant was just another example of the screwy, scatter-brained sense of silliness that's all a part of slaving in the sensational Sixty-Three sweatshop! The Roarin' One was indulging in some good-natured joshing by ribbing Affable Al about the perennial pesky pranks that our lovable leader persistently pulls around the office, like handing out wacky gag contracts for everyone to sign!

This answer relies on rhetorical tricks that range from smokescreen alliterations to the revealing use of "slaving" as a historically volatile expression. These tricks seek to redirect the discussion back to the chatty tone in which Marvel editors typically addressed their readers and draw attention away from issues of working conditions and creative ownership. For the informed reader to whom Moore addresses these statements, the fictionalized editor's ruse must fail. Through its ironic engagement with earlier paratexts, *1963* "direct[s] attention to

46. *The Comics Journal* #137 (9/1990) features an interview with Steve Bissette and Scott McCloud (Groth 1990b) about creators' rights and reprints a panel discussion on "Creator vs. Corporate Ownership." See also Wiater and Bissette (1993).

the *occasion . . . of its uttering* . . . to reveal the otherwise covert aspects of that occasion, including the unstated motives and assumptions of both the speaker and the assumed and presumably sympathetic audience" (Morson 1989, 71). The parody, in that sense, does not "quote 'out of context'" but "rather [engages] in 'too much' context—in a context the targets would rather have overlooked" (72). "Parody historicizes" by unearthing the precursor text's undisclosed "irony of origins" (78), a "denial of history" like Lee's attempts to cement his image as the creator of the Marvel universe serving as an "invitation to parody" (79).

The next letter from Hutty in issue #2 (5/1993) again refers to *The Comics Gazette*, this time to an article that had

> reprinted a memo from the Sixty-Three sweatshop with your letter-heading on it . . . , which was signed by Affable Al himself. The memo was talking about the up and coming DOUBLE IMAGE EIGHTY-PAGE GIANT ANNUAL, and there was this bit where Affable Al is talking about all the neat surprise guests that the annual will have, and he says "That ought to keep the little ***s happy!" I just wondered what it was that the Affable Al meant by that.

This passage recalls an infamous memo by Marvel's then editor in chief Jim Shooter, in which he had instructed his editors to explain to readers why some of the characters in the *Marvel Super Heroes Secret Wars* series (5/1984–4/1985) did not comply with previous incarnations. The memo read: "If you guys would talk up the wonderful job I'm doing, we could–trick the little fucks– make it clearer to the charming readers that, despite my stylistic differences from other writers, we're all writing the same characters" (qtd. in Pustz 1999, 60). When *The Comics Journal* published the memo in its "Newswatch Column" (#97, 4/1985), Marvel employees argued that the reference to the "little fucks" was typical of the company's in-house humor (Pustz 1999, 60), and not an expression of disregard for their customers. The explanation offered by the spoofed editors of *1963* ridicules this reaction by revising it into an act of shameless pandering: "You see, what Affable Al meant by that throwaway remark is exactly what it says: 'That ought to keep the little STARS happy!' Because that's how we think of each and every one of you . . . as little stars, scintillating soulfully in the shining skies of Sixty Three-dom . . . !"

While Hutty's first two letters highlighted the work-for-hire practices of Marvel and its editor in chief's dismissive attitude toward the audience, his letter in issue #3 turns to questions of original creation and the legal disenfranchisement of comic book writers and artists. Hutty is confused because he has read in *The Comics Gazette* that the superhero U. S. A. (Captain America) was created by Ed "The Emperor" Evans (i.e., Jack "King" Kirby, with echoes of Joe Shuster) in 1941 and was sold to Morrie Moorenheimer (i.e., Marvel's Martin Goodman, DC's Mort Weisinger) "for only thirty-eight dollars." Hutty's version clashes with Marvel's official story:

> I mean, in "Here Come The Heroes: The Sixty-Three Success Story" by Affable Al Moore, the Affable One reminisces for three pages about how HE created U. S. A. . . . and there's this bit about how Evans eventually went blind after producing thousands of pages of artwork in inadequate lighting conditions, whereupon he was fired, and how he is now living in a dumpster.

The letter evokes *Origins of Marvel Comics,* and it raises questions about rivaling claims to creative ownership and intellectual property, especially about Lee's tendency to take credit for stories and characters. The references to Goodman, Weisinger, and Evans's decreasing eyesight further evoke Superman creators Shuster and Siegel, who had sold the rights to Superman early on and fought largely unsuccessful legal battles to regain them for the rest of their lives.[47]

The answer to Hutty's letter expresses Moore's disregard for Marvel's and DC's treatment of writers and artists whose creations still generate massive revenue:

> We've done our best to make sure he has everything he needs for a contented retirement! . . . We make sure that every month, complimentary copies of all our cavortin' comics are delivered right to the doorstep of the Emperor's dumpster! Not that the optically obscured old-timer can actually read them, but he tells us they give him a "warm feeling" just the same.

47. On these battles, see Gordon (2017; 2020). Moore is commenting on what Gordon calls the popular "brand narrative" conveyed by Siegel and Shuster from 1975 onward, a narrative that "has three key elements: creators of Superman, lifelong pals, and victims of corporate greed" (2020, 107).

Pressed into commenting on such a cynical disposition, Al promptly uses his "Amphitheater" column in the next issue (#4, 7/1993) to explain his modus operandi. "I fondly remember working with all-time greats like Ed 'The Emperor' Evans, which was an incredible learning experience, at least for Ed," he writes. "I'd hand him a manuscript that said, 'Maybe something about space monster. Big fight. Good guys win.' . . . Then he'd take it away and tidy up a few loose ends like character concept, plot, panel breakdowns and suggested dialogue." The Marvel method spoofed here allowed Lee to claim credit even though others may have been more intimately involved with the construction of the stories, and Moore ensures that this information remains part of superhero history. But as my analysis above has shown, telling the history of Marvel Comics in the 1960s as a tale of good heroes like Kirby versus evil villains like Lee would have to substitute the productive uncertainties I have traced about acts of origination with a false sense of certainty.

Conclusion

The transformation of "Stan's Soapbox" into "Al's Amphitheater" illustrates what the fake Hutty letters and the imaginary editorial responses reveal: that Moore's parody ventures into the territory of satire, where the point of ridicule is no longer the precursor text but the whole disposition of the Marvel metaverse. Moore's use of forced alliterations undercuts Lee's prose by taking it to its extreme, mocking it as a form of authorial posturing in issue #4:

> It's that magical moment when your medicinally modified man-god materializes in the midst of a merely mortal mob and mulls over the many musings that move in a mysterious manner through his moderately mystical mentality!! My modest manifesto this month mostly makes mention of a massive and momentous mainstay of the medium, a maestro who manages to manufacture milestones of modern mythology month after month; a moral mediator; a magnificent masterpiece of maleness whose magnetic masculine musk makes maidens murmur messages of matrimony at his merest movement; a monarch; a man's man; Me.

This passage does not simply spoof Lee's verbal style. It attacks an editorial voice and flamboyant persona that ostensibly obscured a

system of economic exploitation. The implied author of Lee's columns is exposed as a pompous huckster with a penchant for gratuitous self-advertisement, while the implied author of Moore's parody, claiming "higher semantic authority than the original" (Morson 1989, 67), is encoded as a more sophisticated, more eloquent, and more honest speaker, beating Lee at his own game.

Moore uses "Al's Amphitheater" as a revisionary paratext to shatter the nostalgic lens through which readers in the 1990s perceived the Silver Age as the glorious moment of the superhero's revitalization. The columns ridicule Lee's moralizing tone and tendency to promote Marvel publications through superficial social consciousness messages. Issue #1 presents a pseudo-moralistic rumination on brotherhood that moves from a comical mode ("Brotherhood is the most important thing there is, because without it, we wouldn't have any brothers. No Marx Brothers. No Everly Brothers. Nothing.") to satire. Al lectures:

> We shouldn't be mean to minority groups. . . . Unlike our cowardly competitors, this company has always fearlessly taken the lead with regard to this sensitive issue . . . [;] we currently feature a person colored a light and inoffensive gray as a minor supporting character in one of our books, with plans to make him completely black in a few years time, assuming we don't get any negative feedback from our regional retailers.

This reactionary stance is cloaked in false rhetoric of bravery. Moore's ventriloquism exposes what is believed to be Lee's hypocrisy and preempts attempts to celebrate Marvel for a progressive political stance. At the end of the column, Al even calls on readers to buy two issues of every comic to help end bigotry.

Significantly, the satire of *1963* includes issues of gender and sexism. In issue #6 (10/1993), the bulletin turns to "Fabulous Flo Steinberg," who had begun her career as Lee's secretary and was frequently called "Stan's 'gal Friday'" or "our gregarious Gal Friday" (*Amazing Spider-Man* #25, 6/1965; #44, 1/1967), terms that capture the gendered hierarchies at Marvel. Moore reproduces Lee's alliterative discourse by describing Flo as "the funny, feisty and fascinating femme fatale who's [sic] features, formed from finest fancy, fanned the first faint flickering flames of our formative fantasies" and ending with a sexist joke about her serving coffee to the *1963* editors. This paratextual retcon emphasizes the discrepancy between Marvel's hip

style and what, from Moore's perspective, was a decidedly unhip sexual politics.

Marvel's sexual politics were, however, somewhat more complex. As I have noted, when reader Martin Ross asked the editors in a letter printed in *Fantastic Four* #6 (9/1962) to get rid of Susan Storm because "she never does anything," many fans sent letters of approval of the single female member of the team and asked for her role to be expanded and for her superpower (invisibility) to feature more prominently. By issue #13 (4/1963), even Ross relented, confessing that he had made a mistake and calling Sue "a friend of mine."[48] But Moore still had a point: Instead of celebrating the comic's "narrative irony, a hyperbolically 'campy' visual style, and a playful reworking of gender and sexual norms" (Fawaz 2016, 95), Moore is adamant about Marvel's less-than-progressive views on women's rights and gender equality. After all, the year when Ross recanted his position on Sue Storm was the same year that saw the publication of Betty Friedan's *The Feminine Mystique,* a far more provocative treatise on American gender roles than anything Marvel had to offer. It would take another decade before American feminists discovered the power of female superheroines ("Wonder Woman for President" on the cover of *Ms.* in 1972[49]), a decade and a half before Lee would "featur[e] the fabulous females of Marvel Comics" in *The Superhero Women* (1977b), and another thirty years before Trina Robbins would publish *The Great Women Superheroes* (1996).[50]

1963 took its critique of Marvel farther than any of the company's own parodies did, and it also surpassed the cross-company ribbing of DC's *The Inferior Five* and Marvel's *Not Brand Echh* and *What the—?!* Its referential complexity displayed Moore's understanding of comic book history and the industry practices of the present. It authorized an author as well as a reader versed in decades of superhero comics and familiar with many of the controversies that had shaped the metaverse. This author and reader had to know the names and reputations of different publishers, artists, writers, and editors to grasp the satire. They also had to be aware of many comics series and their

48. Fawaz discusses this at length (2016, 102–5).

49. See also Steinem (1972).

50. For a feminist perspective on superheroines, see L. Robinson (2004). On Wonder Woman, see Lepore (2014); Berlatsky (2015); Ormrod (2020). On gender in the superhero genre, see Stuller (2010); Cocca (2016); Goodrum, Prescott, and Smith (2018).

histories (including their production and reception contexts), conscious of the publishers' efforts to promote their historical significance, informed about legal disputes over trademark protection and ownership rights, and cognizant of the past and present of genre-inherent authorization conflicts. Instead of catering to a mainstream audience interested in entertaining stories and spectacular graphics, *1963* aimed for the more informed readers, the fans who deemed an awareness of comic book history and knowledge about the industry practices behind the paratextually and epitextually produced façade crucial to their engagement with the comics. If comic books faced increasing competition from superhero iterations in other media, such as television, computer games, and movies, parodies like *1963* sought to continue the authority of the printed narratives by refashioning the genre from a critical meta-perspective. They also paved the way for alternative treatments of superhero comics like Peter Bagge's "The Megalomanical Spider-Man" and "The Incorrigible Hulk" in *Strange Tales* #1–3 (2009), which functioned simultaneously as spoofs of Spider-Man and tributes to Spider-Man parodies (*MAD*, *Not Brand Echh*). Finally, they authorized many of the techniques and meta-perspectives that would shape superhero spoofs in the decades to come.

COLLECTING COMICS

Mummified Objects versus Mobile Archives

On December 6, 1964, the *New York Times* ran the short article "Old Comic Books Soar in Value; Dime Paperbacks of 1940's Are Now Collector Items" on page 141 of its New York edition. It was one of the first major recognitions of the collector's culture that was emerging in conjunction with letter pages, bulletins, and fanzines. The article emphasized the economic rather than the cultural validation of comics by proposing a trajectory from cheap entertainment that "tidy parents either threw away or sold by the hundred weight to the junk dealer" to more valuable "collector items" reeling in "prices ranging from \$2 to \$25 . . . at Louis Cohen's backdate magazine store on the Avenue of the Americas between 43d and 44th Streets." Most precious were comics from the 1940s like *Captain Marvel Adventures*, *Superman*, and *Batman*, the article states, suggesting that as early as the mid-1960s, readers were not only interested in present iterations of their favorite characters but also eager to preserve the genre's past.

The *New York Times* article provides a fairly detailed account of the people congregating at Louis Cohen's store. It evokes stereotypical notions of superhero fandom ("kooks") but then unfolds a broader tableau of "nostalgic men in their 20's and 30's, pop artists study-

ing the techniques of early cartoonists and colleges and universities studying the 'social attitudes' of the times that are reflected in them." This tableau registers the extension of superhero comics beyond the realm of the genre's juvenile followers, noting its appeal to older fans ("nostalgic men in their 20's and 30's"), its growing influence in the art world ("pop artists"), and its increasing academic recognition ("colleges and universities"). The store appears as an unofficial archive not only for those who read and research comics, but also for those who write and draw them, as "some of the cartoonists who originally created the comics visit [the] store occasionally to purchase their own works. They study them for story content for adaptation to today's society."[1]

As Bill Schelly suggests in *The Golden Age of Comic Book Fandom,* the article "set off a brush fire of copycat pieces in newspapers and periodicals across the country" (1999, 89), with headlines like "Leapin' Lizards! Old Comic Books Sell 6 for $40," "Old Comic Books Were Best, Milwaukee Collector Claims," and "Nothing Funny in Vintage Books' Prices" (87). In its February 15, 1965, edition, *Newsweek* tapped into the same discourse in an article titled "Superfans and Batmaniacs": "Able to draw 1,000 times its original price! Is it a bird? A plane? No—it's the June 1938 issue of Action Comics, which introduced the immortal Superman to the lists of American folk idols and has since become a $100 collector's item among the country's band of first-edition comic-book fanatics." Such expressions of surprise about the value of the periodicals rarely noted that a growing number of collectors was actively engaged in establishing a much wider network. As Jules Feiffer observed around the same time:

> There are old comic book fans. A small army of them. Men in their
> thirties and early forties wearing school ties and tweeds, teaching
> in universities, writing ad copy, writing for chic magazines, writing
> novels—who continue to be addicts, who save old comic books, buy
> them, trade them, and will, many of them, pay up to fifty dollars
> for the first issues of Superman or Batman; who publish and mail
> to each other mimeographed "fanzines"—strange little publications

1. By the late 1970s and in the 1980s, the comic book shop, of which Mr. Cohen's store was a forerunner, became a central hub of fan interaction (Swafford 2012). Woo views the comic book store as a space for the "reproduction of comic-book fandom" (2011, 127).

deifying what is looked back on as "the golden age of comic books." (1965, 185)

Comics historians point to the 1960s as the moment when "comics became collectible—that is, sought after for preservation by fans of the medium—for the first time" (Pustz 1999, 15). And while some have argued that collecting was largely an industry-driven effort (Sullivan 1995), a more complex story comes into view when we follow the different actors involved in collecting and archiving comic books.

Collecting and Archiving

It is certainly true that the major publishers promoted their comics as collectables to encourage brand loyalty and secure long-term investment in their products. Marvel advertised their comics as "collectors' items" by the early 1960s, for instance on the cover of *The Fantastic Four* #11 (2/1963) and throughout their bulletins, with announcements about upcoming releases like "This ish will be a collector's item before the year's end" (*Amazing Spider-Man* #27, 8/1965) or "Each ish is certain to become a treasured collectors' item minutes after it's off the press!" (*Amazing Spider-Man* #34, 3/1966). When the company introduced the *Spectacular Spider-Man* series in 1976, the cover prominently announced: "First Issue! Collector's Edition!" Readers also talked about their collecting efforts in (perhaps strategically selected or, in some cases, invented) letters. "Many of us are probably collectors or followers of many different magazines," Doug Austin writes in *Amazing Spider-Man* #10 (3/1964); "a couple of my friends and I have formed a library of Marvel Comics, and we're very proud of our collection," Mel Brown reports in issue #33 (2/1966), emphasizing the social aspects of reading and collecting. Recognizing the commercial potential of this discourse, Marvel launched a series called "Marvel Collectors' Item Classics" (1965–1969) that reprinted "classic" stories, formally acknowledged collecting as a legitimate activity, and created an institutionally sanctioned form of keeping a selection of older stories in print.

A similar discourse was taking place at DC. In a letter printed in *Batman* #156 (6/1963), Jan Kodner writes: "I have been a Batman fan for a long time, and this [February issue of *Batman*] is the best comic

of my whole collection." I have already cited Mike Friedrich's letter from *Batman* #166 (9/1964), in which he uses his extensive collection to establish his authority as a critic: "Before I begin, I'd like to tell you (or rather boast) that I have been reading *Batman* for quite a few years now and my collection goes back to the early 1940's. So I consider myself a fairly good authority on *Batman*."[2]

This discourse did not appear out of nowhere, as DC had started to encourage reader interest in the history of their characters in the late 1950s and early 1960s. Predating Marvel's celebration of collector's items, the company had run an advertisement in *Batman* #134 (9/1960) to promote their *Superman Giant Annual*. "Presenting the Greatest Superman Stories Ever Told!," the ad announced:

> Now you can read them <u>all</u> in one giant collection! See Superman's first exploits! Read the first Supergirl story! Learn how Jimmy Olsen met Superboy! See the origin of Lori the Mermaid! Witness the "Execution of Krypto!" [F]rom Lois Lane #1 "The Witch of Metropolis!" Plus many other favorite stories of yester-year! On sale everywhere!

Superman was not the only character DC afforded with a succession of eighty-page *Giant Annual* editions, a new format that facilitated the reprinting of older material and provided readers with a sense of complete access ("read them <u>all</u>") to the sprawling body of backstories. The company published dozens of collections, including several devoted to Batman, in an effort to canonize particular characters and specific elements of their history, especially their origins—thus the focus on first appearances, first meetings, and first stories in the *Superman* ad. In the initial *Giant Batman Annual* (6/1961), references to origins abound: "'HOW TO BE THE BATMAN!' including the ORIGIN," the cover proclaims, promising information about "the origins of the Batcave," "strange costumes," "thrilling escapes," "tales of the bat-signal," and "amazing inventions plus secrets of the UTILITY BELT and the famed BATARANGS." I read these annuals as an attempt to control serial sprawl by reiterating authorized versions of key characters as well as an attempt to counter the problem

2. Friedrich extended his status as an expert fan when he turned to the pages of *Batmania* #19 (9/1974) to recount how he managed to have a story published by DC ("Blood, Sweat, and Tears"). An author's note below the article lists Friedrich's published work with DC and also identifies him as the owner of an underground comics company and magazine.

of serial forgetfulness in long-running series, where older stories may fade from the memories of readers and creators alike and where new followers may be unaware of a character's or series' history. What we also see is the emergence of an archival sensibility: the start of an archive of superhero stories that needs narratives of beginning to constitute its special power and authority over the documentation and interpretation of comic book history.

An advertisement for the *Secret Origins Annual* in *Batman* #141 (8/1961) added another facet to this interest in origins: "At last! The giant comic book you've dreamed about is here," the ad declared. "A collection of original origin stories of our favorite superstars . . . The Superman-Batman Team • Wonder Woman • Flash • Green Lantern • J'onn J'onzz • Challengers of the Unknown • Adam Strange • Green Arrow . . . All together in one magazine! Don't miss this spectacular issue! You'll treasure it all your life!" The title of the annual conveys a sense of mystery, promising access to special secrets if readers buy the comic. The fact that it offers "original origin" stories insinuates that there are different versions and implies that the past is flexible rather than fixed. Pitching the annual as a treasure worth holding on to for life works against the public perception of comics as disposable objects. Annuals offered at once a nostalgic gaze into the past by reprinting "favorite stories of yester-year," as the *Superman* ad suggests, and a manual for making sense of current stories, whose prehistory they selectively retell for an audience that, in many cases, was not even born at the genre's onset. These publications bring certain stories from the archive back into circulation and invest ongoing narratives with historical currency.

Beyond the world of comics, and only a year after "Old Comic Books Soar in Value" appeared, *Newsday* ran David Zinman's article "Comicdom's Cult of Collectors" (November 4, 1965), a relatively nuanced take on the emerging collectors' culture whose interest in superhero comics of the past was matched by formats like the annuals. The article describes the Academy of Comic-Book Fans and Collectors, the first nationwide organization for fans founded by Jerry Bails, as "a close-knit, bustling group. Collectors correspond, publish at least 30 fan magazines, hold national conventions and costume parties, swap back issues, and buy and sell old magazines." The academy had introduced the annual Alley Awards in 1962, which recognized the best comics and creators of the previous year and were promoted heavily in fanzines like *Alter-Ego*, providing an orga-

nizational structure and forum for the emerging network of comics fandom.[3]

Zinman derived his insights from visiting David A. Kaler, the executive secretary of the Academy of Comic-Book Fans and Collectors, and from interviews with doubtful industry professionals like Bill Finger, who speaks of a "cult of collectors," and Pat Masuli, executive editor of Charlton Comics, who wonders whether fans have much impact on the genre's development. While the article displays a certain irritation with the "age disparity" and resulting "friction" between grown-up fans like Kaler and the genre's underage followers—"Many collectors are men in their 20s and 30s who treasure boyhood memories of the derring-do of the costumed superheroes . . . [b]ut the majority of the academy's 2,000 members are children and teenagers"—it also conveys information about this new culture. "Collectors even have their own language," Zinman writes. "A 'fanzine' is an amateur fan magazine, a 'crudzine' is a bad fan magazine, 'faned' is a fan editor, 'pro' is a professional in the comic field, and 'comicdom' is the world of comic enthusiasts." The article finally illustrates the close connection between fandom and industry, as well as the permeability of the border between comics creation and reception, when Zinman states that Kaler "shares a two-room, ground-floor apartment with two other comic book devotees who have recently become strip writers for the Marvel Comics group . . .—Roy Thomas, 24, and Dennis O'Neil, 26" (a photograph of the three men in front of a shelf filled with comics is included).

Taken together, paratextual chatter, formats like DC's *Giant Annuals* and Marvel's *Collectors' Item Classics* series, and mainstream newspaper coverage indicate that today's interest in the history of the genre and the preservation of its past is not an entirely new phenomenon but rather the latest realization of a popular genre practice.[4] In the 1960s, it was fan publications like *The Guidebook to Comics Fandom*, published by Bill Spicer, with a grading system and sections on "Why People Collect Comics," "A Glossary of Fan Terms," and "Col-

3. Awards are a typical element of fandom. *Batmania* #3 (1/1965) introduced the annual "Batmania Ballot," encouraging fans to vote for their favorite stories and covers of *Detective Comics* and *Batman*.

4. Marvel also introduced a line of paperback anthologies that reprinted essential stories in a black-and-white format. *The Amazing Spider-Man Collector's Album* (Lancer Books, 1966) promotes "His Origins . . . His Exploits . . . His Enemies plus Never-Revealed Secrets" on the cover.

lecting Back Issues" written by Jerry Bails (Schelly 1999, 93), that con-
stituted collecting as a central comics-related practice.[5] Ed Lahmann's
"So—You Want to Collect Comics?" in *Alter Ego* #5 (3/1963) compiled
"a basic list [of superhero comics] to give the new collector some idea
of what comprises a well-rounded collection" (Thomas and Schelly
2008, 59), while Biljo White had featured a regular "Profile on Collec-
tors" section in his *Komix Illustrated* fanzine since 1962 and included
a similar section in *Batmania*. White became a well-known collector in
his own right. His "White House of Comics"—a cinder-block build-
ing in his backyard—soon proved too small to contain his collection
of Golden Age comics (Schelly 1999, 47–48) and was supplanted by a
bigger archival space, which White dubbed "The New White House
of Comics" in a detailed portrait of the place, including information
about its ordering system (*Batmania* #15, 5/1967b, 17–20).

All of these activities transformed individual readers and collec-
tors into a community of fans who not only consumed the comics
but became actively involved in assembling, ordering, discussing,
and preserving the first twenty-plus years of the genre. They fostered
the professionalization of collecting that enabled the *Overstreet Comic
Book Price Guide* (since 1970), an annual publication that covers every-
thing concerning the collection of Golden Age comics. A little over a
decade later, Marvel reinforced the centrality of collecting as a genre
practice through a special bonus insert in *Amazing Spider-Man* #234
(11/1982), which was titled *The Marvel Guide to Collecting Comics* and
written by Mark Burbey and edited by Mike Friedrich, and which
walked interested readers through the process of starting a collection.

Publications like the *Overstreet Comic Book Price Guide* and *The
Marvel Guide to Collecting Comics* anticipated the speculators' boom of
the 1980s and '90s. This was the time when "new investors enter[ed]
the comic book market," new publishers like Valiant Comics and
Image Comics appeared, and "gimmick publishing . . . attract[ed]
new readers and create[d] artificial scarcities that would drive invest-
ment prices, heightened media interest in the prices of rare comics in
the wake of the first Sotheby's auction, and the arrival of a monthly
price guide in the form of *Wizard*" (Beaty 2012, 168–69). In this
period, trade publications like *Diamond Dialogue* profiled prominent

5. Some fanzines announced the centrality of collecting in their titles: *Comi-
collector* (early 1960s) and *The Comic Collector's News*, the first "fanzine devoted
exclusively to comic art in the 1940s" (Schelly 1999, 16). This tradition is continued
through magazines like the *Jack Kirby Collector* (TwoMorrows), launched in 1994.

comics collectors (reviving White's "Profile on Collectors"), Sotheby's and Christie's auctioned off the rarest issues and most valuable collections of old superhero comics (taking the most spectacular items from stores like Mr. Cohen's and private collectors), and magazines like *Wizard* fanned the flames of the boom by promoting comics as an investment through a monthly updated price guide (delivering more up-to-date information than the *Overstreet Comic Book Price Guide*). The boom ended in the mid-1990s, which is also when collectors confronted new challenges like the growing eminence of graphic novels that "generally do not appreciate in value" (Overstreet in "The 1990 Market Report," qtd. in Beaty 2012, 162) and the migration of many activities to online platforms.

Writing critically about this boom-and-bust period was *Comics Journal* columnist Darcy Sullivan. A staunch critic of Marvel's hip consumerism, or "kiddie hustle" (Sullivan 1992), Sullivan wrote in a piece called "More from the Moolahverse": "Comics are so object-based . . . that the most vital way of interacting with them is to engage their function as objects, rather than as narrative vehicles; that is, to buy them. . . . Buying comics (or 'collecting' them, to use the industry's aggrandizing jargon) is more important than reading them" (1995, 4). Sullivan foregrounds the agency of comic books as physical objects, or nonhuman actors in my Latourian terminology. He does not idealize collecting as a personally meaningful activity but recognizes that framing comics as collectibles follows commercial considerations and is sanctioned by a particular industry jargon. Though it is difficult to ascertain whether buying and collecting comic books have historically been more important than reading them, Sullivan is right to read these comics as more than "narrative vehicles," even though his attribution of agency to the industry alone is shortsighted. As I argue throughout this book, superhero comics evolve through a combination of material artifact, serialized content, paratextual discourse, and epitextual commentary.

Recognizing the materiality of superhero comics and their agency as serial physical objects, this chapter examines collecting and archiving as central authorization practices.[6] I am particularly interested in an unusual publication format that encapsulates the connection between collecting/archiving and genre evolution: the so-called

6. Beaty and Woo discuss related practices of listing, ranking, and curating (2016, 1–2).

museums-in-a-book that were released by Running Press and officially licensed by DC and Marvel: *The Marvel Vault: A Museum-in-a-Book™ with Rare Collectibles from the World of Marvel* (Roy Thomas and Peter Sanderson, 2007), *The DC Vault: A Museum-in-a-Book™ Featuring Rare Collectibles from the DC Universe* (Martin Pasko, 2008), *The Batman Vault: A Museum-in-a-Book™ Featuring Rare Collectibles from the Batcave* (Robert Greenberger and Matthew K. Manning, 2009), and *The Spider-Man Vault: A Museum-in-a-Book™ with Rare Collectibles Spun from Marvel's Web* (Peter A. David and Robert Greenberger, 2010). As my analysis of and beyond these books will show, while perhaps more obviously involved with the preservation and conservation of the genre's past, collecting and archiving also enable the superhero's continuation and proliferation through the creation of what I call mobile archives. I read these practices as instruments of serial memory management revolving around the productive tension between musealization, according to which superhero comics can take on the status of "archivally mummified" objects (Huyssen 1995, 19, 33) that mostly commemorate the past, and mobilization, through which they come to function as archives that activate the past to authorize present and future iterations. "Readers of comics are . . . (not always unfairly) stereotyped as obsessive collectors," Jared Gardner suggests, and "the desire to possess comics—to hunt down every stray work by a favorite creator, to contain and reassemble the scattered pieces of a fragmentary comics universe—is a familiar one for many readers" (2012, 173). In the case of the superhero's multidecade multiverses, the obsession to collect fragments into a larger whole is an especially vexing endeavor. It necessitates not only collaborative efforts among collectors and archivists but specific narrative mechanisms, such as retcons and reboots as well as different forms of continuity and multiplicity management, to bring at least a semblance of order to an otherwise unruly corpus.

Viewed through a Latourian lens, following the actors not only means following "the traces left behind by their activity of forming and dismantling groups" (2005, 29) but also examining how these actors utilize their own tracing practices (from indexing to cataloguing) to secure the genre's ongoing "circulation" and "collective existence" (36, 12). I understand collecting and archiving as activities of reassembling a constantly evolving comics collective. This understanding embraces recent conceptions of archives as dynamic processes rather than stable repositories. Marianne Hirsch and Diana

Taylor view them as "engines of circulation" shaped by practices "of selecting, ordering and preserving the past" that challenge more conventional "notions of fixity, authenticity, and legitimacy." The authors see "the archive as the site of potentiality, provisionality, and contingency," as well as a "site for critical reflection and contestation of its social, political, and historical construction" (2012, n. pag.). As Aleida Assmann maintains, "the archive is not just a place in which documents from the past are preserved; it is also a place where the past is constructed and produced" (2011, 13). In Jacques Derrida's seminal formulation: "Archivization produces as much as it records the event" (1995, 17).

Archives thus have agency. They "are not just sources or repositories as such, but constitute full-fledged historical actors" (Burton 2005, 7). As noted, Latour advocates the study of specific workspaces, such as the artisan's workshop and the engineer's design department, where objects become active "through meetings, plans, sketches, regulations, and trials," as well as of "accidents, breakdowns, and strikes" as occasions where "silent intermediaries become full-blown mediators" (2005, 80, 81). Studying workspaces means thinking about when and how private acts of collecting become mediators of genre evolution as publicly displayed and shared activities that authorize new actors—retailers like Mr. Cohen selling back issues, collectors like Biljo White searching for missing items, experts like Jerry Bails and Bob Overstreet developing grading rubrics and pricing systems. For Latour, rediscovering the hidden or forgotten agency of objects "by using archives, documents, memoirs, museum collections" means "artificially produc[ing], through historians' accounts, the state of crisis in which machines, devices, and implements were born" (81). But the archive itself can be studied from an actor-network perspective. "For archives do not simply arrive or emerge fully formed," Antoinette Burton maintains, "nor are they innocent of struggles for power in either their creation or their interpretive applications" (2005, 6).[7]

Burton suggests that only by investigating "the backstage of archives—how they are constructed, policed, experienced, and manipulated" (2005, 7)—can we become fully aware of their agency. In superhero comics, this awareness has always been present, as practices of collecting foreground the agency of the material carrier medium to be allocated and archived. For a serial genre, the state

7. For an actor-network perspective on collecting, see Cheetham (2012).

of crisis these practices produce and reflect is not an artificial one, but one that is germane. Collecting and archiving are logical consequences of this perpetual state of crisis, and they have been routine maneuvers since the 1960s. As I argue in this chapter, they are key mediators in the genre's centripetal/centrifugal dialectic.

Collecting Batman

The "drive to serialize" that Christoph Lindner identifies as "an endemic feature of our twenty-first century, hypermediated world" (2014, ix) is often a drive toward conservation and preservation, or musealization, rather than toward innovation and radical change.[8] Take Chip Kidd's *Batman Collected* (1996), a 250-plus-page hardcover book devoted to the author's lifelong fascination with DC's caped crusader, especially the merchandise inspired by this serial figure.[9] In size and weight alone, the book differs from the flimsy floppies of the genre's early years. The high-quality paper, professional photography by Geoff Spear, and annotations of the displayed materials create a discrepancy between the cheap ephemerality of some of the content and the museum-like aura insinuated by the book's aestheticized delivery.

Batman Collected is an early example of publications that transport superhero history from the brittle pages of comic books into the sturdier and more respectable format of the bound book. Later publications like Roy Thomas's *The Stan Lee Story* (2019) and similar books by Taschen have driven the bookishness of *Batman Collected* to an extreme, as if to suggest that what used to be downgraded as an ephemeral form of juvenile escapism has finally accrued the gravitas of legitimate history. *The Stan Lee Story* weighs a whopping seventeen pounds and is many times bigger than any conventional history book. Lee's foreword serves as an authenticating gesture—marveling about his life as it is "chronicled in such a fantastic volume"—and comments on its size and heft, congratulating the readers who "truly belong in our wondrous world of Marvel super heroes" if they are "able to lift this book" and emphasizing the haptic pleasures of handling this massive tome: "I'd love to write more, but I'm sitting with

8. See also Baetens and Frey (2015, ch. 9).

9. Daniels's *Batman: The Complete History* (1999) also presents a substantial selection of merchandise and toys.

a copy of what is possibly the world's biggest book and I can't wait to read it myself" (2019, 7). More than two decades earlier, *Batman Collected* had participated in the "transition from the book's declining technical function to its artistic auratization" in an early phase of digitization, when books and libraries "ceded their predominance as media of cultural memory to other data-carriers" and sought to compensate for their loss of cultural authority by acting "as central metaphors for that memory" (Assmann 2011, 346). This is also the moment when the comics industry underwent a process of reconsolidation after the bust of the speculators' bubble.

Batman Collected is a thoroughly object-centered publication that foregrounds the materiality of the items in Kidd's collection. This includes facsimile reproductions of original sketches by Carmine Infantino, Frank Miller, and David Mazzucchelli, but also seemingly trivial pieces of merchandise, such as a Batman bubble bath bottle or toothbrush from the 1960s. For a collector like Kidd, these items have value because they are twice enchanted: by Batman's mythical resonance and by personal memories of a childhood obsession never outgrown. If the sketches are more easily presented as treasures from Kidd's private archive and mark an idealized moment of artistic creation that precedes the act of mechanical reproduction (Walter Benjamin) that would eventually turn them into mass artifacts (never mind the fact that the original artwork was created according to specific genre conventions and followed editorial constraints and material limitations), the bath bottle, toothbrush, and many other licensed household items in *Batman Collected* surface from what Assmann calls a "storehouse for cultural relicts . . . [that] have only lost their immediate addressees . . . [and] are de-contextualized and disconnected from their former frames which had authorized them or determined their meaning" (2008, 99). Part of the aim is to rescue these relicts from oblivion, to recontextualize and reframe them as collectibles and "give . . . them the chance of a second life" (103), transforming them from forgotten waste products that outlasted their usefulness to carriers of personal and cultural memory. By collecting, cataloguing, and publicly displaying these products, *Batman Collected* unearths "archives of the forgotten artifacts and ephemera of American popular culture" (Gardner 2012, 150) to promote a history that transcends a narrow focus on the stories and their creators by authorizing the collector as an actor in genre evolution. The ancillary products *Batman Collected* showcases, especially merchandise but

also fan-created artifacts like needlepoint representations of Batman and Robin or self-created Bat-vehicles, speak to a history that takes the comics' embeddedness in postwar consumption culture seriously and considers this embeddedness a central reason for the superhero's popularity.

Kidd appears as a "super collector" (Geraghty 2014, 130) and "curatorial consumer" (Tankel and Murphy 1998, 66) who uses the authority of his collection and his long-term involvement in the industry to promote his own take on the superhero. The curatorial consumer, Jonathan David Tankel and Keith Murphy suggest, acts as "a curator, an archivist, and a preservationist for artifacts that have meaning for their cultural lives" and primarily seeks "aesthetic pleasure and personal satisfaction," rather than financial gain, from artifacts commonly derided as worthless (1998, 66). Kidd does so by minimizing the distance between the most mundane objects—the back cover underneath the dust jacket looks like an old cardboard display carton with a faded Batman logo, remnants of tape, and an express sticker—and revered museum artifacts, referenced through a molded Italian Batman plastic glider from 1966 that casts the super-hero in a Tutankhamun-like, mummified pose. In Kidd's collection, there is no clear distinction between high and low, between the canon and the trash can. Referencing the work of Krzysztof Pomian, Assmann notes, "a part of what is now treasured in the archive may . . . once have been classified as junk." In Kidd's case, this includes display stands, shopping boxes, and other forms of packaging that most sellers and consumers would have thrown away as soon as they "lost their primary function" but that are salvaged and "endowed with the quality of relics that have been spared the 'tooth of time'" (Assmann 2011, 369).[10] For Kidd, all objects associated with Batman are, on principle, worth preserving, and thus also worth collecting. And while the "£.500" printed onto the display cartoon of the plastic glider underscores the discrepancy between the originally low pop status of the merchandise and its more recent currency as valuable memorabilia, it also acknowledges the fact that collecting superhero

10. For Feiffer, the junk status of comics made them attractive. "Comic books, first of all, are junk," he writes. "Junk is there to entertain on the basest, most com-promised of levels. It finds the lowest fantasmal common denominator and pro-ceeds from there. . . . Junk is a second-class citizen of the arts; a status of which we and it are constantly aware. There are certain inherent privileges in second-class citizenship. Irresponsibility is one. Not being taken seriously is another" (1965, 186).

comics and their ancillary products takes place in a commercialized market dominated by professionals who act more like "gallery owners, museum curators, and . . . other patrons of the arts" (Beaty 2012, 37) than fans looking to complete their collections.[11]

It is not that Kidd's collectibles are necessarily encoded as art, even though some of the artifacts are presented in this fashion. Rather, the conceptualization of comics "as art's mass cultural 'other' by institutional forces in the art world" (Beaty 2012, 25) is no longer seen as a liability but becomes part of an aesthetic appeal that seeks to cleanse the materials from their commercial stain without denying their initial status as mass objects. *Batman Collected* therefore verifies and complicates Beaty's assertion that "efforts to avoid the tainting aspect of the mass culture critique through an optimistic focus on comics as the vox populi of the American people contributed to the status of comics as a non-art" (30). The book channels this vox populi through its autobiographical paratexts, Kidd fashioning himself as an all-American boy, as well as through its presentation of the materials as toys and household items that have shaped the lives and imagination of whole generations.

Recalling the way in which superhero comics were presented from the beginning of the genre as authored texts, offering biographical context for creator figures like Kane, Shuster, and Siegel, *Batman Collected* emphasizes the figure of the white male collector: Kidd himself, whose collection differs from those of conventional museums by being intensely and overtly personal. Kidd derives his authority from the scope of the collection and his credibility as a longtime collector and devoted fan. When Gardner observes that "collection itself [i]s fundamentally an autobiographical narrative, one told by the arrangement of texts and images from the past to tell a story to the present" (2012, 176), he provides the blueprint for *Batman Collected*.[12] The first few pages of the book are filled with personal references, from a dedication to "My Mom and Dad" to Batman-themed fam-

11. See Tankel and Murphy: "The acquisition, collection, and preservation of comic books resembles the activities of museums and libraries more than the purchase and use of disposable artifacts of mass culture" (1998, 66). These practices are part of comic books' larger trajectory from "disposable to durable" and from a mass to a fringe medium (Jenkins 2020, 2, 4).

12. Gardner adds: "The archival and the autobiographical are intimately connected" (2012, 176). See Pearce: "Collections are psychic ordering, of individuality, of public and private relationships, and of time and space. They . . . act as material autobiographies" (1995, 279).

ily photographs from the mid-1960s. These photographs accompany Kidd's introductory essay, which narrates childhood memories of watching the ABC series and identifies Batman as a personal obsession and an American myth: "Like the rest of the nation's tykes at the time, I was transfixed. Unlike most others, though, I never got over it. This was not a choice, a conscious decision. It just happened. I was, I *am*, obsessed by this character, this American myth" (1996, 19). When collectors like Kidd assemble and publicly display their collections, what else is acting through them? And what makes them act? When Kidd recalls his early transfixion with Batman as "not [being] a choice, a conscious decision. It just happened," he acknowledges that "we are all held by forces that are not of our own making" (Latour 2005, 43), reminding us once more of the superhero's serial agencies.

Kidd authorizes his exceptional take on this mythical character by connecting his obsession with Bruce Wayne's obsessive quest for justice. The photograph of him as a two-year-old wielding a Batman hand puppet made by his mother is echoed two pages later by an isolated panel from Batman's initial origin story that shows the crying boy realizing that his parents are dead. The introduction explicates: "Any book about Batman is by definition also about obsession: Bruce Wayne is unable *not* to fight crime; I am unable not to pursue collecting Batman. It remains an enigma even to me. Why does anyone collect anything? To fill an unknown void? To adore an imagined god? To keep looking for a face in the dark?" (1996, 19). That these questions are impossible to answer—If the void is unknown, how can it be filled properly? If god is imagined, how can the adoration be effective? If we keep revisiting our childhood, how can we ever grow up?—is exactly the point, as the motivation for many collectors is the eternal pursuit of an unattainable goal. "*The collection is never really initiated in order to be completed*," Jean Baudrillard writes, and "the point where a collection closes in on itself and ceases to be oriented towards an unfilled gap is the point where madness begins" (1994, 13). Collecting becomes an open-ended endeavor, a "serial game" (11) premised on the fantasy of control, or a sense of closure, over a sprawling mass of materials that structurally resembles the consumption of open-ended serial narratives.[13]

13. Collectors seek "a sense of closure, perhaps by completing a set or aspiring to perfect objects" (Pustz 1999, 81).

Cheap comics and the mass-produced merchandise they spawned may have once been designators of popular taste, but they transform Kidd from collector to curator.[14] *Batman Collected* was "written, designed and art-directed by Chip Kidd" (title page), whose tripartite job description complicates stereotypes of collectors as geeks or socially awkward loners.[15] Instead of entering a state of oblivion as cast-offs from an earlier generation, these artifacts are rescued, reevaluated, and curated as carriers of nostalgically charged personal memories. This nostalgia is organized around a childhood memory of lying in bed with the chicken pox and finding solace in a Batman night-light he was given by his father, as Kidd recalls in the introduction. The double page that frames the opening paragraphs of this introduction shows an extreme close-up of the lighted object in the actual socket of Kidd's childhood bedroom as well as a series of images of the night-light in its original packaging. This display of the objects is not merely nostalgic. By presenting the night-light as a unique item from Kidd's past and a mass-produced item, the book insinuates that the significance of the object does not so much "derive from qualities uniquely inherent in the artifact, but rather from the value received from the collectors' interactions with the artifacts and, equally, the curatorial behaviors themselves" (Tankel and Murphy 1998, 67).

According to *Batman Collected*, these popular products must be preserved as intensely personal and culturally significant historical items. Early press coverage of comics collecting in the 1960s had already registered this combination of personal veneration and cultural esteem when Zinman's "Comicdom's Cult of Collectors" was accompanied by a photograph of a well-dressed David Kaler posing with his collection in his apartment. For Kidd, this takes the form of a coffee-table book that celebrates Batman memorabilia as representatives of American culture. Like art objects in a glossy museum catalog, they are thoroughly aestheticized, even fetishized, as part of the

14. Kidd "has played an important curatorial role in the history of comics by bringing out glossy, high production value coffee table books devoted to DC superheroes" (Baetens and Frey 2015, 199).

15. Collecting comics was often labeled as cultish behavior. See Zinman (1965) and *Newsweek's* "Superfans and Batmaniacs" (1965). On stereotypes of collectors, see Geraghty (2014, pt. 1).

collector's investment.[16] But they are also dehistoricized and decontextualized, at least to an extent. As Jenkins reminds us, collecting popular artifacts entails three different components: It expresses a sense of the archival because it preserves traces of the past for present and future engagement and serves as a "locus for conflicting claims and bids on legacy and tradition"; it counteracts the ephemeral state of superhero comics by using objects in the collection as "vehicles for expressing autobiographical and collective memories"; and it embodies the residual in the form of "old ideologies which still exert a claim on our current thinking" by legitimizing the obsessive consumption of mass products as a meaningful activity in a wholly commercialized culture (2015, 302). That *Batman Collected* can celebrate superhero history without taking into account the social disparities, racialized divisions, and gendered inequalities that made the 1960s such a volatile decade (suggesting, for instance, a doubtful homogeneity of "the rest of the nation's tykes"), indicates a complex convolution of the archival, the ephemeral, and the residual that comics historians still have not unraveled.

"Every passion borders on the chaotic, but the collector's passion borders on the chaos of memories" (2007, 60), Benjamin writes in "Unpacking My Library: A Talk about Book Collecting" (1931). It is no coincidence that Kidd places this sentence at the beginning of his introduction. Benjamin connects the collector's inner world—his or her memories and passion—with a state of chaos that can only be controlled by personally significant borders that demarcate the extent of the collection, determine its organization, and structure the collector's life. What we find here is a tension between repetition and variation, proliferation and preservation, chaos and collection, centrifugality and centripetality: "a dialectical tension between the poles of disorder and order" (Benjamin 2007, 60) that organizes serial storytelling as much as it shapes the collecting of superhero comics. Kidd captures this tension when he presents Batman as "a modern phenomenon . . . relying on the twentieth century's two great inventions, mass media and mass production. A myth is nothing if it's not repeated, and the power to do so has never been greater. The vari-

16. Beaty connects the fetishization of collecting with a sense of nostalgia "transforming an affective (Freudian) fetish into one that is more strictly economic (Marxian)" (2012, 154).

ations on a theme that make up this book are proof of that" (1996, 19).[17]

Repetition and variation constitute the core structure of serial storytelling, which may explain why comics are one of the most widely collected forms of American (popular) culture. As Beaty holds, "one of the most common activities in fandom is collecting, the amassing of large quantities of material pertinent to a fannish interest. Not all fans are collectors, and not all collectors are necessarily fans, although the two positions do overlap . . . to a considerable degree" (2012, 154).[18] In addition to the quality of comic books as "a physical, possessable text" (J. A. Brown 1997, 22), which makes the medium particularly attractive for collectors and distinguished it for many decades from the immateriality of radio programs, television shows, and movies, these periodicals are broadly available but must be physically stored, as well as categorized, unless a collector risks the chaos and disorder Benjamin associates with absent organizing procedures. In that sense, comics are predisposed to be collected as well as integrated into the collector's lifeworld precisely because they differ from other collectibles. They do not have to be "removed from ordinary use" (Belk 1995, 66) to gain aesthetic and exchange value. "To *use* a comic would thus already entail experiencing it aesthetically," Gregory Steirer maintains, which creates an "identity between use value and aesthetic value" (2014, 458). If "collecting is an always-available repertoire of consumer-good interactions (at least with respect to material goods), then we can ask how comic-book consumers are encouraged by publishers, retailers, each other, the comic book itself and extrinsic or complimentary forces . . . to engage and find value in particular activities within this repertoire" (459). It is this interaction among the consumers, publishers, retailers, and the comic book itself that informs my analysis of collecting and archiving as mediators of superhero evolution.

17. While Regalado reads "the American superhero . . . as an important cultural response to American modernity" (2015, 11), I would suggest that the figure's serial agencies make it an active component, indeed a mediator, rather than merely a reflector of American modernities.

18. Sabin asserts: "Comics fandom grew out of comics collecting" (1993, 62). On comic book collecting, see also Inge (1984); Sokolow (1997/1998); Woo (2012).

Mummified Objects: The Museum-in-a-Book Format

When Benjamin described the collector's efforts as a "struggle against dispersion" (1999, 211), he captured the dialectic of centrifugal sprawl and centripetal containment that not only defines the super- hero genre but also shapes what Assmann calls "the tension between the canon and the archive, or . . . between the contraction of cultural memory and its expansion" (2008, 102). According to Assmann's dis- tinction, the museum-in-a-book publications discussed in this sec- tion would align with the notion of the canon, whereas the mobile archives analyzed in the next section would be closer to the notion of the archive. But this does not quite work. While the museum books contract the memory of superhero history to a mainstreamed narra- tive with select images and artifacts, they also make available previ- ously unavailable archival materials, expanding our understanding of comic book history, albeit in a controlled fashion. The comic books themselves, acting as mobile archives, also contract and expand the memory of the genre through retcons and other forms of revising the past. Both museum books and ongoing superhero series create an "actively circulated memory that keeps the past present as the *canon*" and encapsulate "passively stored memory that preserves the past as the *archive*" (Assmann 2008, 98). The main difference is that the museum books lack the open-endedness of the comics and are thus more confined in their ability to expand comics memory. The docu- ments and artifacts of the past are limited, while the possibilities of future acts of canonization are, at least in theory, unlimited.

Seeking to grasp the tensions between remembering and forget- ting, between the canon and the archive, I turn to four rather unusual treatments of superhero history: *The Marvel Vault: A Museum-in-a- Book™ with Rare Collectibles from the World of Marvel*, *The DC Vault: A Museum-in-a-Book™ Featuring Rare Collectibles from the DC Universe*, *The Batman Vault: A Museum-in-a-Book™ Featuring Rare Collectibles from the Batcave*, and *The Spider-Man Vault: A Museum-in-a-Book™ with Rare Collectibles Spun from Marvel's Web*. I read these museum books as part of what Andreas Huyssen identifies as a trend since the 1990s toward a "musealization" of the past: as indicators of a "museal gaze" (1995, 14, 19, 34) that shapes how we construct our presents, pasts, and futures.[19]

19. On comics in actual museums, see Beaty (2012, ch. 8).

The titles of these publications carry multiple layers of meaning, most prominently through the trademarked museum-in-a-book format, but also through the references to Marvel's and DC's "vaults." These references present the publishers as the owners but also as the custodians and curators of their back catalogs. They tap into the institutional authority of the museum and make the most in commercial terms of the art appeal of twentieth-century popular culture, which makes sense in view of Beaty and Woo's observation that "the comics world is relatively underdeveloped in terms of prestige-making institutions" (2016, 1). Obviously, comic books are no longer regarded as "the lowest, most despicable, and most harmful form of trash," as John Mason Brown alleged in the *Saturday Review of Literature* (1948, 31), or as "a poisonous mushroom growth" and "cultural slaughter of the innocents," as Sterling North opined in the *Chicago Daily News* on May 8, 1940. Instead, they are increasingly taken seriously as aesthetic artifacts as part of a process Art Spiegelman and Françoise Mouly call "out of the trash and into a treasury" (2009, 9), evoking Assmann's observation that "the movable and indeed unfixable borderline between value and worthlessness, between cultural waste and the cultural archive, is the effect of continuous decisions and negotiations" (2011, 379). A similar negotiation between trash and treasury, waste and archive, worth and worthlessness, occurs in superhero comics, where the museums-in-a-book act as a memory-making institution.

The museum books differ in shape and form from the thin periodicals to which they are devoted as well as from tomes like Paul Levitz's *75 Years of DC Comics: The Art of Modern Mythmaking* (2010) or Roy Thomas's *75 Years of Marvel from the Golden Age to the Silver Screen* (2014). They have the rectangular format and spiral binding of a family photo album and conjure up a sense of personal recollection, intimate memories, and participatory practices characteristic of what Beaty labels "fannish epistemologies" (2012, 9) rather than of the more distanced appreciation associated with books about art. The format recalls the scrapbooks that collectors of newspaper strips and comic book fans created before publishers started reprinting stories and before collecting became a popular pastime with specific rules and regulations.

These publications bring together fairly conventional, heavily illustrated narratives told by industry insiders about Marvel's, DC's, Spider-Man's, and Batman's "origins" and their multidecade evolu-

tion, spiked with facsimile reproductions of what are presented as "original" artifacts. These facsimile reproductions sanction the books' claim to museum status. As Latour and Adam Lowe suggest, facsimiles, or copies more generally, create the original rather than dilute its aura. "No copies, no original. To stamp a piece with the mark of originality requires the huge pressure that only a great number of reproductions can provide" (2011, 278). Thus, the books' claim to museum status is misleading, on the one hand, considering that museums usually derive authority from their ability to display original artifacts invested with unique aesthetic value (artworks), the aura of the exotic (artifacts from foreign cultures), or the aura of the extinct (artifacts from bygone periods).[20] But in creating the original by affording it with a trajectory, they, on the other hand, attest to its "fecundity" (Latour and Lowe 2011, 279), and thus also its cultural productivity. Ironically, while the ultimate goal for an ambitious collector would be to own a pedigree collection of comics in pristine or near-pristine condition—often ensured by buying two copies of each issue, one for reading and one for preservation[21]—is digitally altered in the museum books to look authentically aged. The cover illustrations of *Amazing Fantasy* #15, *Amazing Spider-Man* #68 (1/1969), *Amazing Spider-Man* #39 (8/1966), *Amazing Spider-Man* #100 (9/1971), and *Amazing Spider-Man* #151 (12/1975) in David and Greenberger's *Spider-Man Vault* (2010, 12, 31, 36, 41, 102) exhibit the same digitally produced scratching pattern, which reveals them as simulacra of timeworn artifacts (see figure 4.1). This is no trivial matter, as mint-condition issues of these comics are not only rare and expensive but also brittle, which complicates facsimile reproduction. Nonetheless, as "digitally manipulated text" that "imitate[s] original sources," these covers exude a false sense of "realness" and "authenticity" (Kirtz 2014, n. pag.).[22]

The museum books can offer such simulacra in the name of authenticity because of the "'epistemic shift' around the changing status of the book in digital culture" (Bukatman 2016, 20), a shift toward a "culture of copies" (Brenna, Christensen, and Hamran 2019, 1) where "the politics of the copy, rather than the 'original'" (D. Taylor 2010,

20. On the history of the museum, see Bennett (1995); Macdonald (2006); Brenna, Christensen, and Hamran (2019).

21. See Marc Wilofsky in *Wizard Magazine* (October 1994): "Collectors just want something that's totally untouched" (qtd. in Beaty 2012, 174). On techniques of preservation and restoration, see Beaty (2012, 175–77).

22. For more on superheroes and digitization, see Gilmore and Stork (2014).

7) prevails but where "much energy is devoted to the search for the original . . . because the possibility of making copies has never been so open-ended" (Latour and Lowe 2011, 278). "Unlike the archive, based on the logic and aura of the original or representative item, the digital relies on the logic and mechanism of the copy that enables the migration from one system or format to another that secures 'preservation,'" Diana Taylor suggests (2010, 8).[23] Of course, superhero comics do not easily lend themselves to auratic display because they have always reached their readers as copies of an otherwise unattainable, nonexistent, original. They are therefore well-versed to deal with the move from original to copy in the digital world and to complicate the traditional "dichotomy between the copies as anchored in the commodity society and the authentic objects in the museums" (Brenna, Christensen, and Hamran 2019, 2). Indeed, if museums can no longer be conceived as "storehouses of the real" but "act as copying machines" (2–3), then the museum books manifest the changing forms and functions of the museum as a memory-making institution.

In order to compensate for their perceived lack of originality, superhero comics can seek legitimacy through a "museal gaze" (Huyssen 1995, 14, 19, 34) directed at a type of popular serial storytelling that was initially intended for immersive consumption rather than distanced aesthetic appreciation, aficionado collecting, and critical analysis. The museal gaze of the museum books is decidedly not an external or scholarly one but is premised on their authors' insider knowledge and their role as industry professionals whose selection of comic book history is authorized by their access to archival material. The books utilize historiographic practices that include the retroactive establishment of creative origins, the sacralization of unpublished materials, the fetishization of sketches, and the nostalgic embrace of promotional materials with which Marvel and DC (often through licensing intellectual property) have ensured a permanent cultural presence. The emphasis on authorship is crucial as "the author remains a nostalgic figure which grants validity" at a time when digitally (re)produced and altered documents "imitate original sources" to evoke the "romantic authority of the pre-contemporary typewriter" (Kirtz 2014, n. pag.) and the artistic veneer of pencil and

23. See also Huyssen: "We are obsessed with re-presentation, repetition, replication, and the culture of the copy, with or without original" (2003, 20–21).

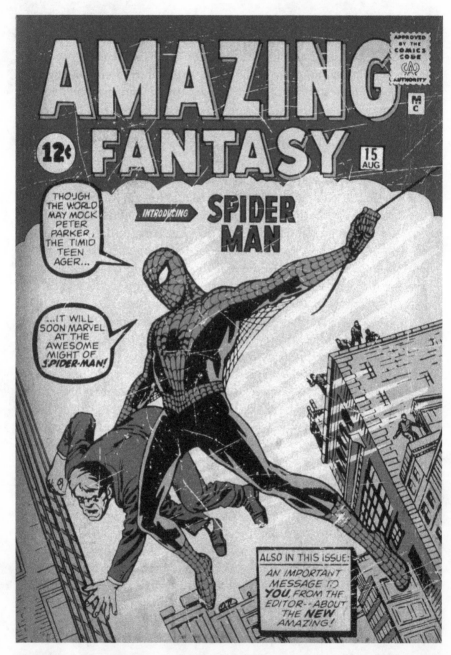

FIGURE 4.1. Identical digital scratching patterns. Peter A. David and Robert Greenberger, *The Spider-Man Vault: A Museum-in-a-Book™ with Rare Collectibles Spun from Marvel's Web,* 2010 © Running Press.

brush.[24] *The DC Vault* assembles handwritten and typewritten correspondence (a memo by M. C. Gaines, letters by government agencies), typewritten scripts (for the first Superman radio program, for William Moulton Marston's *Wonder Woman* strip), and facsimiles of inked pages (for *Superman, Batman, World's Finest,* and other comics). In this regard, the museum books resemble the digitally altered or even digitally created paratexts that often conclude graphic novel collections or reprints of superhero story arcs and generally reify traditional notions of individual authorship and creative originality while hiding traces of digital production (Kirtz 2014, n. pag.).

The museum books feature artifacts to which readers rarely have access, such as a set of "original drawings" by Carl Pfeufer from the early days of Marvel (1941–1942) in the *Marvel Vault* or later work by Klaus Janson and Jim Lee in the *Spider-Man Vault.* Further examples from the *Marvel Vault* are facsimiles of Stan Lee's typewritten synopsis of the first *Fantastic Four* story outline from 1961, the program for the first Mighty Marvel Comic Convention of 1975, and an assortment of items Marvel sent to the members of the Merry Marvel Marching Society. The *Spider-Man Vault* even includes a facsimile of artwork by Steve Ditko, with splotches of whiteout and pasted on, soon-to-be-iconic, Spider-Man lettering that would become the opening splash of *Amazing Fantasy* #15 (see figure 4.2), and with handwritten production details still visible. These artifacts seem valuable because they are not easily owned; they stake their credibility on a claim to archival documentation heightened by their display as exclusive treasures.[25] They create a sense of closeness to the workplaces and design spaces that "birthed" the comics, where intermediaries become mediators (Latour 2005, 81). The museum books further recall the fanzines of the 1950s and '60s, which had prized materials unavailable to the average reader, and they promise a backstage glimpse behind the stories into their production processes: recalling "the unearthing of preparatory material, sketches and uninked pencil drawings" that Beaty

24. Thomas's *The Stan Lee Story* taps into the authority of the typewriter by appropriating the cover of *Origins of Marvel Comics* (hands hovering over a typewriter from which superheroes emerge) to present Lee's foreword. The foreword itself is cast in a typewriter font and evokes a pre-digital aesthetics running throughout the book, as every chapter opening mimics a typewritten page.

25. Some original art was donated to libraries and museums; some was sold to fans by artists trying to make extra money; some of it was tied up for decades in court battles, as Kirby's litigation against Marvel indicates.

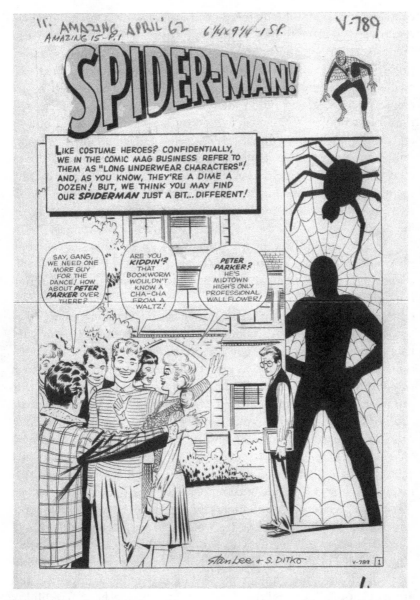

FIGURE 4.2. Opening splash page, pencils and inks. Steve Ditko. *Amazing Fantasy* #15 (8/1962) © Marvel Comics.

finds in the old EC fanzines and that "are regarded as testifying to the truth behind the work" (2012, 112–13).

Digital technology enables the museum books to create facsimile reproductions that look authentic at a first glance. In the case of the Pfeufer sketches, the pencil drawings, the faded yellow of the

drawing paper, and the material used to make these facsimiles seem remarkably real—one has to flip them over to find the tiny word "reproduction" on the bottom. This emphasis on their materiality, preproduction status, and the haptic pleasures of taking them out of the plastic sleeve (like opening up a Mylar bag to inspect a rare comic) works against online displays of comic book artifacts and their reduction to digitized images that can be downloaded but, as endlessly reproducible digital copies, seem to lack an aura. "We can link to an image but we cannot hold, touch, taste, or smell a person or object," Diana Taylor observes about "the paradoxical ubiquity and seeming no-where-ness of the digital archive" (2010, 9). This condition proves especially problematic for collectors, who tend to be, in Benjamin's words, "beings with tactile instincts" (1999, 206).

The Batman Vault resembles other museum books in its choice of illustrations and the gist of its historical narrative. It reprints iconic covers and tells the familiar tale of Batman's transformations through the decades. Like the *Marvel Vault* and *Spider-Man Vault,* it acknowledges the significance and effects of character extensions into other media (mostly television and movies) and reprints previously unpublished material (scripts, sketches, in-house letters) as well as paratextual material usually excluded from commercial reprint formats, such as advertisements featuring Batman and Robin or Kane's authorial origin story in "Meet the Artist." The reproductions range from an "authorized Batman Mask" that had been included in a Golden Book collection of stories from 1966 and a booklet by Sheldon Mayer on "How to Draw Batman" from 1978, to a publicity brochure for the 1990s animated television cartoon series and pencil sketches that inspired the sets for Tim Burton's *Batman* (see figure 4.3). In all of these cases, readers can (re)immerse themselves in the aesthetic experience, putting on the mask or (re)watching the cartoons or the film.

The Batman Vault begins with a foreword by Jerry Robinson, who, after decades of debate, is now recognized as the "inventor" of Batman's most intriguing antagonist, the Joker. Robinson appears as an authenticating figure whose firsthand knowledge lends credibility to the historical narrative and the artifacts presented in the museum book. His sentiments frame this narrative as a largely nostalgic one premised on personal memories and intimate relationships between producers and consumers: "*The Batman Vault* is a trip down memory lane for me," Robinson muses (2009, 4), pointing to a long history

FIGURE 4.3. Back cover detail. Robert Greenberger and Matthew K. Manning, *The Batman Vault: A Museum-in-a-Book™ Featuring Rare Collectibles from the Batcave,* 2009 © Running Press.

of disputed author roles and authorial origin stories by reiterating his own version of events. But the main authors of the *Batman Vault* are Robert Greenberger and Matthew K. Manning. According to the acknowledgments at the end of the book, Greenberger wrote most of the text and Manning "stepped in to polish and add his own perspective" (2009, 191). As his introductory essay reveals, Manning is a self-declared Batman fan turned comic book writer turned DC historiographer, giving the role of "unofficial guardian of pertinent Batmania folklore" that Kane had bestowed on Biljo White a more official sheen. As we learn from the author credits, he "can't remember a day when he wasn't writing and drawing comics" (2009, 191), a confession that roots his authority in an insider pedigree that begins almost at birth. In his introductory essay, he expresses his passion for Batman in terms that emphasize intimacy between historiographer and historical object and work against the grain of academic analysis by insisting on personal identification, emotional attachment, and an inside perspective as prerequisites for writing about the subject: "I first met Batman in 1989," and "it wasn't long before I found my way into a comic shop" (5).

Once Manning has demonstrated his credibility and signaled to his readers that he is one of them despite his commercial mandate, he pitches the book and his role as the purveyor of its contents:

> For you longtime collectors and fans who, like me, have read thousands of Batman comics, dating back to before your parents were even an idea in your grandparents' minds, this book will still show you images you've never seen, give you bits of trivia and history that you didn't even know existed. For those of you new to Batman, this book will serve as a nice introduction and help you get your feet wet. So go ahead, crack open *The Batman Vault*, and get better acquainted with the Dark Knight. (2009, 5)

The statement emphasizes Manning's comic book credentials ("read thousands of Batman comics") and suggests that even the most dedicated and expert "collectors and fans" will find something new in this publication. Manning celebrates comic books as a popular medium that can unite generations of producers and audiences, a notion that counters conceptions of comics as ephemeral entertainment and grounds this museum book in personally meaningful history. Manning acts as a popular historian who establishes a "transgenerational framework" for Batman at a moment when the "living memory" of Golden and Silver Age comics is "giv[ing] way to a cultural memory that is underpinned by media—by material carriers such as . . . museums . . . and archives" (Assmann 2011, 6). For those without personal memories of the comics, he offers a vicarious trip into the past through "images you've never seen" and "bits of trivia and history that you didn't even know existed." Manning promises to make the past come alive through "original" artifacts not explicitly identified as reproductions in the introduction. He positions the museum book as an epitextual extension of the superhero stories it celebrates, creating a role for himself as a bridge-builder and gap-closer who, because he straddles the worlds of industry and fandom, can offer access to comic book history across the thresholds of time and material ownership.

The introductions to the *DC Vault* and the *Marvel Vault* are even more explicit about their creation of comic book memories. Presenting the rationale behind the *DC Vault*, Martin Pasko imagines the book as a mixture of tourist attraction and time machine:

The following pages are a guided tour of how it all came to be. They're a museum in a book, a time capsule of glossy paper and vivid inks, taking you behind the scenes of more than seventy years of astonishing creativity and innovation. You'll be present at the birth of Superman and Batman and the countless casts of characters who've succeeded and complemented them. You'll meet an amazing array of talent—names you've never heard and some you've most likely memorized, like Siegel, Shuster, Kane, Finger, Marston, Infantino, Swan, Kubert, Kirby, O'Neil, Adams, Miller, Gaiman, and Lee. You'll peer over their shoulders as they scribble notes for plots, work out character and costume designs, and make the deals that send their brainchildren from the printed page into the hearts and imaginations of five generations. And you'll see their real-world trials, tribulations, birth pains, and secrets, chronicled in sketches, memos, memorabilia and collectibles, all locked away and hidden until now, when you open . . . *The DC Vault.* (2008, 7)

Pasko promises an archive waiting within the pages of the museum book to be activated by the reader, who is invited to step inside the book as one would into a museum to become, if not an actual actor in the evolution of the genre, at least an interested bystander empowered to witness the activities of all-male canonized creators. Familiar tropes include the alleged behind-the-scenes access, as well as the focus on origins ("birth of Superman and Batman"; "birth pains") and on scenes of graphic enunciation and labored makings of the storyworld ("scribble notes for plots, work out character and costume designs"). That the treasures and the immersive experience they offer were "locked away and hidden" heightens the exclusivity of the publication (and justifies the $49.95 price tag), but it reveals little about the "archive stories"—the "narratives about how archives are created, drawn upon, and experienced by those who use them to write history" (Burton 2005, 6).

Peter A. David's introductory remarks in the *Spider-Man Vault* are equally obtuse when it comes to information about the creation of the Marvel archive and the selection processes that shaped this museum book. He emphasizes the affective potential of Spider-Man's origin story by focusing on the experience of engaging with the Marvel archive, reminding readers that "it helps to see the story through new eyes and be reminded of the raw, emotional power of the events

that forged the webslinger we've all come to know and love" (2010, 9). David addresses a community of like-minded readers subsumed into an all-inclusive "we" that supposes a consensus on the superhero's popularity and recalls Marvel's metaverse creation, the "world of Marvel" Lee celebrated in editorial columns and letter pages. This backward orientation also informs the labeling of the *Marvel Vault* as

> a book of memorabilia, in the broadest possible definition of that word. Memorabilia can be a published comic book, a computer printout, a type-filled sheet of paper, a scribbled sketch tossed away when a larger finished drawing is done, only to be retrieved from the wastebasket (and not always by the person who tossed it there). Memorabilia . . . can be anything that records the history of Marvel Comics (or Timely, as it was initially called), from 1939 to the present, and shows why and how things turned out the way they did, instead of some other way. . . . And it's all there, when you apply the strength of Ben Grimm or Thor or Ol' Greenskin and pry open—the Marvel Vault. (Thomas and Sanderson 2007, 7)[26]

Assmann's distinction between archive and waste is very much present here, as is Latour's notion that archives and workspaces can grant insights into moments when things could have evolved differently. But as Jan Baetens and Hugo Frey maintain, "archival publications can . . . imply a false sense of the whole direction of history, making presentation far too teleological" (2015, 229). While the museum books trace the coincidences and contingencies that shaped the superhero genre, they still present the present as an inevitable outcome.

Phrases like "crack open" (*Batman Vault*) and "pry open" (*Marvel Vault*) suggest a particular way of handling these museum books and the reproduced artifacts they contain. They recall haptic sensibilities reminiscent of childhood, or Baudrillard's "invested affect" (1994, 7): cracking open a birthday present or prying open a chest filled with toys. Moreover, the introduction to the *Marvel Vault* conflates history with memory and archival material with memorabilia. What we find here is an object-oriented nostalgia that claims to activate history through the reader's ability to engage directly with materials assumed to have stimulated the imagination of past generations—to

26. 1939 marks the publication of *Marvel Comics* #1, featuring the Human Torch and Namor the Sub-Mariner.

turn mummified objects into telling objects.[27] As these and other pas-
sages indicate, the "seduction of the innocent" that Fredric Wertham
identified as the harmful potential of comic books in the 1940s and
1950s has transitioned into the "seduction of the archive" that Huys-
sen (2003, 5) and Carolyn Steedman (2001, x) describe as a core fea-
ture of the digitized present.

Consider also the differences between vault and archive. Labeling
the museum books "vaults" appears as a self-conscious classification
of comic books as a type of commercial popular storytelling that has
produced pleasure for generations of readers because it has flown
under the radar of public acceptance and cultural veneration. When
Bob Kane sought to set the record straight about his creatorship of
Batman, he did not address his concerns to any official institution.
Instead, he sent his "Open Letter to All 'Batmanians' Everywhere" to
fanzine editor Biljo White, asking him to store this "first comprehen-
sive document authored by myself" for posterity: "May I suggest that
you keep this original copy so that the historians of comic folklore
may one day think it valuable enough to lock it in their vault" (1967,
30). Evoking the more expansive company vaults and acting as their
authorized extensions, the museum books claim a vault-like three-
dimensionality that promises access beyond the two-dimensional
limits of the printed page, and they allocate the exclusive author-
ity over the "rare collectibles" they pretend to offer in the hands of
comics publishers that command vaults filled with unknown mate-
rial. While archives tend to collect, classify, and preserve remnants of
the past for future reemplotment, vaults come across as more unruly,
more mysterious, and more adventurous places of fun and entertain-
ment. Of course, vaults, caves, and lairs appear frequently in com-
ics, which further authorizes the use of the term in the titles of the

27. Bal reads "collecting as a narrative" and thinks of collected items as "tell-
ing objects" (1994, 100). On collecting and object-oriented forms of (nostalgic) long-
ing, see Stewart (1993); on the evocation of nostalgia in early superhero comics, see
Cremins (2016). Dick Lupoff and Don Thompson's *All in Color for a Dime*, which col-
lects essays on characters like Batman, Captain Marvel, the Human Torch, and the
Justice League of America and unites writers involved in 1960s fanzine production
(Ted White, Tom Fagan, Roy Thomas, etc.), advertised itself on the cover as "the big
nostalgia book about the comics heroes and superheroes" and identified intersect-
ing roles for the early commentators. "Each author was asked to be a three-headed
monster," Lupoff and Thompson's introduction explains, "one head being that of a
misty-eyed nostalgic, another that of a bibliographically inclined research scholar,
and the third that of a social-literary-artistic critic" (1970, 10–11).

museum books. This connection between the vaults of the storyworld and the vaults of history is therefore by no means coincidental. As Paul Levitz asserts: "There has never been a singular 'DC Vault' in which all the treasures are hidden," but the vault is nevertheless "a very special place" whose "most important location is in your mind" (2008, 6).

Entry to the vaults is controlled by those who own the materials; it is subject to "a deliberate policy of remembering" (Assmann 2011, 6). The museum books speak to a desire to control, or at least counterbalance, the centrifugal effects of serial proliferation by promoting canonical narratives based on the aura of objects from the vault. They are also political texts since they produce "archival memory . . . in the form of testaments, certificates, and documents that serve to authenticate claims relating to power, ownership, and descent" (Assmann 2011, 328) at a time when "media users have seized hold of all of mass culture *as an archive* . . . to be plundered . . . [where] each media commodity becomes . . . an original to be memorized, copied, and manipulated—a starting point or springboard for receivers' creativity, rather than an end unto itself" (De Kosnik 2016, 4). If "the availability of archival sources of all kinds online arguably makes us all archivists now," as Burton holds, and if, "given the convergence of virtual archives and corporate commodity culture, it would seem that we are all archive consumers—at least potentially—as well" (2005, 4), the possibilities for uncontrolled proliferation seem endless.

What's more, the archive as an institution implies the implementation of particular "system[s] of recording . . . , storage and retrieval" (Steedman 2001, ix) that do not necessarily burden the vault. Marvel and DC are notoriously opaque when it comes to their in-house archives, rarely granting access to correspondence, business contracts, and other material of historical interest. As the museum books indicate, this does not preclude them from promoting their vaults as being "imbued with . . . power and authority" and embracing "notions of historical accuracy, of authenticity, authorship, property (including copyright), specialized knowledge, expertise, cultural relevance, even 'truth' [as they] are underwritten by faith in the object found in the archive" (D. Taylor 2010, 4, 5). By evoking such a "circular legitimating epistemic system" (5), the publishers issue self-fulfilling prophecies that turn reproductions into rare collectibles and memorabilia into history-making objects. The museum books are physical manifestations of a commercially driven impulse to pre-

serve the legacy of the comic book in the age of online communication. They enlist musealization practices to counteract the centrifugal effects of digitization with a centripetal move toward canon formation and genre consolidation.

With the printed comic book in relative crisis, it is no surprise that there is concern with the superhero's history: a profound interest in preserving what once was a thriving serial medium.[28] But this concern is also part of larger historical trend. In his studies on cultural memory, Huyssen discerns practices of musealization and a museal gaze through which Western societies negotiate their relationship to the past, solidify their grasp of the present, and make predictions about the future. In *Twilight Memories,* he diagnoses a fear of historical "amnesia," a "struggle for" and "an obsession with memory" (1995, 7, 9), starting in the late 1980s and 1990s with the fall of the Soviet empire, the waning of personal memories of the Holocaust, and the onset of digitization. He finds an "obsession with memory in contemporary culture" and a "memory boom" that expresses a deeply felt "need for temporal anchoring" and serves "as a reaction formation against the technical processes that are transforming our *Lebenswelt* (lifeworld)" (5, 7). If the museum had long stood as a stable signifier of tradition, heritage, and canon, the current "museummania" signals a resistance against the "planned obsolescence of consumer society" (14).

Similar arguments have been made about other "memory institutions" (De Kosnik 2016, 26), such as libraries and archives. According to Huyssen, we are witnessing a shift from the museum, and arguably also from libraries and archives, as an officially sanctioned institution to musealization as a "key paradigm of contemporary cultural activities" (1995, 14). If the museum was an effect of the modern era, an attempt to secure cultural and national traditions threatened by the ravages of modernization (15), musealization may be a way of dealing with the uncertainties brought on by digitization. "The anxiety about loss and forgetting," Diana Taylor writes, "might explain our current obsession with archives and the nostalgia both for embodiment and for the object" (2010, 15). As book-bound museums

28. According to *Comichron*, a website run by "John Jackson Miller and other comics history archaeologists" that estimates comic book sales based on numbers from Diamond Comic Distributors, even the best-selling issues rarely sell more than 150,000 copies per month, many selling less than 100,000 (http://www.comichron.com/index.php).

that contain reproductions of archival artifacts, the vault publications react to the threat of the digital and its challenge to the survival of the printed comic book by offering such embodied nostalgia, providing the haptic pleasure of handling what feel like memorabilia of a bygone era.[29] They indicate a continuing interest in the documentation and circulation of superhero history (as in Marvel Unlimited, a subscription service with access to more than 28,000 titles) and suggest that the shift to digitization will not necessarily erase the backlog of comic book content, even though one wonders how much of this backlog will be digitized and what the criteria for selection will be—surely not the criteria of the historian, but those of the commercial publisher.[30] Some of the older content will certainly be treated as "disposable data" and thus confined to the status of a mere intermediary—a link in a series whose agency within the network of superhero comics lies dormant—rather than as a mediator in the publisher's "usable past."[31]

As suggested, the museum books create an aura for drawings and artifacts that never had an aura. If the digitally produced copies of artifacts with no stable origin can do so, it is because digitization tends to "lend them an aura, to reenchant them beyond any instrumental functions they may have had" (Huyssen 1995, 33). As Huyssen writes in a passage in *Present Pasts* that deals with the effects of digitization on the status of photography: "Digitalization makes the 'original' photograph auratic" by completing "the move from the photograph to its digital recycling" (2003, 20). The museum books therefore play into a pervasive "longing for the authentic" (Huyssen 1995, 33) among contemporary superhero aficionados, most likely those who have purchased, perused, or collected comics for years and who are now seeing them fall to the wayside of digitization— those who do not just "own" the comics as material artifacts but see them as "texts they have helped to make meaningful" (Gardner 2012, 173) through one form of active engagement or another.

29. On these issues and nostalgia more generally, see Boym (2001).

30. Beaty and Woo remind us that "neither Marvel nor DC Comics consistently keeps the work of Jack Kirby in print" (2016, 51). Aldama sees a need to "archive the representation of Latinos in mainstream comic book *storyworlds*" and to "excavat[e] the representational archive" (2017, xviii–xix). Schneider and Palmer argue that "access to original materials has contributed to and influenced" (2016, 20) the scholarly debate about Batman's sexual orientation. This includes DC's denial of permissions to reprint images in articles focusing on gay readings of the character.

31. Huyssen distinguishes "between usable pasts and disposable data" (2003, 18).

The reproductions of rare comic book materials become "mummified" objects that issue an attractive promise: to "yield experience, a sense of the authentic" (Huyssen 1995, 33) for readers with memories of personal comic book encounters and even for new readers who want to relive the experiences of an earlier generation of followers. Offering these followers a museal gaze, the museum books strive to "resist . . . the progressive dematerialization of the world which is driven by . . . the visual realities of computer networking" (34) even though they are products of this networking. They express a "desire to anchor ourselves in a world characterized by an increasing instability of time and the fracturing of lived space" (Huyssen 2003, 18) by reproducing artifacts never meant to survive their use-by date: intended to provide only momentary satisfaction but ending up as collectors' items.

Musealization may be the next logical step in the evolution of a print-bound genre threatened with the migration of content and resources to other media. Gardner observes: "Declining sales in serial comic books suggest that . . . a chapter in the history of the form might be coming to an end" (2012, 191). This assessment can be connected with larger anxieties about the changes that digitization has brought to our experience of time. According to Huyssen, "the past is selling better than the future," and one way of selling the past is to mobilize "memory and musealization . . . [as] a bulwark against obsolescence and disappearance" (2003, 20, 23). By musealizing superhero history, the museum books function as such a bulwark, but they might also usher in the ossification of what used to be a lively culture of interaction and immersion in a thriving serial genre. But perhaps this lively culture is taking place somewhere else and the museum books are only one part of the puzzle, with the comics themselves behaving in a much more unruly fashion, resisting the curatorial desire to contain them within the covers of a book, even if it is the kind of haptically enhanced, auratically charged time capsule the museum books claim to be.

Mobile Archives

Readers who had missed the first decade of superhero narratives or had not preserved their comics could still gain access to the genre's past by the 1950s. Even before DC launched its *Giant Annuals* and Marvel reprinted stories in *Collector's Item Classics,* the companies'

regular series were beginning to express a sense of genre history. *Batman* #100 (6/1956) celebrated its anniversary by displaying six covers from Batman's past, emphasizing the historicity *and* the currency of the character. The cover gallery offers a historical arrangement not unlike a library exhibition or display of prized items from a private collection. It signals a sense of historicity as a form of constant updating, as an ongoing process of renovation and renewal, by featuring the cover of *Batman* #1 (3/1940), with its announcement of "All Brand New Adventures of The Batman and Robin"; issue #47 (6/1948), with its retelling of Batman's origin story; issue #48 (8/1948), with revelations about "The 1,000 Secrets of the Batcave"; and issue #61 (10/1950), with information on "The Origin of Batplane II!" The cover insinuates the presentness of the character and content of the issue by printing "All New Stories" at the top of the page, as well as through the wavy "100th Batman issue!" band in the middle, which highlights the ongoing continuity of the series and expresses a sense of constant actualization. The past newness of the vicariously reexperienced past and the present newness of the immediately experienced present commingle in this single paratext.

I have already discussed the practice of updating origin stories, the offering of contemporary versions of a superhero while reminding creators and readers of the "set of key components" (Uricchio and Pearson 1991, 185) that define a character. Batman's origin story, initially told in *Detective Comics* #33 (11/1939), was reprinted in *Batman* #1 and expanded less than a decade later in *Batman* #47, and it has been retold, with variations, many times since. But in the 1950s, another type of story appeared that further emphasized the history of the series. "The 100 Batarangs of Batman," written by Bill Finger, penciled by Sheldon Moldoff, and inked by Charles Paris (*Detective Comics* #244, 6/1957), retroactively invented an origin for one of the caped crusader's choice gadgets. "Famous are the weapons which Batman and Robin use in their war against crooks . . . The mighty batmobile, the swift Batplane, utility-belts, ropes, and belt-radios!," the editorial voice on the opening splash announces. "Not so well-known, however, is their strangest piece of equipment—the batarang! Here, for the first time, is the full story of that device—the origin, the different forms and dramatic uses of . . . The 100 Batarangs of Batman."

In the story, Batman and Robin appear three times in front of a batarang-filled cabinet to select the most fitting weapon for the case.

Readers learn that there are magnetic and seeing-eye batarangs, as well as flashbulb and bomb batarangs, the latter two being labeled and visible in the cabinet while the use of the first two is illustrated though flashbacks. Early on in the story, Batman recalls receiving his first batarang, and the story culminates in his use of a giant "batarang X" to catch the criminals. As the flashbacks fill in gaps in the character's past, they convey the sense of an archive of unrealized stories or story options undergirding current iterations of the character on which contemporary creators could draw to tell new stories. As soon as the flashbacks visualized elements from the superheroes' past, these elements became part of the series' history. They had officially happened. "The 100 Batarangs of Batman" therefore taught readers that the archive of the series was just as malleable as its future, always ready to be revisioned and reconstituted.[32] "Archives are not inert historical collections," Stuart Hall notes. "They always stand in an active, dialogic, relation to the questions which the present puts to the past" (2001, 92).

Such retroactive additions to the serial archive were soon amended with DC's and Marvel's official reprint formats as well as repeated investigations of comic book history in fanzines. The second issue of *Batmania* (10/1964) chronicled Batman's appearances before the introduction of his sidekick Robin in *Detective Comics* #38 (4/1940). Biljo White frames "Batman before Robin" by citing interest in the history of the character among those without access to the archive: "No doubt there are many younger fans who have no idea of The Batman of the late thirties. In an effort to answer many, many inquiries about the early days of Batman I decided to sort through my lifelong collection of old comics for the Detective Comics which featured Batman" (10/1964, 5). While White focused on a short moment in the early history of the genre, elaborately researched and illustrated later articles like "Evolution of the Batmobile" (*Batmania* #4, 4/1965c) and "Evolution of the Bat-Plane" (*Batmania* #8, 1/1966b) delved into the transformative *longue durée* of the superhero's vehicles and gadgets. Notable, too, is that White's historiographical work was only possible because he had been a longtime collector, a private archivist

32. Stories from the same period like "The Secret of Batman's Utility Belt!" (*Detective Comics* #185, 7/1952) and "The True History of Superman and Batman" (*World's Finest Comics* #81, 3/1956) communicate a similar notion of archival malleability.

whose "White House of Comics" served the triple purpose of storage, library, and archive.

Taken together, the retroactive origin stories of Batman in *Detective Comics* #33 and of the batarang in *Detective Comics* #244, DC's recurrent updating of Batman's origins, and the *Batmania* coverage that was interested in the origins of the character and central elements of his world express a fascination with the beginnings and consecutive evolution of the superhero—with the past and how it creates the present. They exemplify the "archival drive" Gardner associates with comic book culture. This "compulsive need to fill in the gaps, to make connections between the issues (the serial gap inherent to comic production, mirroring and complicating the gaps between the frames themselves) that drives the collector in search of missing issues" (2012, 173), is closely connected with the "drive to serialize [that] is . . . a compulsion, perhaps an addiction" (Lindner 2014, ix) in twentieth- and twenty-first-century popular culture. It channels the agencies of narrative and archival seriality, with origin stories functioning as storytelling engines (O'Neil qtd. in Pearson and Uricchio 1991b, 24) and with archives working as "engines of circulation . . . that both mobilize different media and are mobilized by them" (Hirsch and Taylor 2012, n. pag.).

Popular serial storytelling fundamentally differs from nonserial storytelling because it produces "evolving narratives" (Kelleter 2017, 14) whose past, present, and future can never be taken for granted. "To analyze commercial series," Frank Kelleter writes, "means to focus on moving targets. These narratives exist, not so much as structures that can be programmatically designed, but as structures whose designs keep shifting in perpetual interaction with what they set in motion" (14). As moving targets, serial narratives mobilize as well as depend on "various agents of continuation in the act of (evolving) storytelling itself" (14), Kelleter notes, recalling Latour's point that the "'actor' . . . is not the source of an action but the moving target of a vast array of entities swarming toward it" (2005, 46).[33] Building on these observations, I read superhero comics as mobile archives that are able to motivate new action. Think again of *Batmania,* which printed indexes by avid collectors who sought to chronicle existing issues of a particular publisher or series. Indexing may seem like an

33. See also Latour's notion of "immutable mobiles" as "all the types of transformations through which an entity becomes materialized into a sign, an archive, a document, a piece of paper, a trace" (1999, 307, 306).

obvious means of counteracting the mobility of a series, as a way to inscribe its past into a written form whose main authority derives from its completeness and correctness. But even indexes are not static entities. With each new serial installment, they become more and more out of date, not to speak of the possibility that they may contain gaps: that one's venture into the genre's past may have failed to unearth a relevant item. The comics' serial agencies outmatch the stabilizing agencies of the index, even though indexes do contribute to the containment of serial sprawl by devising classificatory systems through which such sprawl can be arrested at least momentarily.

Indeed, indexes (like genres and archives) possess agency. They produce the history they record and serve as sources for future engagements with the past. Take *Batmania* #21 (4/1975), #22 (2/1976), and #23 (7/1977), which reprinted Raymond L. Miller's "Batman Index" from issues #78–80 of *The Rocket's Blast-Comicollector* fanzine. They were preceded by Miller's "Detective Comics Index" in issues #19 (9/1974) and #20 (12/1974), another reprint from *The Rocket's Blast-Comicollector* (#76–77), and by Tom Fagan and Biljo White's "Batmemorabilia" section that offered "reviews of all published Batman and Robin adventures. Beginning with a record of Robin's adventures in *Star Spangled Comics* #65–92" (*Batmania* #6, 10/1965, 14–16). By the 1980s, fan-based (but industry-sanctioned) indexes like George Olshevsky's *The Marvel Comics Index,* consisting of multiple, character-based publications between 1976 and 1982, acted as mediators for similar formats released by the publishers themselves, including the *Official Marvel Index to The Amazing Spider-Man* (4/1985), while stories like "The Kid Who Collects Spider-Man" (*Amazing Spider-Man* #248, 1/1984) acknowledged the significance of collecting comics and amassing superhero memorabilia.[34]

There was, of course, no actual, physical archive that stored and made the comics listed in these and similar indexes available, even though White's "White House of Comics" contained a substantial collection and Olshevsky once owned "the world's only complete collection of Marvel superhero comics."[35] Less well-equipped readers had to communicate with each other to buy, sell, or swap issues or visit comic book stores for back issues. Starting with issue #2, *Batmania*

34. The story revolves around the terminally ill Tim Hanson, whom Spider-Man visits in the hospital. Tim is a fan and has assembled scrapbooks of newspaper clippings about his favorite superhero.

35. http://www.wmca.de/bsv_williams/marvel_bibel/olshevsky.htm.

included "BaTrader," a "restricted buy-sell-trade advertising service for the collector of Batman comics and related items" whose "purpose [was] to provide the fan a place to help locate that hard-to-find item, not for the benefit of the comic-profiteer," according to White (10/1964a, 23). By issue #14 (2/1967a, 20–23), the offerings had become more diverse, with one reader seeking to sell or trade "Marvel original art" and another advertising a copy of Hero-Hobby fanzine #6. The same issue even ran a full-page ad offering "15,000 comic books for sale," including "complete runs of Batman from #1 on, Detective #39 on, and World's Finest #2 on." What we see at work here is the gradual constitution of a dispersed but increasingly interconnected network of collectors as well as the emergence of a Batman archive beyond the corporate control of DC, the moment "when a relatively random collection of works, whose movement appears simply to be propelled from one creative production to the next, is at the point of becoming something more ordered and considered" (Hall 2001, 89).

Superhero comics constitute a peculiar archive—a "living library" in Bukatman's Benjaminian terminology (2016, 17), a "living archive" in Hall's terms (2001, 91), or a mobile archive in my nomenclature— that constantly oscillates between the three elemental functions of the archive identified by Diana Taylor:

> An archive is simultaneously an authorized place (the physical or digital site housing collections), a thing/object (or collection of things: the historical records and unique or representative objects marked for inclusion), and a practice (the logic of selection, organization, access, and preservation over time that deems certain objects "archivable." (2010, 4)

Performing these three interconnected functions, archives enact a centripetal force by enabling the containment of the past and a centrifugal counterforce by providing the source materials for new engagements with their contents.

The archival logic of the superhero lies in the dialectical tension between expansion and contraction, incompleteness and totality, open-endedness and closure, authority and contestation. Hall notes: "An archive is inevitabley [sic] heterogeneous: but it cannot simply be open-ended. It does not consist of simply opening the flood-gates to any kind of production in any context, without any ordering or inter-

nal regularity of principle" (2001, 91).[36] The tension Hall describes is already rooted in the etymology of the archive. "The word 'archive' is derived from the Greek *arkhé*," Assmann observes, "which has a double meaning: 'beginning' and 'government'" (2011, 327). In *Archive Fever*, Derrida proposes the double notion of "commencement" and "commandment" (1995, 9), reading the *arkhé* "as a place where things begin, where power originates, its workings inextricably bound up with the authority of beginnings and starting points," as Steedman summarizes (2001, 1). It is this archival "desire to find, or locate, or possess that moment of origin, as the beginning of things," the "desire to recover moments of inception" (3), that often shapes superhero historiography, where the search for origins — encapsulated in titles like Gerard Jones's *Men of Tomorrow: Geeks, Gangsters and the Birth of the Comic Book*, Peter Coogan's *Superhero: The Secret Origin of a Genre*, and Chris Gavaler's *On the Origin of Superheroes: From the Big Bang to Action Comics No. 1* — has been one of the most influential modes of engagement.

This desire to trace the genre to its origins and demarcate beginnings is persistently counteracted by the superhero's serial agencies. As Jean-Matthieu Méon argues, superhero comics must manage their serial backlog, deciding again and again what should be remembered in order to reduce the constraints of the past on the present while nonetheless utilizing the affordances of the archive. Méon identifies three forms of continuity management through editorial mediations of serial continuity in Marvel comics, each of which characterizes superhero comics as mobile archives: textual and paratextual mediations of the comics themselves, practices of selective reprinting, and text-based reference publications (2018, 195–97). He emphasizes the enduring significance of narrative continuity — the conceit that stories are set in a shared universe unless a storyline is explicitly marked as taking place within an alternative world — despite the increasing transmedial dispersion of characters and the overall trend toward multiplicity (191). Proposing that Marvel's treatment of "continuity as a creative and commercial resource" and as "a memory ready to be activated and to be, like an archive, mined for new stories, with an already established engagement from the readers" (194), is representative of the "dominant memory regime in mainstream comics"

36. Hall bases this argument on Foucault's *Archaeology of Knowledge* (1972).

(191), Méon recognizes a basic need for different types of "memory management" (195) that stems from long-term serial storytelling.[37] He concludes that the power to enforce particular kinds of memory management lies predominantly with the publishers (192), but it is also subject to the kinds of authorization conflicts I trace throughout this book.

An early example of textual and paratextual mediations is *The Avengers* #4 (3/1964), where narrative captions and footnotes guide readers through the reintroduction of Jack Kirby and Joe Simon's Captain America from the 1940s comics into the Marvel universe of the 1960s (Méon 2018, 196). Because the memory of Captain America may have been distant or even nonexistent for many readers, as the initial run (1941–1950) had ended more than a decade earlier, Lee and Kirby made sure to authorize the new version by creating memories of the character. The cover announces that the issue will revive this superhero, exclaiming "Captain America Lives Again!" and placing a portrait of Cap in action at the center of the image. In addition, Cap is flanked by Giant-Man, Iron Man, Thor, and the Wasp, four active members of the Avengers whose appearance legitimizes his initiation into the team. The opening splash includes an editor's note placing this story in a context that includes not only the diegetic past but also that of its creators as well as Marvel at large. "The Mighty Marvel Comics Group is proud to announce that Jack Kirby drew the original Captain America during the Golden Age of Comics . . . and now he draws it again," the note declares. "Also, Stan Lee's first script during those fabled days was Captain America—and now he authors it again! Thus, the chronicle of comicdom turns full circle, reaching a new pinnacle of greatness!" Here, the early years of the genre are classified as part of a teleological development, a chronicle culminating in "a new pinnacle of greatness" that originates with characters like Captain America, who sanctions one of Marvel's strongest claims to fame in the rivalry with DC's early flagship characters Superman, Batman, and Wonder Woman, and "turns full circle" with Marvel's latest versions of these characters, still written and drawn by Lee and Kirby. What we find here is a discourse of exciting newness, enduring continuity, and instant historicity—the splash promises "a tale destined to become a magnificent milestone in the Marvel Age of

37. On different types of serial continuity, see Reynolds (1992, ch. 2); Friedenthal (2017).

Comics!"—that offers a sense of ownership and participation in Marvel's editorial decision-making processes ("Bringing you the great superhero which your wonderful avalanche of fan mail demanded!") and synchronizes the past, present, and future of the narrative. Cap is alive again, turning the past into the present and offering material for future stories; Lee and Kirby draw on their past experience with the character to create what is promised to become riveting new stories. Even those who might not have been around when Cap was active in the 1940s and early 1950s get the chance to witness, and become part of, history in the making: "We sincerely suggest you save this issue. We feel you will treasure it in time to come," the editorial note reads.

A few years earlier, DC had already shown how older stories could become treasures by reviving the Flash, whose Golden Age variant was featured in the Silver Age story "Flash of Two Worlds!" (*The Flash* #123, 9/1961), written by Gardner Fox, penciled by Carmine Infantino, and inked by Joe Giella. This story introduced the concept of parallel worlds by placing the old Flash (Jay Garrick) in universe Earth-One and the new one (Barry Allen) in Earth-Two, moving from linear to multilinear narratives that would come to dominate the genre from the 1970s onward.[38] Reviving Jay Garrick was both an act of archival retrieval and a means of canonizing a present and a past version of the character. The story brought the old Flash from the 1940s, where he had starred in *Flash Comics* from issue #1 (1/1940) to issue #104 (2/1949), into the 1960s, where he encountered the new Flash in a series of stories. "Flash of Two Worlds!" is hailed as "a spectacular story that is sure to become a classic!" on the cover, which depicts the two versions of the Flash speeding toward a man at a construction site about to be struck by a metal beam (see figure 4.4). But the two superheroes are also moving toward the reader, who may be equally overwhelmed by the anachronistic presence of the two superhero incarnations. The archive acts as an engine of circulation here, propelling the past Flash into the present and into the storyworlds of contemporary readers. With "Flash of Two Worlds!," Barry Allen was no longer merely the Flash, but the new Flash, an update of an earlier version whose relevance for the series had not ended with the discontinuation of *Flash Comics* in 1949.

While inactive for more than a decade, the old Flash had remained part of the archive that writers and artists but also readers could con-

38. For further analysis, see Wandtke (2012, 139–41).

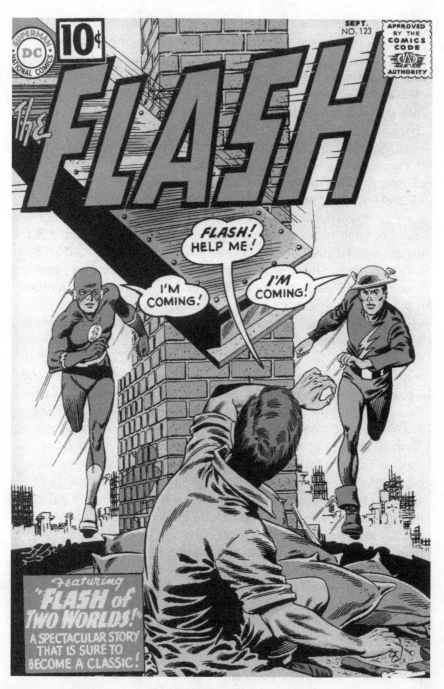

FIGURE 4.4. "Flash of Two Worlds." Gardner Fox, Carmine Infantino, John Broome. *Flash* #123 (9/1961) © DC Comics.

sult to enrich current stories. "Flash of Two Worlds!" acknowledges this in its final panels, where the superhero informs his fiancé Iris about time-traveling to the Golden Age. Frustrated with her inability to understand, he turns to the reader: "The only ones who'd really believe it would be the readers of *Flash Comics!* That's why I'm going to look up Gardner Fox who wrote the original Flash stories and tell it to him! He can write the whole thing up in a comic book!" The Flash is breaking the fourth wall here, appealing especially to readers who had followed *Flash Comics* or were in possession of back issues. He also diegetically authorizes the creation of archive-driven stories like the one that readers were holding in their hands. Sure enough, collectors like Biljo White would soon dig into their collections to retrieve segments of the genre's past, while a Marvel character like Johnny Storm would access "his prized collection of old comic mags" in *Strange Tales* #114 (11/1963) to ponder the whereabouts of the discontinued Captain America as a prelude to his rebooted reintroduction in *The Avengers* #4.[39]

"Flash of Two Worlds!" performs archival work by serving as "the reference memory . . . [that] provides a kind of counterbalance against the necessarily reductive and restrictive drive of the working memory" (Assmann 2008, 106). By transforming the old Flash from his status as a dormant part of the genre's reference memory into an active part of its working memory, the story mobilizes the authority of the archive to expand the scope of the narrative present as well as the very logic of the superhero universe to which DC had subscribed up until this point. Apart from authorizing parallel universes in which different versions of a character can exist, the story suggests that the past is not really the past, but a reservoir of characters, styles, and storylines waiting to be mined by creators and readers.

A major means of reconciling the archival drive of the present with the archival drive of the past is the practice of retroactive continuity, or retcon. DC's twelve-issue series *Crisis on Infinite Earths* (4/1985–3/1986) and Marvel's retroactive revamping of Captain America and sidekick Bucky Barnes are often hailed as prominent examples of a "corporate narrative memory" (Méon 2018, 190) that reorganizes the relationship between past and present according to current needs. Retcons are intraserial narrative maneuvers that ret-

39. I follow Yockey's (2017, 27–28) reading of this comic. See also fanzine articles like Robert Mallory's "The Batman of Old and New" (*Batmania* #19, 10/1974) that continue the investigation of the superhero palimpsest.

roactively rearrange, add to, or subtract material from a series' past. Especially in long-running series and "large-scale media franchises" (Friedenthal 2017, 24), they are an essential "world-building technique," having evolved from "being an occasional tool utilized by comics creators to a de facto way of creating a superhero 'universe' out of disparate books and stories that were never meant to cohere in the first place" (8, 69). They propose the "notion of an alterable and debatable past" (13), a past that is "entirely mutable" (73), treating the archive as a storytelling engine rather than a stable repository. As David Hyman concludes about the genre's "competing drives": "The aetiology and evolution of superhero revision is characterized by . . . the interplay between . . . the imposition and maintenance of narrative stability and coherence . . . and the disruption of this stability resulting from the ongoing need to generate interest by introducing new elements" (2017, 5).

This is not the place to engage in the kind of in-depth analysis of retcons that Friedenthal provides, but it is worth pointing out that this mechanism developed in the 1950s and '60s, when fans-turned-pros like Paul Levitz and Roy Thomas and a new generation of writers and artists who had grown up reading superhero comics began to create narratives that established a dialogic relation with the stories of previous decades, which they had enjoyed as youngsters, and who brought a new sensibility to the genre by placing a premium on the contingency and continuity of characters, setting, and plot developments (Friedenthal 2017, 33–34). Friedenthal notes that retroactive continuity allowed these creators to "engage with history and memory, both in terms of the fictional universe/continuity within which they are writing and the real world context in which those older stories were originally created" (34).

As I have shown, engagements with this genre history and memory included paratextual authorization practices and collective metaverse construction.[40] Indeed, the very term "retroactive continuity" entered the discourse through an editorial statement on the letter page of *All-Star Squadron* #18 (2/1983): "As for what Roy [Thomas] himself . . . is trying to do [in this series], we like to think an enthusiastic ALL-STAR booster at one of Adam Malin's Creation Conventions in San Diego came up with the best name for it, a few months

40. Ahmed and Crucifix speak of "drawing memories [and] memories of drawing" and of "styles and archives as two interlaced trajectories into th[e] excavation of comics memory" (2018b, 4, 3).

back: 'Retroactive Continuity.' Has kind of a ring, don't you think?" (qtd. in Friedenthal 2017, 53). While the term is attributed to fandom in a characteristic move of legitimizing corporate concepts through claims of fan involvement, the establishment of the retcon as "not the exception to the regular flow of superhero stories but rather the new norm" (Wandtke 2012, 193) was based on a number of editorial decisions that led to the publication of *Crisis on Infinite Earths* a few years later.[41]

Crisis on Infinite Earths is generally seen as an act of clearing serial sprawl that could no longer be contained through the multiverse concept, which had been used to explain different versions of DC's characters in parallel worlds. *Crisis* curbed this sprawl by reducing the number of active characters and resetting the action to a single universe, in which all following stories were set (Friedenthal 2017, 78). But how was this curtailment authorized, what kinds of actions did it make possible, and which further actions did it enable? Adam C. Murdough argues that *Crisis* "functioned as a powerful mythological mediator in the introduction of new ways for superhero stories to interact with their own fictional and historical contexts and with their audience" (qtd. in Friedenthal 2017, 72). The series turned those who were involved in its creation into archivists of DC history, with Peter Sanderson acting as the company's main researcher, digging through decades of stories to enable a retcon that not only revised the history of a single series but constituted "an epic rewriting and retranscription of DC Comics' history . . . [that] turned this kind of retconning of past stories into a tool that defined a new way for comics to engage with their history—by willfully (and retroactively) ignoring, forgetting, and/or negating it" (72). Wolfman famously suggested that *Crisis* was erasing "all of the dumb stuff" from DC's story archive and that it acted as a form of *"corrective history"* (qtd. in Friedenthal 2017, 89), an assessment that underscores the political dimension of archival management and the authorizing force of revisionary events such as *Crisis*. "The activity of 'archiving' is thus always a critical one, always a historically located one, always a contestatory one, since archives are in part constituted within the lines of force of cultural power and authority," Hall insists. To engage in an archival practice like retconning means "enter[ing] critically into existing configurations to re-open the closed structures into which they have ossified"

41. On rewriting as a central genre practice, see Dony (2014).

(2001, 92). In superhero comics, retcons can be a conservative force by revising older styles and stories to reaffirm (or canonize) them and their makers, or a progressive force of reimagining the serial past to enable new meanings in the present (Friedenthal 2017, 41).

In addition to retconning and rebooting—the latter an editorial interference with a series that changes its relationship to the past, for instance by completely resetting the continuity or ignoring central elements from the series' past—selective reprinting became a major archival practice. The DC Comics Classics Library series reissued "Flash of Two Worlds!" in 2009, while earlier publications like *Origins of Marvel Comics* and its sequels or formats like Marvel Collectors' Items and DC Giant Annuals kept certain stories in circulation and relegated others to the status of passive archival material. Yet if we take Jules Feiffer's list of early comics—*"Whiz, Startling, Astonishing, Top Notch, Blue Ribbon, Zip, Silver Streak, Mystery Men, Wonder World, Mystic, Military, National, Police, Big Shot, Marvel-Mystery, Jackpot, Target, Pep, Champion, Master, Daredevil, Star-Spangled, All-American, All-Star, All-Flash, Sensation, Blue Bolt, Crash, Smash,* and *Hit Comics"* (1965, 23)—and if we factor in the characters covered in Trina Robbins's *The Great Women Superheroes*—Miss Fury, Black Cat, Spider Queen, Silver Scorpion, Black Canary, Mary Marvel, Wonder Woman, Catwoman, and many others—we will notice that only a fraction of them entered the superhero canon in the same way in which the majority of early superhero publishers beyond DC and Marvel (Quality Comics, EC Comics, Fawcett Publications, Dell Publishing) are often excluded.

Even a publication like the *Marvel 70th Anniversary Collection,* advertising itself as "a compilation of the greatest stories from 70 years of Marvel history" (back cover), reduces the thousands of stories in the Marvel archive to a slim selection of just nineteen stories across almost 350 pages. The collection includes tales of the Sub-Mariner, the Human Torch, Captain America, the Fantastic Four, Spider-Man, the Hulk, Daredevil, Dr. Strange, the X-Men, Iron Man, and the Avengers, but, as editor John Rhett Thomas writes in his introduction, "there isn't enough room" (2009, 4). The canon is more crowded than the archive, lacking space because items are not merely stored but move around and circulate. What makes this collection special is that it resulted from an online solicitation of fan suggestions. Senior vice president of sales David Gabriel wanted "to open the contents of the book up to fandom at large, to put some feelers

out to see what kinds of stories could be curated for [the] collection," Thomas writes. "He turned to yours truly, editor of *Marvel Spotlight* and administrator of the website and message board forums of MarvelMasterworks.com, to see what the loyal Marvel fans assembled there would nominate as worthy inclusions." The final outcome "was largely culled from their suggestions, advice, and very enthusiastic lobbying" (4), Thomas asserts, recognizing the role of fans in the canonization process but noting nonetheless that the final authority rested in the hands of the publisher (*"largely* culled").

Another type of text-based reference publication marking the line between inclusion and exclusion, remembering and forgetting, the canon and the archive, are company retrospectives like *Marvel 75th Anniversary Magazine* (2014) and compendiums like *The Marvel Encyclopedia: Updated and Expanded* (2014), and chronological retellings of a company universe like *The Marvel Saga: The Official History of the Marvel Universe* (1985–1987).[42] The *Marvel Encyclopedia: Updated and Expanded* (Dougall et al. 2014) is a case in point. It is striking that such a thick, 400-plus-page hardcover book exists at a time when online formats like the Marvel Database seem much more accessible (no charge), participatory (anybody can register and contribute), and exhaustive (more than 265,000 pages) than anything a print publication could offer. But the print version offers officially authorized character guides, written by "best-selling author and . . . former editor-in-chief" Tom DeFalco, "Executive Editor of Marvel Comics" Tom Brevoort, and "Marvel's first official archivist" Peter Sanderson (2014, 8). While collaboratively produced, it differs from the more dispersed forms of authorship in the Marvel Database. The book may even serve as a reference guide for online contributions by providing official character biographies and related information. Collectors might further value the pleasure of handling an elaborately designed hardcover volume that can be displayed on a bookshelf over accessing the material online. At a time when "the editable hyperlink, rather than the stable footnote, has become the de facto source of information" and when wikis like the Marvel Database are "not an ossified body of fact, but rather a constantly evolving set of interpretations of the past" (Friedenthal 2017, 8, 157), an authorized but not quite ossified print encyclopedia might serve as a counterweight against

42. Meón discusses all of these briefly (2018, 198–99).

the infinitely malleable, inherently unstable knowledge production online.[43]

The *Marvel Encyclopedia* contains editorial paratexts that invest the publication, and Marvel history at large, with a sense of cultural capital often lacking online. Stan Lee's introduction is filled with his typical hyperbole and tongue-in-cheek praise, but the fact that it is Lee's voice (as well as his iconic signature, appended to the text), known from decades of commentary, marks the book as a legitimate Marvel publication destined for receptive readers for whom this voice will sound intimately familiar. Lee is speaking as the officially recognized creator of many of the characters featured in the book, and he emphasizes the special authority he derives from this role by recalling the moments when he "first dreamed up some of the more prominent characters you will find in this volume" (2014, 9). While he has been invested in the migration of Marvel characters to other media, he still speaks as a representative of the pre-digital era who may compose his introduction on a computer but is more enthralled with the printed book about which he is writing. "There's so much more that I could say, but if I do it'll keep me from leaving my computer and reaching for my beautiful, brand-new Marvel Encyclopedia which is proudly sitting on my corner table," he concludes. "I seem to see a glow around that voluminous volume, as though it's illuminated by some supernatural aura, some mystic radiance emanating from the combined power of the fantastic characters within its pages" (9). The appeal of the book is the aura of the printed object—in its contents, but also in its haptic heft and beauty: "As I slowly reach out to touch the cover of this magnificent book, I wonder—as you may wonder, too—what magic lies within?" (9).

Ralph Macchio's foreword, which precedes Lee's introduction, insinuates that such a magical supernatural aura can be contagious and that the serial agency of the comics can turn fans into professionals. Macchio had started out as a fan and letter hack and ended up as an editor and writer for the company. If Lee is Marvel's elder statesman, Macchio represents a younger generation of fans-turned-pro: "I was one of those youths totally absorbed by the Marvel brand. In fact, I turned my childhood passion into my life's work," he writes and then cites some of the characters he has worked on since joining Marvel in 1976 (Spider-Man, Daredevil, Thor, Captain America)

43. The *Marvel Encyclopedia* was first published in 2006, revised in 2009 and 2014, with a new edition in 2019.

COLLECTING COMICS • 261

(2014, 6). Dispensed by a self-declared "dyed-in-the-wool Marvelite" whose career path would be a "dream come true" for many, Macchio's stamp of approval for this "comprehensive reference guide" and its offer of "access of all things Marvel" is especially powerful, and it serves as a reminder that paratextual editorial memory management is not limited to memories of comic book characters and content but includes the whole history of the metaverse.

Conclusion

In one of his oversized comic strips published in *Co-Mix: A Retrospective of Comics, Graphics, and Scraps* (2013), Art Spiegelman depicts himself as a smoking toddler wearing glasses and a diaper, holding his magnum opus *MAUS* (1986/1991) upside down. Pondering the changing reception of comics, the toddler notes: "Funny thing about comics—first they kill off literacy, and now they're the last bit of print culture still flourishing" (2013, 90). Dated 2009, Spiegelman's strip reads as an apt commentary on the medium's close association with its material form, cultural reception, and archival potential. Two decades earlier, Marvel had released a retail display poster for their Masterworks series that announced the acceptance of superhero comics as a form of literature whose history should be preserved in libraries alongside the classics (see figure 4.5).[44] It shows a library with bookshelves in the background and a desk and reading light in the foreground. Hardcover collections of The Incredible Hulk, The Avengers, The Amazing Spider-Man, and All-New X-Men are on display. For sale are "The Stories That Started It All," which had not ended up as waste but are now available in sturdy "hardcover collector's editions." Prefiguring Spiegelman's deadpan presentation of the turned-over *MAUS*, Spider-Man is hanging upside down in a visual pun on the poster's central claim to Marvel's offbeat hipness: "25 years ago, we turned the comics world upside down" (Saffel 2007, 216).

The claim made by the poster and reiterated by Spiegelman two decades later is that comics have achieved their much-deserved recognition, that efforts like Lee's and Spiegelman's to elevate the medium were successful, and that the ephemerality of the serial artifact has been replaced by the stability and endurance of the printed

44. We should not underestimate the role of librarians and archivists in the preservation and curation of superhero comics. For a historical overview, see Robb (2017).

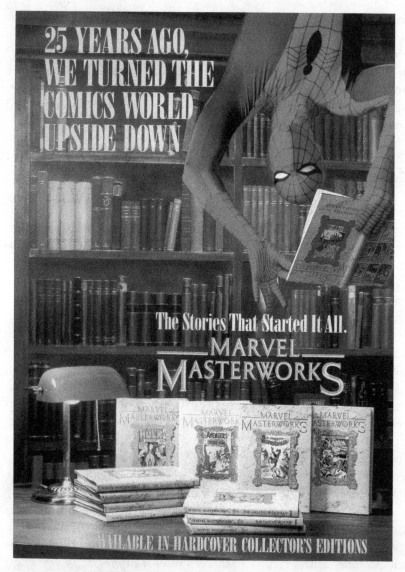

FIGURE 4.5. Marvel Masterworks advertisement, 1989. Steve Saffel, *Spider-Man the Icon: The Life and Times of a Pop Culture Phenomenon*, 2007 © Titan Books.

book. Even today, when substantial chunks of the comic book market have migrated online, massive publications like Marvel's *Civil War* box set (2016)—eleven hardcover books spanning over 4,000 pages, presented in an elaborately designed durable cardboard box for a hefty price—indicate that collecting and archiving physical objects

continue to function as authorizing practices despite the prominence of digital production, communication, and storage.

In his related analysis of the high-priced artist's editions by publisher IDW, Jean-Paul Gabilliet discerns a larger trend toward "the multiplication of 'classics' issued in pricey, oversized hardcover books containing facsimile reproductions of original artwork" (2016, 17). In the case of the artist's editions, very low print runs (250 for Gil Kane's *The Amazing Spider-Man*) and extremely high prices (about $150) suggest an "economic and cultural elitism" (19) supported by the books' paratextual framing: by prefaces or forewords that "underscore the quasi-hagiographic concerns running through a collection devoted to one creator" (20). In addition to contributing to the canonization of certain artists, these books aim to rescue the artwork from its mass-cultural status by displaying it in its ostensibly original, preproduction form:

> Packaging comics narratives in volumes the size of original artwork and removing the coloring that adorned the pages when they were first published in magazines or graphic novels predicate a return, both symbolical and practical, to the roots of the creative process— *before* the technological process leading from original art to printed art, *before* the commercial process that transforms the handiwork of an author into a commodity marketed according to the identities of the creator and series. (20)

In these publications, "equating the 'reconstruction' of the author's intentions and the return to some genesis of each original art page appears as a deceptively self-evident and truly anachronistic assumption," Gabilliet notes, since "original art pages have always been black and white templates created first and foremost in order to be reduced, colored and printed in mass-produced magazines" (21). Sharing my interest in construction sites and making-of moments, the comics connoisseur who buys an artist's edition inhabits the role of an "archaeologist-*cum*-aesthete" who wishes "to gain access to the traces, gestures, hesitations, changes of mind, and thousand occurrences making up the authors' daily lives," and whose "enjoyment of a narrative told in comics is equaled if not overtaken by the discovery of another one: the simultaneous, concealed narrative of the creative process" (23). But in this process, he or she will inevitably treat the comic as a mummified object: "The story in which they

immerse themselves is not the diegesis imagined by the creators but the history of the comic's production reconstructed by means of the imprint of the creators' craftsmanship in a medium where pictures are worked into narrative construction" (23–24).[45] This shift from hermeneutic to archaeological reading practices (24) substitutes the reductive focus on the comics text with an equally reductive preoccupation of them as objects. The same can be said about the museum books, which seek to secure the survival of the comic book through an affiliation with the printed book.

The *Marvel Masterworks* series, the *Civil War* box set, the artist's editions, but also the museum books, Kidd's *Batman Collected,* and the *Marvel Encyclopedia,* underscore Diana Taylor's diagnosis that the "digital era is obsessed with archives" (2010, 4). On the one hand, we are witnessing "a great longing today for the old comics and other vintage popular culture precisely because they are disappearing" (Baetens and Frey 2015, 224). Museum books and "replica editions" like the facsimile reproductions of Tintin books by the Belgian Foundation Moulinsart (221) make this abundantly clear. On the other hand, the genre keeps revising and reimagining itself by utilizing the affordances of digital media. Chip Kidd and Dave Taylor's *Batman: Death by Design* (2012) is an instructive example. Considering Kidd's involvement in the preservation of comics culture—his books on Jiro Kuwata's *Bat-Manga* (Kidd, Spear, and Ferris 2008); the production history of *Batman: The Animated Series* (Dini and Kidd 1998); *Batman Collected*—the retro rendition of the caped crusader in *Death by Design* makes sense. However, from the book's display of vintage-looking facsimiles of pencil sketches on the opening and closing pages to the promise of "a thrilling graphic picture story only from DC Comics / available at your local news agent" on the inside back cover, the "retro-narrative modes" that shape the actual storyline and its visual delineation and that present Batman as "the perfect hero for nostalgia-obsessed pop culture" (Baetens and Frey 2015, 227) remind us that the superhero's serial past is always up for grabs.[46] This unfolds through memorabilia publications like the museum books but also through new stories that may stand outside of ongoing serial continuities but use the resulting leverage to engage

45. The majority of artwork was not preserved. "The best stuff I ever inked—it's lost forever; I can't find any of it," John Romita once noted (Thomas and Amash 2007, 32).

46. See also Yockey (2012).

with the history of the genre, including its materiality. Kidd remarks that the final pages ("endpapers") of *Death by Design* were created as part of a letterpress workshop at Indiana University (2012, 105); Taylor comments in the appended sketchbook that "all the work in this book is produced with good old-fashioned pencils, first in blue and then 'inked' in graphite. . . . The shading and color I overlaid on computer" (111). This combination of analog and digital production techniques captures the current fascination with digitally mediated vintage and retro culture (Baetens and Frey 2015, 228).[47]

Musealization and mobilization define the contemporary superhero. Apart from the arrival of new digital tools, distribution systems, and modes of reception, digitization is forcing the genre to reconsider, reconstruct, and reconsolidate its backstory. In addition to serial proliferation and transmedia spread (archival mobilization as a centrifugal force), processes of genre conservation and preservation (archival mummification as a centripetal counterforce) stabilize the genre at a time when the initial carrier medium may be on its way to becoming obsolete, being supplanted by digital subscriptions and graphic novel collections.

In the digital environment, collecting thus confronts a new problem landscape. "The comic book collecting hobby and the comics industry, both traditionally based in print, . . . begin to mutate in the digital age," Frederick Wright holds. "Once a quest that often took years of visits to flea markets, garage sales, used bookstores, and the local comics shop, completing an entire run of a comic book title may become as easy as downloading a file from the Internet." What has changed most fundamentally is the "factor of materiality" and with it the "social practices of comic book collecting" (2008, n. pag.). As Gregory Steirer puts it, the

> digital-comic marketplace . . . has introduced considerable complication into the collection-based underpinnings of the medium. Whereas collecting has historically been premised upon the material qualities of physical objects published in limited supply, digital comics are functionally immaterial and lack natural supply constraints. (2014, 455)[48]

47. On print culture and the book in the digital era, see Starre (2015).

48. See also Romaguera: "The availability of an online archive of any and all previous instalments provides a level of narrative accessibility that few other forms of serial fiction have" (2015, 2).

Traditional comic book collectors with large physical connections still exist, but as comics are read more and more on computer screens and accessed via subscription-based online services, the question is how these new activities reshape established collecting practices. Moreover, "before a comic is printed, it may only exist in completed form—written, drawn, inked, colored, lettered, and so forth—as an electronic file" (F. Wright 2008, n. pag.). There is, then, no longer an original artwork with which collectors could increase the monetary value and cultural capital of their collections.

What does this mean for the evolution of the genre? For one thing, digitization is changing the nature of collecting. "The shift to digital distribution does not necessarily preclude collecting as a mode of consumption," Steirer asserts:

> Whether or not the collecting culture associated with physical comics is able to migrate to digital comics—or whether a new form of collecting culture specific to digital comics will develop—depends . . . on how the digital comic gets coded, literally, as an object. Can consumers . . . perform the panoply of forms of consumption that underpins collecting, or has the digital comic been constructed via programming to limit how consumption takes place? At present, the answer is emphatically the latter. (2014, 461)

Most problematically, those digital comics that can be legally purchased through services such as the subscription-based Marvel Unlimited (launched in 2007), which is indeed "a curated selection" of the company's back catalog (Steirer 2014, 460), resist many of the practices afforded by the printed comic book, such as owning, reselling, organizing, and displaying one's collection (461–62). Digital services have not only changed the ways in which people access and read their comics, they have also changed how they interact with the comics and with each other. If the collectors' culture of the 1960s had fostered "quasi-organised networks" of aficionados and retailers interested in communicating with like-minded others about comics as well as about their activities as collectors and sellers (463), digital comics authorize a different interaction, replacing the "synthesising system of the secondary market . . . [with] the additive, rhizomatic system(s) of social media with its reliance on 'likes,' links and recommendations" (464).[49] Steirer therefore asserts: "The growth of the

49. Beaty speaks of "the networks that constitute the comics world" (2012, 42).

electronic sell-through market for digital comics in the United States . . . signals the end of collecting as the organising logic of American comics culture" (456).[50]

Viewed from an actor-network perspective, the question becomes how immaterial objects may exert agency in a digital world and how they might make other actors act. I would suggest that they can do so by enabling new types of archival practices that may or may not be based on more traditional forms of collecting and that may capitalize on the whole history of the genre, including the many authorization conflicts that have shaped its evolution. The question is how the twin dynamics of musealization and mobilization will play out in the digital era. Following Abigail De Kosnik, we can see that digital culture authorizes an increasing number of "rogue archivists" and "'rogue' memory workers" (2016, 2) with whom the more conventional copyright- and trademark-based ownership logic of the publishers and their parent companies must contend. These archivists create "rogue archives" characterized by "constant (24/7) availability; zero barriers to entry for all who can connect to the Internet; content that can be streamed or downloaded in full, with no required payment, and no regard for copyright restrictions . . . ; and content that has never been, and would likely never be, contained in a traditional memory institution" (2). Rather than initiate the "proliferation of different canons (or canons of difference)," these archives authorize "the elimination, or extreme diminishment, of 'the very idea of sharing common references or approaches,'" undermining "the very notion of canonicity itself" (64).[51]

If Steirer's diagnosis of "the end of collecting as the organising logic of American comics culture" were true, a book like *Batman Collected* would represent either an early counterreaction to the spread of online communication, with Kidd casting himself in the role of the obsessed collector, or an indication of a "repertoire of consumer-good interactions that make up collecting as a practice" (Steirer 2014, 455). My sense is that rather than witnessing the end of collecting as an organizing logic, we are seeing different adaptations to the new problem landscape, in the same way in which the emergence of an interconnected and publicly visible collector's culture in the 1960s laid the groundwork for direct market distribution, specialty stores, changes

50. Stevens and Bell even ponder whether "comic book readers [are] 'fans' if they collect digital files instead of physical texts" (2012, 756).

51. De Kosnik is quoting from Burdick et al. (2012, 23).

in storytelling and packaging, and a secondary market for collectors' paraphernalia in later decades (Steirer 2014, 455).[52] Among the more recent adaptations to digitization is a shift to graphic novel collections of storylines and anthology formats that collect canonical stories from earlier stages of the genre, as well as a more profound move toward an archival sensibility whose primary interest lies less in the completion of a collection of physical objects than in the researching, documenting, assembling, and annotating not just of comic books but of the evolution of the genre as a whole. These archival activities frequently unfold online, but rather than fully supplant earlier, non-digitized efforts to preserve superhero history (rummaging through back-issue bins, swapping doubles), they can still be based on physical collections. "Comics [have] succeeded in maintaining their viability as a print medium," Aaron Kashtan notes, "while also successfully transitioning to digital platforms" (2018, 4).

Consider this: The Pedigree Comics website describes the company as "unique to the industry, offering everyone a chance to buy, consign or sell only ultra high grade, CGC and CBCS certified, Marvel Silver, Bronze and Copper age comics and magazines."[53] The website functions as a veritable archive, categorizing the offerings into the sections "inventory," "auctions," and "vault," each of which lists available (and sometimes already sold) comic books from various periods and includes information about their condition, rarity, and pricing, as well as photographs of them in special casings with their grade clearly visible. The site connects singular physical objects with their digital representation (and vice versa) and gives potential buyers and interested viewers a chance to search through substantial segments of superhero history. Because "access is not dependent on purchase," as Lincoln Geraghty writes about a comparable site, Pedigree Comics offers a "repository for fans and collectors" and "a

52. Steirer lists "speciality covers, poly-bagged inserts, limited print runs and variant editions" as elements of the commercially driven efforts on the part of the publishers "to reframe their comics as collectibles" (2014, 455).

53. See https://www.pedigreecomics.com/page/about-us. CGC stands for "Certified Guarantee Company," the largest grading service for comics founded in 2000; CBCS abbreviates "Comic Book Certification Service," a competitor of CGC. The Pedigree Comics company derives its name from "pedigree collections," which Beaty defines as "a rare collection of extremely well-preserved comic books, such as the file copies held by a publisher . . . [that was] never damaged by its movement through distribution channels or by having been read" (2012, 163).

visual archive of what collectible objects are available and which ones might add cult status and value to their own collections" (2014, 66).

These online repositories and their archival affordances work against what Lev Manovich identifies as a central problem of the current trend to digitize collections, archival materials, and museum holdings. The problem is not a lack of available content but the sheer number of digitized items and the heterogeneity of institutions putting these items online, which make "the past look . . . un-periodic and un-systematized" (2017, 263). It is this sense of unperiodicity and unsystematization that challenges established mechanisms of managing superhero sprawl and necessitates new forms of centripetal containment. Online culture has developed many such maneuvers, from sites like Pedigree Comics and fan-driven wikis like the Marvel and DC Databases to large platforms like Comic Vine, which offers participatory formats (a wiki, forums, a community section). Rather than assemble physical copies of superhero comics, these databases and platforms map substantial parts of the genre's history into the vast digital archive. They perform functions that letter pages, bulletins, and fanzines had taken on in the past. But they also move away from collecting comics toward the collaborative construction of a giant genre database through which its massive archive can be combed, classified, and ordered in a way that transcends the capacities of any individual collector or even any single group of collectors (Gardner 2012, 149).

So what should we think about when we think about superhero archives past and present? First, we should recognize the tension between containment and sprawl that structures serial storytelling as much as it shapes the authority of the archive. When Hall considers archiving as "a practice which both has its limits and its disciplines yet has no definite sense of origin, boundary or termination" (2001, 91), and when he embraces the archive as a living entity and an always unfinished, always transforming phenomenon, he captures the close connection between seriality and the archive. "'Living' means present, on-going, continuing, unfinished, open-ended" (89), Hall explains, referencing Foucault's understanding of archives in *The Archaeology of Knowledge* as "series full of gaps, intertwined with one another, interplays of differences, distances, substitutions, transformations" (1972, 37). This notion of the seriality of the archive also informs Steedman's observation that "to want to make an archive in the first place, is to want to *repeat*" (2001, 6), and to repeat, with varia-

tions or Foucauldian differences, distances, substitutions, and trans-formations, is a core principle of serial narration.

Like serial storytelling, "archives are places not just of informa-tional continuity but also of informational gaps" (Assmann 2011, 330). While it is tempting to identify these gaps and speculate about what is missing, we must also gauge the agency of the gap itself as a structural prerequisite for serial storytelling and its archival drive. Without intervals between installments, there is no serial narrative, only an endless strain of narration. I have already indicated what can happen in these intervals, how conducive they are in terms of activat-ing readers and connecting the reception of a series with its ongoing production in perpetual "feedback loop[s]" (Kelleter 2017, 13). But "the stakes of archiving seriality" (Crucifix 2018, 9) involve more than the identification of gaps and the interplay of absence and presence, exclusion and inclusion. Foucault writes:

> The archive is first the law of what can be said, the system that gov-erns the appearance of statements as unique events. But the archive is also that which determines that all these things said do not accu-mulate endlessly in an amorphous mass, nor are they inscribed in an unbroken linearity, nor do they disappear at the mercy of chance external accidents. . . . The archive is . . . that . . . which defines at the outset the *system of its enunciability*. (1972, 129)

Foucault's observation captures much of what the collections, museum books, reprint editions, indexes, retcons, and encyclope-dias discussed throughout this chapter are all about. By conserv-ing mummified objects and creating mobile archives, these formats shape a system of enunciability by determining what can be authori-tatively known and thus legitimately said. Yet by resisting a totalitar-ian impulse toward completeness, superhero comics also embrace the unconventional, the makeshift, and the mobile.

AUTHORIZING DIVERSITY

Let's return, for a brief final moment, to the first years of the comic book superhero in an effort "to redescribe as mobile what has established itself as settled" (Kelleter 2014a, 4). Let's grab *Captain America Comics* #5 (8/1941), either one of the original floppies if you are lucky enough to own one or affluent enough to shell out thousands of dollars for an eighty-year-old issue. You might, of course, also consult one of the many available reprints or digital versions. Thinking about the different material forms through which this single comic book has been reaching readers for eight decades foregrounds many of the controversies covered in this book, from questions of originality and auratic power (what makes the original mass-produced, flimsy, and cheap artifact so special that people are willing to spend major money for a copy?) to practices of collecting and archiving (who has collected and held on to this comic book, and why, and which archival and reprint formats make it presently available?), to notions of digital transformation (what does it mean when we can readily access the comic online and read it on a computer screen or any other digital device?).

Instead of revisiting these questions, this coda zooms in and out of a single scene in one of the stories contained in this comic book

installment, Joe Simon and Jack Kirby's "Captain America in Killers of the Bund," to extrapolate ideas about the current state of the superhero genre and its evolution since the early 1940s. I am particularly interested in the scene in which Captain America encourages the Sentinels of Liberty, his fan club in the comics and in the off-text world, "to act as secret agents" in search of "hidden Bund hideouts so Cap can mop 'em up!" (see figure 5.1). In keeping with Latour's assertion that "every single interview, narrative, and commentary, no matter how trivial it may appear, will provide . . . a bewildering array of entities to account for the hows and whys of any course of action" (2005, 47), I want to think about what we can learn about the superhero's evolution from this more or less randomly chosen, single scene. For one, it creates a sense of interactive immersion, allowing readers to recognize themselves in and through the story as fans whose reading experience is intensified through the comic's real-world references to Nazi infiltration (the German American Bund being a Nazi organization operating in the US) in a nation about to enter World War II. The comic assigns these readers/fans a meaningful role in the unfolding national drama as well as in the ongoing fictional diegesis, where they may picture themselves as Captain America's sidekicks and as youthful defenders of American democracy. The fans appear as "reader surrogates"[1] whose double purpose is to be Cap's followers and good patriots, and they model off-text behavior like enlisting in the Sentinels of Liberty club.

Comic books at the time were not very subtle about their desire to turn readers into fans, as an advertisement reprinted in Joe Simon and Jim Simon's *Comic Book Makers* indicates. "Captain America Declares a 'State of Unlimited Junior National Emergency'!," the ad proclaims as it summons the youth of the nation to the Sentinels fan club, promising to reward them with a special membership charter and a gold certificate of merit, and mentioning the most patriotic deeds reported by fan clubs in the very pages of the comic (2003, 45). Especially notable is the sense of individual membership in a meaningful collective, a standard offer of popular serial storytelling: "Join more than 20,000 patriotic young Americans in a noble crusade against spies, fifth columnists, and traitors to the United States of America!!!" (45). Reading comics is conceived as a communal endeavor here, one that pits together righteous Americans against evil enemies in a dichotomous

1. Kukkonen defines "reader surrogates" as "characters whom readers follow and identify with as the story unfolds" (2010, 42).

FIGURE 5.1. "Captain America in Killers of the Bund." Joe Simon and Jack Kirby. *Captain America Comics* #5 (8/1941) © Marvel Comics.

worldview that no longer works in more recent Captain America comics, where the superhero is more conflicted and sometimes flirting with fascism and where national consensus on anything political is virtually impossible.

But Captain America's politics have been amply discussed (Dittmer 2013; Stevens 2015), which is why I turn to the raced and gendered makeup of the group of fans depicted in "Captain America in Killers of the Bund." While all of these fans are rendered in a caricatured style, one of these fans is drawn as a "coon" figure, a racist holdover from nineteenth- and twentieth-century blackface minstrelsy, while a single girl is standing in the background. These two figures are as remarkable as they are problematic. They are remarkable because Simon and Kirby imagine an inclusive comic book fandom several months before the Double V campaign was launched in the *Pittsburgh Courier* (February 7, 1942) and around the same time President Franklin D. Roosevelt signed Executive Order 8802 (June 25, 1941), which mandated the racial integration of the American defense industry following political pressure from African American activists like A. Philip Randolph and Walter White. The lonely girl in the crowd is also remarkable as her presence registers the significance of female readers as well as the growing significance of working women in the war effort and their increasing public visibility as the nation geared for violent conflict abroad.

The remarkable fact that Simon and Kirby's imaginary fan community is already diverse (notwithstanding the racially deprecating portrayal of the Japanese in other scenes, as well as the conveniently

evil visual portrayal of the Germans) and thereby advertises Captain America's exploits as a popular narrative for the nation, is undermined by the use of a politically outdated yet obviously still resonant iconography—a racist visual archive rearing its ugly head in a comic addressed primarily to children and teenagers. While the history of female superheroines is fraught with chauvinistic and misogynist representations despite the efforts of feminists since the 1970s to reclaim Wonder Woman and her female allies as icons of gender equality and women's rights, the representation of African American characters (and other ethnic minorities) is perhaps even more difficult to fathom.[2] Nonetheless, when Gloria Steinem writes that "the Wonder Woman stories are not admirable in all ways" and acknowledges that "her wartime adventures sometimes had highly jingoistic and even racist overtones" (1972, 205, 207), the superheroine's ability to foster intense and lasting authorization conflicts that drive the evolution of the genre becomes clear. The superhero's ability to function as a "cultural nexus" (J. A. Brown 2019, 2), as a fulcrum point for competing conceptions and disparate dispositions, is already present in 1941, but the "elasticity of contemporary comics studies, with its embrace of inter- and multidisciplinarity, collaboration, and border crossings" and its recognition that "superheroes can, if given the space, speak beyond themselves and their originating medium," which Ellen Kirkpatrick and Suzanne Scott have recently diagnosed (2015, 120), remains an ongoing project.[3]

Characters like Captain America, but also Batman and Spider-Man, the main protagonists of my study, are ambivalent and indeterminate in terms of their political symbolism and affiliations, attracting controversies over their political convictions (especially Captain America), sexual orientation (Batman, as well as the recently queer Wonder Woman), and ethnic background (Spider-Man). While they have been claimed as champions of a liberal and progressive America (Fawaz 2016), with Captain America being celebrated for introducing the African American superhero the Falcon in issue #117

2. I have already referenced scholarship of the superhero's gender politics. Additional sources are Peppard's *Supersex: Sexuality, Fantasy, and the Superhero* (2020) and the special issue of *American Literature* on Queer Comics edited by D. Scott and Fawaz (2018). On the superhero's queerness, see also Franklin (2001); Later (2020). On female fandom, see Healey (2009); Edwards (2012); Orme (2016); S. Scott (2019).

3. See related attempts to decolonize fan studies and recognize nonwhite actors in fan cultures, such as Pande (2018; 2020).

(9/1969), they have also been recognized as agents of "racist myths of belonging" and as figures with fascist leanings (Curtis 2020, 51). Neal Curtis references "What If Captain America Were Not Revived Until Today?," a story printed in *What If?* #44 (4/1984) in which the Sentinels of Liberty are enlisted by Captain America to protect a white supremacist senator (Curtis 2020, 53). Considering the even more overtly fascist Captain America of the *Hail Hydra* story arc by Jonathan Mabarry and various artists (#1–5, 3–7/2011) as well as racist online discussions surrounding stories like "A Simple Case" (*Batman* #44, 11/2015), accounts of an increasing liberalization of these characters and of the genre at large appear dubious.[4] After all, the current movement of the genre toward greater inclusivity must contend with a backlash that often cites traditional genre conventions to reject characters like the Afro-Mexican Miles Morales as Peter Parker's successor, the African American Sam Wilson as Captain America, the Pakistani American Kamala Khan as Ms. Marvel, or the Korean American Amadeus Cho as the Hulk. It would be easy to argue that these characters and the comics' conception of American identities and communities is simply a sign of the times, of a nation becoming more and more liberal and progressive in its political outlook, or the result of daring publishers, editors, writers, and artists, perhaps pressured by an increasingly vocal fan base, to try to create more timely superheroes. But such progressive narratives must acknowledge more regressive counternarratives that seek to curb the diversification of the superhero by insisting on the characters' transhistorical validity as predominantly white, male, and able-bodied creatures.[5]

A more complex argument, and one that is supported by the insights offered throughout this book, would be to multiply the human and nonhuman actors involved in the genre's evolution and to approach this evolution through the lens of authorization conflicts. This includes a critical look at the narratives themselves, as the example of the black fan in the Sentinels of Liberty indicates and as stories like "The Batman Nobody Knows!" by Frank Robbins and Dick Giordano (*Batman* #250, 7/1973) underscore. The story depicts three inner-city boys sitting around a campfire at a retreat sponsored by Bruce

4. I discuss the fascist reception of "A Simple Case" in Stein (2020a). See also Dittmer (2013) on Captain America as a nationalist superhero.

5. See Cocca: "The word 'superhero' pretty much assumes that the hero in question is male, and white, and heterosexual, and able-bodied" (2016, 6). On superheroes and disability, see Alaniz (2014); Smith and Alaniz (2019).

Wayne (Batman fans are imagined as exclusively male). Scared by the darkness and the howling of an owl, each of the boys claims that he knows what the real Batman is like. The second boy pictures Batman as an African American (like himself) who is flying with motorized plastic wings and operating jet-propelled rockets, evoking a tradition of black superheroism: "Muhammed Ali—Jim Brown—Shaft—an' Super-Fly all rolled into one!"[6] It is no coincidence that the boy cannot imagine any black superheroes and therefore locates the referential frame for his fantasies outside the genre. While black superheroes like Black Panther (*Fantastic Four* #52, 7/1966) and Luke Cage (*Luke Cage, Hero for Hire* #1, 6/1972) had started to appear in the Marvel universe in the mid-1960s and early 1970s, it took DC longer to integrate their comics with substantial black characters like Black Lightning (*Black Lightning* #1, 4/1977). From more provocative treatments like Robert Morales and Kyle Baker's *Truth: Red, White & Black* (1–7/2003) or Ta-Nehisi Coates, Roxane Gay, Yona Harvey, and Nnedi Okorafor's *Black Panther* stints (since 2016), to attempts to offer strong black female figures in Jazmin Truesdale's Aza Comics universe, it is fair to speak of an evolution of black representation in superhero comics rather than of a straight progression.[7]

To further complicate teleological accounts and recognize that things could have been different (Latour 2005, 89) at many junctures in superhero history, we may look at one final example where questions of racial representation are subject to conflicting bids for prevalence. "And Who Shall Mourn for Him?," from *Silver Surfer* #5 (4/1969), written by Stan Lee with art by John and Sal Buscema, is a story about the African American physicist Al B. Harper, who saves the Silver Surfer from Galactus because he "knows how it feels to be pushed around" and gives his life in saving the earth. Published less

6. See also Brooker (2000, 18–19). This story anticipates recollections of storyworld immersion by academics. Nama opens his book on black superheroes with personal remarks about the significance of racial representation (but sticks to a gendered notion of superhero fandom): "With the Falcon I was able to imagine myself as a superhero, rising above my socioeconomic environment, beating the neighborhood bullies, commanding respect from my male peers, and enjoying approval from all the pretty girls that made me feel so nervous. . . . The image of a black man gliding through the air, compelling attention, awe, and respect, made a lasting impact on my imagination" (2011, 2).

7. See https://www.azacomics.com/. For historical accounts, see J. A. Brown (2001); Nama (2011); Whaley (2016); Austin and Hamilton (2019); Darowski (2020); Wanzo (2020). On Latinx superheroes, see Aldama (2017).

than a year after the assassination of Martin Luther King Jr., the story captured the zeitgeist by depicting a selfless black hero. But it also triggered complaints, for instance by a reader whose letter in issue #7 (8/1969) rejected "a recent trend by Marvel to put the Negros [sic] in the spotlight. . . . when you start your own civil rights protest, well, I'm against that. . . . For months you've been knocking 'us' (you know who I mean). . . . I'm not a racist, just a concerned Marvelite who doesn't want his favorite comic company to be ruined" (qtd. in Fingeroth 2019, 200–201). It is difficult to ascertain who or what is acting here, whether it was the political climate that made Marvel put out more inclusive stories and caused the reader's objection, the comic book makers who wanted to take a stand, or the fact that popular serial narratives routinely elicit such responses from those involved in their serial pursuits.[8] The reaction of the Marvel editor to the letter is significant, albeit rather cautious, and it expresses uncertainly about the source of action: "But such matters as racism and equality *do* concern us . . . We think that many people . . . have too long turned their backs or averted their eyes to the more unpleasant things that are going on every day. Maybe we felt we could do something . . . to change things just a bit for the better" (qtd. in Fingeroth 2019, 201). That this exchange does not seem too far removed from current debates about diversity and representation in comics (and in comics studies) should remind us that the world does not move "like an arrow, but [like] a boomerang" and that "those who speak of the *spiral* of history . . . are preparing a boomerang," as Ralph Ellison's narrator muses in *Invisible Man* (1982, 5). It is, therefore, only fitting that a book that started with DC's and Marvel's reboots in the 2010s ends with remarks about the superhero's implication in the conflicts that continue to trouble US society and culture. Superhero comics are indeed a playground for rehearsing what makes us all act.

8. Cohen (2004) makes a connection between consumption, market segmentation, and the beginnings of identity politics in the 1960s.

REFERENCES

Abrams, Nathan. 2014. "A Secular Talmud: The Jewish Sensibility of *Mad* Magazine." *Mad Magazine and Its Legacies.* Ed. Judith Yaross Lee and John Bird. Special issue of *Studies in American Humor* 30: 111–22.

Adams, Mitchell. 2020. "The Secret Commercial Identity of Superheroes: Protecting the Superhero Symbol." Burke, Gordon, and Ndalianis, 89–104.

Adler, Bill. 1966. *Bill Adler's Funniest Fan Letters to Batman.* New York: Signet.

Adler-Kassner, Linds. 1997/1998. "'Why Won't You Just Read It?': E. C. Comic Book Readers and Community in the 1950s." *Reader: Essays in Reader-Oriented Theory, Criticism, and Pedagogy* 38/39: 101–27.

Ahmed, Maaheen, and Benoît Crucifix, eds. 2018a. *Comics and Memory: Archives and Styles.* Cham: Palgrave Macmillan.

———. 2018b. "Introduction: Untaming Comics Memory." Ahmed and Crucifix 2018a, 1–12.

Ahrens, Jörn, and Arno Meteling, eds. 2010. *Comics and the City: Urban Space in Print, Picture and Sequence.* London: Continuum.

Alaniz, José. 2014. *Death, Disability, and the Superhero: The Silver Age and Beyond.* Jackson: UP of Mississippi.

Alberich, R., J. Miro-Julia, and F. Rosselló. 2002. "Marvel Universe Looks Almost Like a Real Social Network." https://arxiv.org/abs/cond-mat/0202174v1 (February 11).

Aldama, Frederick Luis. 2017. *Latinx Superheroes in Mainstream Comics*. Tucson: U of Arizona P.

——, ed. 2020. *The Oxford Handbook of Comic Book Studies*. New York: Oxford UP.

——, ed. 2021. *The Routledge Companion to Gender and Sexuality in Comic Book Studies*. New York: Routledge.

Allen, Rob, and Thijs van den Berg, eds. 2014a. Introduction. Allen and van den Berg, 1–7.

——. 2014b. *Serialization in Popular Culture*. New York: Routledge.

Altman, Rick. 1999. *Film/Genre*. London: British Film Institute.

The Amazing Spider-Man Collector's Album. 1966. New York: Lancer Books.

Anderson, Benedict. 2006. *Imagined Communities: Reflections on the Origins and Spread of Nationalism*. 1983. Rev. ed. London: Verso.

Apeldorn, Ger. 2009. "'What Hath Kurtzman Wrought?' An Issue-by-Issue Look at Those Mid-1950s *Mad* Comics Imitators." *Alter Ego* 3.86 (June): 4–59.

Assmann, Aleida. 2008. "Canon and Archive." *Cultural Memory Studies: An International and Interdisciplinary Handbook*. Ed. Astrid Erll and Ansgar Nünning. Berlin: De Gruyter. 97–107.

——. 2011. *Cultural Memory and Western Civilization: Functions, Media, Archives*. 1999. Cambridge: Cambridge UP.

Austin, Allan W., and Patrick L. Hamilton. 2019. *All New, All Different? A History of Race and the American Superhero*. Austin: U of Texas P.

Avery-Natale, Edward. 2013. "An Analysis of Embodiment among Six Superheroes in DC Comics." *Social Thought & Research* 32: 71–106.

Baetens, Jan. 2001. "Revealing Traces: A New Theory of Graphic Enunciation." *The Language of Comics: Word and Image*. Ed. Robin Varnum and Christina T. Gibbons. Jackson: UP of Mississippi. 145–55.

Baetens, Jan, and Hugo Frey. 2015. *The Graphic Novel: An Introduction*. New York: Cambridge UP.

Bails, Jerry. 1965. "If the Truth Be Known or 'A Finger in Every Plot!'" *Capa-alpha #12* (September).

Bainbridge, Jason. 2009. "'Worlds within Worlds': The Role of Superheroes in the Marvel and DC Universes." Ndalianis 2009b, 64–85.

——. 2010. "'I Am New York'—Spider-Man, New York City and the Marvel Universe." Ahrens and Meteling, 163–79.

Bakhtin, M. M. 1968. *Rabelais and His World*. Trans. Hélène Iswolsky. Cambridge: MIT.

——. 1973. *Problems of Dostoevsky's Poetics*. Trans. R. W. Rotsel. Ann Arbor: Ardis.

Bal, Mieke. 1994. "Telling Objects: A Narrative Perspective on Collecting." Elsner and Cardinal, 97–115.

Banhold, Lars. 2017. *Batman: Re-Konstruktion eines Helden*. Berlin: Bachmann.

Barker, Kim. 2015. "Holy Blurring of Core Copyright Principles, Batmobile!" *Graphic Justice: Intersections of Comics and Law*. Ed. Thomas Giddens. New York: Routledge. 19–35.

Barker, Martin. 1989. *Comics: Ideology, Power and the Critics.* Manchester: Manchester UP.

Barthes, Roland. 1977. "The Death of the Author." 1967. *Image, Music, Text.* Ed. and trans. Stephen Heath. London: Fontana. 142–48.

Batchelor, Bob. 2017. *Stan Lee: The Man behind Marvel.* Lanham: Rowman & Littlefield.

Baudrillard, Jean. 1994. "The System of Collecting." Elsner and Cardinal, 7–24.

Beaty, Bart. 2005. *Fredric Wertham and the Critique of Mass Culture.* Jackson: UP of Mississippi.

———. 2012. *Comics versus Art.* Toronto: U of Toronto P.

Beaty, Bart, and Benjamin Woo. 2016. *The Greatest Comic Book of All Time: Symbolic Capital and the Field of American Comic Books.* New York: Palgrave Macmillan.

Belk, Russell W. 1995. *Collecting in a Consumer Culture.* London: Routledge.

Benjamin, Walter. 2007. "Unpacking My Library: A Talk about Book Collecting." 1931. *Illuminations.* Ed. Hannah Arendt. Trans. Harry Zohn. New York: Schocken. 59–68.

———. 1999. *The Arcades Project.* 1982. Trans. Howard Eiland and Kevin McLaughlin. Cambridge: Belknap P of Harvard UP.

Bennett, Andrew. 2005. *The Author.* Abingdon: Routledge.

Bennett, Tony. 1995. *The Birth of the Museum: History, Theory, Politics.* London: Routledge.

Ben-Porat, Ziva. 1979. "Method in Madness: Notes on the Structure of Parody, Based on MAD TV Satires." *Poetics Today* 1.1–2: 245–72.

Berlatsky, Noah. 2015. *Wonder Woman: Bondage and Feminism in the Marston/Peter Comics, 1941–1948.* New Brunswick: Rutgers UP.

Blythe, Hal, and Charlie Sweet. 2002. "The Superhero Formula." *Storytelling* 2.1: 45–59.

Boichel, Bill. 1991. "Batman: Commodity as Myth." Pearson and Uricchio 1991a, 4–17.

Bolling, Ben. 2012. "The U. S. HIV/AIDS Crisis and the Negotiation of Queer Identity in Superhero Comics, or, Is Northstar Still a Fairy?" Pustz 2012, 202–19.

Booth, Paul. 2017. *Digital Fandom 2.0: New Media Studies.* New York: Lang.

Bordwell, David. 1985. "The Bounds of Difference." *The Classical Hollywood Cinema: Film Style and Mode of Production to 1960.* Ed. David Bordwell, Janet Staiger, and Kristin Thompson. New York: Columbia UP. 70–84.

Bourne, Mike. 1970. "Stan Lee: The Marvel Bard." Fingeroth and Thomas, 97–102.

Boyd, Brian. 2010. "On the Origins of Comics: New York Double-Take." *The Evolutionary Review* 1.1: 97–111.

Boym, Svetlana. 2001. *The Future of Nostalgia.* New York: Basic.

Bramlett, Frank, Roy T Cook, and Aaron Meskin, eds. 2017. *The Routledge Companion to Comics.* New York: Routledge.

Brenna, Brita, Hans Dam Christensen, and Olav Hamran, eds. 2019. *Museums as Cultures of Copies: The Crafting of Artefacts and Authenticity.* London: Routledge.

Brod, Harry. 2012. *Superman Is Jewish? How Comic Book Superheroes Came to Serve Truth, Justice, and the Jewish-American Way.* New York: Free Press.

Brooker, Will. 2000a. *Batman Unmasked: Analysing a Cultural Icon.* London: Continuum.

——. 2000b. "Containing Batman: Rereading Frederic Wertham and the Comics of the 1950s." *Containing America: Cultural Production and Consumption in 50s America.* Ed. Nathan Abrams and Julie Hughes. Birmingham: U of Birmingham P. 151–67.

——. 2012. *Hunting the Dark Knight: Twenty-First Century Batman.* London: I. B. Tauris.

Brown, Jeffrey A. 1997. "Comic Book Fandom and Cultural Capital." *Journal of Popular Culture* 30.4: 13–31.

——. 2001. *Black Superheroes, Milestone Comics, and Their Fans.* Jackson: UP of Mississippi.

——. 2012. "Ethnography: Wearing One's Fandom." Smith and Duncan, 280–90.

——. 2019. *Batman and the Multiplicity of Identity: The Contemporary Comic Book Superhero as Cultural Nexus.* New York: Routledge.

Brown, John Mason. 1948. "The Case against the Comics." *Saturday Review of Literature* (March 20): 31–32.

Brown, Matthew J., Matthew J. Smith, and Randy Duncan, eds. 2020. *More Critical Approaches to Comics: Theories and Methods.* New York: Routledge.

Bukatman, Scott. 2003. *Matters of Gravity: Special Effects and Supermen in the 20th Century.* Durham: Duke UP.

——. 2009. "Secret Identity Politics." Ndalianis 2009b. 109–25.

——. 2016. *Hellboy's World: Comics and Monsters on the Margins.* Oakland: U of California P.

Burdick, Anne, et al. 2012. *Digital Humanities.* Cambridge: MIT.

Burke, Liam, ed. 2013. *Fan Phenomena: Batman.* Bristol: Intellect.

Burke, Liam, Ian Gordon, and Angela Ndalianis, eds. 2020. *The Superhero Symbol: Media, Culture & Politics.* New Brunswick: Rutgers UP.

Burton, Antoinette, ed. 2005. *Archive Stories: Facts, Fictions, and the Writing of History.* Durham: Duke UP.

Cangialosi, James. 1999. "Writing for Himself: Stan Lee Speaks." McLaughlin, 166–73.

Cavett, Dick. 1968. "*The Dick Cavett Show:* An Interview with Stan Lee." McLaughlin, 14–19.

Cawelti, John G. 2012. "*Chinatown* and Generic Transformation in Recent American Films." 1979. *Film Genre Reader IV.* Ed. Barry Keith Grant. Austin: U of Texas P. 279–97.

Cheetham, Fiona. 2012. "An Actor-Network Perspective on Collecting and Collectables." *Narrating Objects, Collecting Stories.* Ed. Sandra H. Dudley et al. London: Routledge. 125–35.

Clarke, M. J. 2014. "The Production of the *Marvel Graphic Novel* Series: The Business and Culture of the Early Direct Market." *Journal of Graphic Novels and Comics* 5.2: 192–210.

Cocca, Carolyn. 2016. *Superwomen: Gender, Power, and Representation.* New York: Bloomsbury.

Cohen, Lizabeth. 2004. *A Consumer's Republic: The Politics of Mass Consumption in Postwar America.* New York: Vintage.

Cohn, Neil. 2013. *The Visual Language of Comics: Introduction to the Structure and Cognition of Sequential Images.* London: Bloomsbury.

Collins, Jim. 1991. "Batman: The Movie, Narrative: The Hyperconscious." Pearson and Uricchio 1991a, 164–81.

Conan, Neal. 1968. "Stan the Man Meets Conan (but Not the Barbarian)." Fingeroth and Thomas, 39–46.

Coogan, Peter. 2006. *Superhero: The Secret Origin of a Genre.* Austin: MonkeyBrain.

Costello, Matthew J. 2009. *Secret Identity Crisis: Comic Books and the Unmasking of Cold War America.* New York: Continuum.

Cotta Vaz, Mark. 1989. *Tales of the Dark Knight — Batman's First Fifty Years: 1939–1989.* London: Futura.

Couldry, Nick. 2008. "Actor Network Theory and Media: Do They Connect and on What Terms?" *Connectivity, Networks and Flows: Conceptualizing Contemporary Communications.* Ed. Andreas Hepp, Friedrich Krotz, Shaun Moores, and Carsten Winter. Cresskill: Hampton. 93–110.

Cremins, Brian. 2016. *Captain Marvel and the Art of Nostalgia.* Jackson: UP of Mississippi.

Crucifix, Benoît. 2018. "From Loose to Boxed Fragments and Back Again: Seriality and Archive in Chris Ware's *Building Stories*." *Journal of Graphic Novels and Comics* 9.1: 3–22.

Cunningham, Brian, ed. 2009. *Stan's Soapbox: The Collection.* New York: Marvel Comics.

Curtis, Neal. 2020. "'America Is a Piece of Trash': Captain America, Patriotism, Nationalism, and Fascism." Burke, Gordon, and Ndalianis, 47–62.

Daniels, Les. 1971. *Comix: A History of Comic Books in America.* New York: Bonanza.

———. 1999. *Batman: The Complete History.* San Francisco: Chronicle.

Darowski, Joseph J. 2020. *The Ages of the Black Panther: Essays on the King of Wakanda in Comic Books.* Jefferson: McFarland.

David, Peter A. 2010. Introduction. David and Greenberger, 6–9.

David, Peter A., and Robert Greenberger. 2010. *The Spider-Man Vault: A Museum-in-a-Book™ with Rare Collectibles Spun from Marvel's Web.* Philadelphia: Running.

Decker, Dwight. 2003. "I Almost Wish I Was Doing Gotham City Instead of New York, Because Then I Would Have Total Freedom." 1981. Interview with Frank Miller. *The Comics Journal Library: Frank Miller. The Interviews: 1981–2003.* Ed. Milo George. Seattle: Fantagraphics. 15–31.

De Kosnik, Abigail. 2016. *Rogue Archives: Digital Cultural Memory and Media Fandom.* Cambridge: MIT.

Denson, Shane. 2011. "Marvel Comics' Frankenstein: A Case Study in the Media of Serial Figures." *American Comic Books and Graphic Novels.* Ed. Daniel Stein, Christina Meyer, and Micha Edlich. Special issue of *Amerikastudien/American Studies* 56.4: 531–53.

Denson, Shane, and Ruth Mayer. 2018. "Border Crossings: Serial Figures and the Evolution of Media." Trans. Abigail Fagan. *NECSUS: European Journal of Media Studies* 7.2.

Dentith, Simon 2000. *Parody.* London: Routledge.

Derrida, Jacques. 1995. "Archive Fever: A Freudian Impression." Trans. Eric Prenowitz. *Diacritics* 25.2: 9–63.

Devlin, Desmond, and Tom Richmond. 2010. "Battyman, Begone!" 2005. *MAD* #455 (July). *MAD About Super Heroes Volume 2.* Ed. John Ficarra and Dave Gibbons. New York: MAD. 104–10.

Dini, Paul, and Chip Kidd. 1998. *Batman Animated.* Photographed by Geoff Spear. New York: HarperEntertainment.

Ditko, Steve. 1990. "An Insider's Part of Comics History: Jack Kirby's Spider-Man." Thomas 2001, 56–59.

———. 2008. *The Avenging Mind.* Bellingham: SD Publishing.

Dittmer, Jason. 2007. "The Tyranny of the Serial: Popular Geopolitics, the Nation, and Comic Book Discourse." *Antipode* 39.2: 247–68.

———. 2010. "Comic Book Visualities: A Methodological Manifesto on Geography, Montage and Narration." *Transactions of the Institute of British Geographers* 35.2: 222–36.

———. 2013. *Captain America and the Nationalist Superhero: Metaphors, Narratives, and Geopolitics.* Philadelphia: Temple UP.

Dony, Christophe. 2014. "The Rewriting Ethos of the Vertigo Imprint: Critical Perspectives on Memory-Making and Canon Formation in the American Comics Field." *La Bande Dessinée: Un "art sans mémoire"?* Ed. Benoît Bertou. Special issue of *Comicalités.*

Dougall, Alastair, et al., eds. 2014. *Marvel Encyclopedia: The Definite Guide to the Characters of the Marvel Universe.* New York: DK.

Duncan, Randy, and Matthew J. Smith. 2009. *The Power of Comics: History, Form and Culture.* New York: Continuum.

Duncombe, Stephen. 1997. *Notes from Underground: Zines and the Politics of Alternative Culture.* London: Verso.

Durand, Kevin K. 2011a. "Batman's *Canon:* Hybridity and the Interpretation of the Superhero." Durand and Leigh, 81–92.

———. 2011b. "*Why Adam West Matters*: Camp and Classical Virtue." Durand and Leigh, 41–53.

Durand, Kevin K., and Mary K. Leigh, eds. 2011. *Riddle Me This, Batman! Essays on the Universe of the Dark Knight.* Jefferson: McFarland.

Eco, Umberto. 1985. "Innovation and Repetition: Between Modern and Post-Modern Aesthetics." *Daedalus* 114.4: 161–84.

———. 1990. "Interpreting Serials." *The Limits of Interpretation.* Bloomington: Indiana UP. 83–100.

———. 2004. "The Myth of Superman." 1972. *Arguing Comics: Literary Masters on a Popular Medium.* Ed. Jeet Heer and Kent Worcester. Jackson: UP of Mississippi. 146–64.

Edwards, Emily D. 2012. "Women's Pleasures Watching Spider-Man's Journeys." Peaslee and Weiner, 177–86.

Eisner, Will. 2001. *Will Eisner's Shop Talk.* Milwaukie: Dark Horse Comics.

Ellison, Ralph. 1982. *Invisible Man.* 1952. New York: Random House.

Elsner, John, and Roger Cardinal, eds. 1994. *The Cultures of Collecting.* London: Reaktion.

Emilsson, Kjartan Pierre. 2016. "Universes, Metaverses, and Multiverses." *Internet Spaceships Are Serious Business: An EVE Online Reader.* Ed. Marcus Carter, Kelly Bergstrom, and Darryl Woodford. Minneapolis: U of Minnesota P. 48–54.

Etter, Lukas. 2017. "Visible Hand? Subjectivity and Its Stylistic Markers in Graphic Narratives." *Subjectivity across Media: Interdisciplinary and Transmedial Perspectives.* Ed. Maike Sarah Reinerth and Jan-Noël Thon. New York: Routledge. 92–110.

———. 2021. *Distinctive Styles and Authorship in Alternative Comics.* Berlin: De Gruyter.

Evanier, Mark. 2008. *Kirby: King of Comics.* New York: Abrams.

Fagan, Tom. 1965a. "Bill Finger—Man behind a Legend." Manuscript. Rpt. Marc Tyler. "Bill Finger mystery quotations: SOLVED." *Noblemania* (October 8, 2012).

———. 1965b. "Con-Cave Coming?" *Batmania* #7 (November): 11–13.

———. 1967a. "Con-Cave '66." *Batmania* #14 (February): 5–7.

———. 1967b. "An Open Letter to Julius Schwartz." *Batmania Annual*: 16.

Fagan, Tom, and Biljo White. 1965. "Robin the Boy Wonder in—Star Spangled Comics." *Batmania* #6 (October): 14–16.

Fawaz, Ramzi. 2016. *The New Mutants: Superheroes and the Radical Imagination of American Comics.* New York: New York UP.

Feiffer, Jules. 1965. *The Great Comic Book Heroes.* New York: Bonanza.

———. 1998. "Spider-Man in the Marketplace." McLaughlin, 131–33.

Ficarra, John, ed. 2010. *MAD about Super Heroes Volume 2.* New York: MAD.

Fingeroth, Danny. 2007. *Disguised as Clark Kent: Jews, Comics, and the Creation of the Superhero.* London: Continuum.

———. 2019. *A Marvelous Life: The Amazing Story of Stan Lee.* New York: St. Martin's.

Fingeroth, Danny, and Roy Thomas, eds. 2011. *The Stan Lee Universe: Interviews with and Mementos from "The Man" Who Changed Comics and Pop Culture.* Raleigh: TwoMorrows.

Fiske, John. 1987. *Television Culture.* London: Methuen.

——. 1992. "The Cultural Economy of Fandom." *The Adoring Audience: Fan Culture and Popular Media.* Ed. Lisa A. Lewis. New York: Routledge. 30–49.

Flanagan, Martin. 2012. "'Continually in the Making': Spider-Man's New York." Peaslee and Weiner, 40–52.

Fluck, Winfried. 2009. *Romance with America? Essays on Culture, Literature, and American Studies.* Ed. Laura Bieger and Johannes Voelz. Heidelberg: Winter.

Ford, Sam, and Henry Jenkins. 2009. "Managing Multiplicity in Superhero Comics: An Interview with Henry Jenkins." Harrigan and Wardrip-Fruin, 303–11.

Foucault, Michel. 1972. *The Archaeology of Knowledge and The Discourse on Language.* Trans. A. M. Sheridan Smith. New York: Pantheon.

——. 2001. "What Is an Author?" 1969. *The Norton Anthology of Theory and Criticism.* Ed. Vincent B. Leitch. New York: Norton. 1622–36.

Frank, Thomas. 1997. *The Conquest of Cool: Business Culture, Counterculture, and the Rise of Hip Consumerism.* Chicago: U of Chicago P.

Franklin, Morris E. III. 2001. "Coming Out in Comic Books: Letter Columns, Readers, and Gay and Lesbian Characters." McAllister, Sewell, and Gordon, 221–50.

Freedland, Nat. 1966. "Super Heroes with Super Problems." *New York Herald Tribune,* Sunday Magazine section (January 9).

Friedenthal, Andrew J. 2017. *Retcon Game: Retroactive Continuity and the Hyperlinking of America.* Jackson: UP of Mississippi.

Friedrich, "Castro" Mike. 1974. "Blood, Sweat, and Tears . . . and Then Some or How to Sell a Batman Story in 12 Easy [?] Lessons." *Batmania* #19 (September): 4–9.

Frow, John. 2006. *Genre.* Abingdon: Routledge.

Gabilliet, Jean-Paul. 2010. *Of Comics and Men: A Cultural History of American Comic Books.* 2005. Trans. Bart Beaty and Nick Nguyen. Jackson: UP of Mississippi.

——. 2016. "Reading Facsimile Reproductions of Original Artwork: The Comics Fan as Connoisseur." *Comics in Art/Art in Comics.* Special issue of *Image [&] Narrative* 17.4: 16–25.

Gaines, Jane M. 1991. *Contested Culture: The Image, the Voice, and the Law.* Chapel Hill: U of North Carolina P.

Gardner, Jared. 2011. "Storylines." *Graphic Narratives and Narrative Theory.* Ed. Jared Gardner and David Herman. Special issue of *SubStance* #124, 40.1: 53–69.

——. 2012. *Projections: Comics and the History of Twenty-First-Century Storytelling.* Stanford: Stanford UP.

Gavaler, Chris. 2015. *On the Origin of Superheroes: From the Big Bang to* Action Comics No. 1. Iowa City: U of Iowa P.

——. 2016. "Kirby vs. Steranko! Silver Age Layout Wars." *Hooded Utilitarian* (July 12).

——. 2018. *Superhero Comics.* London: Bloomsbury.

Gehring, Wes D. 1999. *Parody as Film Genre: "Never Give a Saga an Even Break."* Westport: Greenwood.

Genette, Gérard. 1990. *Narrative Discourse Revisited.* 1983. Trans. Jane E. Lewin. Ithaca: Cornell UP.

———. 1997. *Paratexts: Thresholds of Interpretation.* 1987. Trans. Jane E. Lewin. Cambridge: Cambridge UP.

George, Milo. 2002. *The Comics Journal Library: Jack Kirby.* Seattle: Fantagraphics.

Geraghty, Lincoln. 2014. *Cult Collectors: Nostalgia, Fandom and Collecting Popular Culture.* London: Routledge.

Gibson, Mel. 2018. "'It's All Come Flooding Back': Memories of Childhood Comics." Ahmed and Crucifix 2018a, 37–56.

Gilbert, Michael T. 2001. "Internal Affairs: DC in the 1940s. The Gardner Fox Letters, Part Two." Thomas 2001, 38–41.

Gilmore, James N., and Matthias Stork, eds. 2014. *Superhero Synergies: Comic Book Characters Go Digital.* Lanham: Rowman & Littlefield.

Gold, Mike. 1976. "Jenette Kahn, Stan Lee, and Harvey Kurtzman Discuss Comics." McLaughlin, 40–47.

Goodrum, Michael. 2016. *Superheroes and American Self-Image: From War to Watergate.* London: Routledge.

Goodrum, Michael, Tara Prescott, and Philip Smith, eds. 2018. *Gender and the Superhero Narrative.* Jackson: UP of Mississippi.

Gordon, Ian. 2012. "Writing to Superman: Towards an Understanding of the Social Networks of Comic-Book Fans." *Participations* 9.2: 120–32.

———. 2013. "Comics, Creators, and Copyright: On the Ownership of Serial Narratives by Multiple Authors." *A Companion to Media Authorship.* Ed. Jonathan Gray and Derek Johnson. Malden: Wiley-Blackwell. 221–36.

———. 2017. *Superman: The Persistence of an American Icon.* New Brunswick: Rutgers UP.

———. 2020. "Siegel and Shuster as Brand Name." Burke, Gordon, and Ndalianis, 105–17.

Gordon, Ian, Mark Jancovich, and Matthew P. McAllister, eds. 2007. *Film and Comic Books.* Jackson: UP of Mississippi.

Grauso, Alisha. 2015. "Interview: Mark Millar on the New Age of Fans." *MoviePilot. com* (March 23).

Gray, Jonathan. 2010. *Show Sold Separately: Promos, Spoilers, and Other Media Paratexts.* New York: New York UP.

Gray, Jonathan, Cornel Sandvoss, and C. Lee Harrington, eds. 2017. *Fandom: Identities and Communities in a Mediated World.* New York: New York UP.

Greenberger, Robert, and Matthew K. Manning. 2009. *The Batman Vault: A Museum-in-a Book™ Featuring Rare Collectibles from the Batcave.* Philadelphia: Running.

Grennan, Simon. 2017. *A Theory of Narrative Drawing.* New York: Palgrave Macmillan.

Groensteen, Thierry. 2010. *Parodies: La Bande Dessinée au Second Degré.* Paris: Skira Flammarion.

Grossman, Gary H. 1977. *Superman: Serial to Cereal.* New York: Popular Library.

Groth, Gary. 1990a. "Jack Kirby Interview." *The Comics Journal* #134 (February): 57–99.

——. 1990b. "Steve Bissette and Scott McCloud." *The Comics Journal* #137 (September): 72–92.

Guynes, Sean, and Martin Lund, eds. 2020. *Unstable Masks: Whiteness and American Superhero Comics.* Columbus: The Ohio State UP.

Hagedorn, Roger. 1988. "Technology and Economic Exploitation: The Serial as a Form of Narrative Presentation." *Wide Angle* 10.4: 4–12.

Hajdu, David. 2008. *The Ten-Cent Plague: The Great Comic-Book Scare and How It Changed America.* New York: Farrar, Straus and Giroux.

Hall, Stuart. 2001. "Constituting an Archive." *Third Text* 15.54: 89–92.

Harrell, Stephen. 1967. "What Has the 'New Look' Done for Batman?" *Batmania Annual*: 9–11, 17.

Harrigan, Pat, and Noah Wardrip-Fruin, eds. 2009. *Third Person: Authoring and Exploring Vast Narratives.* Boston: MIT.

Harvey, Robert C. 1996. *The Art of the Comic Book: An Aesthetic History.* Jackson: UP of Mississippi.

Hatfield, Charles. 2005. *Alternative Comics: An Emerging Literature.* Jackson: UP of Mississippi.

——. 2012. *Hand of Fire: The Comics Art of Jack Kirby.* Jackson: UP of Mississippi.

Hatfield, Charles, and Bart Beaty, eds. 2020. *Comics Studies: A Guidebook.* New Brunswick: Rutgers UP.

Hatfield, Charles, Jeet Heer, and Kent Worcester, eds. 2013. *The Superhero Reader.* Jackson: UP of Mississippi.

Hayward, Jennifer. 1997. *Consuming Pleasures: Active Audiences and Serial Fictions from Dickens to Soap Opera.* Lexington: UP of Kentucky.

Healey, Karen. 2009. "When Fangirls Perform: The Gendered Fan Identity in Superhero Comics Fandom." Ndalianis 2009b, 144–63.

Herman, David. 2002. *Story Logic: Problems and Possibilities of Narrative.* Lincoln: U of Nebraska P.

——. 2009. *Basic Elements of Narrative.* Chichester: Wiley-Blackwell.

Hills, Matt. 2002. *Fan Cultures.* London: Routledge.

Hirsch, Marianne, and Diana Taylor. 2012. "The Archive in Transit." *On the Subject of Archives.* Ed. Marianne Hirsch and Diana Taylor. Special issue of *E-misférica* 9.1–2.

Hodel, Mike. 1967. "Silver Age Stan and Jack (or: 'Will Success Spoil Spider-Man?')." Fingeroth and Thomas, 161–69.

Horstkotte, Silke. 2015. "Zooming In and Out: Panels, Frames, Sequences, and the Building of Graphic Storyworlds." Stein and Thon, 27–48.

Howe, Sean. 2012. *Marvel Comics: The Untold Story.* New York: HarperCollins.

Hultkrans, Andrew. 2004. "Steve Ditko's Hands." *Give Our Regards to the Atomsmashers! Writers on Comics.* Ed. Sean Howe. New York: Pantheon. 208–25.

Hurd, Jud. 1969. "Legend Meets Legend." Fingeroth and Thomas, 77–80.

Hutcheon, Linda. 1985. *A Theory of Parody: The Teachings of Twentieth-Century Art Forms.* New York: Methuen.

———. 1989. "Modern Parody and Bakhtin." Morson and Emerson, 87–103.

Huyssen, Andreas. 1995. *Twilight Memories: Marking Time in a Culture of Amnesia.* London: Routledge.

———. 2003. *Present Pasts: Urban Palimpsests and the Politics of Memory.* Stanford: Stanford UP.

Hyman, David. 2017. *Revision and the Superhero Genre.* Cham: Palgrave Macmillan.

Infantino, Carmine. 2001. *The Amazing World of Carmine Infantino: An Autobiography.* Ed. J. David Spurlock. Lebanon: Vanguard.

Inge, Thomas. 1984. "Collecting Comics Books." *American Book Collector* 5.2: 3–15.

Irving, Christopher, and Seth Kushner. 2012. *Leaping Tall Buildings: The Origins of American Comics.* New York: Powerhouse.

Iser, Wolfgang. 1974. *The Implied Reader: Patterns of Communication in Prose Fiction from Bunyan to Beckett.* Baltimore: Johns Hopkins UP.

Jacobs, Will, and Gerard Jones. 1985. *The Comic Book Heroes: From the Silver Age to the Present.* New York: Crown.

Jauß, Hans Robert. 1982. *Toward an Aesthetic of Reception.* Trans. Michael Shaw. Minneapolis: U of Minnesota P.

Jenkins, Henry. 1992. *Textual Poachers: Television Fans & Participatory Culture.* New York: Routledge.

———. 2006. *Fans, Bloggers, and Gamers: Exploring Participatory Culture.* New York: New York UP.

———. 2007. "Transmedia Storytelling 101." *Confessions of an Aca-Fan* (March 21).

———. 2009. "'Just Men in Tights': Rewriting Silver Age Comics in an Era of Multiplicity." Ndalianis 2009b, 16–43.

———. 2012. "Introduction: Should We Discipline the Reading of Comics?" Smith and Duncan, 1–14.

———. 2015. "Archival, Ephemeral, and Residual: The Functions of Early Comics in Art Spiegelman's *In the Shadow of No Towers.*" Stein and Thon, 301–22.

———. 2020. *Comics and Stuff.* New York: New York UP.

Jewett, Robert, and John Shelton Lawrence. 1988. *The American Monomyth.* Lanham: UP of America.

Jones, Gerard. 2004. *Men of Tomorrow: Geeks, Gangsters and the Birth of the Comic Book.* New York: Basic.

Kane, Bob. 1967. "An Open Letter to All 'Batmanians' Everywhere." *Batmania Annual:* 23–30.

Kane, Bob, with Tom Andrae. 1989. *Batman & Me.* California: Eclipse.

Kasakove, David. 2011. "Finding Marvel's Voice: An Appreciation of Stan Lee's Bullpen Bulletins and Soapboxes." Fingeroth and Thomas, 130–36.

Kashtan, Aaron. 2018. *Between Pen and Pixel: Comics, Materiality, and the Book of the Future.* Columbus: The Ohio State UP.

Kelleter, Frank, ed. 2012. *Populäre Serialität: Narration–Evolution–Distinktion. Zum seriellen Erzählen seit dem 19. Jahrhundert.* Bielefeld: transcript.

———. 2014a. *Serial Agencies: The Wire and Its Readers*. Winchester: Zero.

———. 2014b. "Trust and Sprawl: Seriality, Radio, and the First Fireside Chat." *Media Economies: Perspectives on American Cultural Practices*. Ed. Marcel Hartwig, Evelyne Keitel, and Gunter Süß. Trier: WVT. 43–61.

———. 2017. "Five Ways of Looking at Popular Seriality." *Media of Serial Narrative*. Ed. Frank Kelleter. Columbus: The Ohio State UP. 7–34.

Kelleter, Frank, and Daniel Stein. 2012. "Autorisierungspraktiken seriellen Erzählens: Zur Gattungsentwicklung von Superheldencomics." Kelleter, 259–90.

Kidd, Chip. 1996. *Batman Collected*. Boston: Bulfinch/Little, Brown and Company.

Kidd, Chip, Geoff Spear, and Saul Ferris, eds. 2008. *Bat-Manga! The Secret History of Batman in Japan*. Trans. Anne Ishii and Chip Kidd. New York: Pantheon.

Kidd, Chip, and Dave Taylor. 2012. *Batman: Death by Design*. New York: DC Comics.

Kindt, Tom, and Hans-Harald Müller. 2006. *The Implied Author: Concept and Controversy*. Berlin: De Gruyter.

Kirkpatrick, Ellen, and Suzsanne Scott, eds. 2015. "In Focus: Gender Identity and the Superhero." *Cinema Journal* 55.1: 120–69.

Kirtz, Jaime Lee. 2014. "Computers, Comics and Cult Status: A Forensics of Digital Graphic Novels." *Digital Humanities Quarterly* 8.3.

Klock, Geoff. 2002. *How to Read Superhero Comics and Why*. New York: Continuum.

Kobler, John. 1941. "Up, Up and Awa-a-y! The Rise of Superman, Inc." *The Saturday Evening Post* (June 21): 14–15, 70, 73–74, 76, 78.

Kraft, David Anthony. 1977. "The *Foom* Interview: Stan Lee." McLaughlin, 54–69.

Kukkonen, Karin. 2010. "Navigating Infinite Earths: Readers, Mental Models, and the Multiverse of Superhero Comics." *Storyworlds* 2: 39–58.

———. 2011. "Metalepsis in Comics and Graphic Novels." *Metalepsis in Popular Culture*. Ed. Karin Kukkonen and Sonja Klimek. Berlin: De Gruyter. 213–31.

———. 2013. *Contemporary Comics Storytelling*. Lincoln: U of Nebraska P.

Kurtzman, Harvey, and Wallace Wood. 1953. "Superduperman!" *MAD* #4 (April–May). Meglin and Ficarra, n. pag.

———. 1953–1954. "Bat Boy and Rubin!" *MAD* #8 (December–January). Meglin and Ficarra, n. pag.

Kwitney, Alisa, ed. 2000. *Vertigo Visions: Artwork from the Cutting Edge of Comics*. London: Titan.

Lang, Jeffrey S., and Patrick Trimble. 1988. "Whatever Happened to the Man of Tomorrow? An Examination of the American Monomyth and the Comic Book Superhero." *Journal of Popular Culture* 22.3: 157–73.

Later, Naja. 2020. "Captain America, National Narratives, and the Queer Subversion of the Retcon." Burke, Gordon, and Ndalianis, 215–30.

Latour, Bruno. 1993. *We Have Never Been Modern*. Trans. Catherine Porter. Cambridge: Harvard UP.

———. 1999. *Pandora's Hope: Essays on the Reality of Science Studies*. Cambridge: Harvard UP.

——. 2005. *Reassembling the Social: An Introduction to Actor-Network-Theory.* Oxford: Oxford UP.

Latour, Bruno, and Adam Lowe. 2011. "The Migration of the Aura, or How to Explore the Original through Its Facsimiles." *Switching Codes: Thinking through Digital Technology in the Humanities and the Arts.* Ed. Thomas Bartscherer and Roderick Coover. Chicago: U of Chicago P. 275–97.

Lawrence, John Shelton, and Robert Jewett. 2002. *The Myth of the American Superhero.* Grand Rapids: Eerdmans.

Lee, Judith Yaross, and John Bird, eds. 2014. *Mad Magazine and Its Legacies.* Special issue of *Studies in American Humor* 30.

Lee, Stan. 1947. *Secrets behind the Comics.* New York: Famous Enterprises.

——. 1974. *Origins of Marvel Comics.* New York: Simon and Schuster.

——. 1975. *Son of Origins of Marvel Comics.* New York: Simon and Schuster.

——. 1976. *Bring on the Bad Guys: Origins of Marvel Villains.* New York: Simon and Schuster.

——. 1977a. "How I Invented Spider-Man." *Quest* (July–August): 31–34, 36.

——. 1977b. *The Superhero Women.* New York: Simon and Schuster.

——. 2014. Introduction. Dougall et al., 9.

Lee, Stan, et al. 2019. *Not Brand Echh: The Complete Collection.* New York: Marvel Comics.

Lee, Stan, and John Buscema. 1978. *How to Draw Comics the Marvel Way.* New York: Simon and Schuster.

Lee, Stan, and George Mair. 2002. *Excelsior! The Amazing Life of Stan Lee.* New York: Fireside.

Lefèvre, Pascal. 2006. "The Construction of Space in Comics." *House / Text / Museum.* Ed. Anthony Purdy. Special issue of *Image [&] Narrative* 16.

Leguèbe, Éric. 1978. "Stan Lee Replies to Éric Leguèbe." McLaughlin, 77–84.

Lepore, Jill. 2014. *The Secret History of Wonder Woman.* New York: Knopf.

Levitz, Paul. 2008. Foreword. Pasko, 6.

——. 2010. *75 Years of DC Comics: The Art of Modern Mythmaking.* Cologne: Taschen.

Lindner, Christoph. 2014. Foreword. Allen and van den Berg 2014b, ix–xi.

Lopes, Paul. 2009. *Demanding Respect: The Evolution of the American Comic Book.* Philadelphia: Temple UP.

Ludlow, Peter, and Mark Wallace. 2007. *The Second Life Herald: The Virtual Tabloid That Witnessed the Dawn of the Metaverse.* Cambridge: MIT.

Lund, Martin. 2012. "American Golem: Reading America through Super-New Dealers and the 'Melting Pot.'" Pustz 2012, 79–93.

——. 2016. *Re-Constructing the Man of Steel: Superman 1938–1941, Jewish American History, and the Invention of the Jewish-Comics Connection.* Cham: Palgrave Macmillan.

Lupoff, Dick, and Don Thompson, eds. 1970. *All in Color for a Dime.* New York: Ace.

Macchio, Ralph. 2014. Foreword. Dougall et al., 6.

Macdonald, Sharon, ed. 2006. *A Companion to Museum Studies*. Malden: Blackwell.

Mallory, Robert. 1974. "The Batman of Old and New." *Batmania* #19 (September): 15–21.

Manning, Matthew K. 2009. Introduction. Greenberger and Manning, 5.

Manovich, Lev. 2017. "Cultural Data: Possibilities and Limitations of the Digital Data Universe." *Museum and Archive on the Move: Changing Cultural Institutions in the Digital Era*. Ed. Oliver Grau, in collaboration with Wendy Coones and Viola Rühse. Berlin: De Gruyter. 259–76.

Mayer, Ruth. 2014. *Serial Fu Manchu: The Chinese Supervillain and the Spread of Yellow Peril Ideology*. Philadelphia: Temple UP.

McAllister, Matthew P. 2001. "Ownership Concentration in the U. S. Comic Book Industry." McAllister, Sewell, and Gordon, 15–38.

McAllister, Matthew P., Edward H. Sewell Jr., and Ian Gordon, eds. 2001. *Comics & Ideology*. New York: Lang.

McCloud, Scott. 1994. *Understanding Comics: The Invisible Art*. 1993. New York: HarperPerennial.

McLaughlin, Jeff, ed. 2007. *Stan Lee: Conversations*. Jackson: UP of Mississippi.

Meadows, Joel, and Gary Marshall, eds. 2008. *Studio Space: The World's Greatest Comic Illustrators at Work*. Berkeley: Image Comics.

Medhurst, Andy. 1991. "Batman, Deviance and Camp." Pearson and Uricchio 1991a, 149–63.

Meehan, Eileen R. 1991. "'Holy Commodity Fetish, Batman!': The Political Economy of a Commercial Intertext." Pearson and Uricchio 1991a, 47–65.

Meglin, Nick, and John Ficarra, eds. 2006. *MAD About Super Heroes by "the Usual Gang of Super-Idiots."* New York: Barnes & Noble.

Meier, Stefan. 2015. *Superman Transmedial: Eine Pop-Ikone im Spannungsfeld von Medienwandel und Serialität*. Bielefeld: transcript.

Mendelsund, Peter. 2014. *What We See When We Read*. New York: Vintage.

Méon, Jean-Matthieu. 2018. "Sons and Grandsons of Origins: Narrative Memory in Marvel Superhero Comics." Ahmed and Crucifix 2018a, 189–209.

Mikkonen, Kai. 2015. "Subjectivity and Style in Graphic Narratives." Stein and Thon, 101–23.

Miller, Frank. 2005. "A Shadow Fell Across Me. . . ." 1988. *Batman: Year One*. By Frank Miller and David Mazzucchelli, with Richmond Lewis. New York: DC Comics. 134.

Miodrag, Hannah. 2013. *Comics and Language: Reimagining Critical Discourse on the Form*. Jackson: UP of Mississippi.

Mittell, Jason. 2001. "A Cultural Approach to Television Genre Theory." *Cinema Journal* 40.3: 3–24.

———. 2006. "Narrative Complexity in Contemporary American Television." *The Velvet Light Trap* 58 (Fall): 29–40.

———. 2015. *Complex TV: The Poetics of Contemporary Television Storytelling*. New York: New York UP.

Molotiu, Andrei. 2012. "Abstract Form: Sequential Dynamism and Iconostasis in Abstract Comics and Steve Ditko's *Amazing Spider-Man.*" Smith and Duncan, 84–100.

Moore, Alan. 1986. Introduction. *Batman: The Dark Knight Returns.* By Frank Miller. London: Titan.

———. 2008. *Alan Moore's Writing for Comics.* Rantoul: Avatar.

Morson, Gary Saul. 1989. "Parody, History, and Metaparody." Morson and Emerson, 63–86.

Morson, Gary Saul, and Caryl Emerson, eds. 1989. *Rethinking Bakhtin: Extensions and Challenges.* Evanston: Northwestern UP.

Murray, Christopher. 2011. *Champions of the Oppressed? Superhero Comics, Popular Culture, and Propaganda in America during World War II.* Cresskill: Hampton.

Nama, Adilifu. 2011. *Super Black: American Pop Culture and Black Superheroes.* Austin: U of Texas P.

Ndalianis, Angela, ed. 2009a. "Comic Book Superheroes: An Introduction." Ndalianis 2009b, 3–15.

———. 2009b. *The Contemporary Comic Book Superhero.* New York: Routledge.

Nelson, Victoria. 2001. *The Secret Life of Puppets.* Cambridge: Harvard UP.

Nobleman, Tyler, Marc. 2012. "Bill Finger Mystery Quotations: Solved." *Noblemania* (October 8).

North, Sterling. 1940. "A National Disgrace (and a Challenge to American Parents)." *Chicago Daily News* (May 8).

Nyberg, Amy Kiste. 1998. *Seal of Approval: The History of the Comics Code.* Jackson: UP of Mississippi.

Oesterreicher, Wulf. 2003. "Autorität der Form." Oesterreicher, Regn, and Schulze, 13–16.

Oesterreicher, Wulf, Gerhard Regn, and Winfried Schulze, eds. 2003. *Autorität der Form—Autorisierung—Institutionelle Autorschaft.* Münster: LIT.

"Old Comic Books Soar in Value; Dime Paperbacks of 1940's Are Now Collector Items." 1964. *New York Times* (December 6): 141.

O'Neil, Dennis. 2001. *The DC Comics Guide to Writing Comics.* New York: Watson-Guptill.

Orme, Stephanie. 2016. "Femininity and Fandom: The Dual-Stigmatisation of Female Comic Book Fans." *Journal of Graphic Novels and Comics* 7.4: 403–16.

Ormrod, Joan. 2020. *Wonder Woman: The Female Body and Popular Culture.* London: Bloomsbury.

Pacinda, George. 1965. "Those behind Batman." *Batmania* #6 (October): 4–7.

Pande, Rukmini. 2018. *Squee from the Margins: Fandom and Race.* Iowa City: U of Iowa P.

———, ed. 2020. *Fandom, Now in Color: A Collection of Voices.* Iowa City: U of Iowa P.

Parsons, Patrick. 1991. "Batman and His Audience: The Dialectic of Culture." Pearson and Uricchio 1991a, 66–89.

Pasko, Martin. 2008. *The DC Vault: A Museum-in-a-Book Featuring Rare Collectibles from the DC Universe*. Philadelphia: Running.

Pearce, Susan M. 1995. *On Collecting: An Investigation into Collecting in the European Tradition*. London: Routledge.

Pearson, Roberta E., and William Uricchio, eds. 1991a. *The Many Lives of the Batman: Critical Approaches to a Superhero and His Media*. New York: Routledge.

———. 1991b. "Notes from the Batcave: An Interview with Dennis O'Neil." Pearson and Uricchio 1991a, 18–32.

Pearson, Roberta E., William Uricchio, and Will Brooker. 2015. "Introduction: Revisiting the Batman." *Many More Lives of the Batman*. Ed. Roberta Pearson, William Uricchio, and Will Brooker. London: British Film Institute/Palgrave. 1–10.

Peaslee, Robert Moses, and Robert G. Weiner, eds. 2012. *Web-Spinning Heroics: Critical Essays on the History and Meaning of Spider-Man*. Jefferson: McFarland.

———. 2015. *The Joker: A Serious Study of the Clown Prince of Crime*. Jackson: UP of Mississippi.

Peppard, Anna F., ed. 2020. *Supersex: Sexuality, Fantasy, and the Superhero*. Austin: U of Texas P.

Pitts, Leonard Jr. 1981. "An Interview with Stan Lee." McLaughlin, 85–100.

Postema, Barbara. 2013. *Narrative Structure in Comics: Making Sense of Fragments*. Rochester: RIT.

Pustz, Matthew. 1999. *Comic Book Culture: Fanboys and True Believers*. Jackson: UP of Mississippi.

———. 2007. "'Let's Rap with Cap': Fan Interaction in Comic Book Letter Pages." *Inside the World of Comic Books*. Ed. Jeffery Klaehn. Montreal: Black Rose. 163–84.

———, ed. 2012. *Comic Books and American Cultural History: An Anthology*. New York: Continuum.

Raphael, Jordan, and Tom Spurgeon. 2003. *Stan Lee and the Rise and Fall of the American Comic Book*. Chicago: Chicago Review.

Regalado, Aldo J. 2015. *Bending Steel: Modernity and the American Superhero*. Jackson: UP of Mississippi.

Regn, Gerhard. 2003. "Autorisierung." Oesterreicher, Regn, and Schulze, 119–22.

Reidelbach, Maria. 1991. *Completely Mad: A History of the Comic Book and Magazine*. Boston: Little, Brown.

Reynolds, Richard. 1992. *Super Heroes: A Modern Mythology*. Jackson: UP of Mississippi.

Ricca, Brad. 2013. *Superboys: The Amazing Adventures of Jerry Siegel and Joe Shuster—the Creators of Superman*. New York: St. Martin's.

Robb, Jenny. 2017. "The Librarians and Archivists." *The Secret Origins of Comics Studies*. Ed. Matthew J. Smith and Randy Duncan. New York: Routledge. 71–87.

Robbins, Trina. 1996. *The Great Women Superheroes*. Northampton: Kitchen Sink.

Robinson, Jerry. 2009. "Foreword: The Birth of the Joker." Greenberger and Manning, 4.

Robinson, Lillian S. 2004. *Wonder Women: Feminisms and Superheroes*. New York: Routledge.

Romagnoli, Alex S., and Gian S. Pagnucci. 2013. *Enter the Superheroes: American Values, Culture, and the Canon of Superhero Literature*. Lanham: Scarecrow.

Romaguera, Gabriel E. 2015. "Waiting for the Next Part: How the Temporal Dimensions of Digital Serialisation Have Changed Author-Reader Dynamics." *Networking Knowledge* 8.4.

Rosenberg, Robin S., and Peter Coogan, eds. 2013. *What Is a Superhero?* New York: Oxford UP.

Round, Julia. 2010. "'Is This a Book?' DC Vertigo and the Redefinition of Comics in the 1990s." Williams and Lyons, 14–30.

Ryan, Marie-Laure. 2001. *Narrative as Virtual Reality: Immersion and Interactivity in Literature and Electronic Media*. Baltimore: Johns Hopkins UP.

Ryan, Marie-Laure, and Jan-Noël Thon, eds. 2014. *Storyworlds across Media: Toward a Media-Conscious Narratology*. Lincoln: U of Nebraska P.

Sabin, Roger. 1993. *Adult Comics: An Introduction*. London: Routledge.

Sadowski, Greg. 2002. *B. Krigstein: Volume One (1919–1955)*. Seattle: Fantagraphics.

Saffel, Steve. 2007. *Spider-Man the Icon: The Life and Times of a Pop Culture Phenomenon*. London: Titan.

Schatz, Thomas. 1981. *Hollywood Genres: Formulas, Filmmaking, and the Studio System*. New York: McGraw-Hill.

Schelly, Bill. 1999. *The Golden Age of Comic Fandom*. Seattle: Hamster.

——. 2006. "*Da Frantic Four!* A Fond Look Back at One of the Silliest Chapters in the Annals of Comic Fandom." Thomas 2006, 26–31.

——. 2010. *Founders of Comic Fandom: Profiles of 90 Publishers, Dealers, Collectors, Writers, Artists and Other Luminaries of the 1950s and 1960s*. Jefferson: McFarland.

Schneider, Edward, and Roxanna Palmer. 2016. "Archiving, Accessibility, and Citation: The Relationship between Original Materials and Scholarly Discussion in Homosexual Interpretations of the Batman Franchise." *Journal of Graphic Novels and Comics* 7.1: 20–34.

Schryer, Catherine F. 1994. "The Lab vs. the Clinic: Sites of Competing Genres." *Genre and the New Rhetoric*. Ed. Aviva Freedman and Peter Medway. London: Taylor and Francis. 105–24.

Schulze, Winfried. 2003. "Institutionelle Autorität." Oesterreicher, Regn, and Schulze, 235–38.

Schumer, Arlen. 2001. "Real Facts & True Lies: The True Story behind 'The True Story of Batman and Robin." Thomas 2001, 126–28.

Scott, Darieck, and Ramzi Fawaz. 2018. "Introduction: Queer about Comics." *Queer about Comics*. Ed. Darieck Scott and Ramzi Fawaz. Special issue of *American Literature* 90.2: 197–219.

Scott, Suzanne. 2013. "Fangirls in Refrigerators: The Politics of (In)visibility in Comic Book Culture." *Appropriating, Interpreting, and Transforming Comic Books*. Ed. Matthew J. Costello. Special issue of *Transformative Works and Cultures* 13.

———. 2019. *Fake Geek Girls: Fandom, Gender, and the Convergence Culture Industry*. New York: New York UP.

Segal, Erwin M. 1995. "Narrative Comprehension and the Role of Deictic Shift Theory." *Deixis in Narrative: A Cognitive Science Perspective*. Ed. Judith F. Duchan, Gail A. Bruder, and Lynn E. Hewitt. Hillsdale: Erlbaum. 3–17.

Sharrett, Christopher. 1991. "Batman and the Twilight of the Idols: An Interview with Frank Miller." Pearson and Uricchio 1991a, 33–46.

Shooter, Jim, and John Romita Jr. 1983. *The Official Marvel Comics Try-Out Book*. New York: Marvel Comics.

Silverstone, Lou, and Mort Drucker. 1966. "Bats-Man." *MAD* #105 (September). Meglin and Ficarra, n. pag.

Silvio, Carl. 1995. "Postmodern Narrative, the Marvel Universe, and the Reader." *Studies in Popular Culture* 17.2: 39–50.

Simon, Joe, and Jim Simon. 2003. *Comic Book Makers*. 1990. Lebanon: Vanguard.

Singer, Marc. 2012. *Grant Morrison: Combining the Worlds of Contemporary Comics*. Jackson: UP of Mississippi.

———. 2018. *Breaking the Frames: Populism and Prestige in Comics Studies*. Austin: U of Texas P.

Sloane, Leonard. 1967. "Advertising: Comics Go Up, Up and Away." *New York Times* (July 20): 60.

Smith, Greg M. 2015. "Comics in the Intersecting Histories of the Window, the Frame, and the Panel." Stein and Thon, 219–37.

Smith, Matthew J., and Randy Duncan, eds. 2012. *Critical Approaches to Comics: Theories and Methods*. New York: Routledge.

Smith, Scott T., and José Alaniz, eds. 2019. *Uncanny Bodies: Superhero Comics and Disability*. University Park: Pennsylvania State UP.

Sokolow, Michael. 1997/1998. "'More Often than Not, It's Put in a Bag': Culture and the Comic Book Collector." *Popular Culture*. Ed. Linda Adler-Kassner and Sherry Linkon. Special double issue of *Reader: Essays in Reader-Oriented Theory, Criticism, and Pedagogy* 38–39: 63–82.

Spiegelman, Art. 2013. "No Kidding, Kids . . . Remember Childhood? Well . . . Forget It!" *Co-Mix: A Retrospective of Comics, Graphics, and Scraps*. Montreal: Drawn & Quarterly. 90.

Spiegelman, Art, and Françoise Mouly, eds. 2009. *The TOON Treasury of Classic Children's Comics*. New York: Abrams ComicArts.

"Stan Lee Talks (2 of 2)." 2007. Batmitey. YouTube (December 9).

Starre, Alexander. 2015. *Metamedia: American Book Fictions and Literary Print Culture after Digitization*. Iowa City: U of Iowa P.

Steedman, Carolyn. 2001. *Dust*. Manchester: Manchester UP.

Stein, Daniel. 2012. "Spoofin' Spidey—Rebooting the Bat: Immersive Story Worlds and the Narrative Complexities of Video Spoofs in the Era of the Superhero Blockbuster." *Film Remakes, Adaptations and Fan Productions: Remake|Remodel*. Ed. Kathleen Loock and Constantine Verevis. Basingstoke: Palgrave Macmillan. 231–47.

———. 2018a. "Bodies in Transition: Queering the Comic Book Superhero." *Queer(ing) Popular Culture*. Ed. Sebastian Zilles. Special issue of *Navigationen* 18.1: 15–38.

———. 2018b. "Can Superhero Comics Studies Develop a Method? And What Does American Studies Have to Do with It?" *Projecting American Studies: Essays on Theory, Method, and Practice*. Ed. Frank Kelleter and Alexander Starre. Heidelberg: Winter. 259–271.

———. 2020a. "Contesting Counternarratives of Crime and Justice in US Superhero Comics." *Conflicting Narratives of Crime and Punishment*. Ed. Martina Althoff, Bernd Dollinger, and Holger Schmidt. Cham: Palgrave Macmillan. 139–60.

———. 2020b. Recuperating Black Family and Kinship Ties through Graphic Narration: Tom Feelings's *Middle Passage* and Kyle Baker's *Nat Turner*." *Migration, Diaspora, Exile: Narratives of Affiliation and Escape*. Ed. Daniel Stein, Cathy C. Waegner, Geoffroy de Laforcade, and Page R. Laws. Lanham: Lexington. 21–41.

———. 2021. "Black Bodies Swinging: Superheroes and the Shadow Archive of Lynching." *Konstruktion und Subversion von Körperbildern im Comic*. Ed. Irmela Fürhoff-Krüger and Nina Schmidt. Special issue of *Closure*, forthcoming.

Stein, Daniel, and Jan-Noël Thon, eds. 2015. *From Comic Strips to Graphic Novels: Contributions to the Theory and History of Graphic Narrative*. 2013. Berlin: De Gruyter.

Steinem, Gloria. 1972. "Wonder Woman." Hatfield, Heer, and Worcester, 203–10.

Steirer, Gregory. 2014. "No More Bags and Boards: Collecting Culture and the Digital Comics Marketplace." *Journal of Graphic Novels and Comics* 5.4: 455–69.

Stephenson, Neal. 1992. *Snow Crash*. New York: Bantam.

Stevens, J. Richard. 2011. "'Let's Rap with Cap': Redefining American Patriotism through Popular Discourse and Letters." *Journal of Popular Culture* 44.3: 606–32.

———. 2015. *Captain America, Masculinity, and Violence: The Evolution of a National Icon*. Syracuse: Syracuse UP.

Stevens, J. Richard, and Christopher Edward Bell. 2012. "Do Fans Own Digital Comic Books? Examining the Copyright and Intellectual Property Attitudes of Comic Book Fans." *International Journal of Communication* 6.1: 751–72.

Stewart, Susan. 1993. *On Longing: Narratives of the Miniature, the Gigantic, the Souvenir, the Collection*. Durham: Duke UP.

Strange Brain Parts. 2019. "The Origin and History of Forbush-Man." YouTube.

Stuller, Jennifer K. 2010. *Ink-stained Amazons and Cinematic Warriors: Superwomen in Modern Mythology*. London: I. B. Tauris.

Suid, Murray. 1976. "Meet the Wizard of Biff! Bop! Pow!" McLaughlin, 48–53.

Sullivan, Darcy. 1992. "Marvel Comics and the Kiddie Hustle." *The Comics Journal* #152 (August): 30–37.

———. 1995. "More from the Moolahverse: The Case against Bookstores." *The Comics Journal* #178 (July): 4–5.

"Superfans and Batmaniacs." 1965. *Newsweek* (February 15): 89–90.

Swafford, Brian. 2012. "Critical Ethnography: The Comics Shop as Cultural Clubhouse." Smith and Duncan, 291–302.

Tankel, Jonathan D., and Keith Murphy. 1998. "Collecting Comic Books: A Study of the Fan and Curatorial Consumption." *Theorizing Fandom: Fans, Subculture and Identity*. Ed. Cheryl Harris and Alison Alexander. Cresskill: Hampton. 55–68.

Taylor, Aaron. 2007. "'He's Gotta Be Strong, and He's Gotta Be Fast, and He's Gotta Be Larger Than Life': Investigating the Engendered Superhero Body." *Journal of Popular Culture* 40.2: 344–60.

Taylor, Diana. 2010. "Save As . . . Knowledge and Transmission in the Age of Digital Technologies." *Imagining America*. Paper 7.

Thomas, John Rhett. 2009. "Welcome to Marvel's 70th Anniversary Collection!" *Marvel 70th Anniversary Collection*. Ed. John Rhett Thomas. New York: Marvel Comics. 4.

Thomas, Roy. 1998. "Stan the Man and Roy the Boy: A Conversation between Stan Lee and Roy Thomas." McLaughlin, 134–65.

———, ed. 2001. *Alter Ego: The Comic Book Artist Collection*. Raleigh: TwoMorrows.

———, ed. 2006. *The Alter Ego Collection Volume 1*. Raleigh: TwoMorrows.

———. 2014. *75 Years of Marvel from the Golden Age to the Silver Screen*. Cologne: Taschen.

———. 2019. *The Stan Lee Story*. Cologne: Taschen.

Thomas, Roy, and Jim Amash, ed. 2007. *Alter Ego Presents: John Romita . . . and All That Jazz!* Raleigh: TwoMorrows.

Thomas, Roy, and Richard "Grass" Green. 1964. "The Inimitable (Who'd Want To?) Bestest League of America Meets Da Frantic Four." Thomas and Schelly, 75–84.

Thomas, Roy, and Peter Sanderson. 2007. *The Marvel Vault: A Museum-in-a-Book™ with Rare Collectibles from the World of Marvel*. Philadelphia: Running.

Thomas, Roy, and Bill Schelly, eds. 2008. *Alter Ego: The Best of the Legendary Comics Fanzine*. Raleigh: TwoMorrows.

Thon, Jan-Noël. 2019. "A Narratological Approach to Transmedial Storyworlds and Transmedial Universes." *The Routledge Companion to Transmedia Studies*. Ed. Matthew Freeman and Renira Rampazzo Gambarato. New York: Routledge. 375–82.

Tilley, Carol L. 2012. "Seducing the Innocent: Fredric Wertham and the Falsifications That Helped Condemn Comics." *Information & Culture: A Journal of History* 47.4: 383–413.

———. 2018. "Superheroes and Identity: The Role of Nostalgia in Comic Book Culture." *Reinventing Childhood Nostalgia: Books, Toys, and Contemporary Media Culture*. Ed. Elisabeth Wesseling. Abingdon: Routledge. 51–65.

Timm, Bruce, and Paul Dini. 2009. *Batman: Mad Love and Other Stories*. New York: DC Comics.

Tye, Larry. 2012. *Superman: The High-Flying History of America's Most Enduring Hero*. New York: Random House.

Uidhir, Christy Mag. 2012. "Comics and Collective Authorship." *The Art of Comics: A Philosophical Approach*. Ed. Aaron Meskin and Roy T Cook. Malden: Wiley-Blackwell. 47–67.

———. 2017. "Comics and Seriality." Bramlett, Cook, and Meskin, 248–56.

Uricchio, William. 2010. "The Batman's Gotham City™: Story, Ideology, Performance." Ahrens and Meteling, 119–32.

Uricchio, William, and Roberta E. Pearson. 1991. "'I'm Not Fooled by That Cheap Disguise." Pearson and Uricchio 1991a, 182–213.

Vanderbilt University. 1972. "Vanderbilt University Symposium with Stan Lee, Jack Kirby, and Others." McLaughlin, 30–39.

Van Gelder, Lawrence. 1971. "A Comics Magazine Defies Code Ban on Drug Stories." *New York Times* (February 4): 37, 44.

Van Gelder, Lawrence, and Lindsey van Gelder. 1970. "Radicalization of the Superheroes." McLaughlin, 20–29.

Walsh, John A., Shawn Martin, and Jennifer St. Germain. 2018. "'The Spider's Web': An Analysis of Fan Mail from *Amazing Spider-Man, 1963–1995.*" *Empirical Comics Research: Digital, Multimodal, and Cognitive Methods.* Ed. Alexander Dunst, Jochen Laubrock, and Janine Wildfeuer. New York: Routledge. 62–84.

Walton, Saige. 2009. "Baroque Mutants in the 21st Century?: Rethinking Genre through the Superhero." Ndalianis 2009b, 86–106.

Wandtke, Terrence R. 2007. "Introduction: Once Upon a Time Once Again." *The Amazing Transforming Superhero! Essays on the Revision of Characters in Comic Books, Film and Television.* Ed. Terrence R. Wandtke. Jefferson: McFarland. 5–32.

———. 2012. *The Meaning of Superhero Comic Books.* Jefferson: McFarland.

Wanzo, Rebecca. 2020. *The Content of Our Caricature: African American Comic Art and Political Belonging.* New York: New York UP.

Warshow, Robert. 2004. "Paul, the Horror Comics, and Dr. Wertham." 1954. *Arguing Comics: Literary Masters on a Popular Medium.* Ed. Jeet Heer and Kent Worcester. Jackson: UP of Mississippi.

Weingroff, Richard F. 2011. "Esquire and Me." Fingeroth and Thomas, 94–96.

Weinstein, Simcha. 2006. *Up, Up, and Oy Vey! How Jewish History, Culture, and Values Shaped the Comic Book Superhero.* Baltimore: Leviathan.

Weldon, Glen. 2016. *The Caped Crusade: Batman and the Rise of Nerd Culture.* New York: Simon and Schuster.

Wells, Earl. 1995. "Once and for All, Who Was the Author of Marvel?" *The Comics Journal* #181 (October): 70–78.

Wertham, Fredric. 1954. *Seduction of the Innocent.* New York: Rinehart.

———. 1973. *The World of Fanzines: A Special Form of Communication.* Carbondale: Southern Illinois UP.

Whaley, Deborah Elizabeth. 2016. *Black Women in Sequence: Re-Inking Comics, Graphic Novels, and Anime.* Seattle: U of Washington P.

White, Biljo. 1964a. "BaTrader." *Batmania* #2 (October): 23.

———. 1964b. "Operation—Batman." *Batmania* #1 (July): 3.

———. 1965a. "Batman before Robin Part II." *Batmania* #7 (November): 4–9.

———. 1965b. "The Batmanians." *Batmania* #3 (January): 21.

———. 1965c. "The Evolution of the Batmobile." *Batmania* #4 (April): 4–8.

———. 1965d. "Open Letter to Editor Jack Schiff." *Batmania* #3 (January): 10–11.

———. 1966a. "The Batmania Philosophy." *Batmania* #12 (October): 4–6.

———. 1966b. "Evolution of the Bat-Plane." *Batmania* #8 (January): 4–8.

———. 1967a. "BaTrader." *Batmania* #14 (February): 20–23.

———. 1967b. "The New White House of Comics." *Batmania* #15 (May): 17–20

White, Biljo, et al. 1964. "The New Look." *Batmania* #1 (July): 4–9, 20–21.

White, Ted. 1968. "A Conversation with the Man behind Marvel Comics: Stan Lee." McLaughlin, 3–13.

Whitted, Qiana. 2019. *EC Comics: Race, Shock, and Social Protest.* New Brunswick: Rutgers UP.

Wiater, Stanley, and Stephen R. Bissette. 1993. *Comic Book Rebels: Conversations with the Creators of the New Comics.* New York: Fine.

Wilde, Jenée. 2011. "Queer Matters in *The Dark Knight Returns*: Why We Insist on a Sexual Identity for Batman." Durand and Leigh, 104–23.

Williams, Paul, and James Lyons, eds. 2010. *The Rise of the American Comics Artist: Creators and Contexts.* Jackson: UP of Mississippi.

Wimsatt, W. K., and Monroe C. Beardsley. 1954. "The Intentional Fallacy." 1946. *The Verbal Icon.* By W. K. Wimsatt. Lexington: UP of Kentucky. 3–18.

Winthrop, John. 2012. "A Model of Christian Charity." 1630. *The Norton Anthology of American Literature. Vol. A: Beginnings to 1820.* 8th ed. New York: Norton. 166–77.

Wolf, Mark J. P. 2012. *Building Imaginary Worlds: The Theory and History of Subcreation.* New York: Routledge.

Wolk, Douglass. 2013. "Superhero Smackdown: Marvel vs. DC Comics." *Slate* (August 16).

Woo, Benjamin. 2008. "An Age-Old Problem: Problematics of Comic Book Historiography." *International Journal of Comic Art* 10.1: 268–79.

———. 2011. "The Android's Dungeon: Comic-Bookstores, Cultural Spaces, and the Social Practices of Audiences." *Journal of Graphic Novels and Comics* 2.2: 125–36.

———. 2012. "Understanding Understandings of Comics: Reading and Collecting as Media-Oriented Practices." *Participations* 9.2: 180–99.

Wright, Bradford W. 2001. *Comic Book Nation: The Transformation of Youth Culture in America.* Baltimore: Johns Hopkins UP.

Wright, Frederick. 2008. "How Can 575 Comic Books Weigh under an Ounce? Comic Book Collecting in the Digital Age." *Journal of Electronic Publishing* 11.3.

Yockey, Matt. 2012. "Retopia: The Dialectics of the Superhero Comics Book." *Studies in Comics* 3.2: 349–70.

———, ed. 2017. *Make Ours Marvel: Media Convergence and a Comics Universe.* Austin: U of Texas P.

Zinman, David. 1965. "Comicdom's Cult of Collectors." *Newsday* (November 4). Schelly, *Golden Age*, 92.

Zorbaugh, Harvey. 1944. "The Comics—There They Stand!" *The Comics as an Educational Medium.* Ed. Harvey Zorbaugh. Special issue of *The Journal of Educational Sociology* 18.4 (December): 196–203.

INDEX

Pustz, Matthew, 5, 27, 35, 37, 45, 50, 53, 55–56, 63–65, 65n34, 67, 70, 118, 122n30, 147–48, 166, 204, 212, 224n13

racial equality, 153
racism, stories about, 65n33
Raphael, Jordan, 2, 9, 18n18, 41, 88, 97, 101–2n16, 102, 134, 146n48
reader interaction, 79, 99–93, 110, 117–26, 137, 140–41, 144–45, 155, 211n1, 227, 245, 266
readerly practices, 30, 39, 49, 64, 84, 89, 166, 185, 197, 229, 264
Real Fact Comics #5, 11, 45–48, 47 fig. 1.2, 63, 74
reboots, 2, 89, 218, 257, 277
Regalado, Aldo J., 4n3, 51, 64, 64n31, 67n37, 72, 227n17
Regn, Gerhard, 20, 22–24
religious rhetoric, 118, 118n26, 153–55, 154n54
repetition, 16, 34, 39, 80, 97, 159, 162, 164, 168, 181, 226–27, 231n23: with a critical distance, 162
reprints of "classic" stories, 115–16, 213–15, 215n4: selective, 258
retcons (retroactive continuity), 89, 218, 228, 255–58, 270: as conservative or progressive, 257
"Return of Doctor Doom, The" (*Fantastic Four* #10), 119, 129
Richmond, Tom, 160
Robbins, Trina, 208, 258
Robin (character), 27, 30, 45–48, 47 fig. 1.2, 57, 59n26, 60–61, 71–72, 72n40, 75–76, 78–80, 97, 158, 177, 222, 236, 246–47, 249: parody of, 167, 170, 171 fig. 3.2, 173–76, 175 fig. 3.3, 178, 181, 183–84, 186–88, 188n30, 194–95
"Robin's Unassisted Triple Play" (*Batman* #172), 53
Robinson, Jerry, 236–37
Romita, John, 55n21, 109–10, 113 fig. 2.5, 139n45, 146n48, 264n45
Rubin (character), 167, 170–72, 171 fig. 3.2
Ryan, Marie-Laure, 90–91, 130n36, 143, 145

Sanderson, Peter, 4, 31, 55n21, 122n29, 218, 228, 234, 236, 238, 240, 257, 259
Schaffenberger, Kurt, 25, 53n17
Schelly, Bill, 53n17–18, 59n27, 65, 66n35–36, 72, 177–79, 177–78n23, 178n24, 211, 216, 216n5
Schiff, Jack, 48, 69
Schumacher, Joel, 158
Schwartz, Julius, 5, 48, 55n21, 60, 63, 67, 70, 74, 118n26
"Scribbly" (Mayer), 165
second wave feminism, 114, 208
secret identity, superhero, 22, 88, 94–96, 94 fig. 2.1, 96 fig. 2.2, 112 fig. 2.4, 124 fig. 2.6, 130–34, 135 fig. 2.8, 140, 168
"Secret of Batman's Utility Belt!, The" (*Detective Comics* #185), 247n32
"Secret War of the Phantom General, The" (*Detective Comics* #343), 61
"Secrets of Spider-Man, The" (*Spider-Man Annual* #1), 140
self-parody, 180, 187–90, 193
Sentinels of Liberty, 43, 57, 65, 149, 272, 275
serial narration, 2–14, 18–20, 26–31, 34–36, 38–39, 42, 45–46, 61, 63–64, 77–78, 83, 90, 98, 106, 114, 135–37, 140, 155, 159, 161–62, 162n9, 169–70, 173, 177–78n, 184, 190, 219–20, 224, 226–27, 231, 243, 245, 248–49, 258, 261, 264, continuity, 1–2, 128, 137, 152–53, 251–52, 252n37; memory, 57, 91; sprawl, 23, 46, 46n12, 80, 89, 194, 213–14, 228, 249, 257, 269
setting, 88–89, 111, 111n21, 135–40
Severin, Marie, 138, 141, 142 fig. 2.9, 188
sexism, 55n21, 56, 58, 58n24, 79n48, 138n42, 164, 167, 207–8
Shooter, Jim, 55–56, 146n48, 190, 204
Showcase, 180–81, 180n25, 197
Shuster, Joe, 9–10, 10n9, 18, 29, 34, 82–83, 146, 168, 172n16, 205n47, 223, 239: biography, 44–45, 45n8; parodies of, 205
Siegel, Jerry, 9–10, 10n9, 18, 29, 34, 83, 146, 168, 172n16, 205, 205n47, 223, 239: biography: 44–45, 45n8
Silver Age of Comics, 14, 16, 28, 200, 207, 238, 253, 268

STUDIES IN COMICS AND CARTOONS

Jared Gardner, Charles Hatfield, and Rebecca Wanzo, Series Editors
Lucy Shelton Caswell, Founding Editor Emerita

Books published in Studies in Comics and Cartoons focus exclusively on comics and graphic literature, highlighting their relation to literary studies. The series includes monographs and edited collections that cover the history of comics and cartoons from the editorial cartoon and early sequential comics of the nineteenth century through webcomics of the twenty-first. Studies that focus on international comics are also considered.

CPSIA information can be obtained
at www.ICGtesting.com
Printed in the USA
BVHW030051310821
615639BV00007B/35